W9-ATW-503

MAY - - 2012

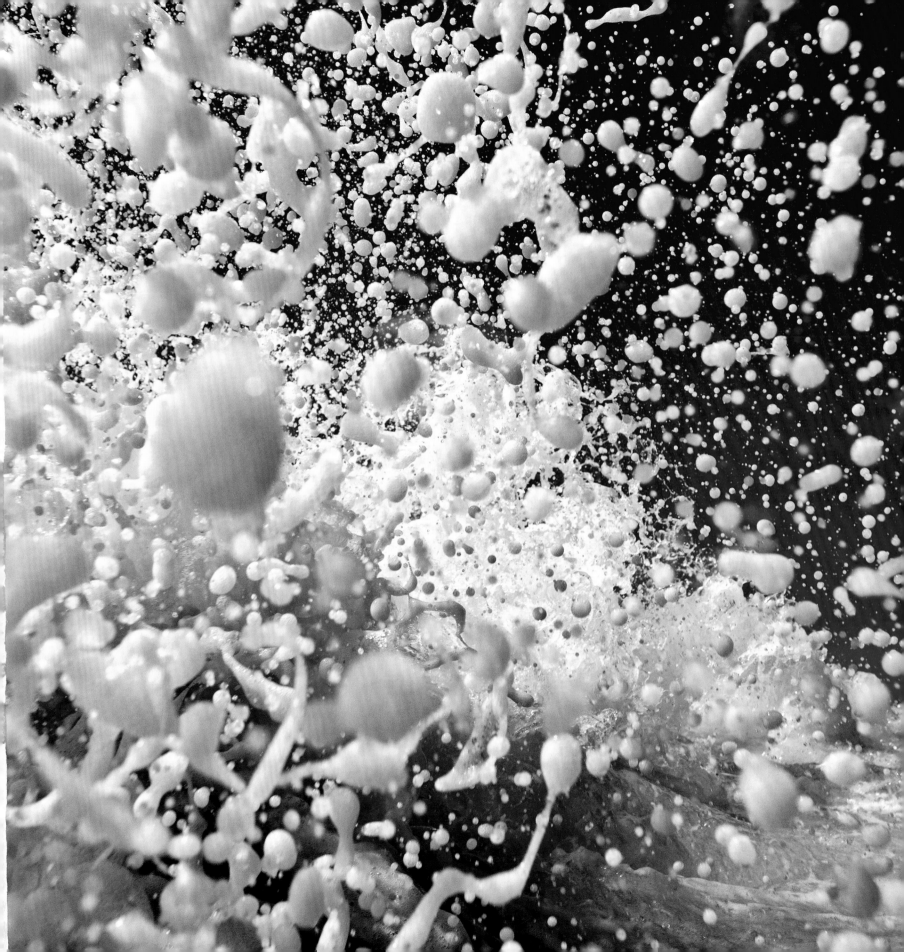

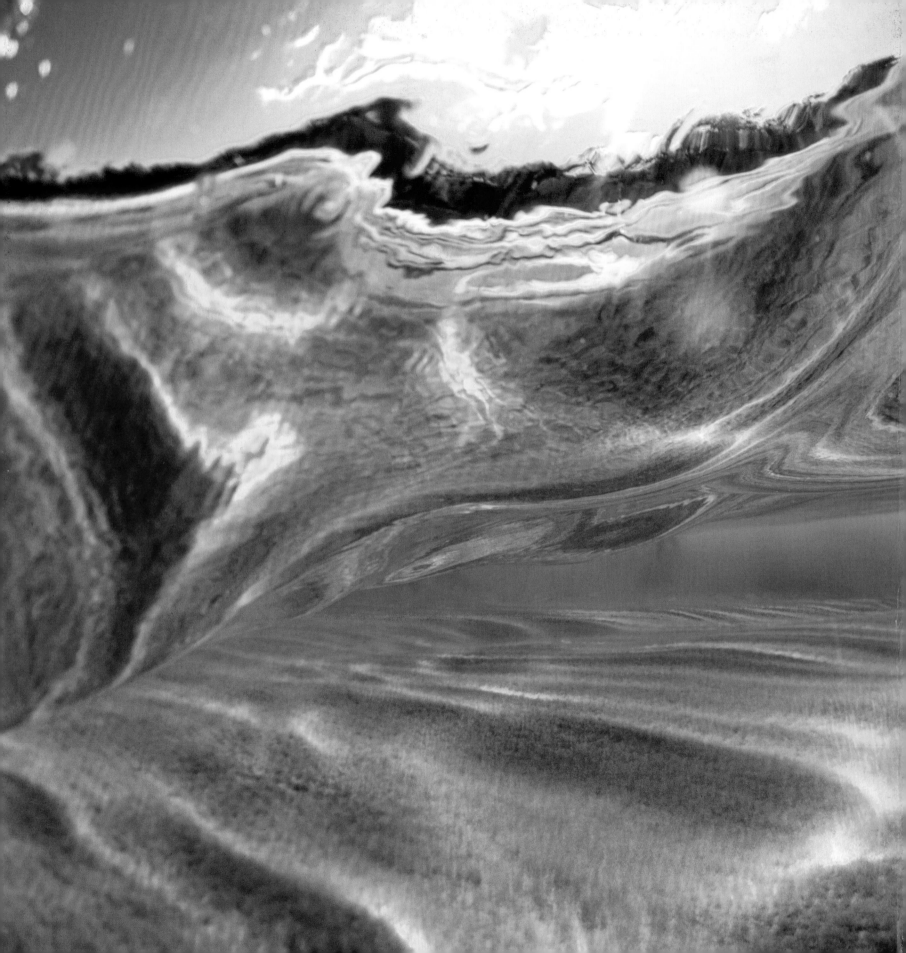

CLARK LITTLE
WITH **JAMIE BRISICK**

FOREWORD BY
KELLY SLATER

CLARK LITTLE
THE ART OF WAVES

1❿
TEN SPEED PRESS
California | New York

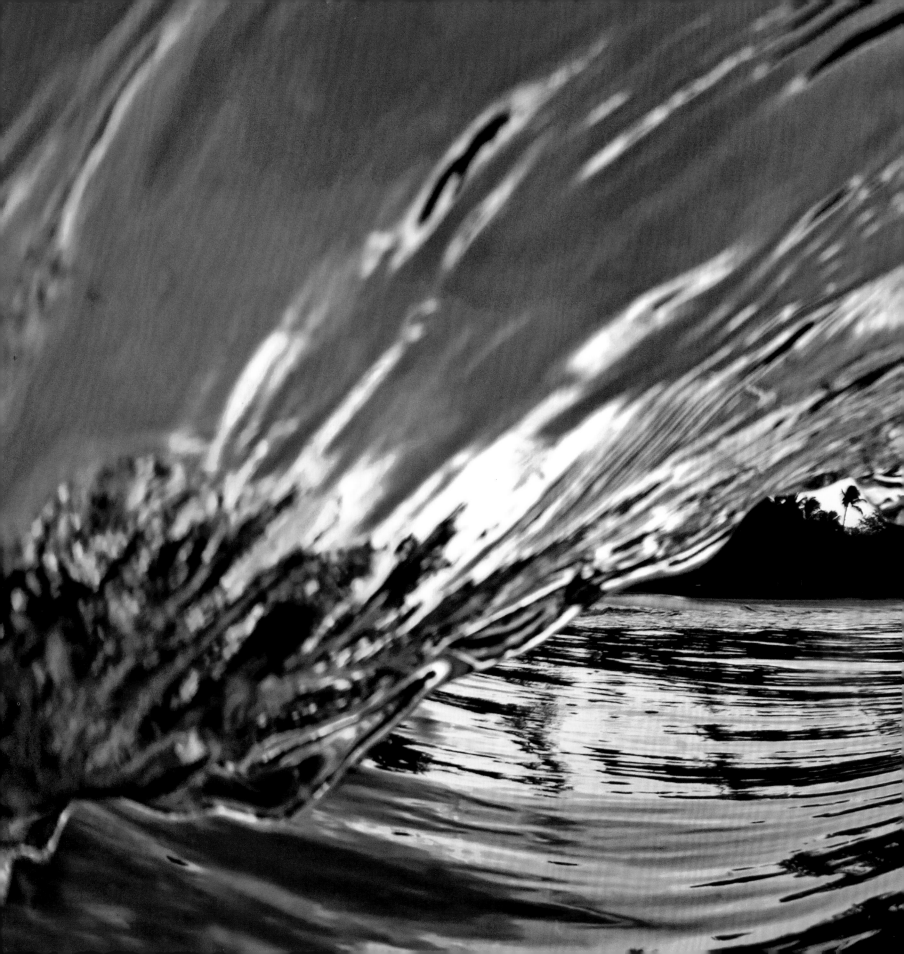

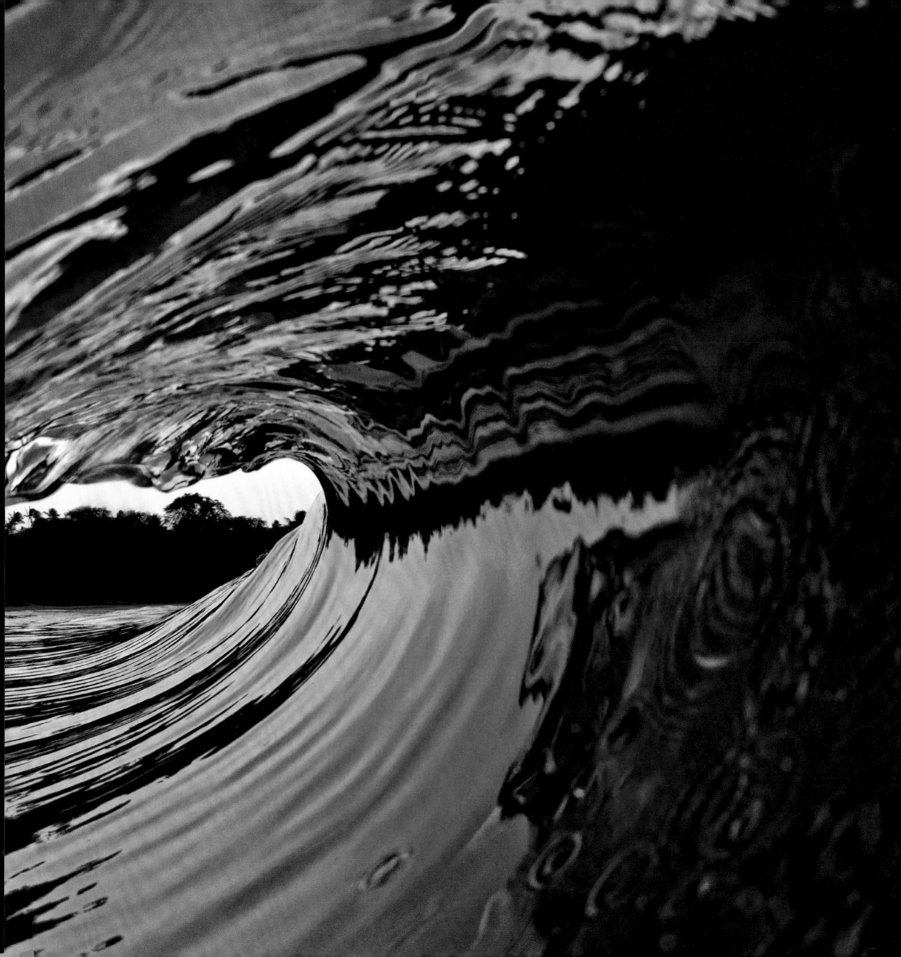

Contents

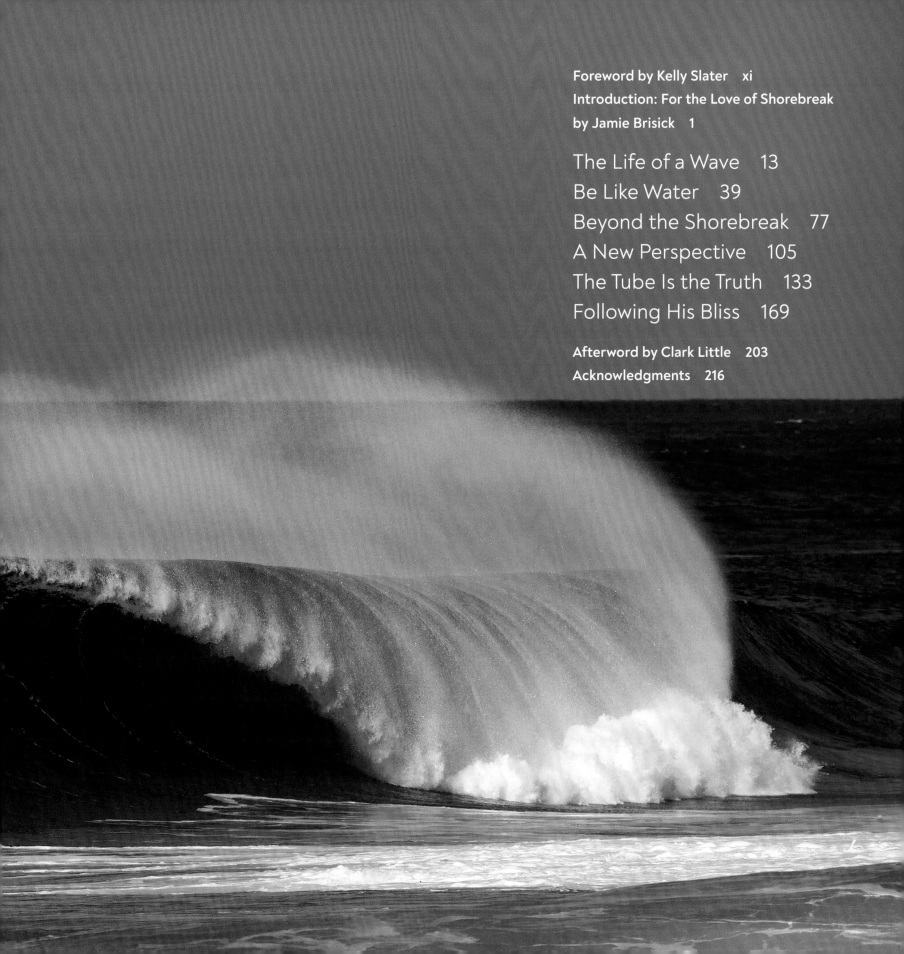

Foreword by Kelly Slater xi
Introduction: For the Love of Shorebreak
by Jamie Brisick 1

The Life of a Wave 13
Be Like Water 39
Beyond the Shorebreak 77
A New Perspective 105
The Tube Is the Truth 133
Following His Bliss 169

Afterword by Clark Little 203
Acknowledgments 216

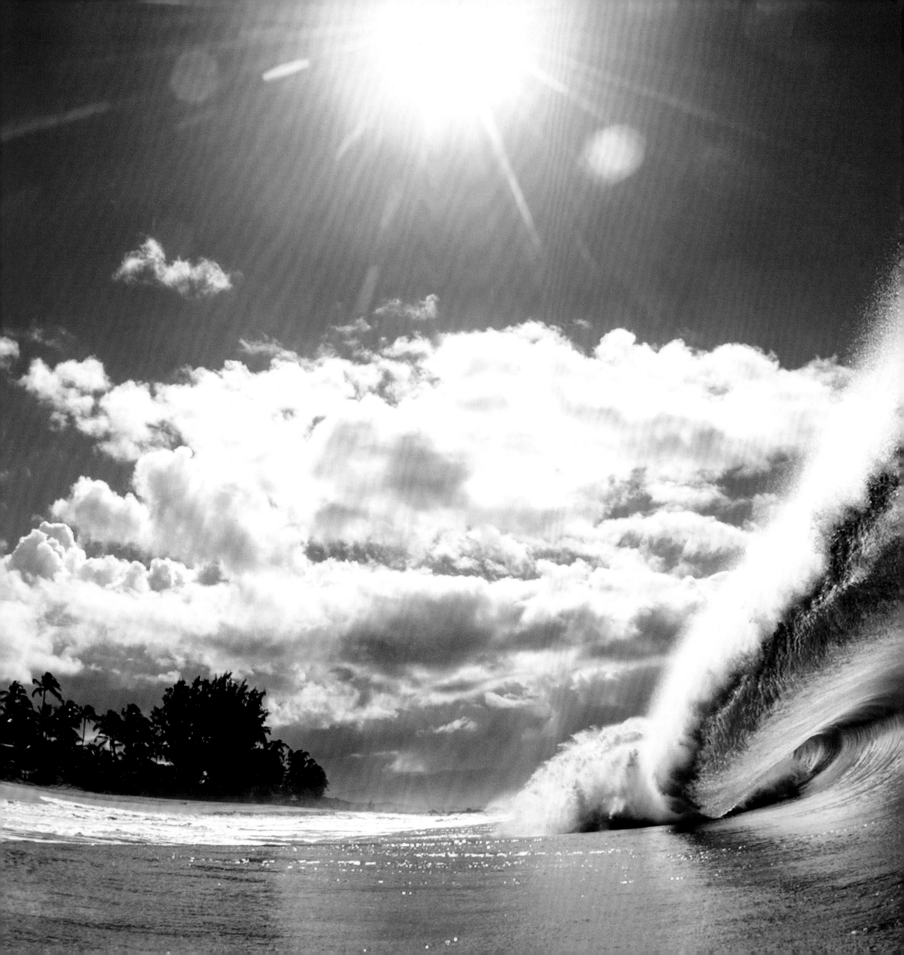

Dedicated in loving memory to my
mother, Doric, and my brother, Brock.

—C.L.

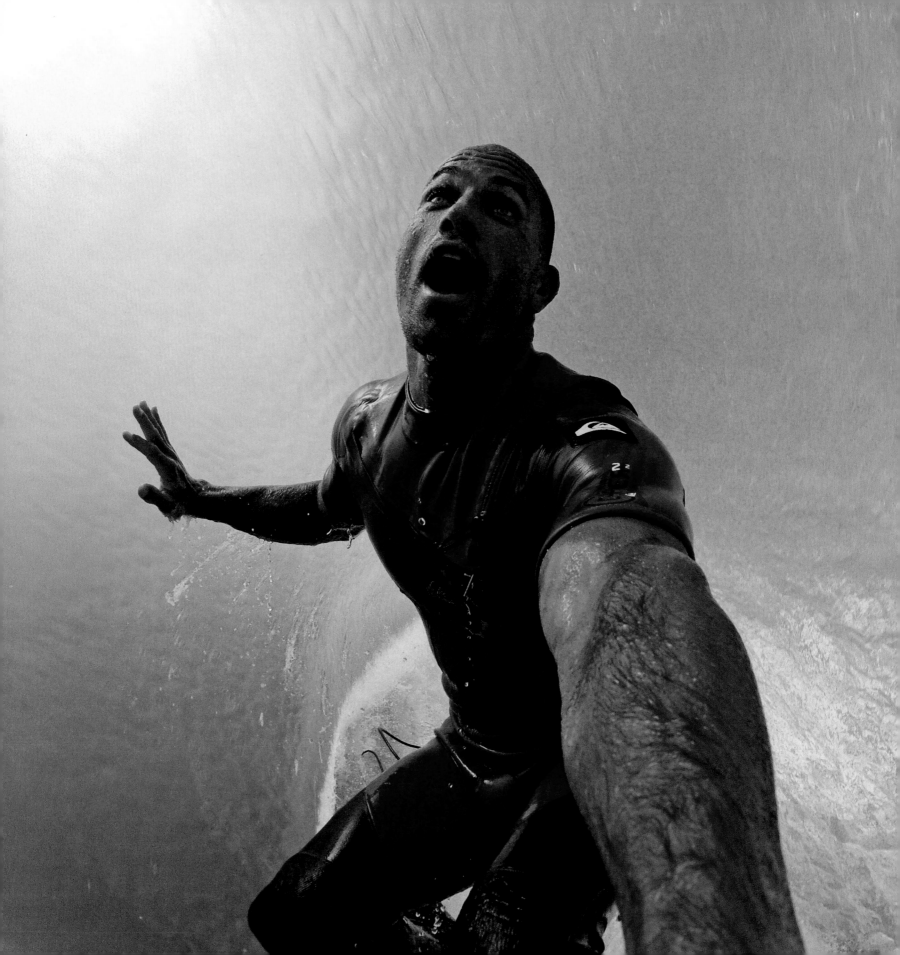

Foreword

By Kelly Slater

We surf because it's exciting and it's scary. It's primal. It makes you feel alive.

The ultimate in surfing is the tube. Getting a good tube is the best part of the experience. I will literally travel to the other side of the earth for one swell, if I know I will get the right tubes for a day or two. It is that addictive. We are all addicted. But if your addiction is surfing, it doesn't seem like an addiction. It just feels like a passion—with an addictive quality.

You may wonder how it feels to be in powerful waves, especially inside a tube. I don't know how to explain the sensation of the barrel to people who don't surf, because it can't be done. I don't think there is a metaphor you can draw or a comparison to what people do in their everyday lives. This incredibly fulfilling and unexplainable thing might be just as hard to describe as those feelings parents have when they see their kid walk for the first time, or ride a bike for the first time, or make a homer in a little league game. It's a very specific feeling, full of emotion, and challenging to express.

Inside the barrel, you become hyper aware. Many who have been there say "Time slows down." The spiritual surfers back in the sixties and seventies would say it's like returning to the womb. If you look at great forces of nature—be they hurricanes, or solar systems, or galaxies—they are all spinning. The tube is the same type of natural phenomenon. Similar to the calm found in the eye of a hurricane, the safest place to be is in the middle of the tube, with all of that energy right there, surrounding you. There are high and low pressures, and you are in the low pressure at the center of the whole force. The excitement is riding that energy and being a part of it. It's not about controlling it. It's just fitting into it—properly. When you are in alignment with the wave, and not thinking about it, that's when the synchronicity happens, and it all just seems to make sense. It's being in the zone and flowing with it. To put it simply, we as surfers are just chasing nature and its energy. And the tube is the center of that energy.

SELF PORTRAIT
Burleigh Heads,
Queensland, Australia
Photo by Kelly Slater

When we were growing up, Clark Little gave no indication that he would take up wave photography, let alone succeed at it. He was kind of a mystery to me. I was close with his older brother Brock, and not as much with Clark, even though we were all hanging around the same house a lot. Brock was more of a surf junkie and a mentor, whereas Clark was in his younger days and having a good time. He was the sidekick brother. Not getting into bad trouble, but pushing the bar a bit.

Ever since we were kids, we called Clark "Turbo" because he liked to drive his four-wheel drive truck really fast. That was back when most of Pūpūkea Heights wasn't developed. The two brothers basically had a four-wheel truck course across from their home. He and Brock, who went on to become a Hollywood stuntman, would bomb their trucks through the empty lot. The big story was when Clark flipped his truck one day. Luckily, nobody died.

We all knew Clark was a good surfer, but he was the polar opposite of Brock. Clark liked shorebreak closeout waves, while Brock liked the big outer reefs. Brock was daring and crazy, but he was also super rough around the edges when it came to doing anything and everything. He didn't quite finish the things he began. He was messy. His motorcycle was always dirty. We called him "Green Cloud." Clark, on the other hand, is cleaner and keeps his things nice. He has obsessive tendencies and does a pretty thorough job of whatever he takes on.

When Clark started out as a photographer, no one was taking photos like his. The first few images that I saw made me think *Oh, duh, this is easy.* I am not talking about the hard work that goes into getting the shots or developing an eye for it, a talent for seeing those images. What I mean is, the up-close perspective inside the waves seemed so obvious, especially to someone like me who surfs every day and also experiences waves from inches away. But as it turned out, the viewpoint in Clark's shots were new to many people. It struck a chord. Though Clark was not the first person to take a picture inside the tube, he had found a different branch on the tree, something unique, and put all of his energy into it. As a result, he became the original. Clark was Bitcoin. He was Band-Aid. What other bandage company do you know besides Band-Aid? Once someone captures something unique and gets it out there, then they corner that idea. They become joined with it in people's minds. Shorebreak photography *is* Clark Little—and Clark Little is shorebreak photography.

Of course, to capture these images you must be a good surfer—one with an eye for what the wave is doing, who understands the mechanics and physics of a wave. A random photographer from the Midwest isn't going to jump into these waves on the North Shore. Nor could a National Geographic photographer. Shooting the shorebreak is a very particular thing. For a surfer like Clark, who grew up in these kind of waves and knows and understands the ocean, it comes naturally. When his wife wanted a picture of a wave above their bed, Clark thought *I can do that.* He bought a crappy waterproof camera, dove into the shorebreak, and started snapping photos from inside tubes. It was a flashbulb moment. He took that idea and ran with it. And when a pursuit is fueled by passion, the business side, marketing side, and every other aspect follows more readily.

Clark was mowing grass and taking care of a botanical garden for years before he started photography at thirty-eight. Maybe he enjoyed that work, but gardens were not his full-on passion. He wasn't seeing gardens differently from other people. (I'll leave plants to Clark's dad, Jim, who's an expert hybridizer of plumeria flowers and raises them on an incredible farm.)

So for me, the underlying message from Clark's work is to commit to what you are doing wholeheartedly. Believe in yourself, believe in the vision, and commit to bringing that to people as you see it, whatever it is. It could be software, art, music. It doesn't matter. It's seeing something and then delivering it to people in your own way.

As you journey through this book, try slowing yourself down to take in the images. Fast-moving waves, and the tubes within them, have been frozen in time. Discover new things you haven't seen before. You may even find images hidden within the photos; in some famous surfing pictures taken over the years, like Denjiro Sato's shot of Gerry Lopez surfing at Pipeline, people have seen things like ancient Hawaiian faces in the waves.

Picture yourself inside some tubes. Get in the zone and let your mind wander.

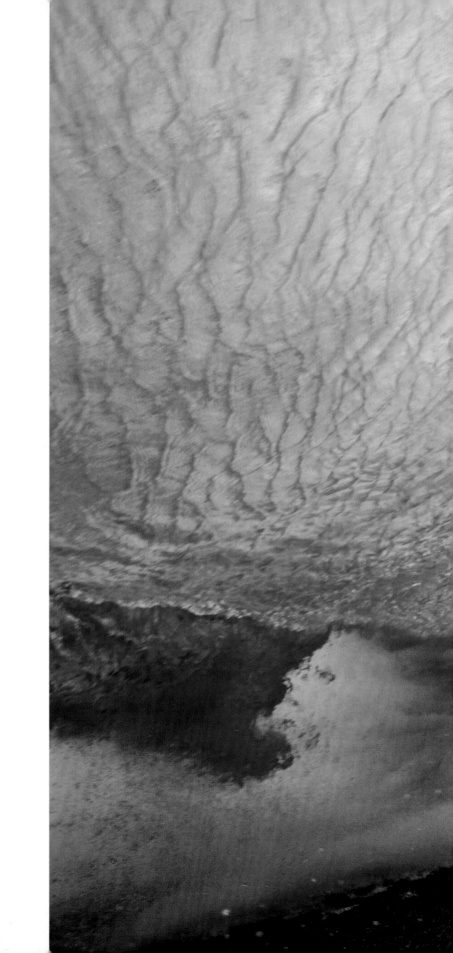

SILVER SURFER
North Shore, O'ahu

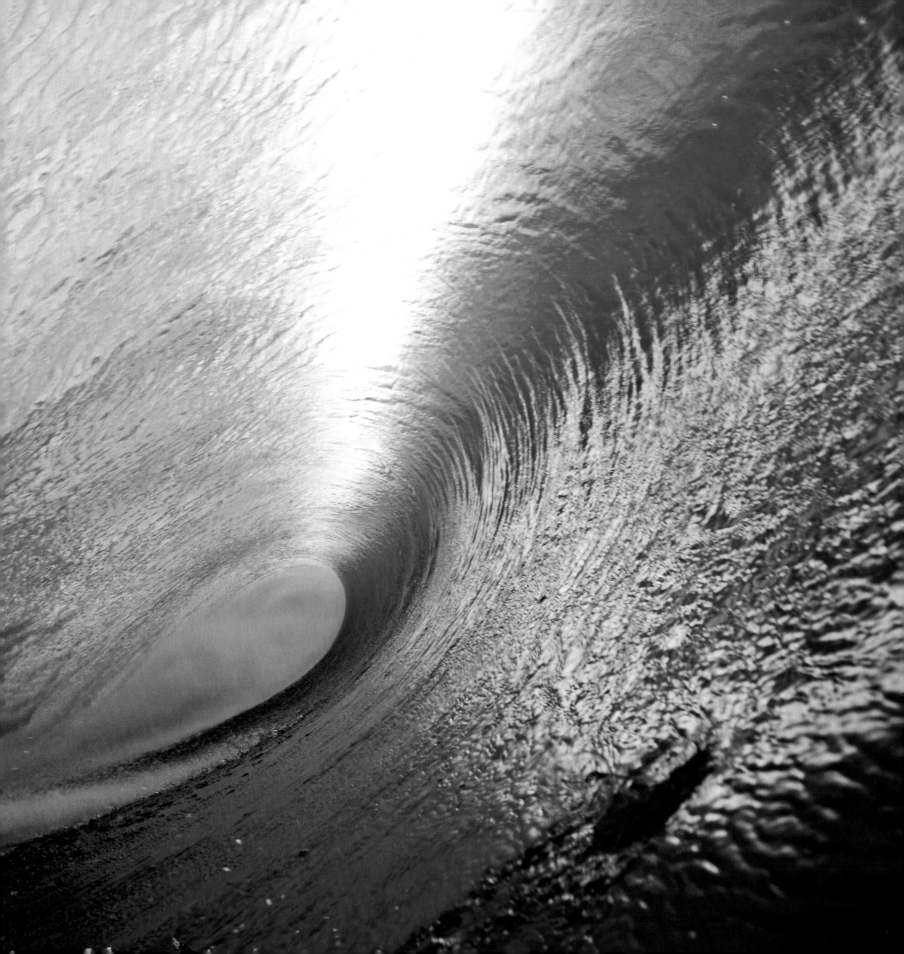

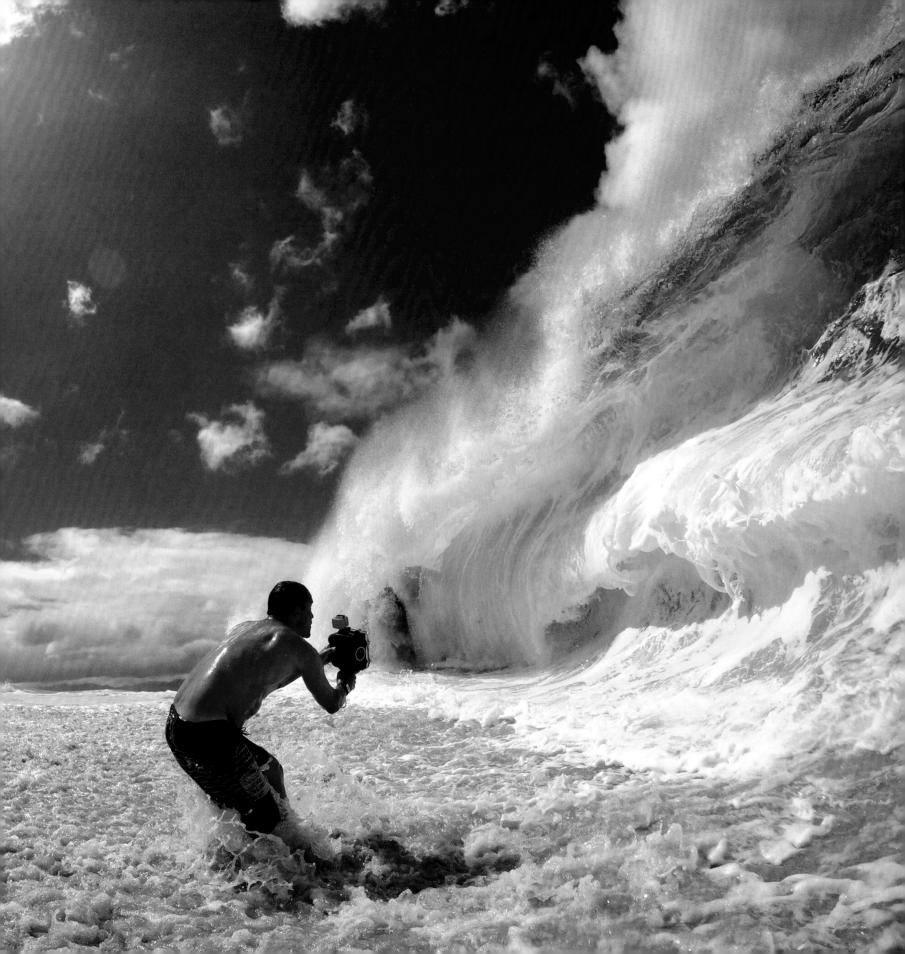

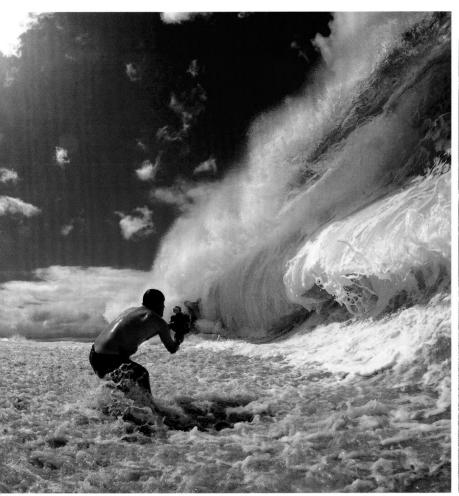
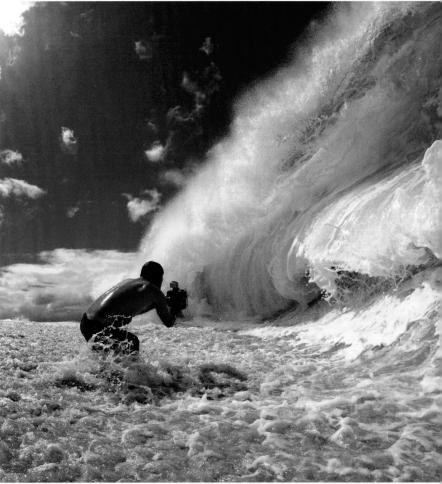

GETTING THE SHOT (SEQUENCE)
North Shore, O'ahu
Photos by Tharin Rosa

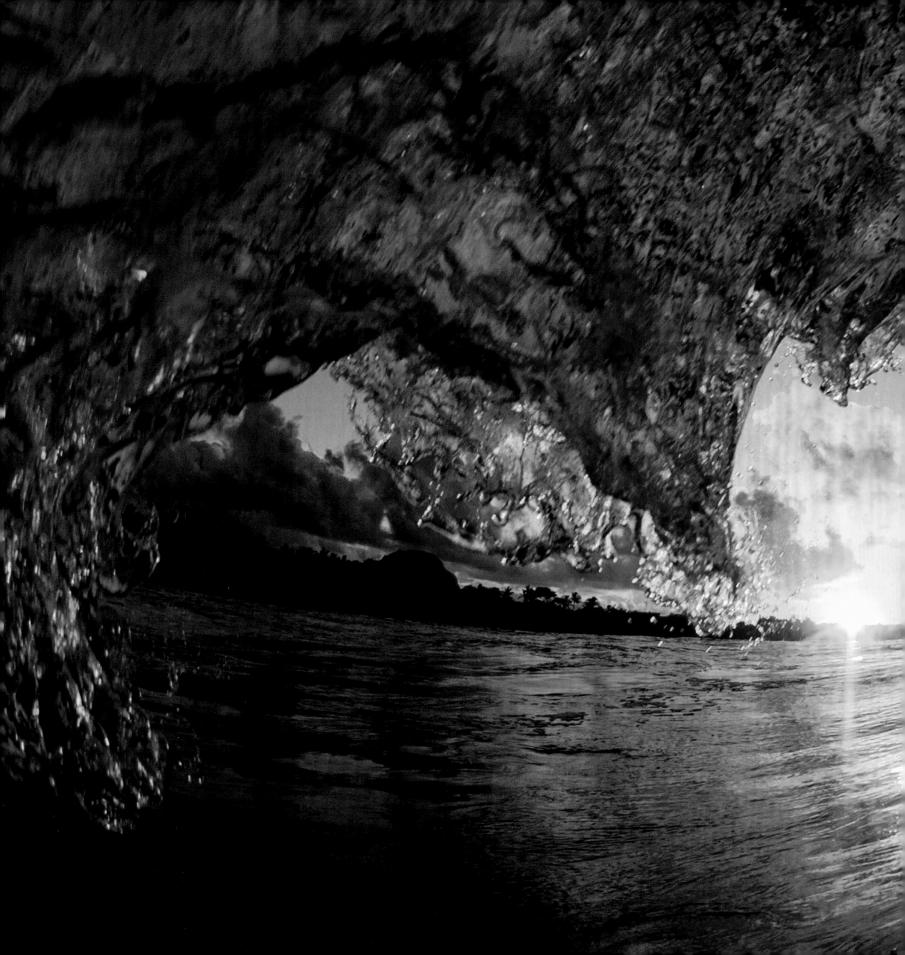

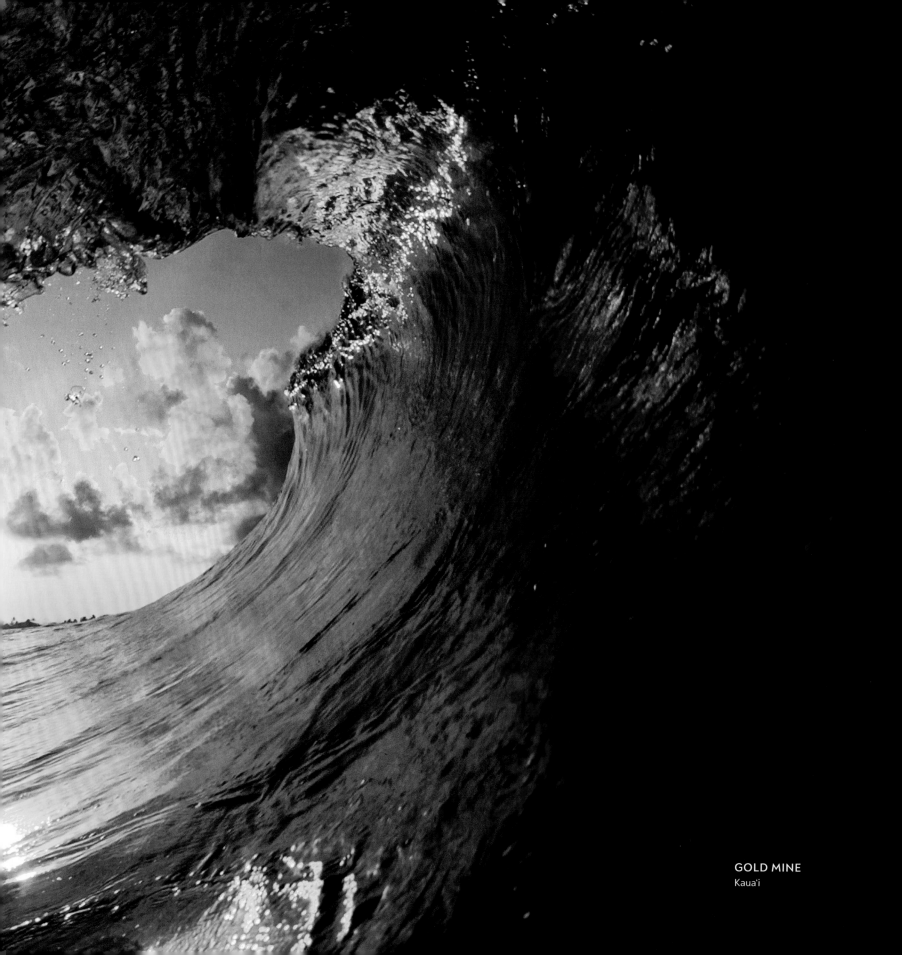

GOLD MINE
Kaua'i

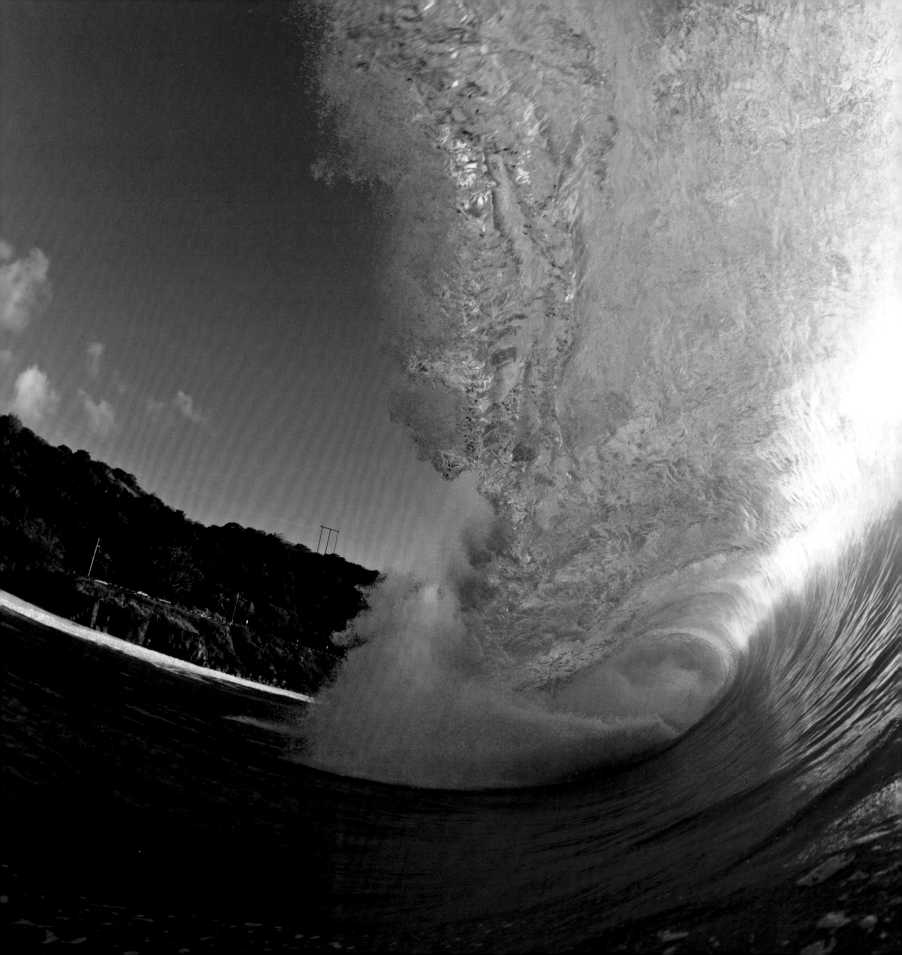

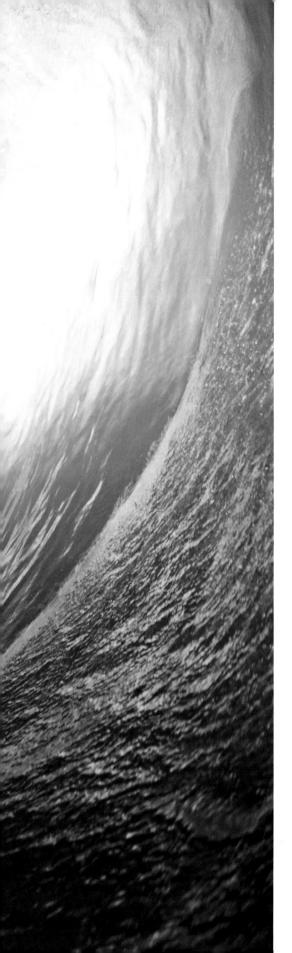

Introduction:
For the Love of Shorebreak

By Jamie Brisick

Clark Little never set out to become the world's best wave photographer, but in hindsight it seems as if he's spent his entire life training to be exactly that. He's been a devout surfer since the age of six, on the North Shore of O'ahu, where the waves are big and powerful, and the light and water color are majestic. Clark and his older brother, Brock, were thrill-seekers. While Brock heaved himself over the ledges of thirty-foot beasts on the outside at Waimea Bay, Clark preferred the Waimea shorebreak, where swells bounced and torqued and tripled up before exploding on shallow, neck-breaking sand. His amygdala registered no fear, and his pain threshold was like an MMA fighter's. Clark is designed to be in dangerous water.

In 2007, Clark's wife, Sandy, bought a photo of a wave, shot from the shore, to hang on their bedroom wall.

Clark saw it and chuckled. "Honey, what are you doing buying a picture of a wave?" he said. "I've surfed the shorebreak all my life. I'm going to go out and get one from inside the barrel."

With a cheap point-and-shoot camera encased in a water housing purchased on Amazon, he threw himself into the Waimea shorebreak, the same wave he grew up surfing, not far from their family home. After a series of requisite beatings, he nailed some shots.

The results were spectacular. The fast shutter speed froze what in real time happens way too quickly for the naked eye to study. The way the wave sucked up the sand. The way the heaving lip resembled blown glass, with reflections of trees and the shoreline.

Because a barreling wave is so powerful and fickle, the tube is an almost sacred space that most surfers see rarely, if ever. Clark had spent his entire surf life getting into the tube—and out of it—without breaking his neck. His lifelong relationship with it was palpable, and the shots he took that day had a sort of ultrasound-like intimacy. For years he had tried using words, with limited success,

THE BAY
Waimea Bay, O'ahu

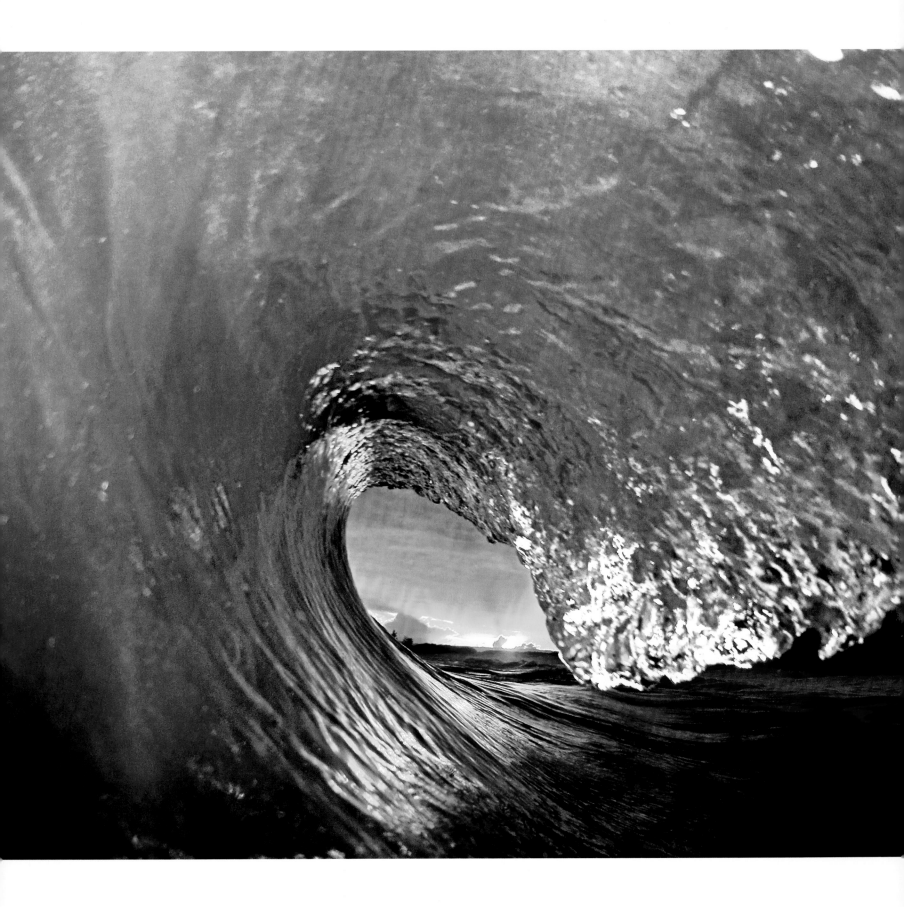

to explain what he saw and experienced. These photos were his first chance to truly share with others the incredible world he was witnessing inside the shorebreak waves.

Clark knew tubing waves, but he also knew something else subconsciously: composition. His father, Jim, taught photography and art at Punahou School and University of Hawai'i Leeward for thirty years. While Clark spent his formative years frolicking in giant surf, he also hung out with his dad in the darkroom on the weekends, and he grew up with photos lying around the house. The Golden Ratio, the well-balanced frame, the nuances of light and color—Clark was exposed to all the principles of good photographic composition. Without thinking, he absorbed this knowledge and applied it years later to frame the shot in a split second, deep inside the tube.

Sandy loved the new wave photos on her walls, and Clark loved hurling himself into thick, tubing shorebreak with a camera. He shared his images with family and friends—they were rapt. He upgraded his camera gear and started to pass his work around. His breakthrough came when he was asked to submit twenty photos to a prominent UK news agency. On a single day in February 2009, several major UK newspapers featured both Clark's images and stories about him. He woke the next morning to more than seven hundred gushing emails, including requests to appear on *Good Morning America, The Today Show, Inside Edition,* and others. Within one year, Clark resigned from his supervisory position at the Wahiawā Botanical Garden and devoted himself full-time to photography.

Since then, Clark's rare combination of skills has sharpened and strengthened. He's gotten even wiser to the whims of the sea and almost Bruce Lee-like in his dances with slamming waves. He has a sense of zen calm in even the heaviest situations. Instead of worrying about getting pummeled, he focuses completely on capturing the decisive moment. And he's expanded beyond the shorebreak, training his lens on the myriad sea life that abounds beneath the surface, and the unique shapes, colors, and perspectives caught from high above it.

This book is a survey of his remarkable body of work. Some of these images have enjoyed long and storied lives; many others have never been published before. Interspersed with essays, interviews, and quotes, the following pages will give you a greater understanding of both Clark Little and that special space inside a breaking wave.

ORANGE CRUSH
North Shore, O'ahu

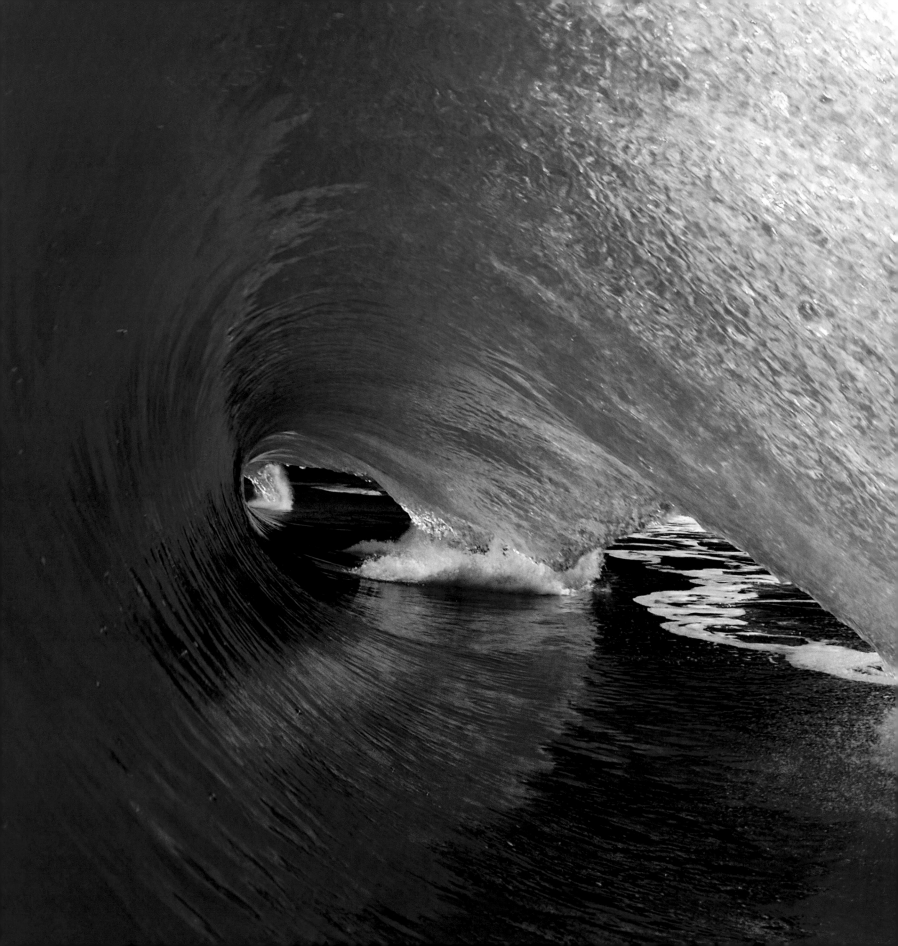

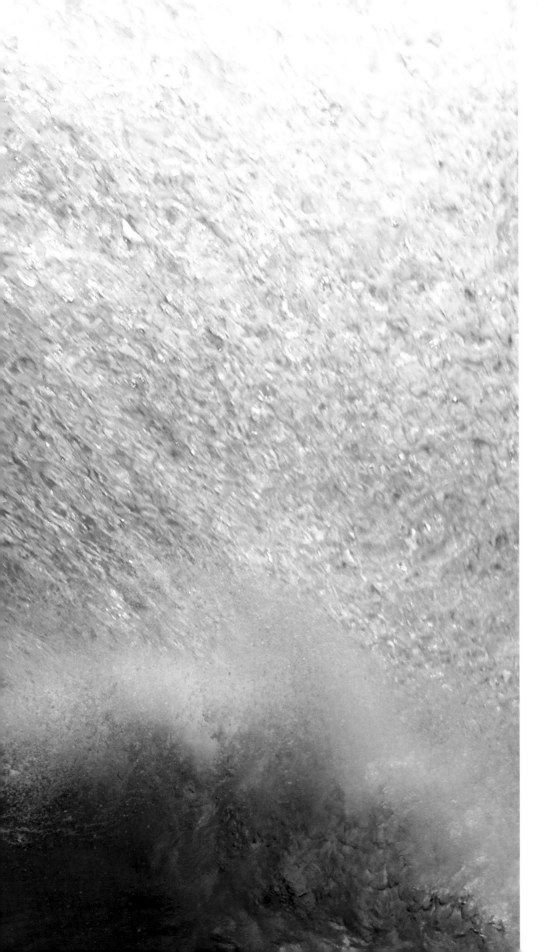

TWIN FALLS
Waimea Bay, O'ahu

Inside the shorebreak at Waimea Bay. Shot with a Nikon D200, my first professional DSLR camera. It was taken in April 2007, only a few months after jumping in for the first time with a cheap point-and-shoot camera. The D200 shoots five frames per second and was a big upgrade from the point-and-shoot, which would take several seconds just to adjust the auto focus before it got a single shot, often missing the wave entirely.

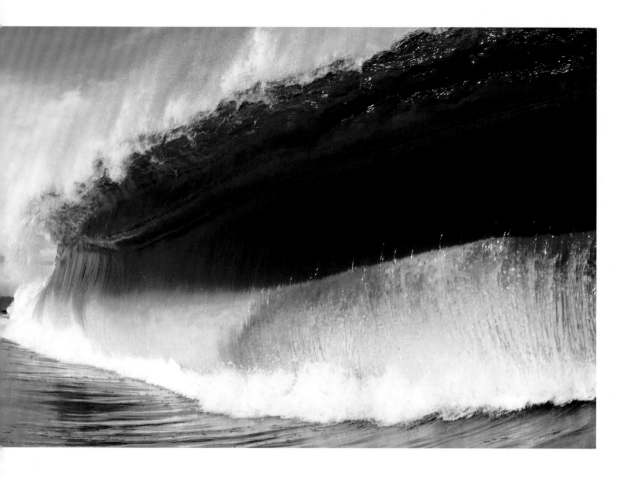

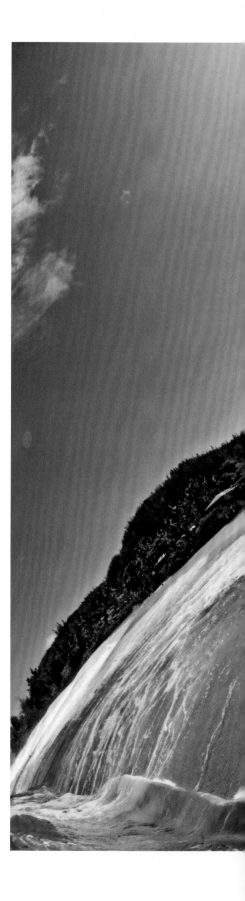

STEAMROLLER
North Shore, O'ahu
(above)

UP AND OVER
North Shore, O'ahu
(right)

The waves in these two photos are essentially identical in size and shape. These are massive surges rolling through shallow water, but barely forming a tube. We call them "kegs," "bulldozers," and "steamrollers." Both waves are bad situations and have a high potential to dish out beatings since I can't swim under them, through them, or find an escape route. The wave on the right is shot from 10 to 12 feet above as I am being sucked "over the falls." After getting sucked over, then I get bulldozed. Notice the sand bottom just a few feet below the surface—it's very shallow. In these situations, there is not much to do but to snap a few shots before my world turns upside down and my skills (and luck) are tested.

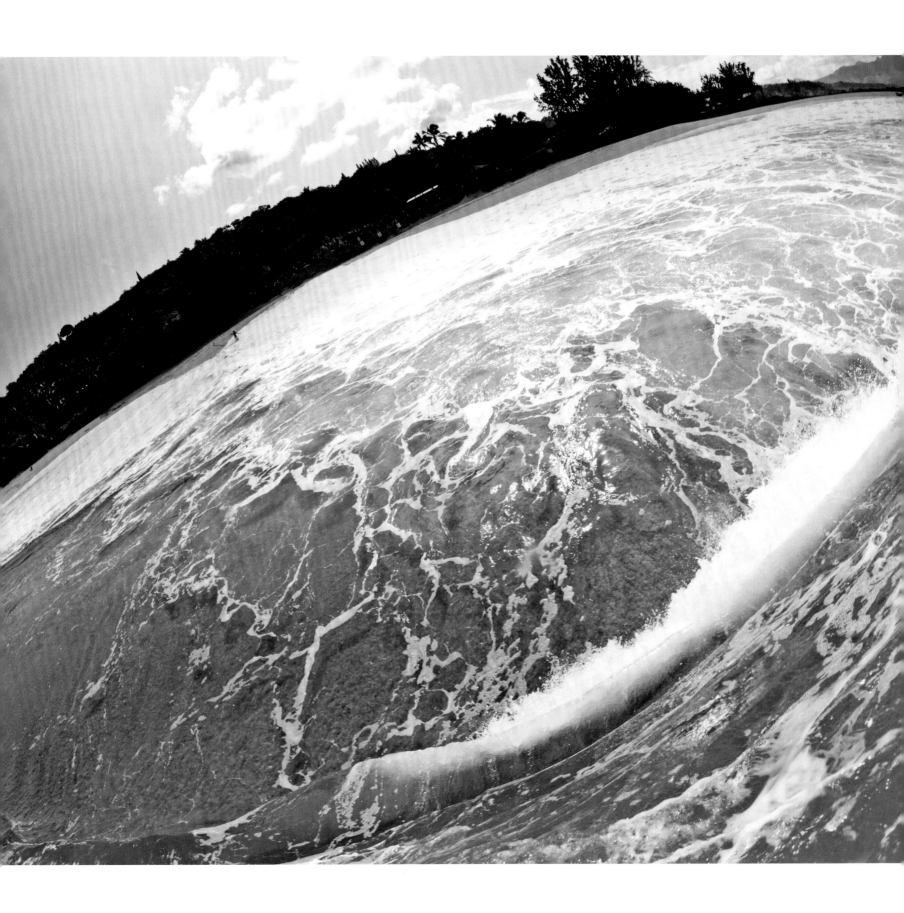

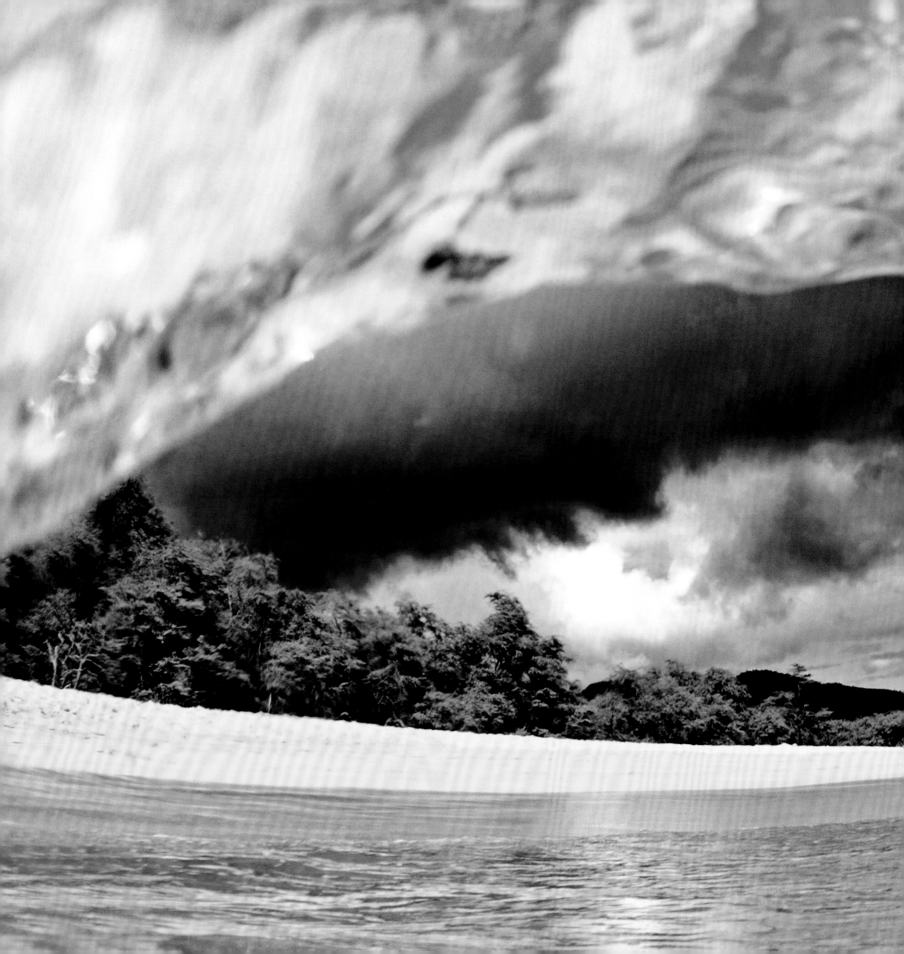

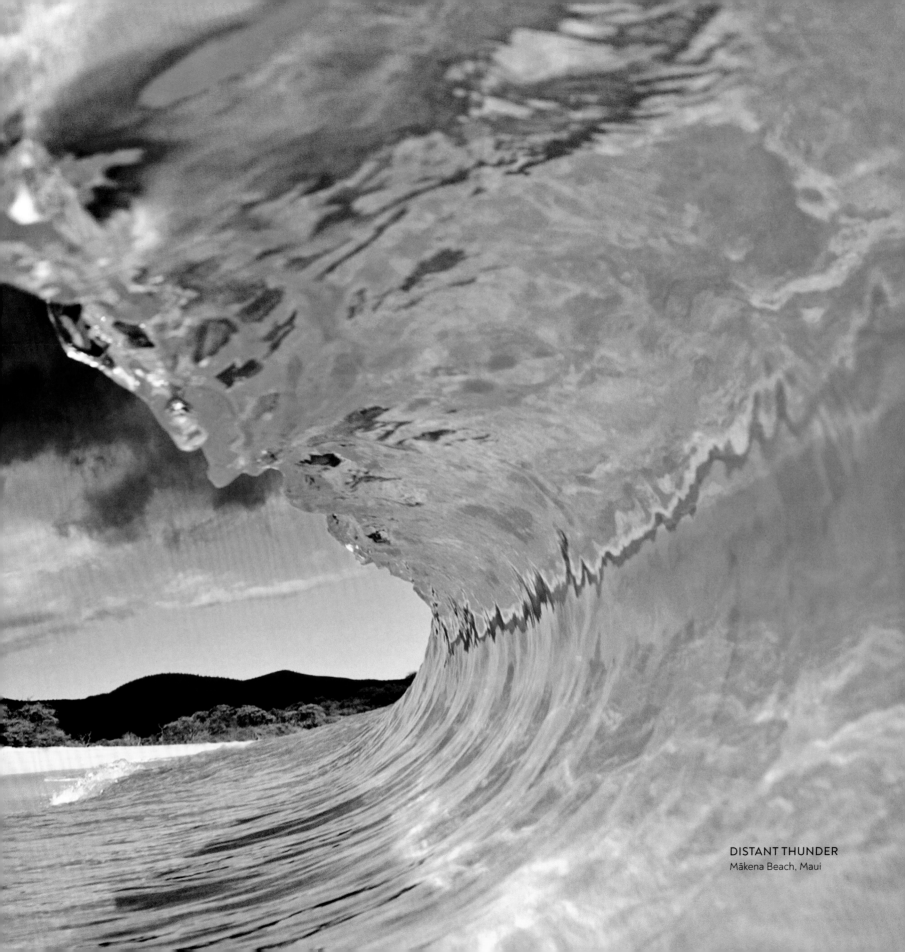

DISTANT THUNDER
Mākena Beach, Maui

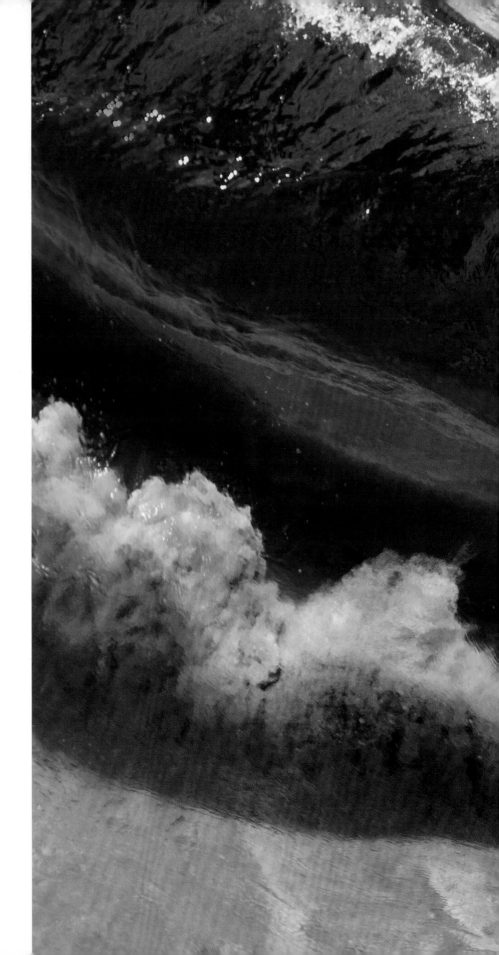

"I'm always chasing that perfect wave
where all the elements come together."

KNOCK OUT
North Shore, O'ahu

Seeing that the sand is getting sucked off the sand bar and pulled up into the face of the wave, it's a guarantee the water is just a foot or two deep. At this moment, I am standing with my swim fins solidly anchored to the sand bottom, leaning in toward the wave, and preparing for the coming impact. My finger is solidly on the camera trigger, capturing a series of shots. *Tak, tak, tak, tak, tak.* I am getting my last pictures in as the tube begins to form. In another second, the wave will enclose me and I will aim for the escape hatch, which is to get myself through the thick wall. For smaller waves, I would just stay in this position and go with the wave, allowing it to take me on a fun ride toward shore. When waves get into the medium range like this wave, I try to get through it, and avoid the ride. On the extra large waves, sometimes I need to ditch my camera entirely (luckily it's on a leash), and use my hands together with my feet in what feels like hand-to-hand combat, so I don't get pulled back into the wave and its fiery explosion.

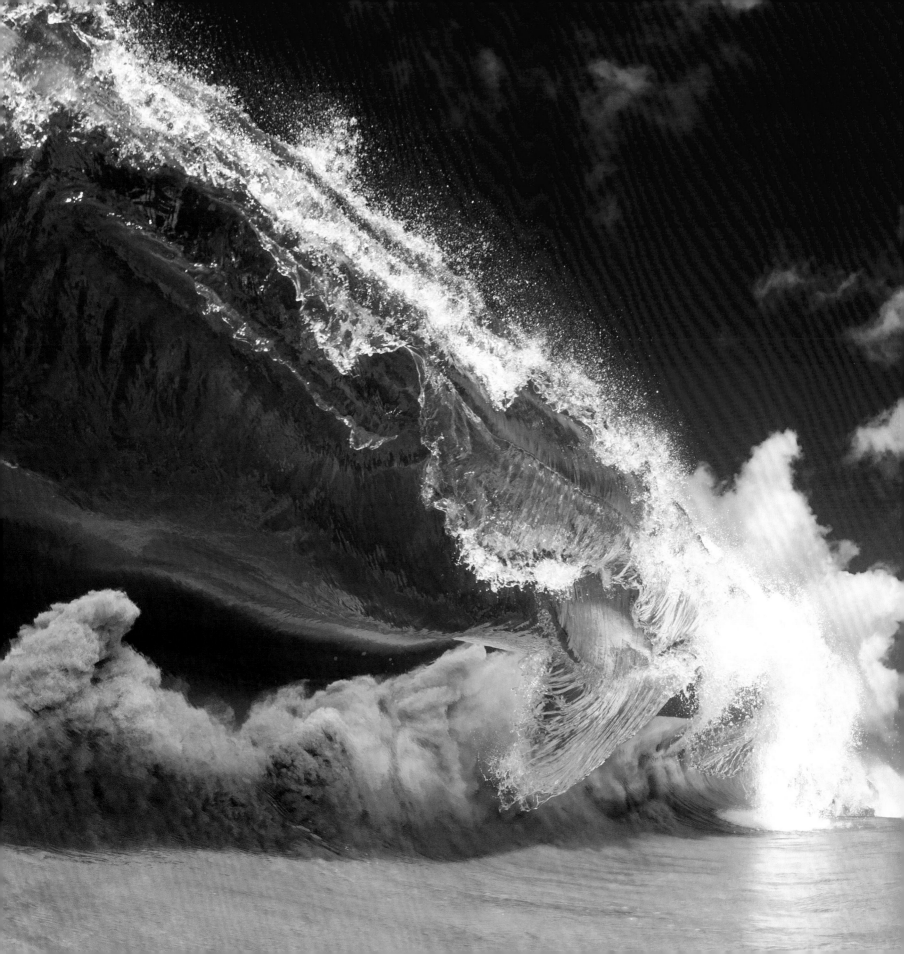

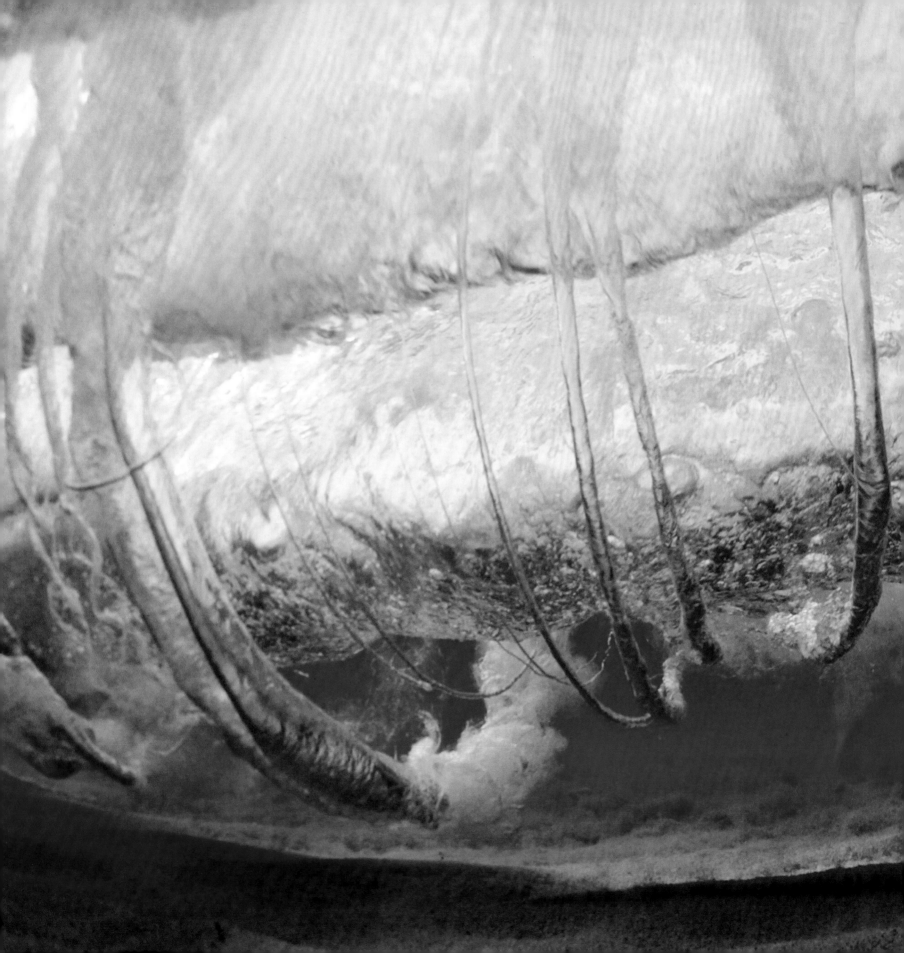

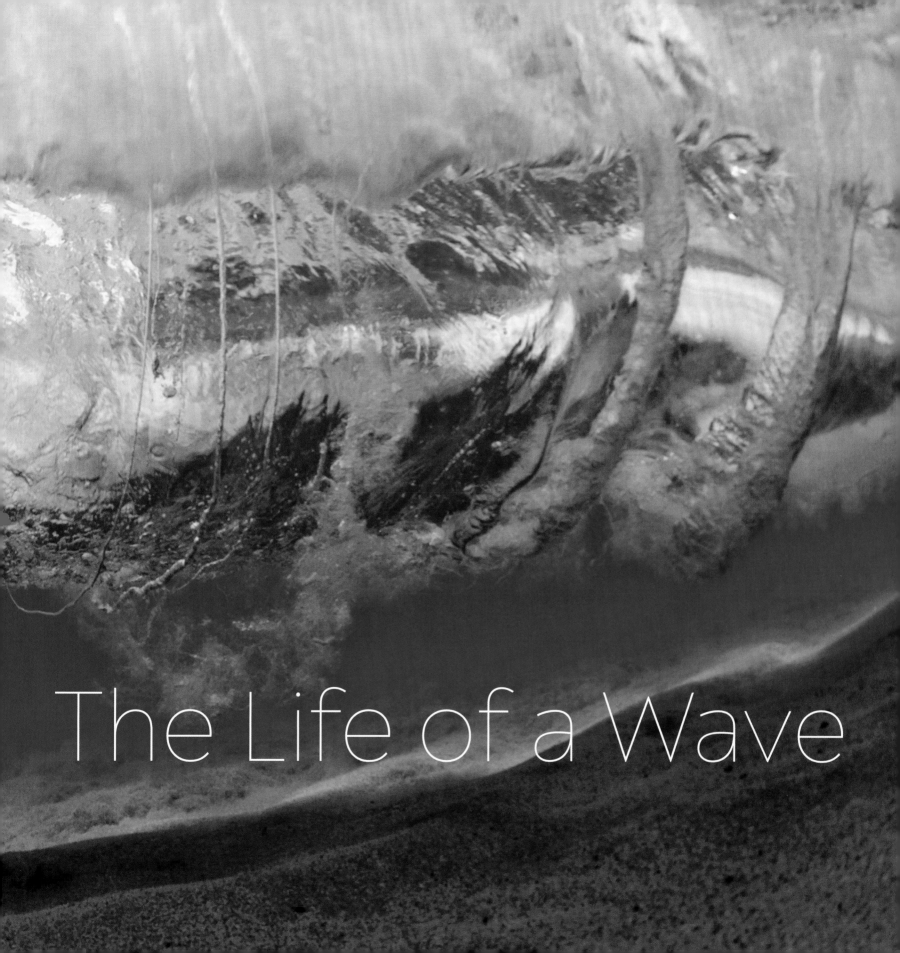

The Life of a Wave

Hawai'i has no continental shelf to slow swells—that's why the North Shore is home to some of the biggest and most powerful waves in the world. That slamming surf is created by distant storms, typically in the North Pacific. Separate bands of cold and warm air collide and spiral around each other, kicking up ground swell that travels across thousands of miles of ocean.

With the help of the internet, Clark can track a swell days in advance and watch it slowly mow toward his home break, Ke Iki. If the swell is big, in the ten-foot-plus range, it shows up onscreen as a purple blob. Clark has a special relationship with these purple blobs. They inhabit his nervous system, keep him glued to his computer and phone. The night before the swell hits, he's up texting with his crew, assessing what combination of tide, wind, and light will yield the perfect window for shooting. On the morning of, he wakes to the sound of thundering surf. He guzzles down coffee, loads his gear into his truck, and heads down the hill to a friend's house, where he and the crew check the waves from the backyard deck.

Ke Iki is not known as a quality surf break for board surfers. There's no reef to make the waves peel. The beach slopes steeply down to meet the water, and that big purple blob hits the shore without any interference. This collision between deep-water swell and terra firma can form perfect arcing tubes right on the sand. Clark explains, "Ke Iki is another animal compared to any other shorebreak in the world. I have seen waves as big as a two-story house break right on dry sand. *Kaboom!* When a huge set's coming—say, twelve feet—I have to decide where I want to put myself to get the image. I'm knee-deep, looking into this cave of water, trying to position my hand as steady and level as I can, and then hitting the trigger on my camera housing as the wave gets close. If that wave's setting up to throw a beautiful curl, I'm holding the trigger with half fear and half excitement, just knowing I'm in the sweet spot. What happens next is another story. With some waves at Ke Iki, I get blasted thirty to forty feet up the beach, covered in sand from head to toe, and coughing out chunks of sand, pebbles, and small rocks. But I got the shot."

TWISTER
North Shore, O'ahu
(previous page)

CLEAR AND PRESENT DANGER
North Shore, O'ahu
(right)

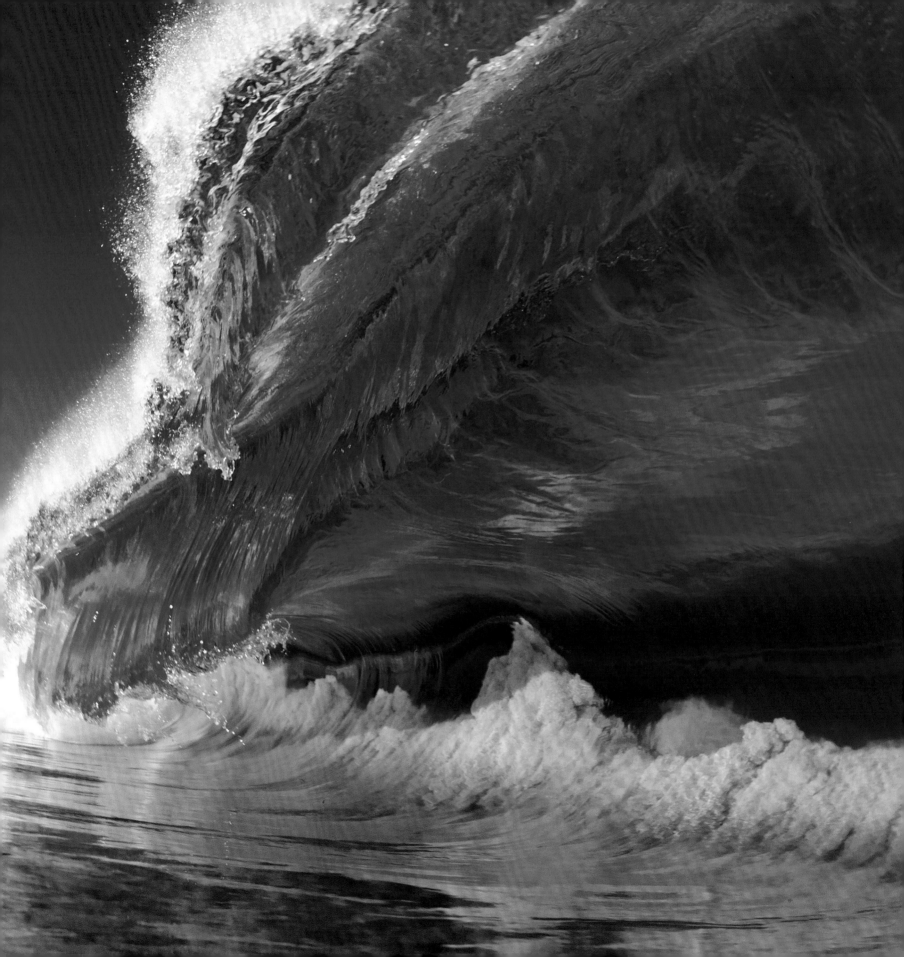

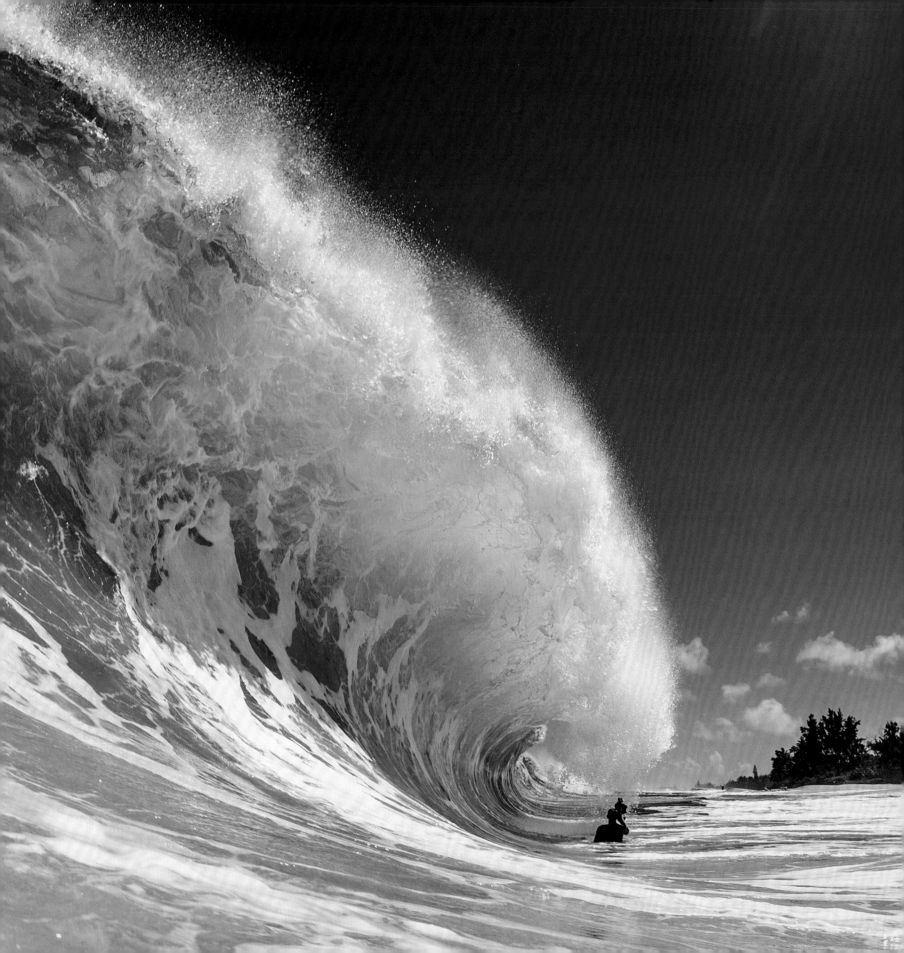

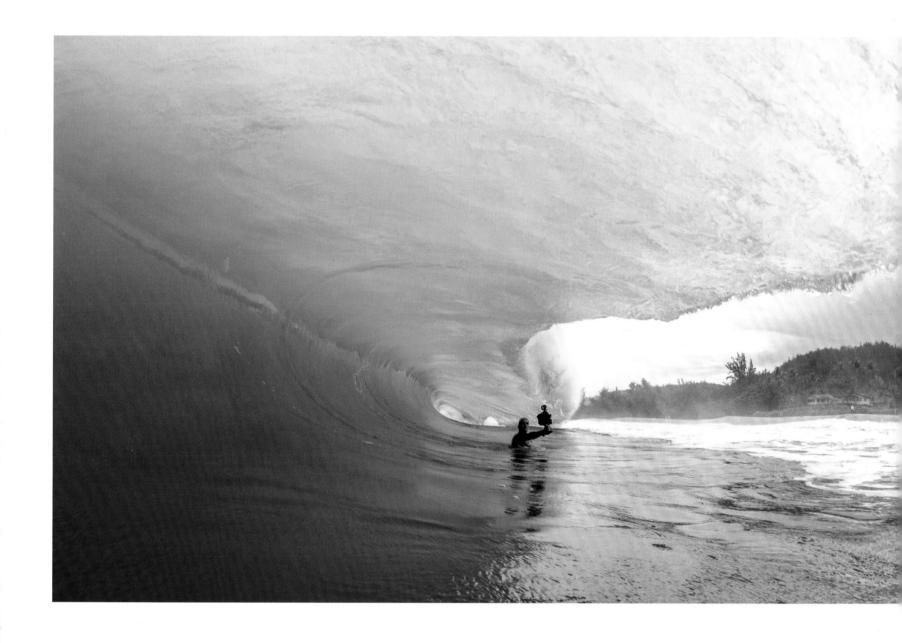

CLARK SHOOTING
North Shore, O'ahu
(left and above)
Photos by Jerrett Lau

CHARIOTS OF FIRE
The Wedge, Newport Beach, California
(next page)

The Wedge has a lot similarities to the shorebreak waves found on the North Shore. Especially the power of the waves and how it can throw a big tube right on the beach. It's a serious shorebreak wave and the only one like it that I've experienced outside the North Shore. The sunset lines right up with the tube, making the end of the day my favorite time to shoot. When I first started going there, hardly anyone else was taking pictures in the water. On the beach was another story. People hang out and watch the sunset. It's a good vibe.

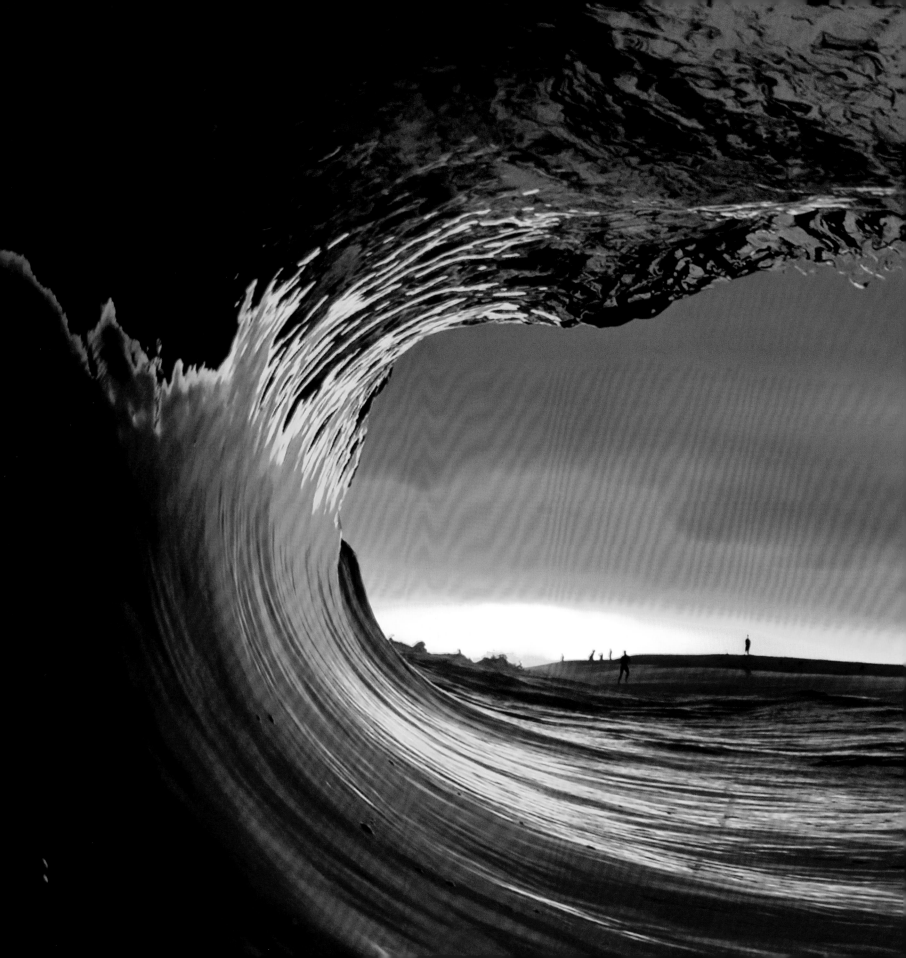

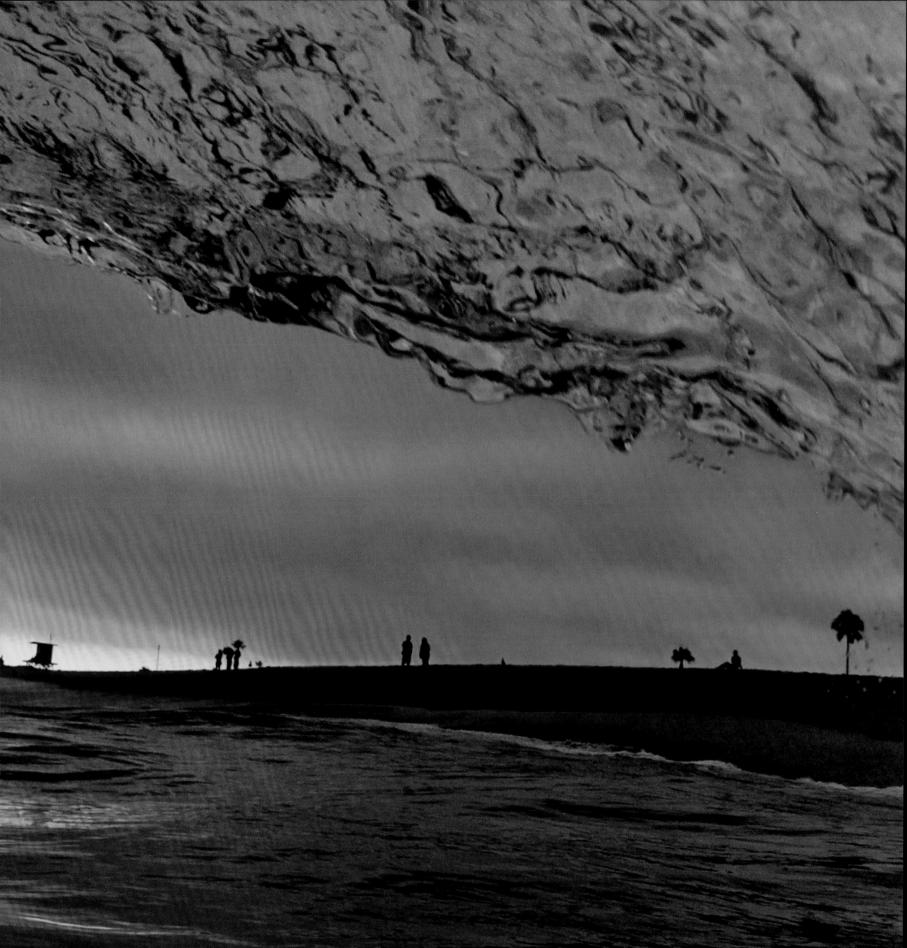

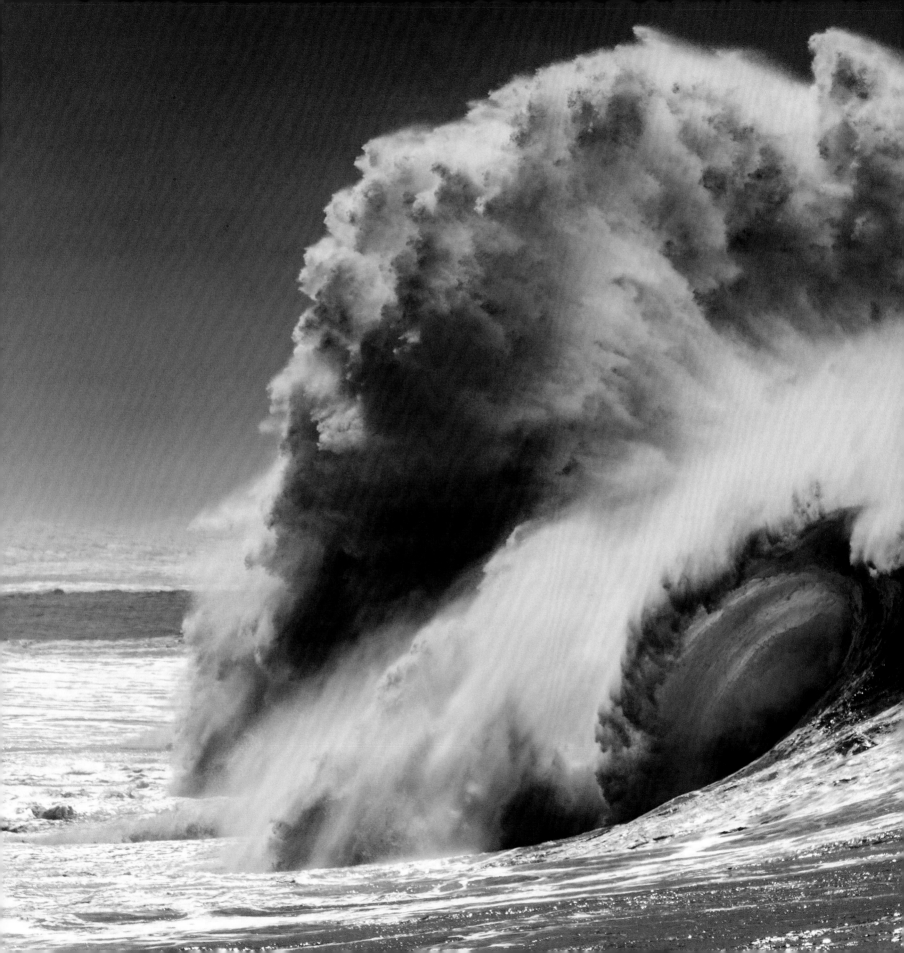

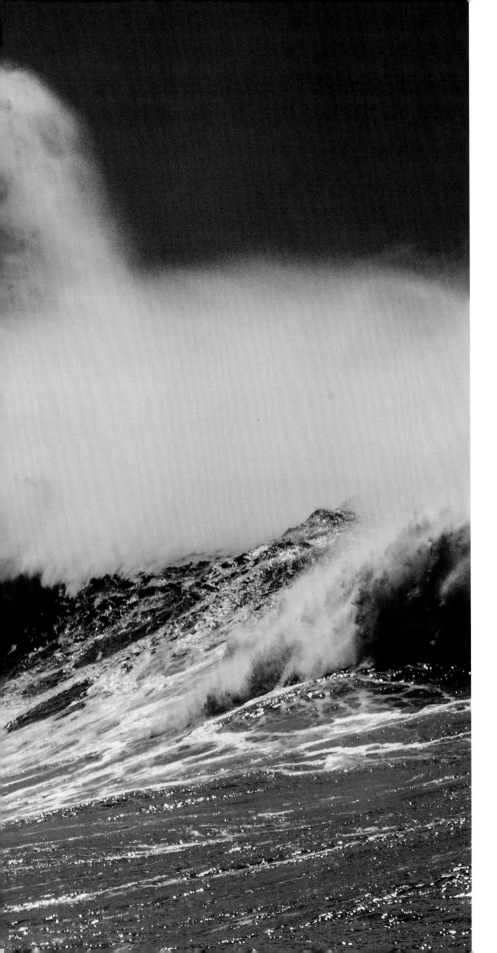

BROCKSWELL
Waimea Bay, O'ahu

Waimea shorebreak during the 2016 Eddie Aikau surf contest. Since 1985, the contest has only been held eight times because of its rules requiring consistently large size surf for an entire day. My brother, Brock, who had been invited to surf in previous Eddie contests and even got second place one year, had just passed away one week prior. Because of its unusual timing, some people called this swell "The Brockswell." I was shooting the surfers in the contest from the land on the church side of the Bay, when a powerful wave came in and exploded against the rocks on the opposite corner. I happened to be looking in that direction and was able to capture this beautiful, powerful, mystic wave. It's really different from anything else I've shot and is named in honor of my brother.

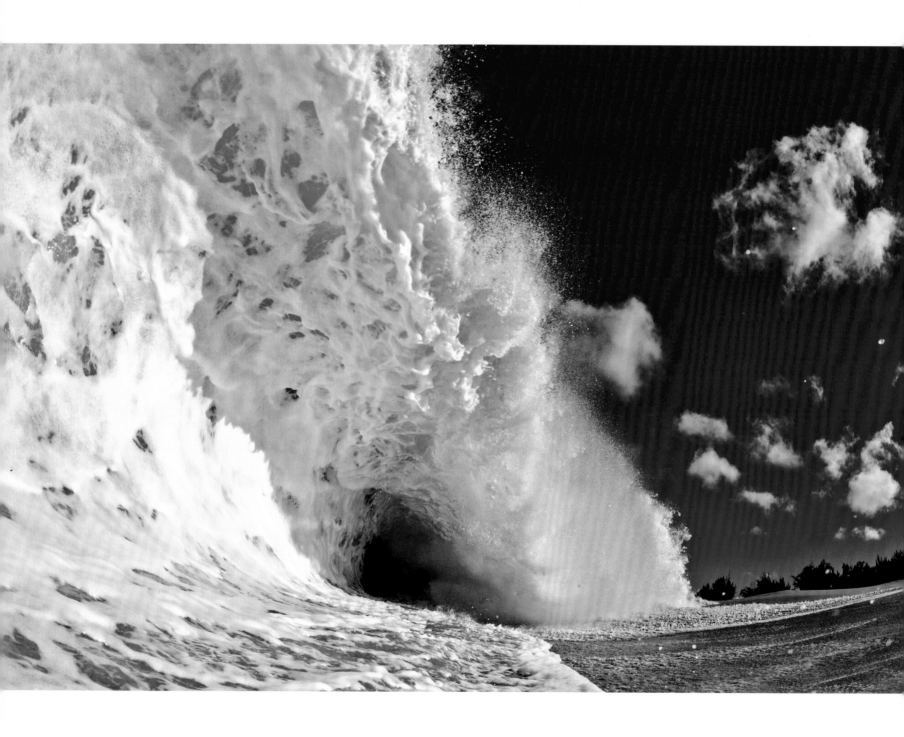

BEACH GRINDER
North Shore, Oʻahu

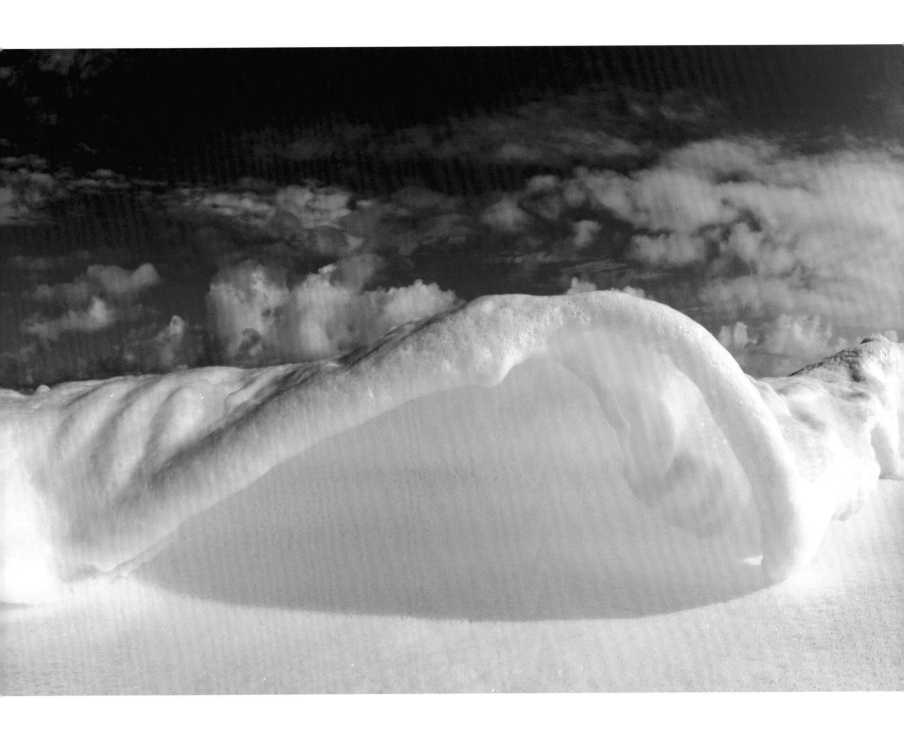

SNOW DAY
North Shore, Oʻahu

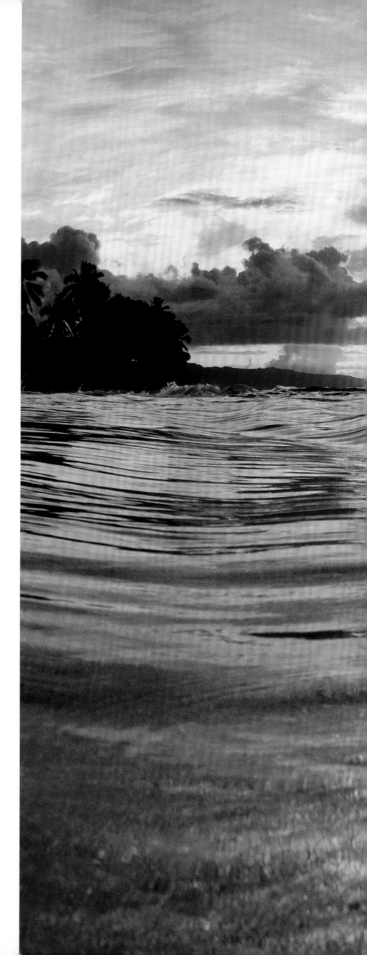

"There are so many things I look at before I go out.
What are the conditions? Where is the sun setting?
Where is the sun rising? Is the water glassy? The
backdrop. The beautiful sandy beach. The coconut
trees. The magic happens when I get in the right
spot and just feel a part of the ocean."

SERENITY
North Shore, O'ahu

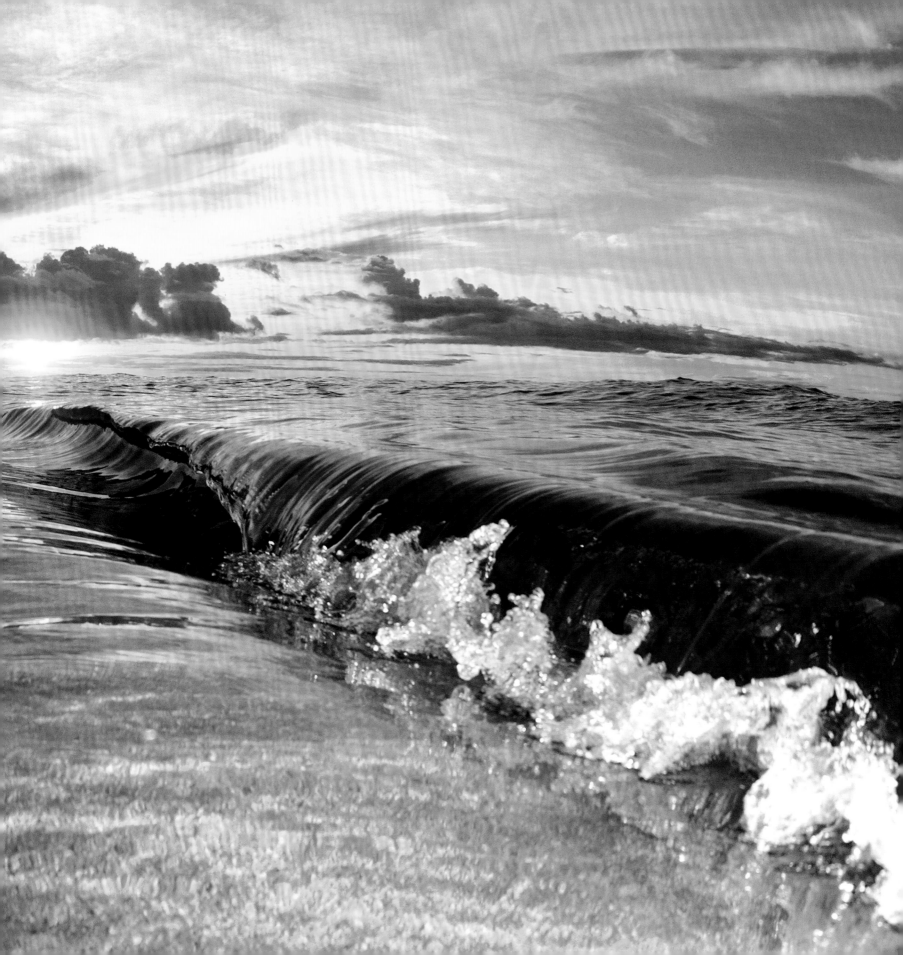

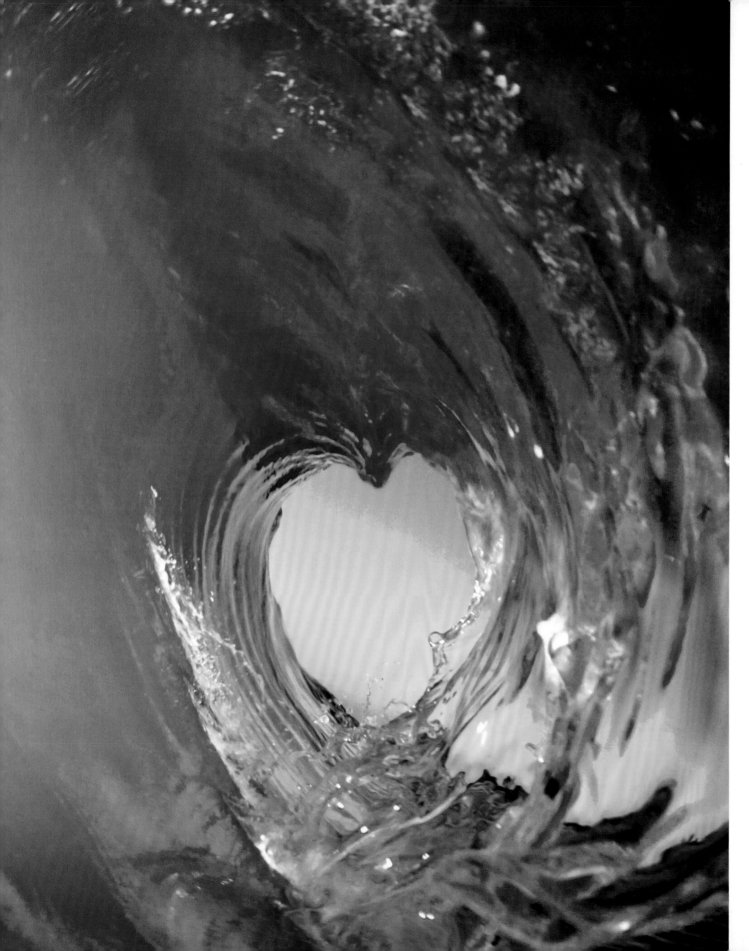

HEART
The Wedge,
Newport Beach,
California
(left)

FLYING FISH
North Shore, O'ahu
(right)

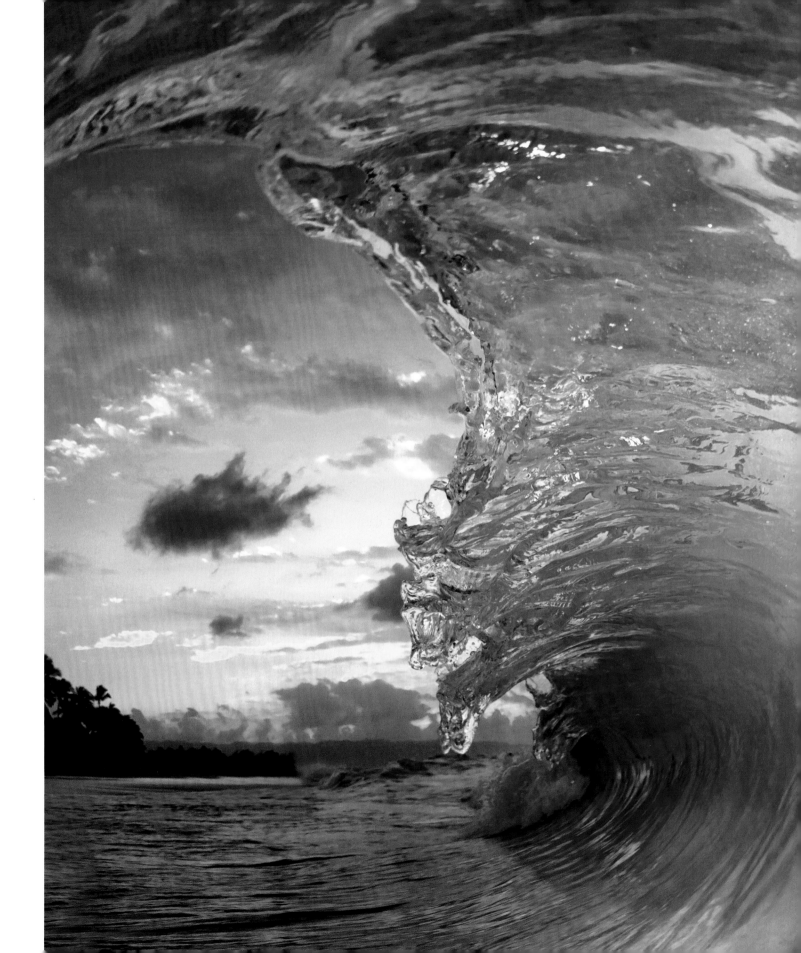

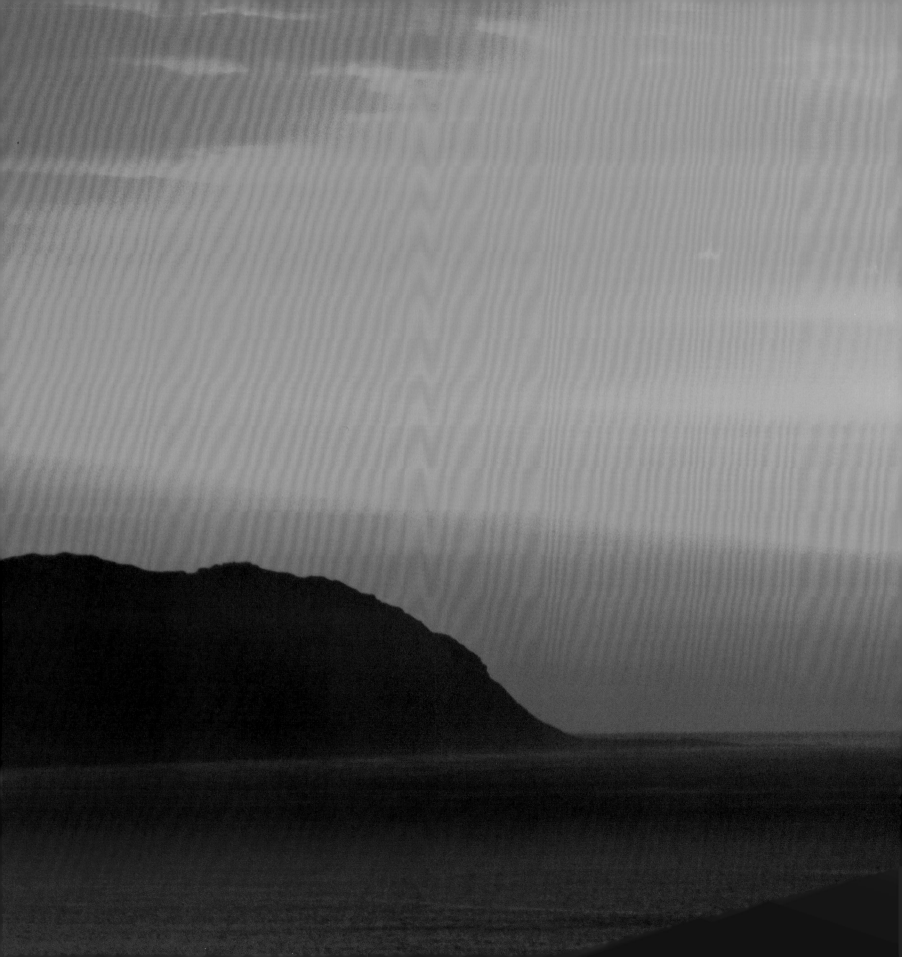

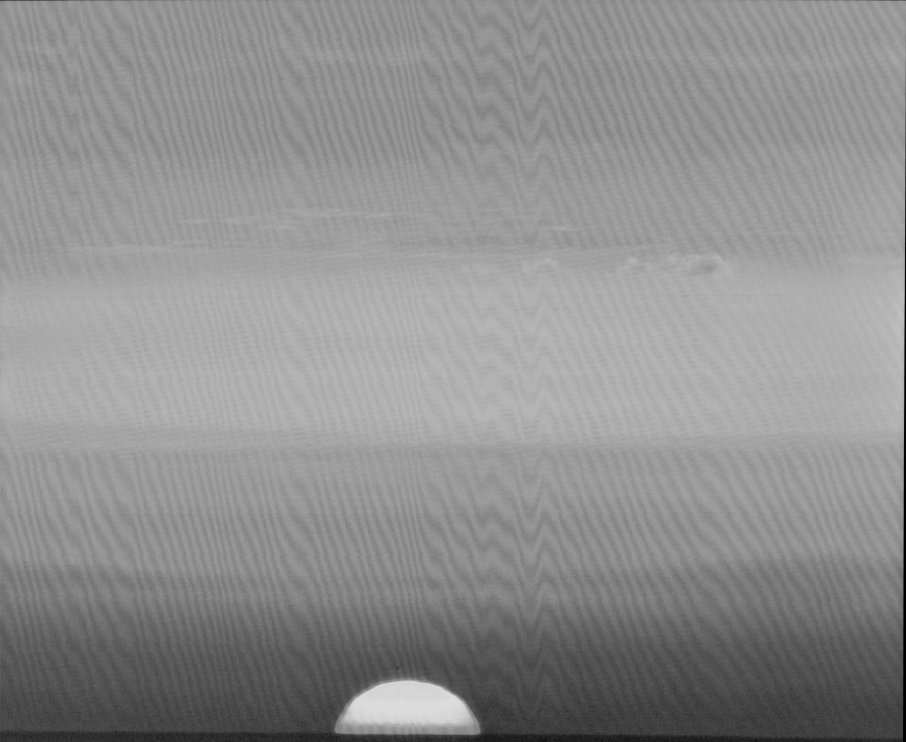

"I feel lucky if I get one great shot for every ten hours I shoot."

HAWAIIAN MAGIC
Ka'ena Point, O'ahu
(previous page)

OBSIDIAN
North Shore, O'ahu
(right)

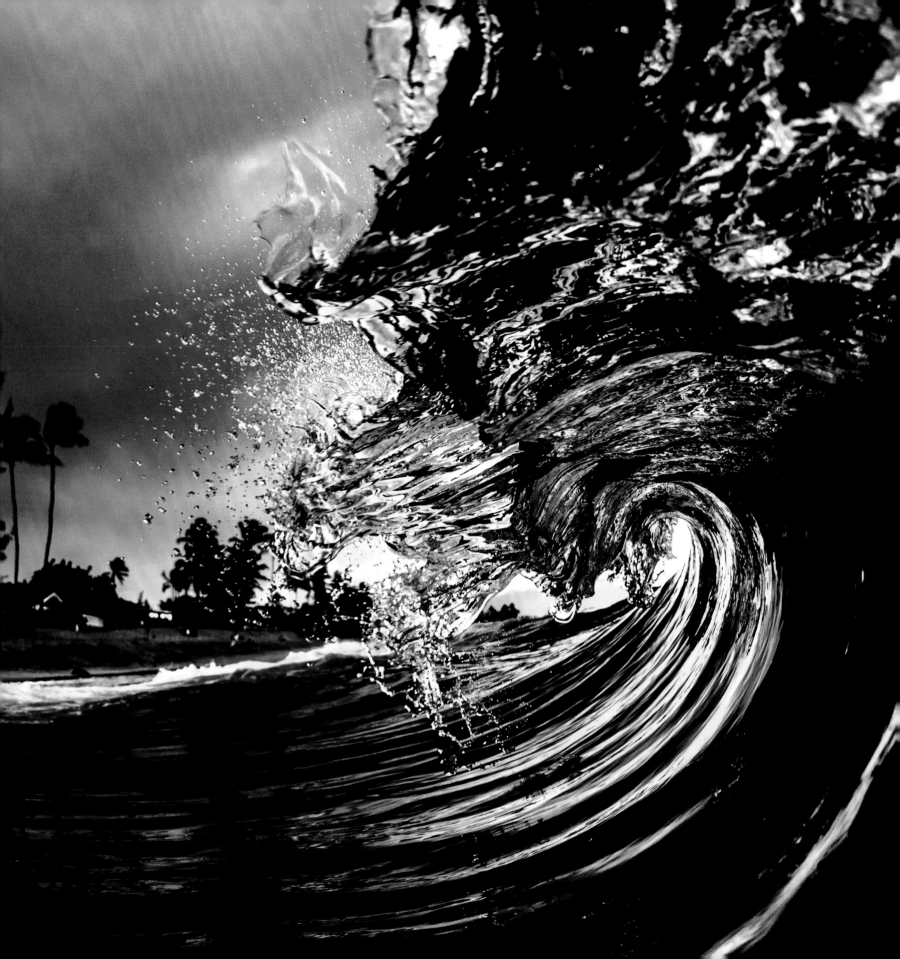

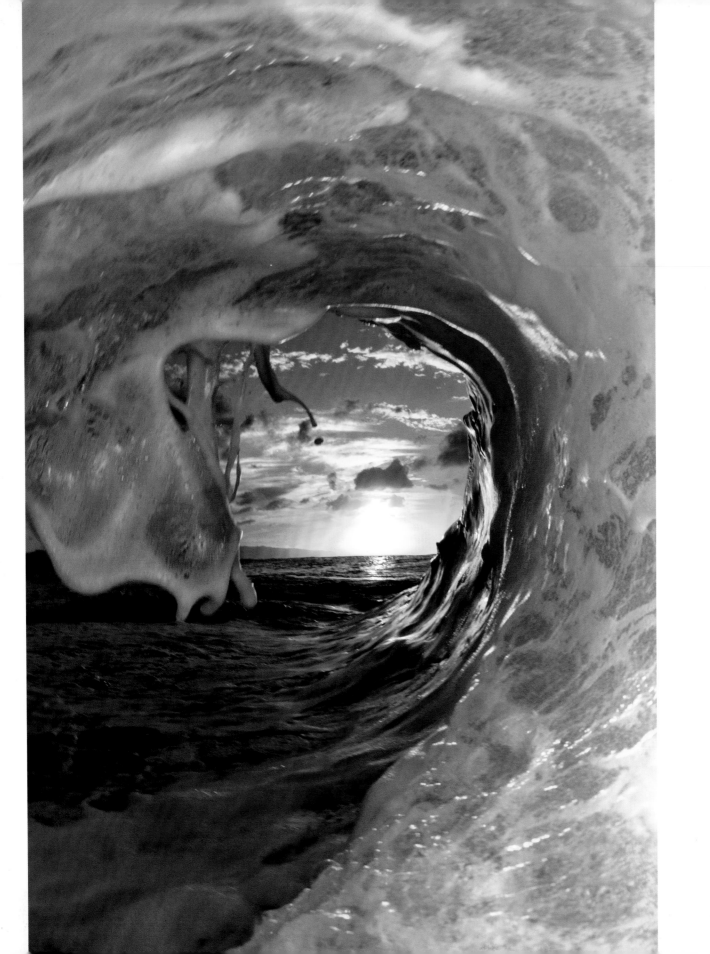

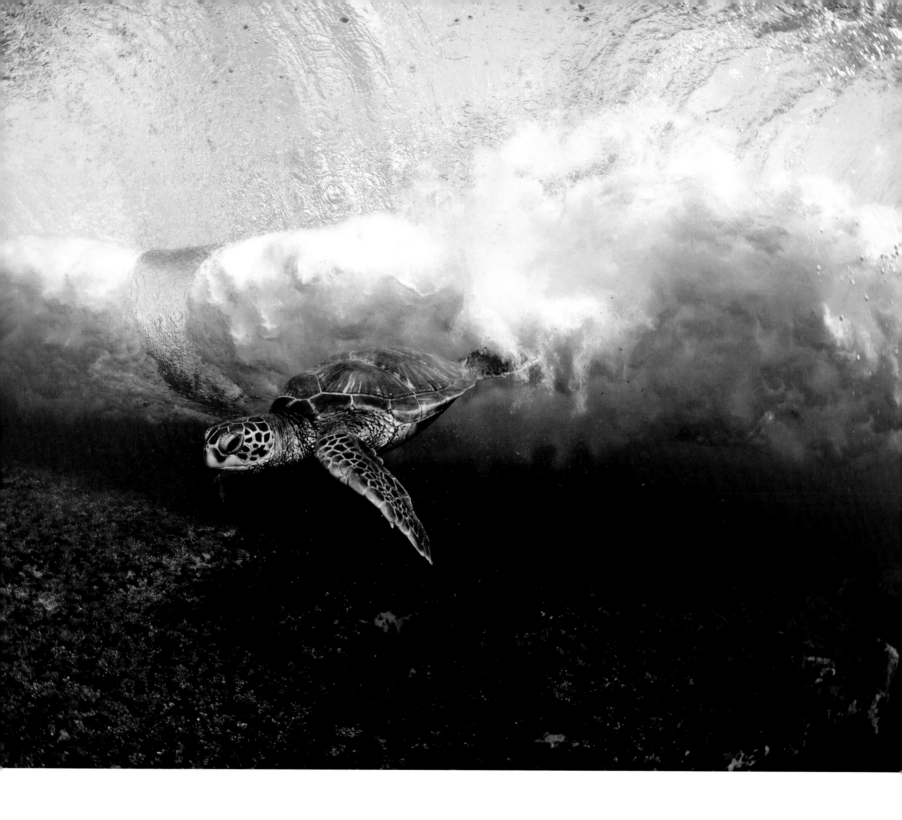

CURTAIN CALL
North Shore, O'ahu
(left)

CLOSE CALL
North Shore, O'ahu
(above)

"I get pounded all day long, and I love it. Every inch of my body gets blasted with salt water, sand, and small rocks. I carry sand and shells and chunks with me. Sometimes my wife gets pissed 'cause I've brought all that stuff into our bed. My ears are full—I can't hear half the time from getting smacked. But you can't avoid it. If you're going to sit and wait for the perfect shot, it's guaranteed you're going to get swatted."

LAST BLAST
North Shore, O'ahu

This shot is achieved by doing what we call the "Run & Gun" or "Ground & Pound" technique. During certain tides and swells, and depending on the formation of the sandbar, big waves can break directly on the beach. Some of these are big enough to fit a truck in them. They are really tricky to shoot, since there is no water to swim in or a safe place in the impact zone to hang out. The only way to get to these are to run at them.

I stand 50 to 100 feet up on a sand mound, away from where they break, and watch each wave approach from a distance, carefully analyzing which one might be the best to shoot. Sets might come in 2, 3, 4, 5 waves. I am specifically looking for one that will throw a big tube right on the dry sand. When I spot a contender, I run at full speed toward the swell and time it so I get there, throw my body down on to the dry sand, just as the wave pitches over me. Laying in the pocket for a few seconds with my arm and camera stretched out, I get my shots in before the wave explodes and sends the water, and me, tumbling toward shore. The whitewater can sometimes surge 150 feet up the beach. That's 50 feet beyond where I started. It's a wild ride.

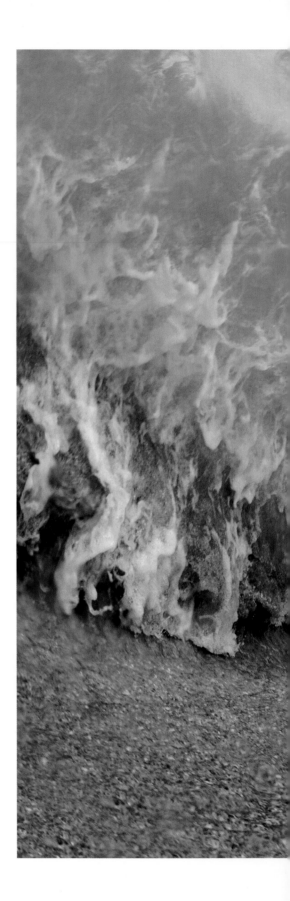

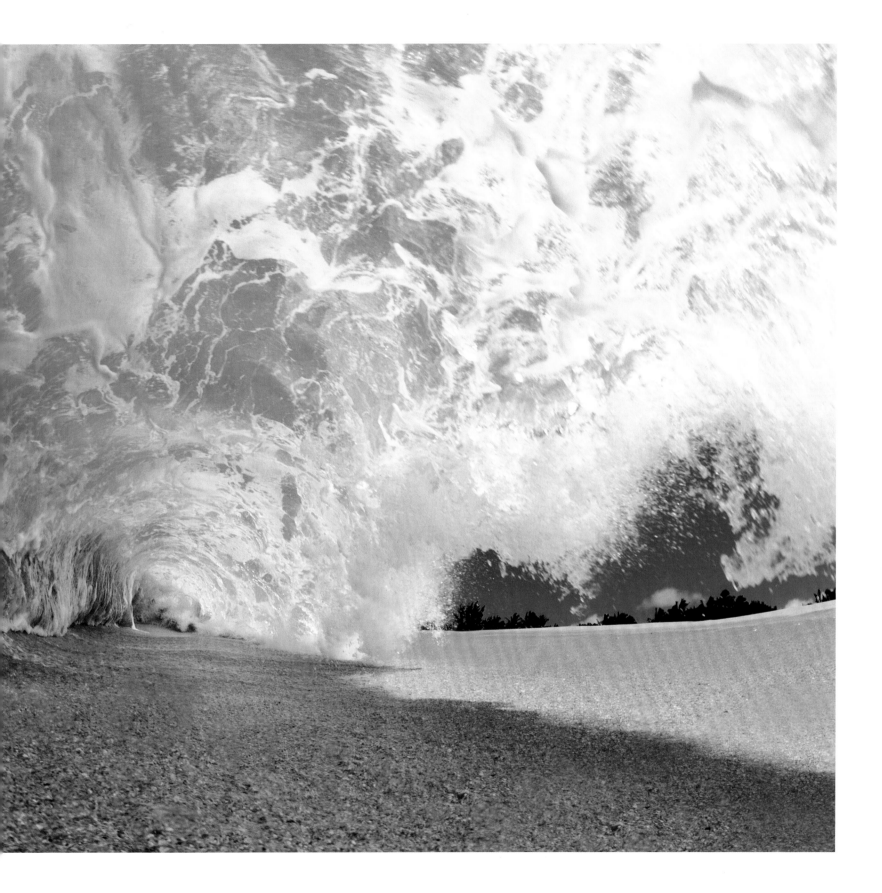

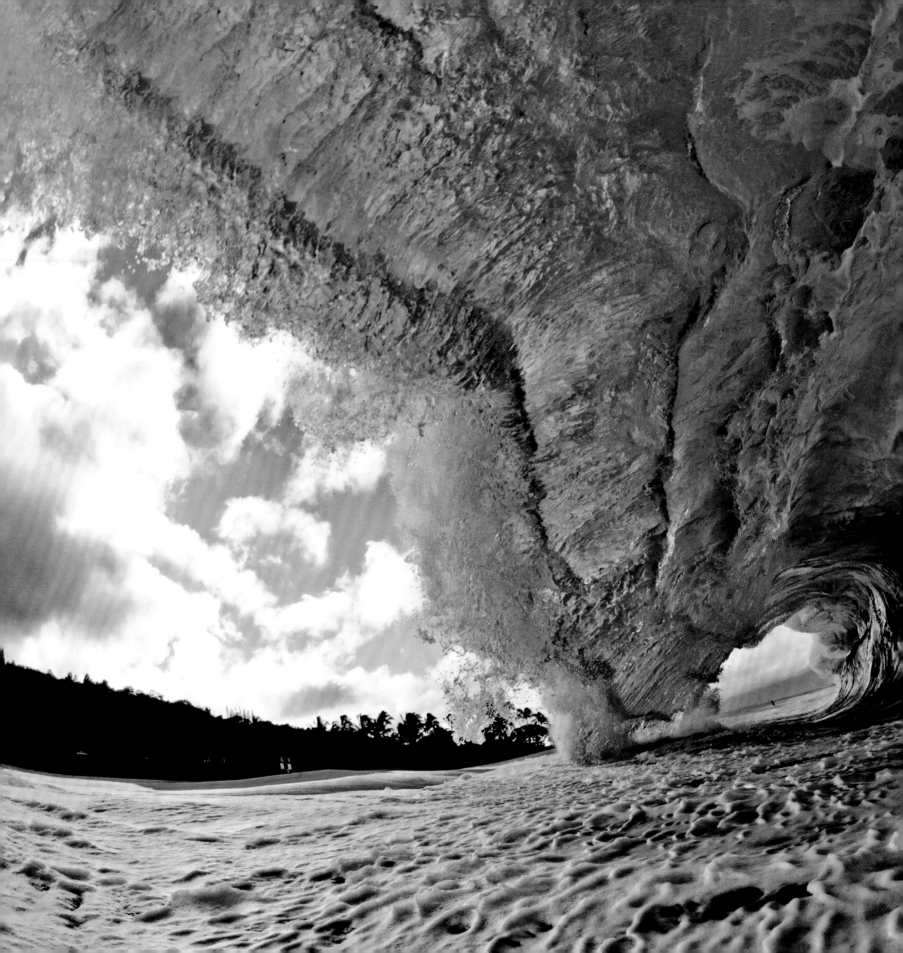

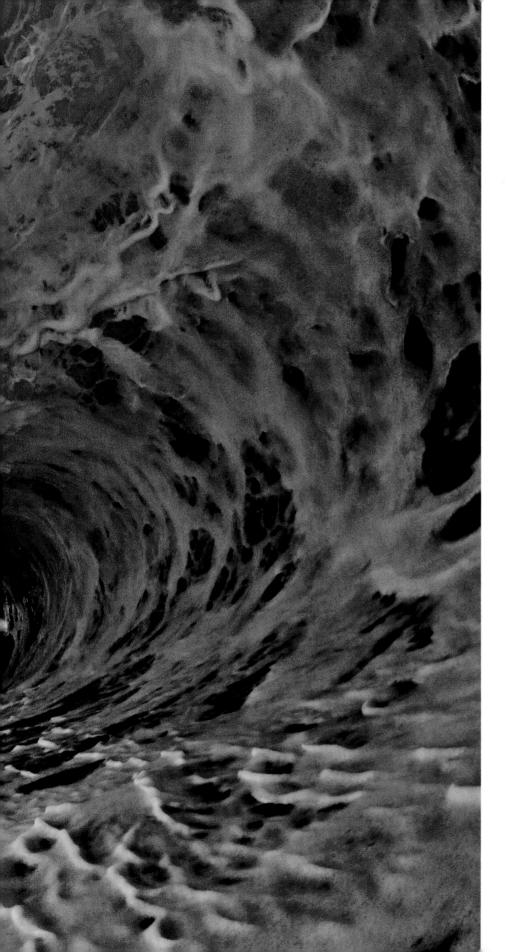

TROPIC GLACIER
North Shore, O'ahu

The ripples in this shot are a big hint. It indicates the wave is large. It may not look big, but it's actually giant. When certain waves this size break on shore, the forward movement of the mass of water combined with the compression created by the tube stirs up a gust of wind as the air tries to escape. It's quick and only happens for a split second as the lip first impacts the water. In this shot, the whitewater covering the wave is swept by this gust, creating a ripple pattern and showing the phenomenon in action.

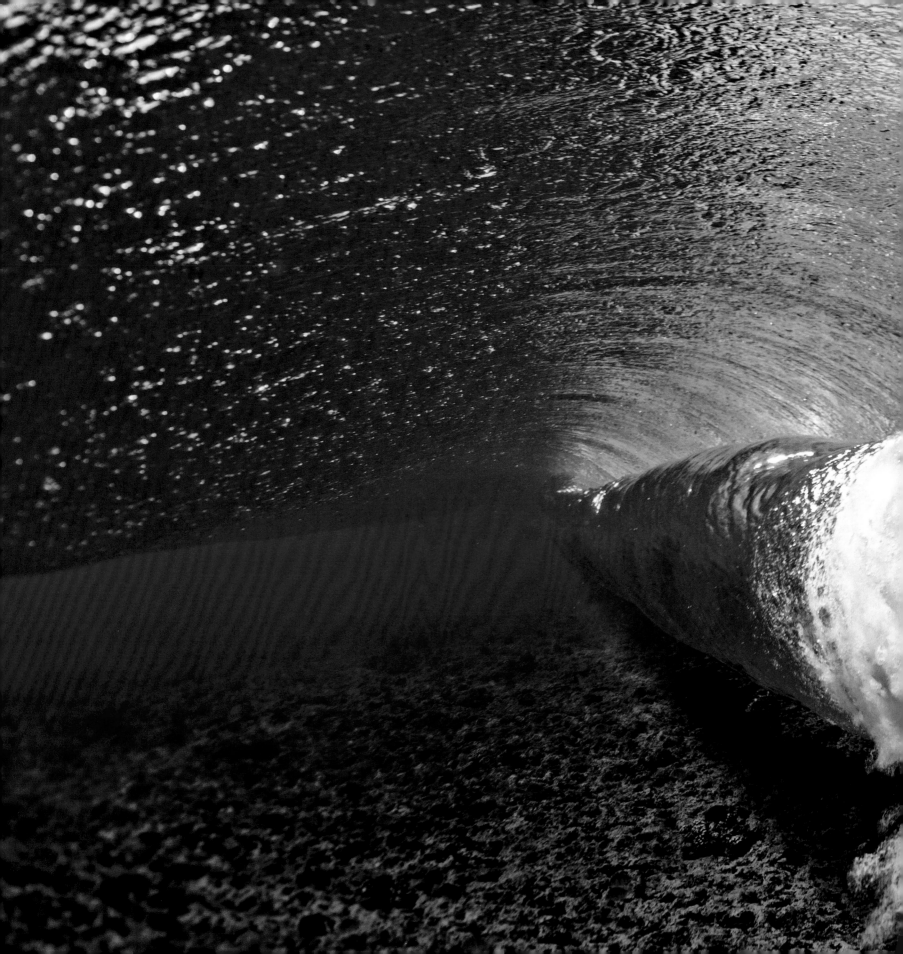

Be Like Water

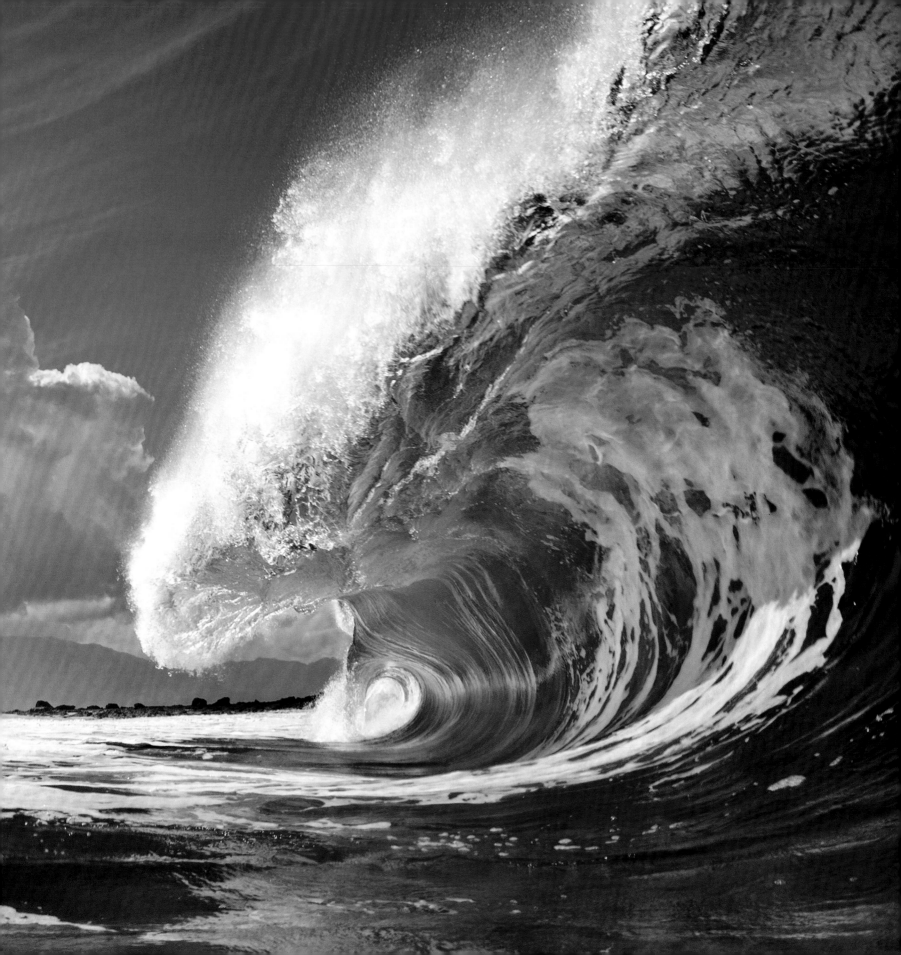

Clark enjoys a preternatural connection with his beloved Ke Iki shorebreak. From his home a thousand feet up Pūpūkea Heights on the island of O'ahu, not only can he hear the whomp of waves hitting the sand, but he can also deduce from that sound their size and shape. Before he's even climbed out of bed, his adrenaline is pumping and his mind is running through possible scenarios. Using his five decades of water knowledge, Clark zeros in on the right swell, the right window of that swell, the right wave of that window, the right spot on that wave, and the right moment to snap the photo in that spot. Here is where Clark is most uniquely Clark—here's where his instincts turn physical.

"I become one with the ocean. I'm swimming along feeling almost like a dolphin in the surf. I get so comfortable that I forget I have a camera in my hand. And when the wave comes and I'm going in for the shot, I don't think; it's all instinct. My brother and I started bodysurfing when we were toddlers, so I'd say I have a special vibe with the ocean, and a certain comfort level when it comes to shorebreak and the sand spinning all around."

Clark is referring to that dance that happens as the wave heaves up and he positions himself right under its lip. Like that famous Bruce Lee quote, "Be like water," it's about fluidity. Since every wave is different, Clark has to adjust his strategy for each wave, reassessing every millisecond. Sometimes he ducks out the back of the wave to safety, right before the lip hits the sand. Other times he assumes a rag-doll softness and just surrenders to the beating. There's the stiff-legged technique, in which he tries to hold his ground against the tonnage of heavy water. And there's that strange eye-of-the-hurricane phenomenon, where the biggest, meanest tube doles out the mildest beating.

The danger factor is real. Clark has separated his shoulder, been whacked in the head by his camera, and nearly drowned. But he has learned that risk is commensurate with reward.

"Getting into the impact zone and having the knowledge to stand up and wait for that wave to jack up and throw over my head is a big key to getting the shot of the sand sucking up. I have to actually fight to get into that position; my heart is pumping, and I can see that the wave is about to get all mutant and break right over my head. So you've got to have a little bit of a screw loose; I have to be willing to take the beatings. Surfing Waimea shorebreak all those years has helped tremendously. The wipeouts taught me how to eat crap, which way to fall when I'm getting sucked over, how to push off and when to hold my breath, how not to panic. There's a lot going on, and it's all intuitive."

BLUE RAINBOW
French Polynesia
(previous page)

JUICE
North Shore, O'ahu
(left)

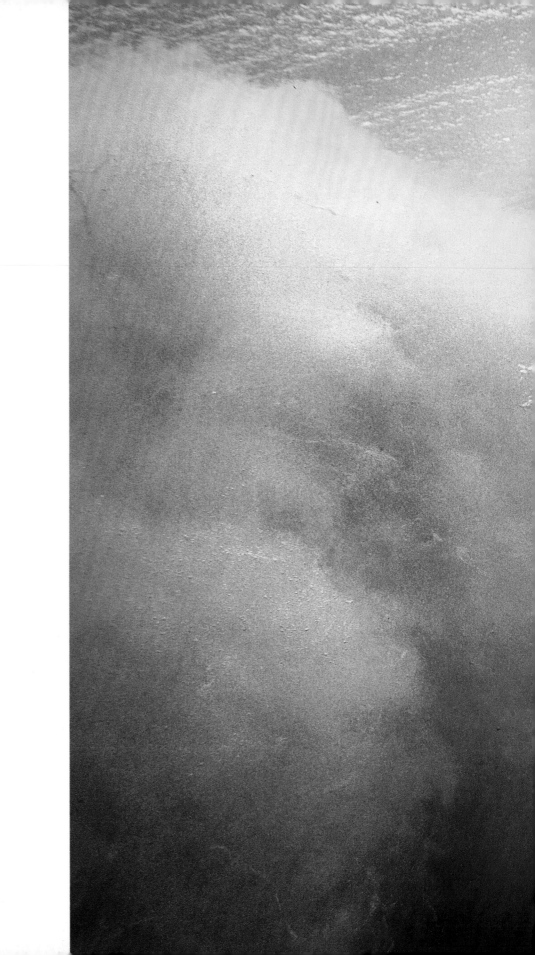

UNDERWATER BOMB
North Shore, O'ahu
Photo by Jerrett Lau

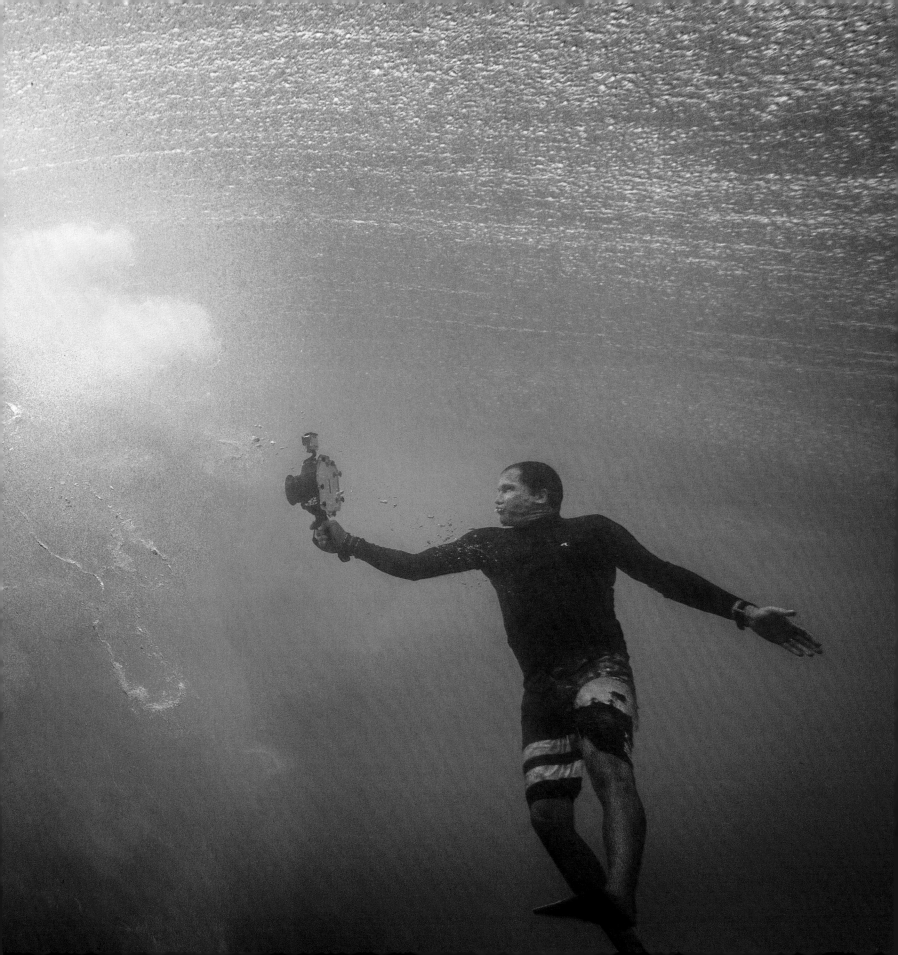

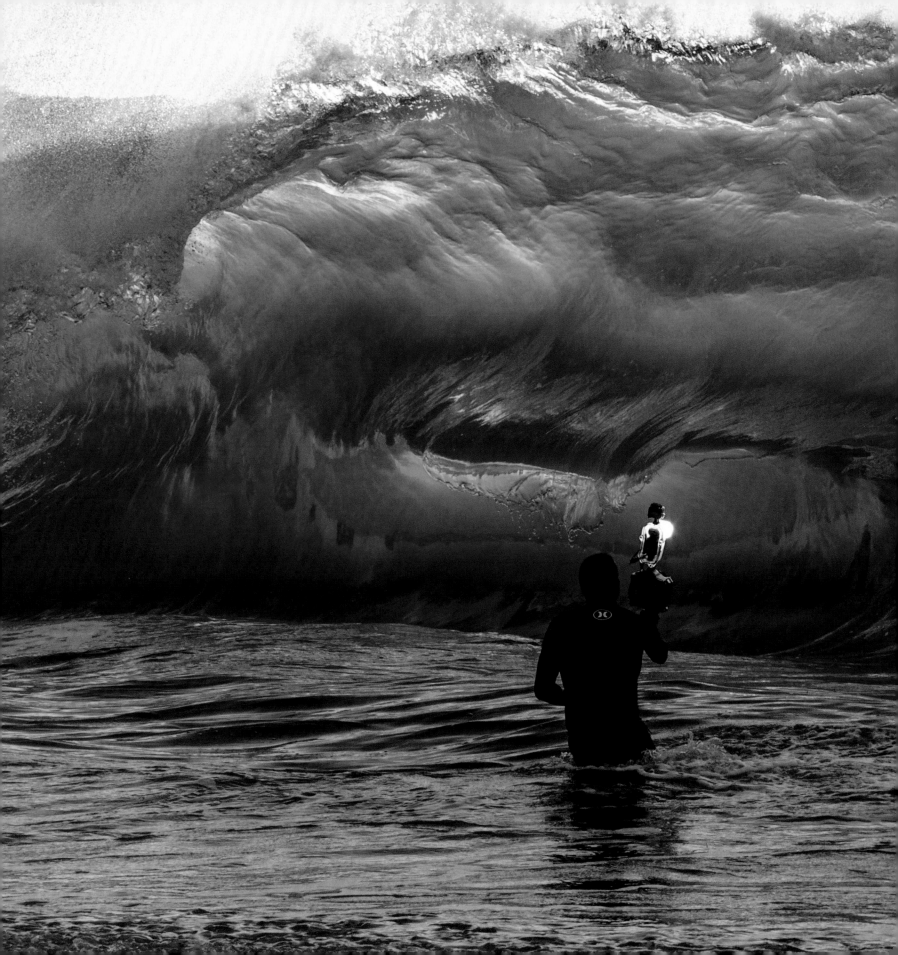

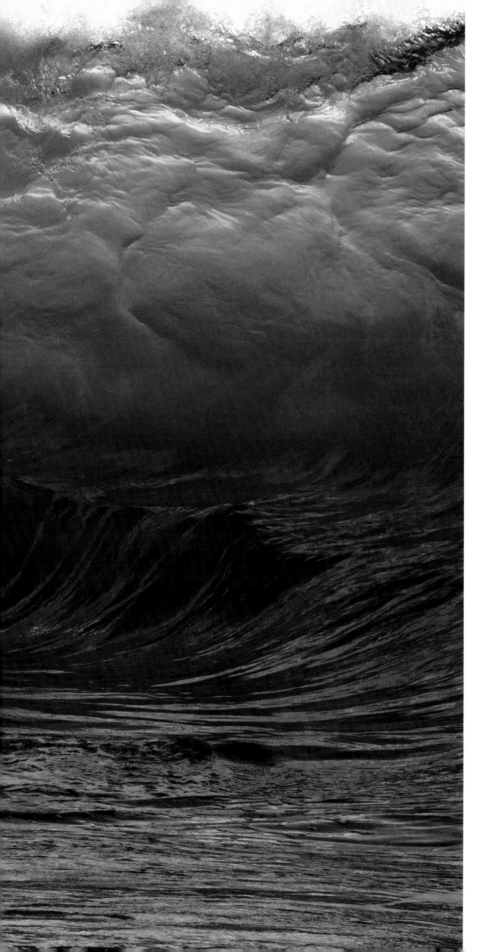

FLASH
North Shore, O'ahu
Photo by Jacob VanderVelde

When I add a strobe flash unit to the top my water housing, it nearly doubles the height of my rig. It's an extra burden to take through waves and increases risks due to its size. But the results are well worth it. Without the flash, waves at night would just be dark masses without highlights or any sense of depth. The entire approach to shooting waves changes. Whitewater will reflect bright white and needs to be limited so the image doesn't blow out. Because the flash recharges between shots, I have to carefully select waves and time exactly when to push my shutter. I don't have the luxury of shooting the usual ten frames per second. Before the sun sets, I can combine my flash with natural light for a second source of light. In this shot, the sun lights up the entire top half of the wave from behind, while I focus my strobe on the lower lip and softly illuminate the forming tube.

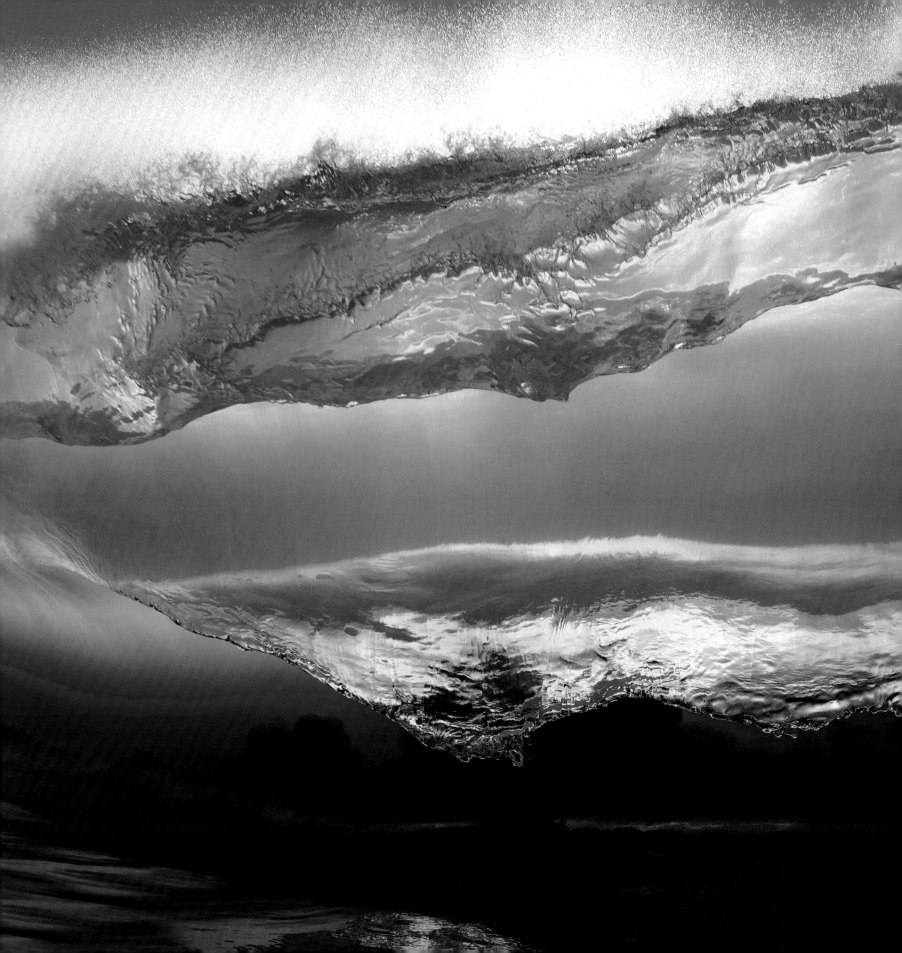

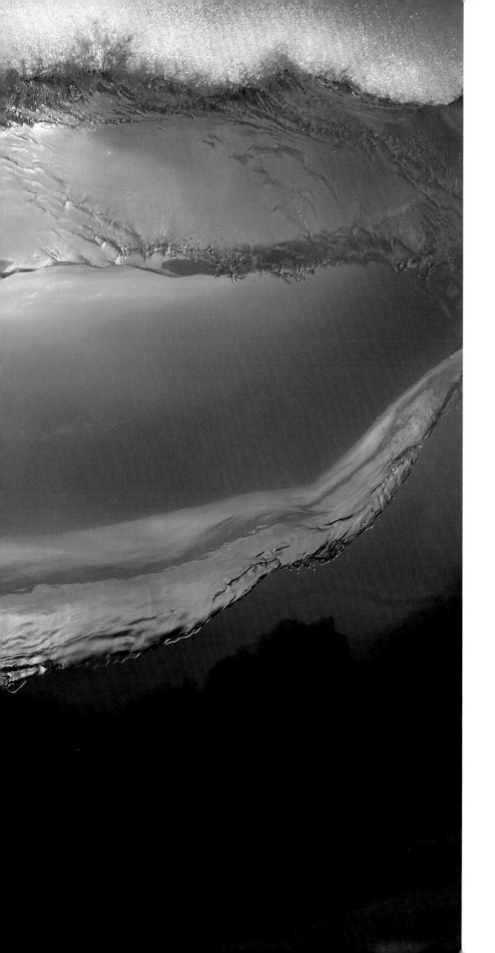

TRIPLE THREAT
North Shore, O'ahu

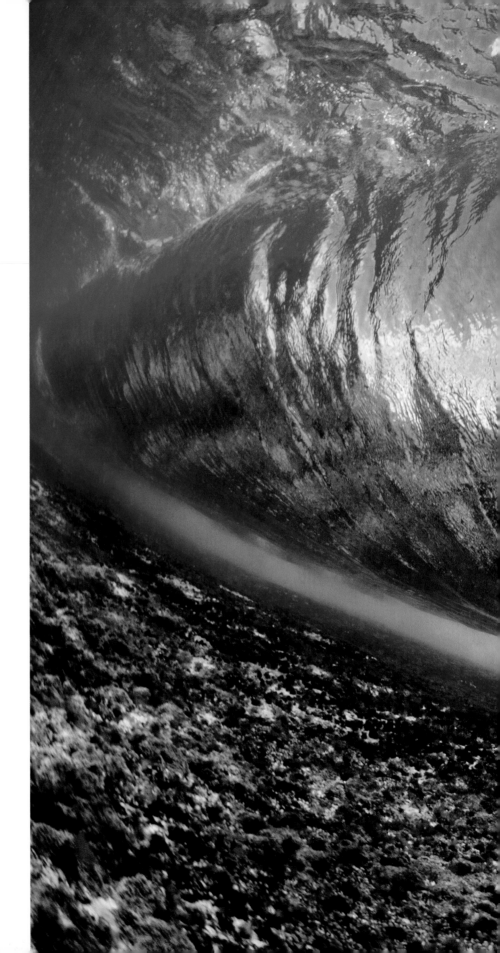

DANCING HONU
North Shore, O'ahu

An endangered Hawaiian green sea turtle barely gets under a tube. When a turtle has an entire ocean to swim in, why would it be this dangerously close to a breaking wave? There is good reason—most of their diet consists of algae and sea grass. Since competition is tight, the turtles need to push their limits and get close to shore (and the waves) to find the best patches to eat. A few times I have seen them miscalculate, get picked up and thrown into the hard reef. They are built like tanks and each time have been able to swim away.

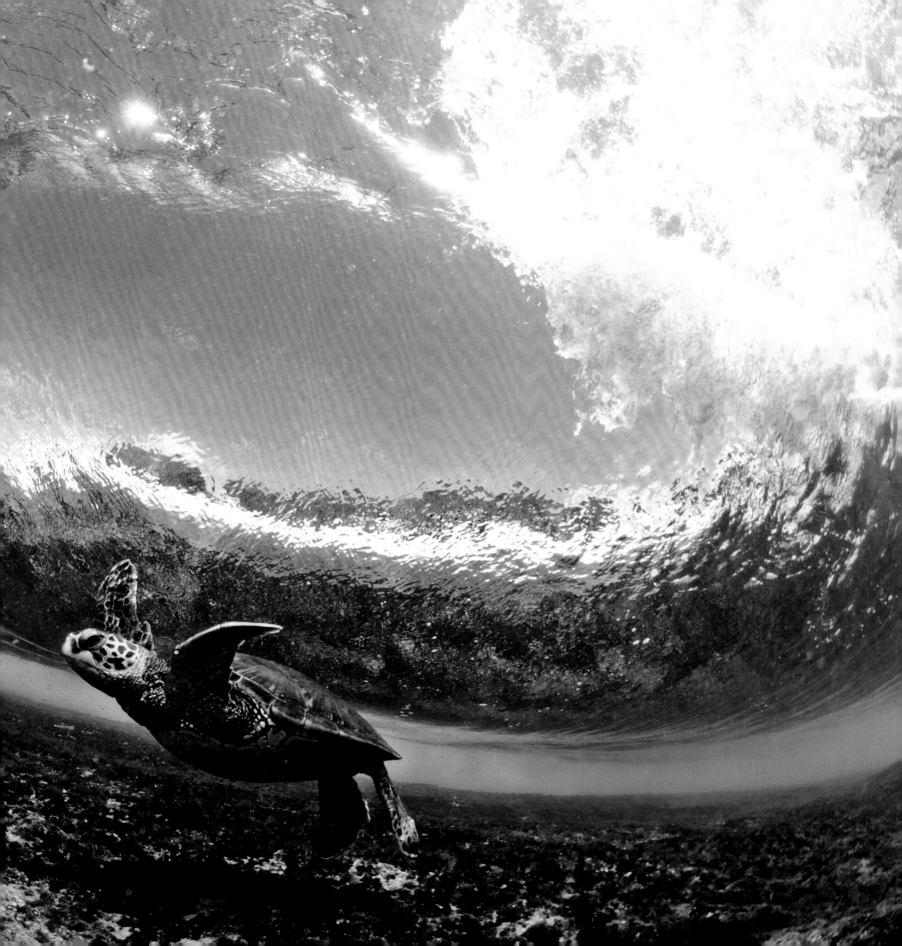

"Like the eye of a hurricane, the heaviest, sickest, gnarliest part of a wave is actually the safest spot to be."

BLUE CURL
North Shore, O'ahu

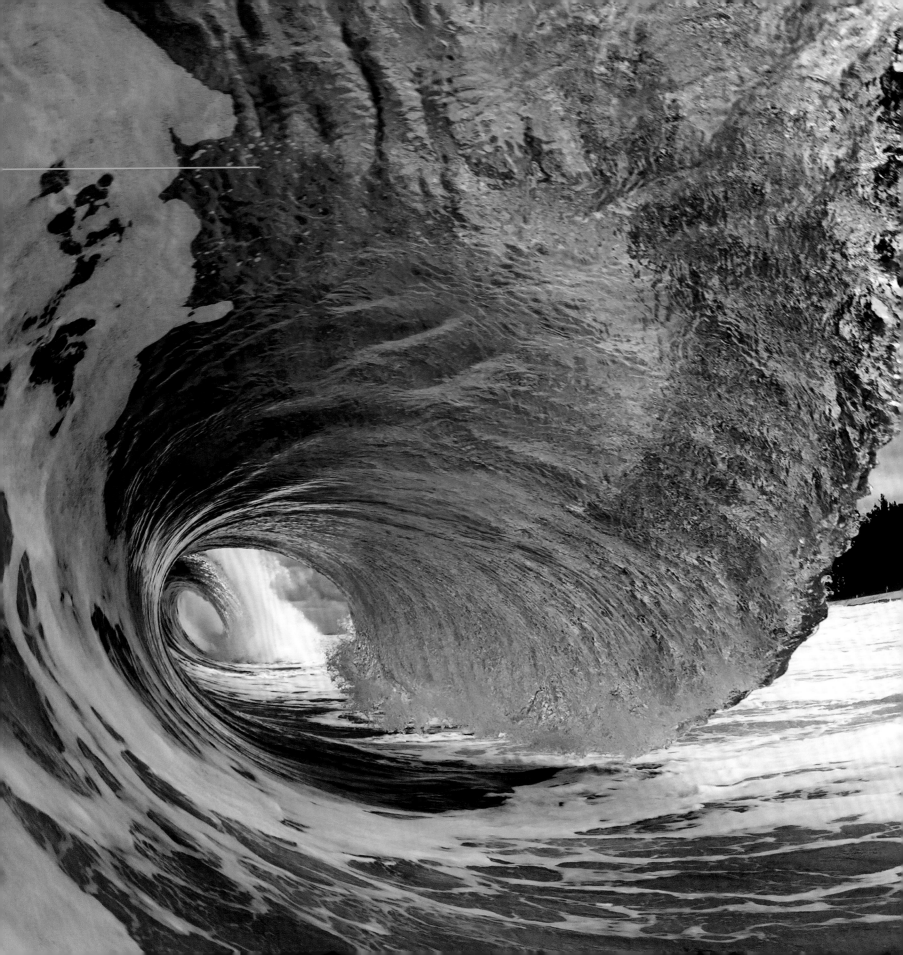

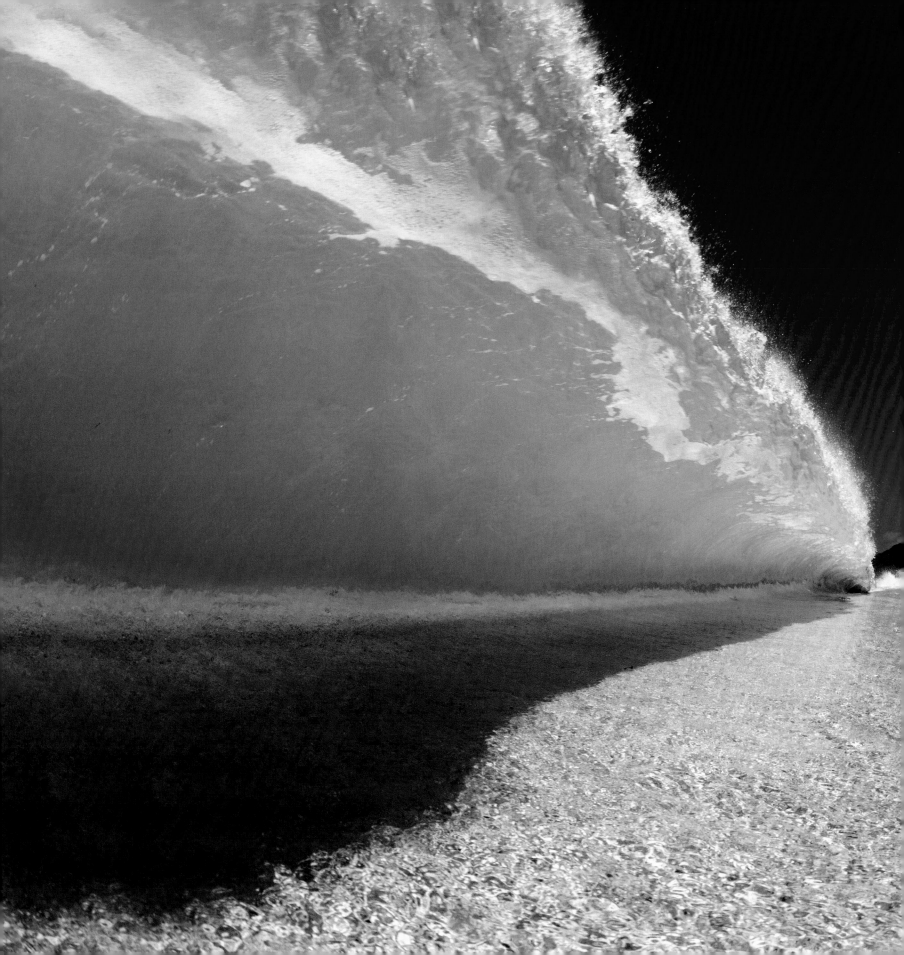

"I love getting thrown over the falls. I love getting tossed in the waves. I love bringing the camera with me—and getting the shot."

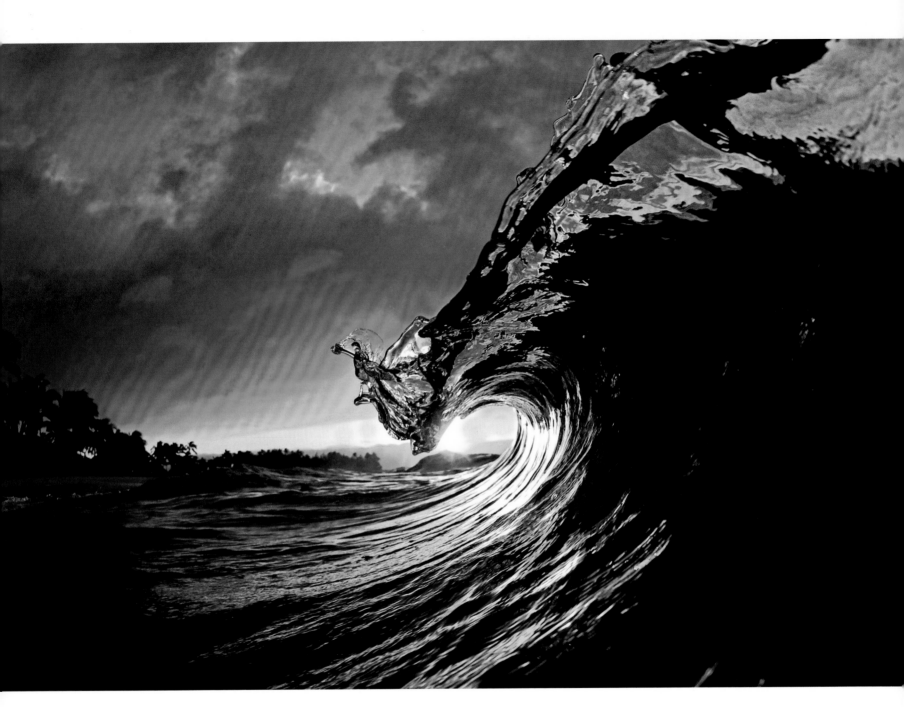

KING KAMEHAMEHA
North Shore, O'ahu

Look closely at the lip of the wave. You can make out the body of a Hawaiian warrior, with his helmet and spear perched on the tip of this wave. The image is named after King Kamehameha I, who united the Hawaiian Islands in 1810 and established the Kingdom of Hawai'i. With the glassy water and the perfect angle at which the bright sun hits the wave, no flash was needed to light it up.

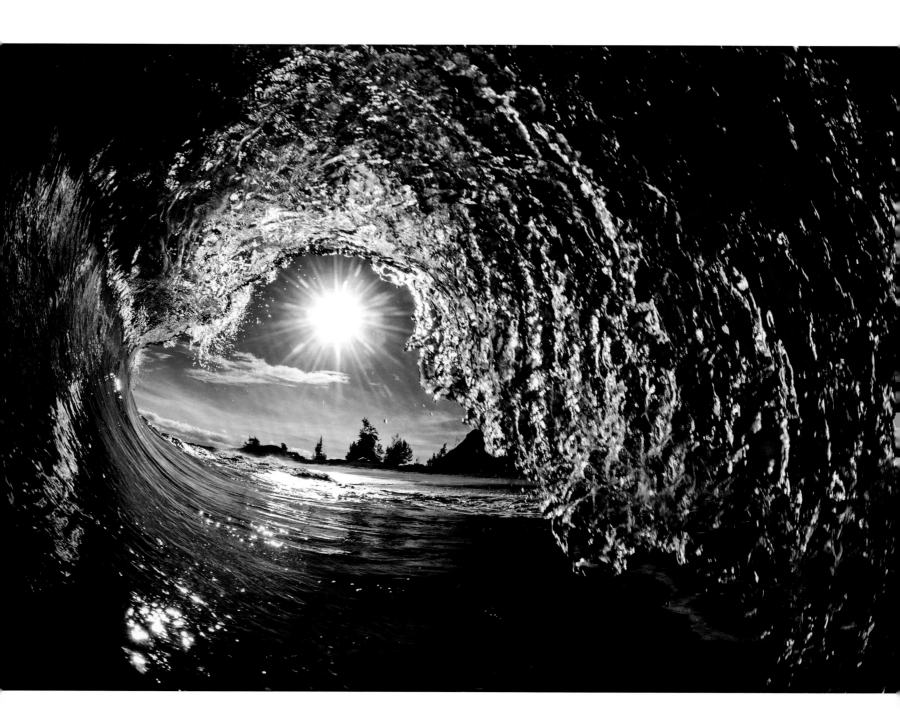

SUN BLAST
North Shore, O'ahu

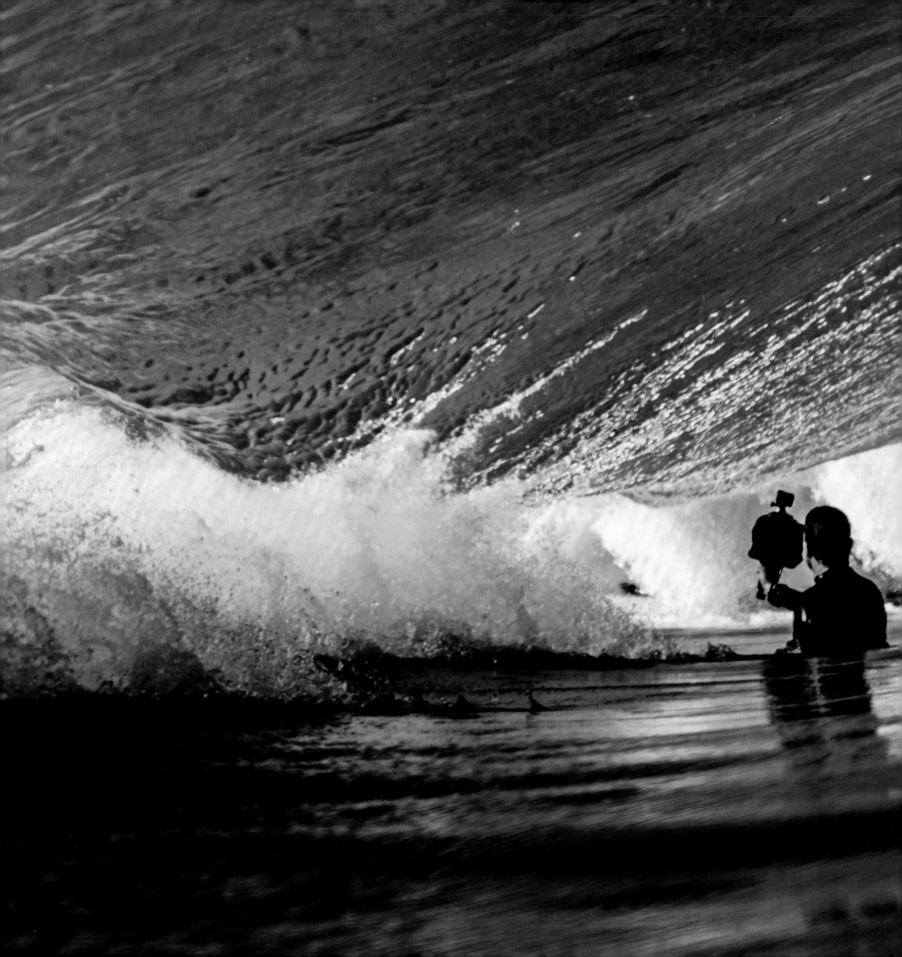

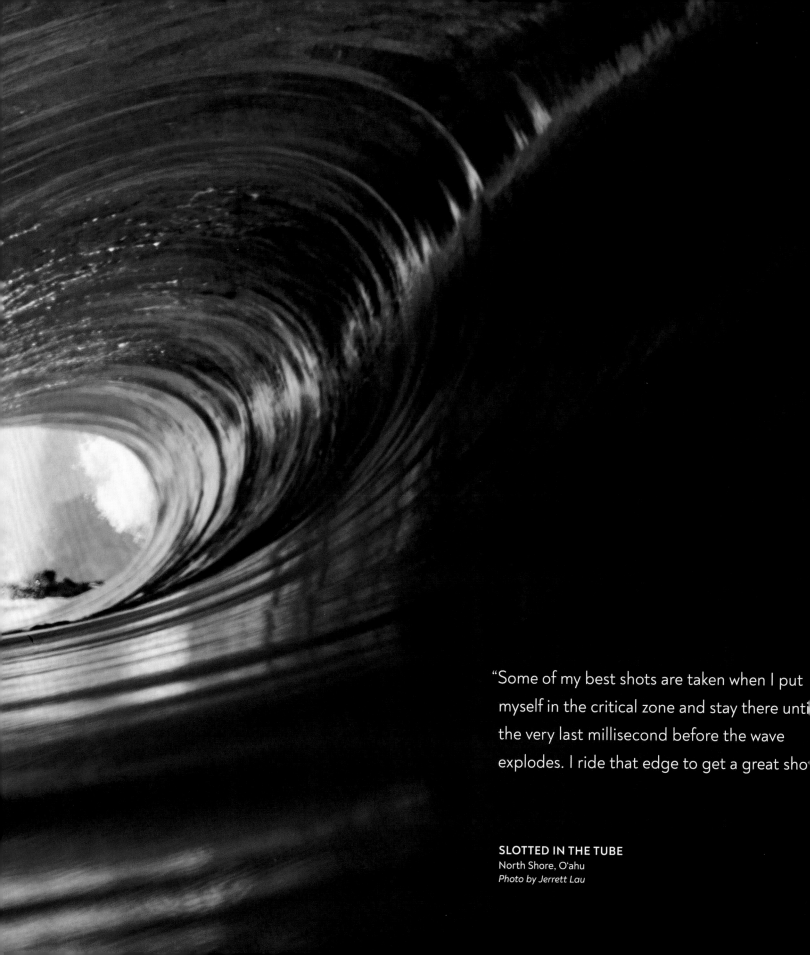

"Some of my best shots are taken when I put myself in the critical zone and stay there until the very last millisecond before the wave explodes. I ride that edge to get a great shot."

SLOTTED IN THE TUBE
North Shore, O'ahu
Photo by Jerrett Lau

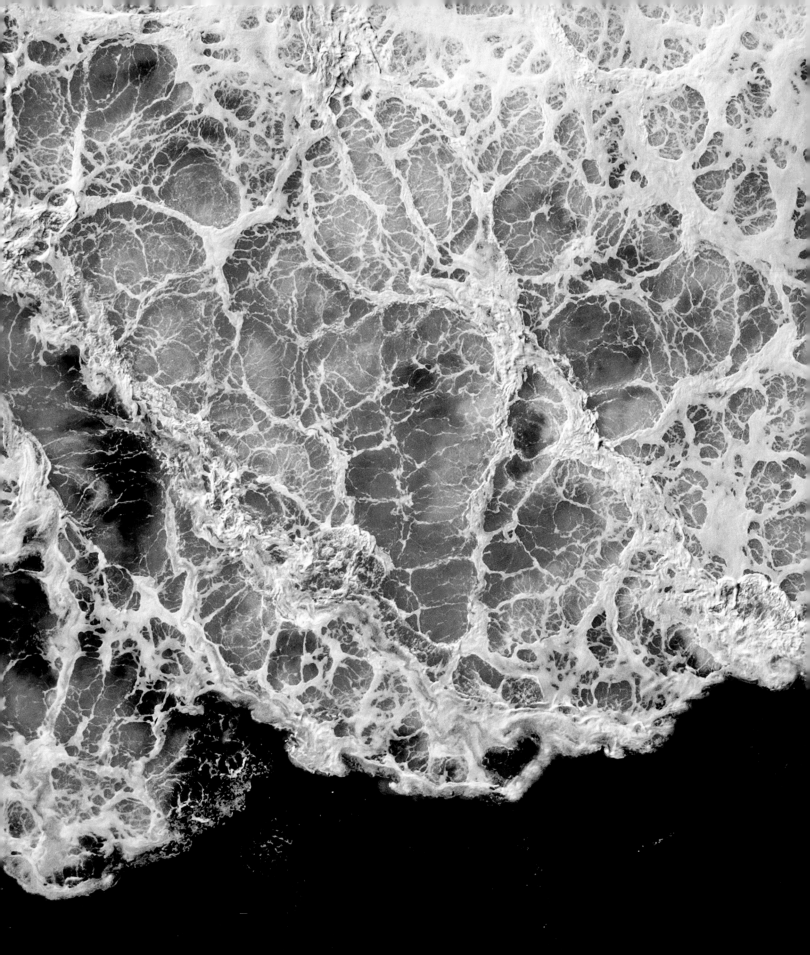

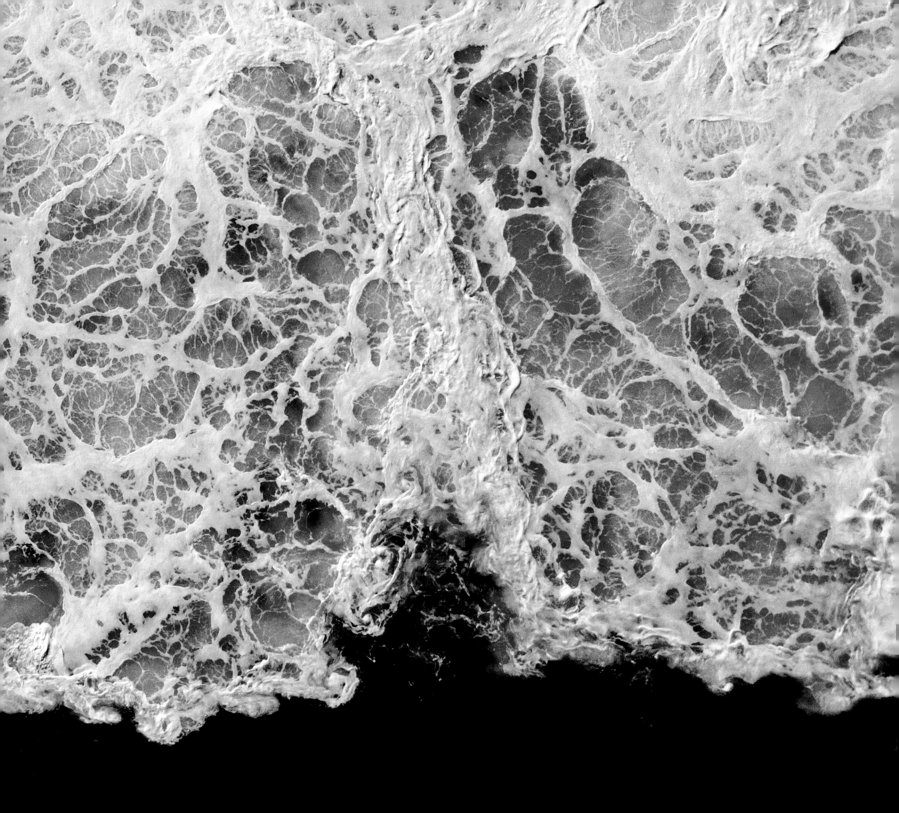

WHITE WASH
North Shore, Oʻahu

"A wave is a moving object. As it hits the sandbars and reefs, it will shift and change. Depending on swell size, tide, wind, and other variables, it will throw differently. Adjusting moment by moment is the key. Knowing when to pursue a wave or when to abort is also critical."

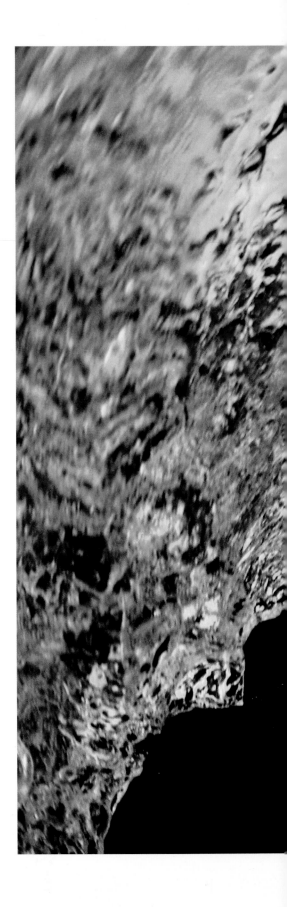

TRIPLE CROWN
North Shore, O'ahu

This picture is unusual in that the golden color in the wave is coming from a bright sunrise happening behind me and then reflecting off of the mountains and the white sand beach in front. You can see a hint of the mountains through the lip of the tube.

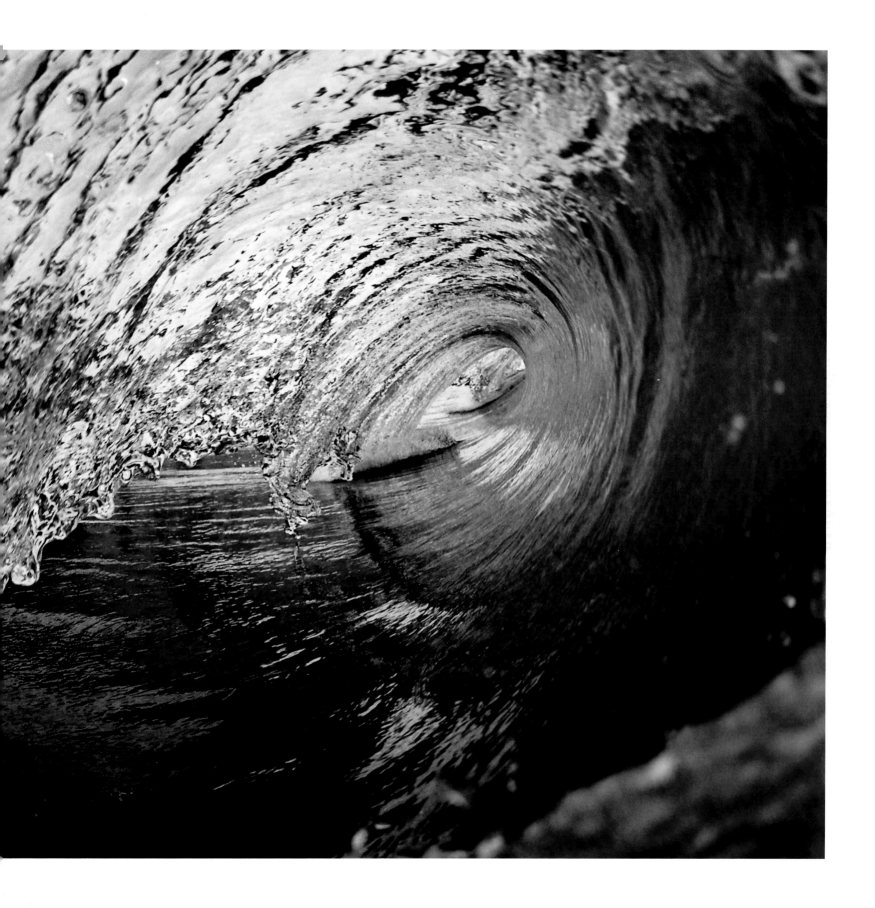

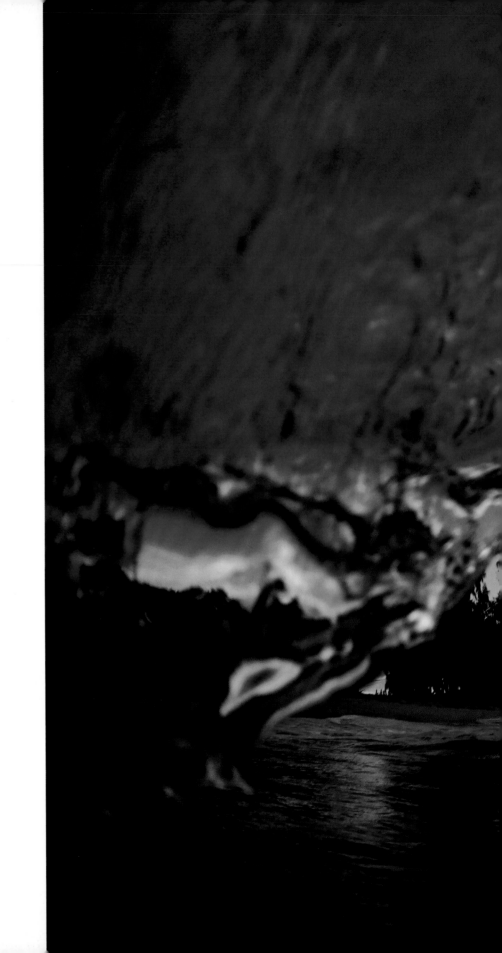

BLUE DREAMS
North Shore, O'ahu

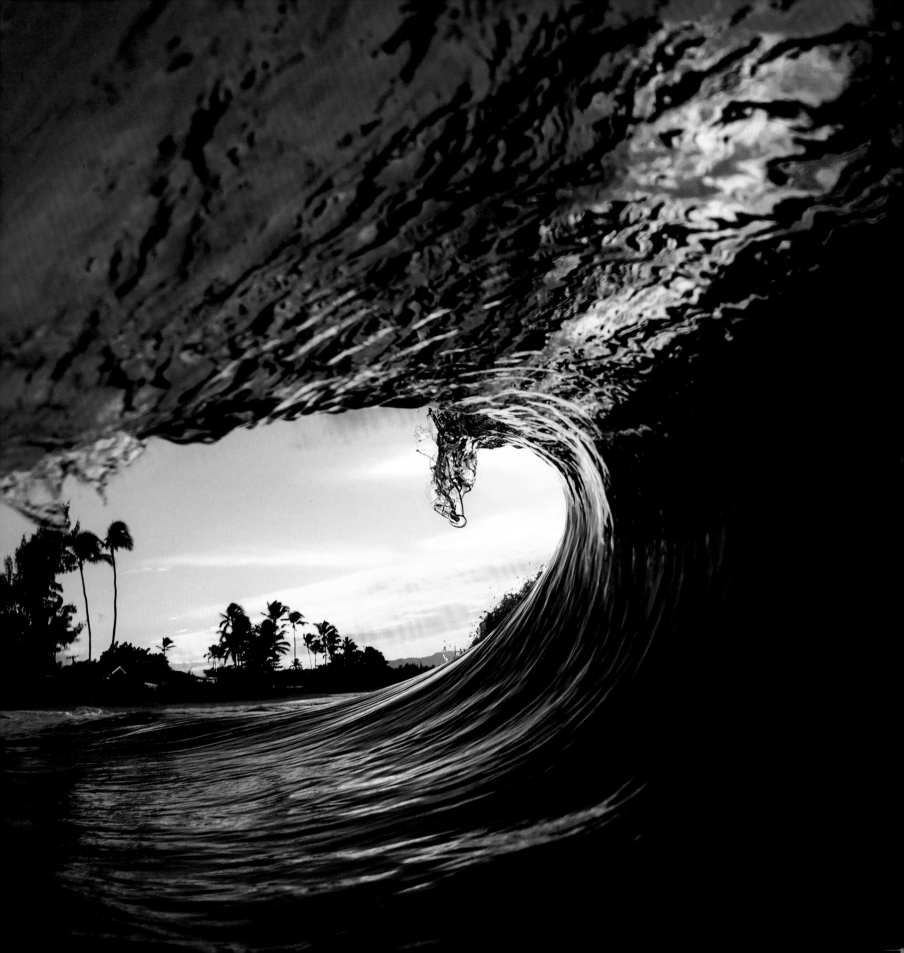

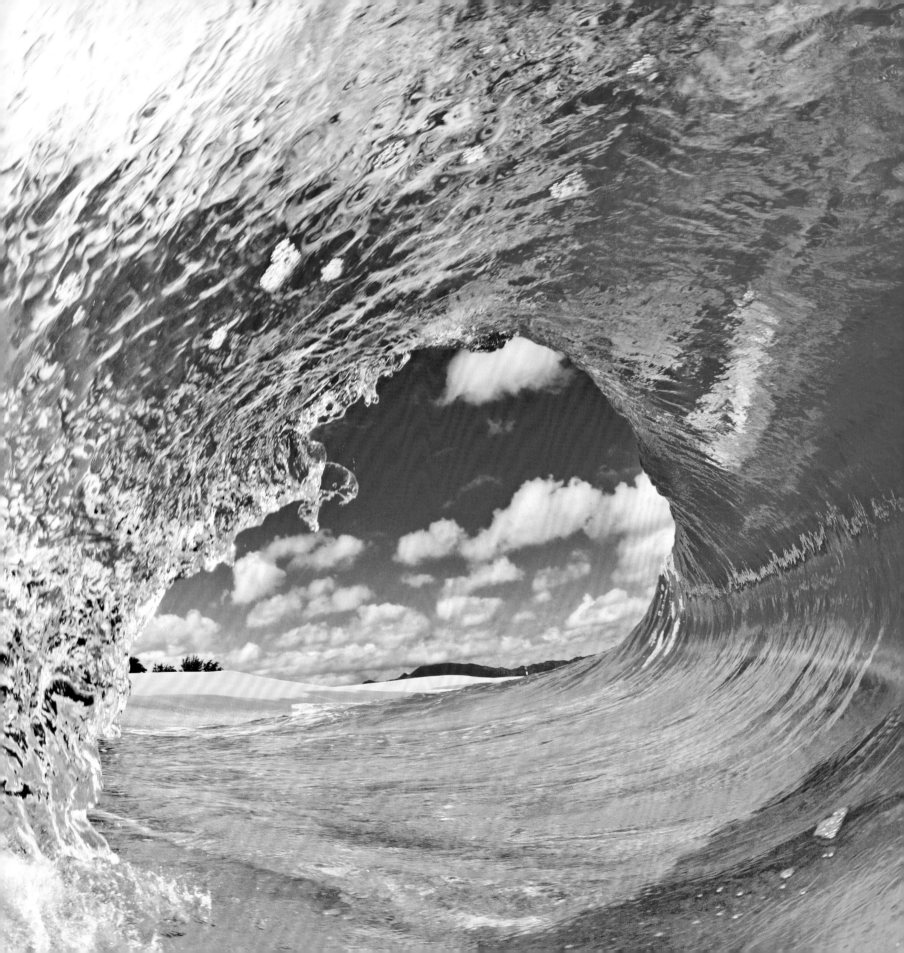

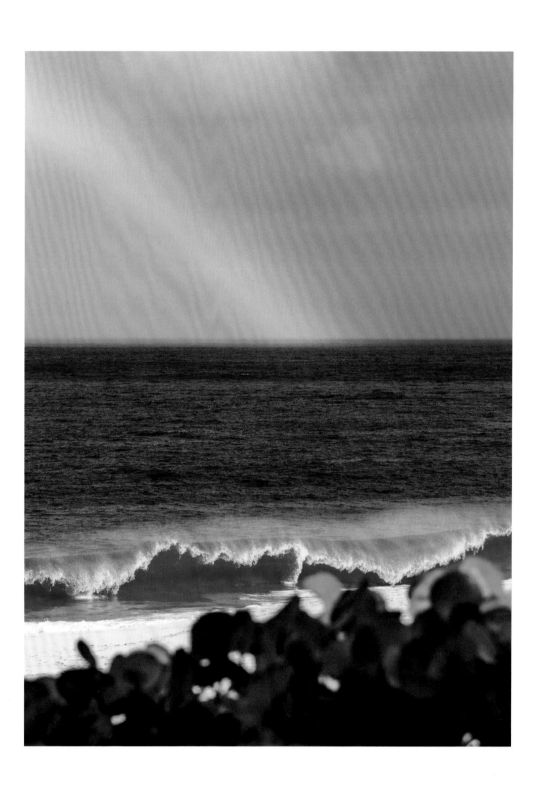

CRYSTAL BALL
North Shore, O'ahu
(left)

BRIGHTER DAYS
North Shore, O'ahu
(above)

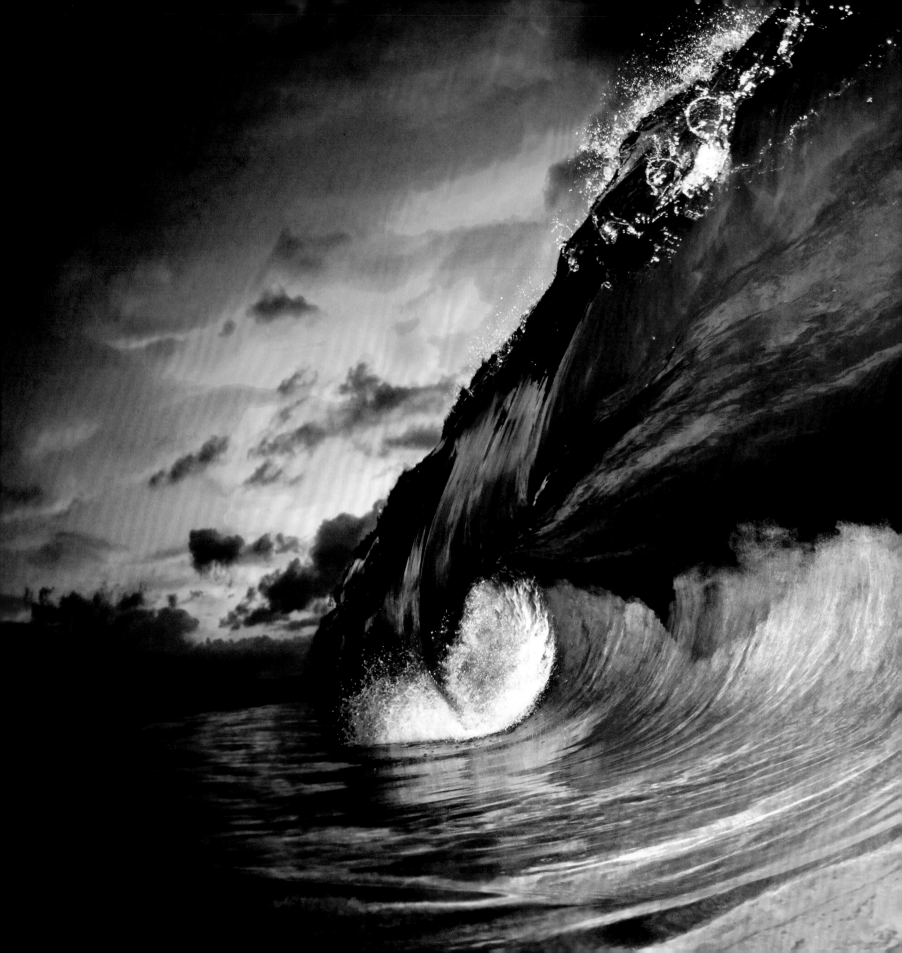

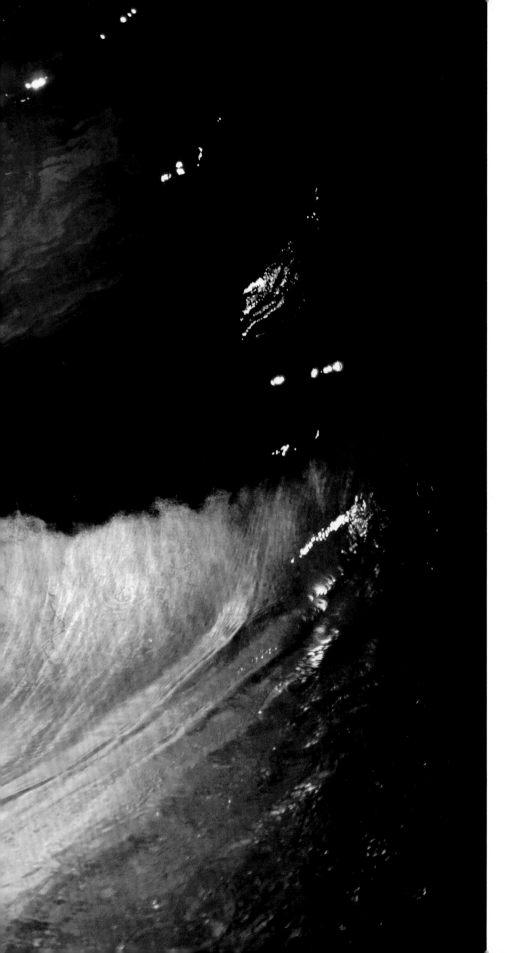

PINK FLASH
North Shore, O'ahu

Utilizing the light from a strobe flash, the inside of the
wave is highlighted, showing a rarely seen view at night—
sand getting pulled up off of the sea floor into a pitch
dark wave. The sunset in the distance illuminates the
clouds above, which in turn adds colorful reflections
to the surface of the water.

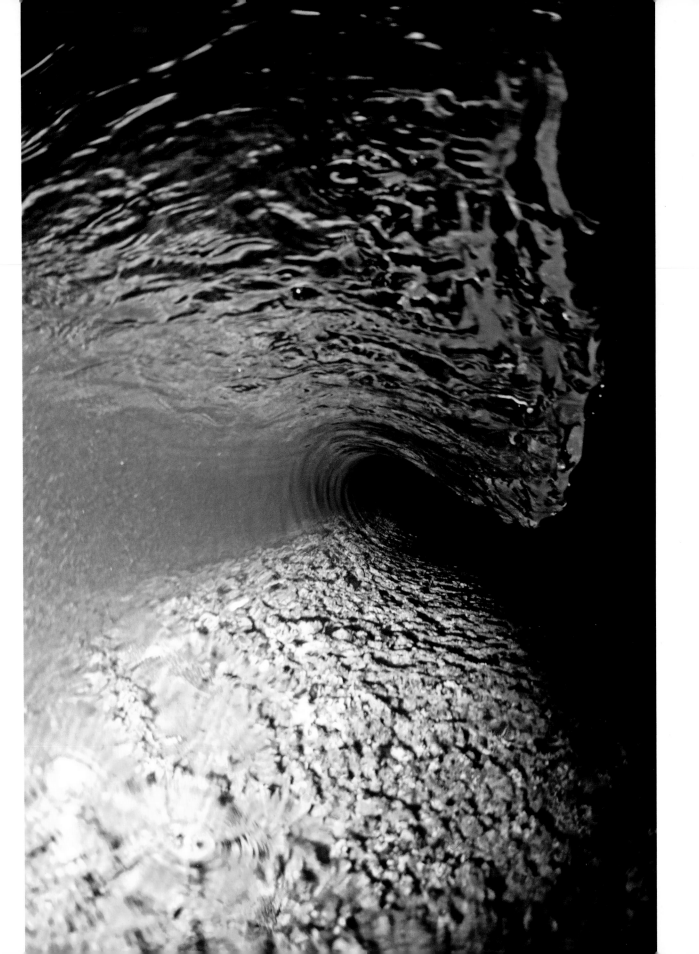

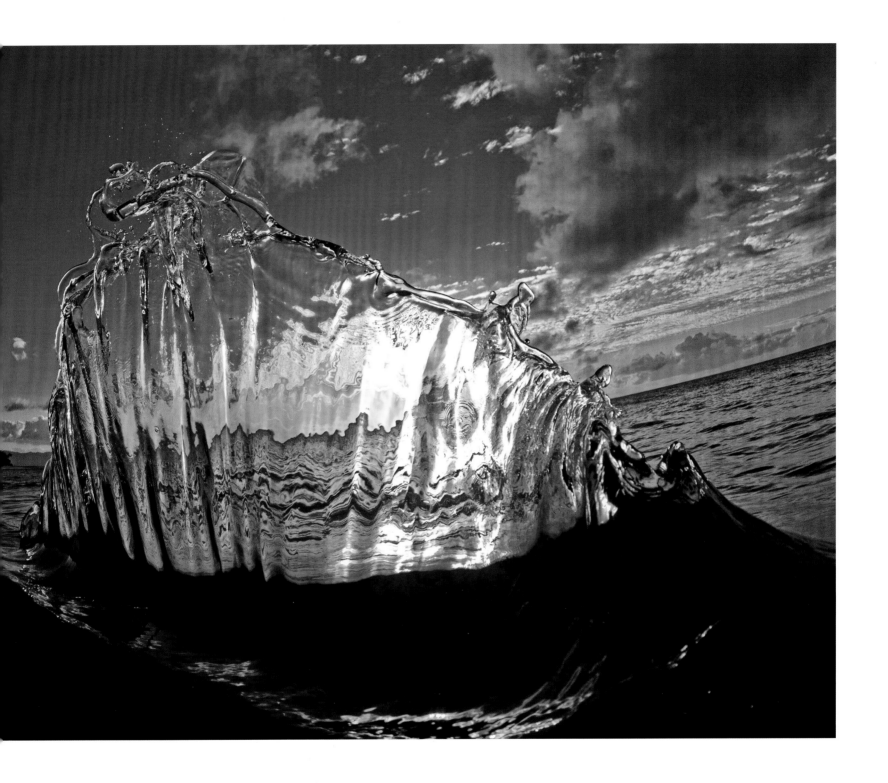

SUNKEN TREASURE
North Shore, O'ahu
(left)

HAWAIIAN CROWN
North Shore, O'ahu
(above)

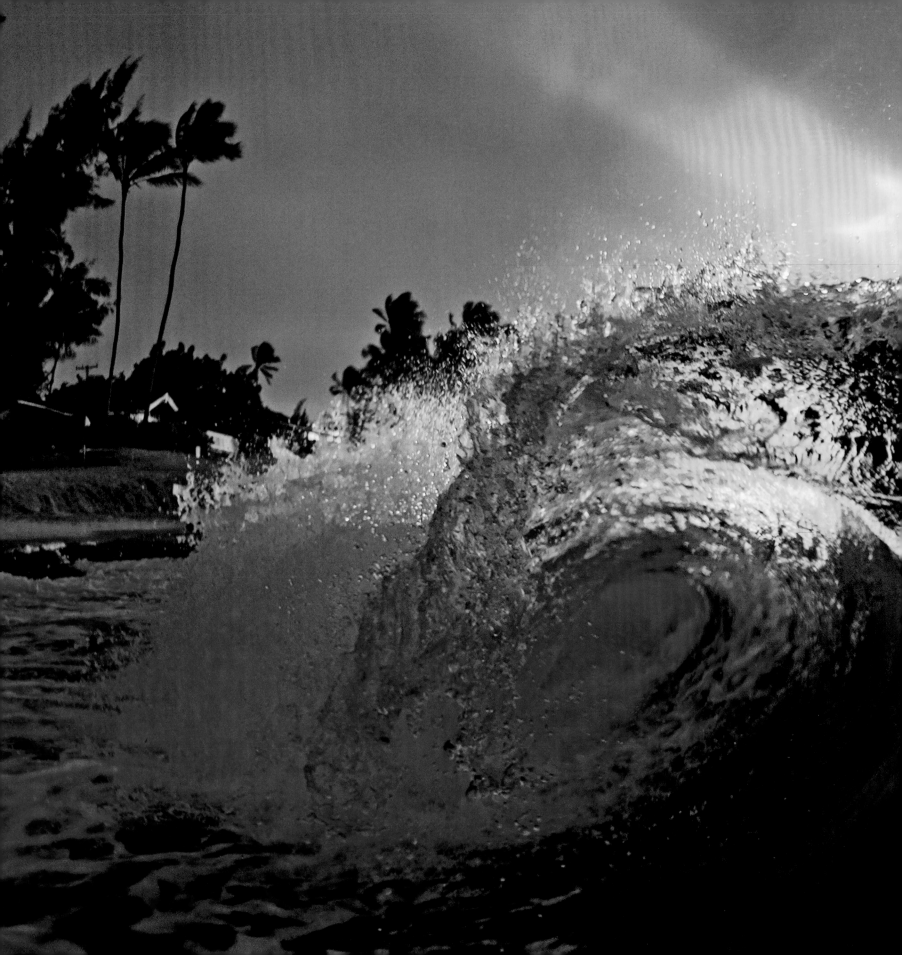

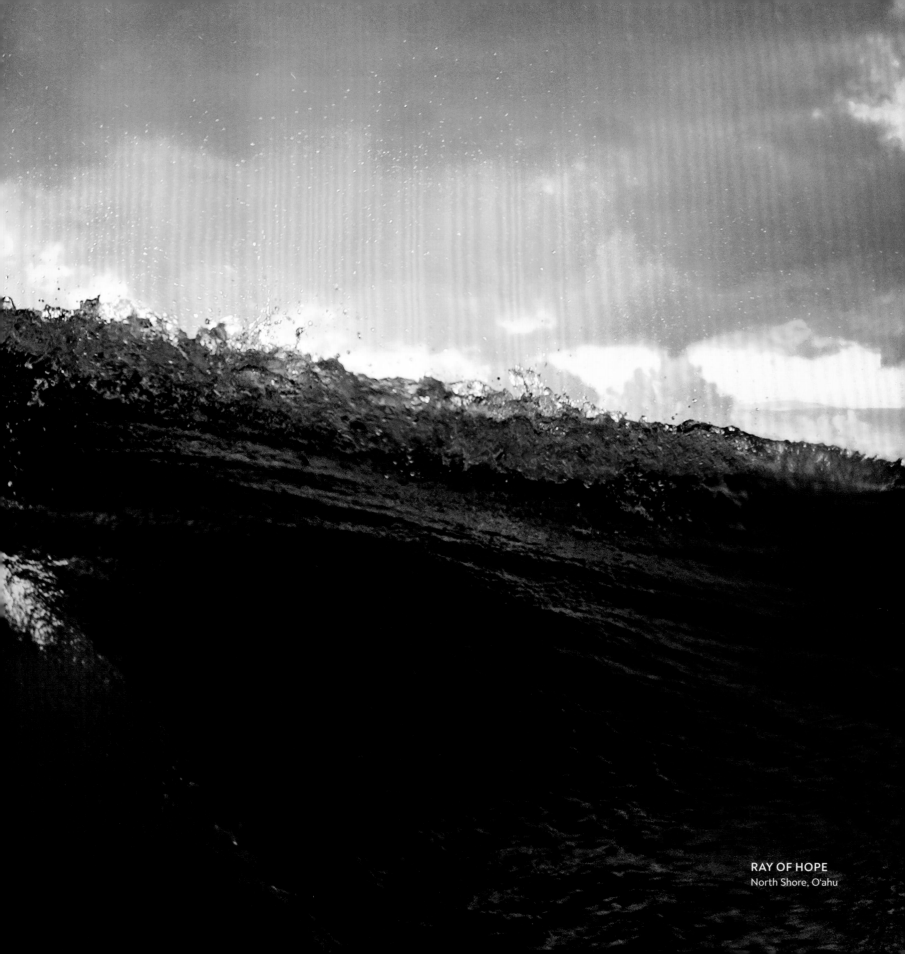

RAY OF HOPE
North Shore, O'ahu

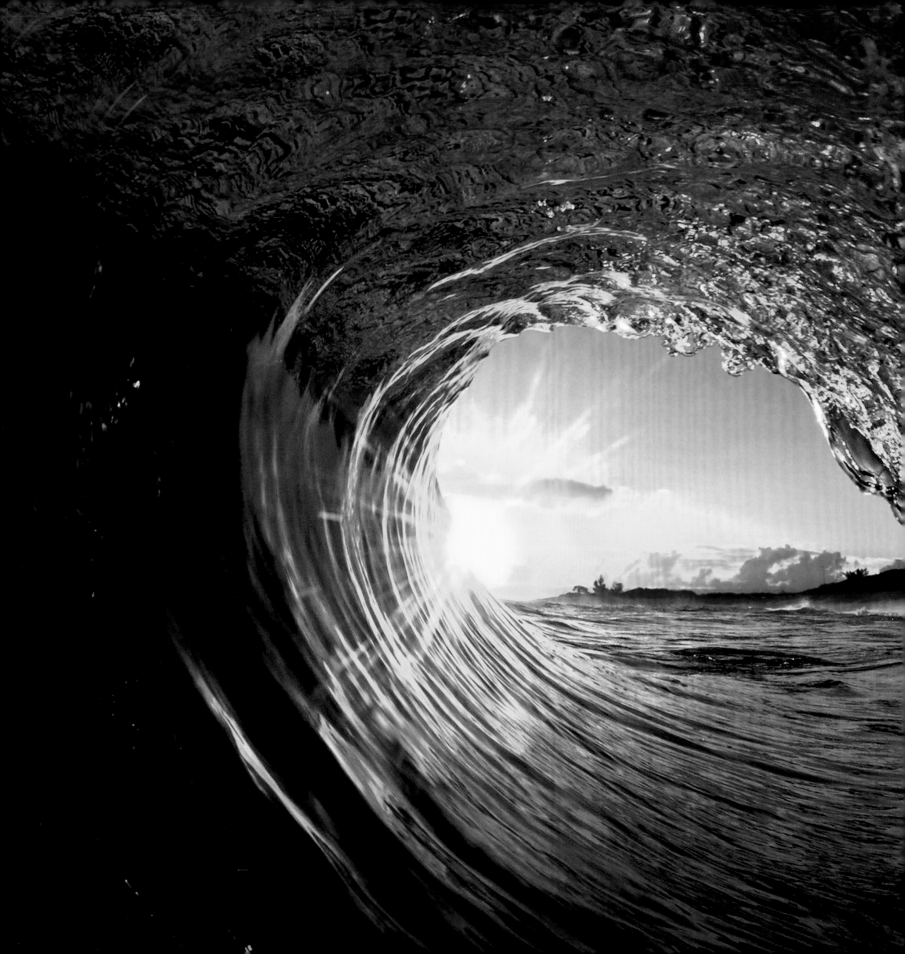

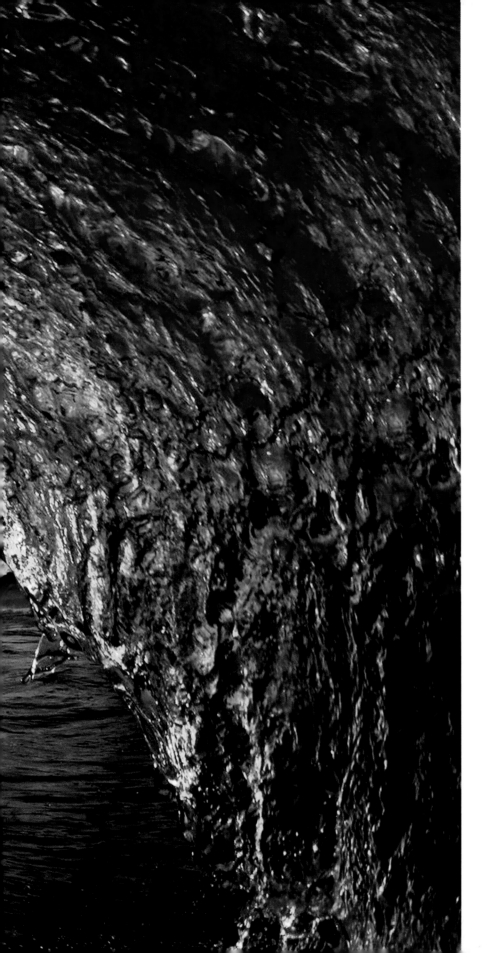

"The excitement and anticipation of that perfect wave coming: it never ends. With all my years in the ocean, I've cultivated a sixth sense of where and when that wave is going to break, and where to put myself."

SUN CURL
North Shore, O'ahu

I tried for a very long time to create this shot—to capture the sun positioned right on the edge of a perfectly tubing wave. Certain natural conditions were necessary: the season for the location of the sunrise, the right swell, calm and light winds, and limited cloud coverage on the horizon. I also dealt with a set of my own challenges, like waking up an hour or more before the sunrise so I could swim out in the dark to be ready with my camera for the short "golden hour" window. Even if all of the factors came together and I was out in the water on a perfect day, I still had one last challenge—to find a wave that would bend precisely toward the sun as it formed a tube. After months of driving to this remote beach, everything finally came together to produce one of my favorite sunrise images.

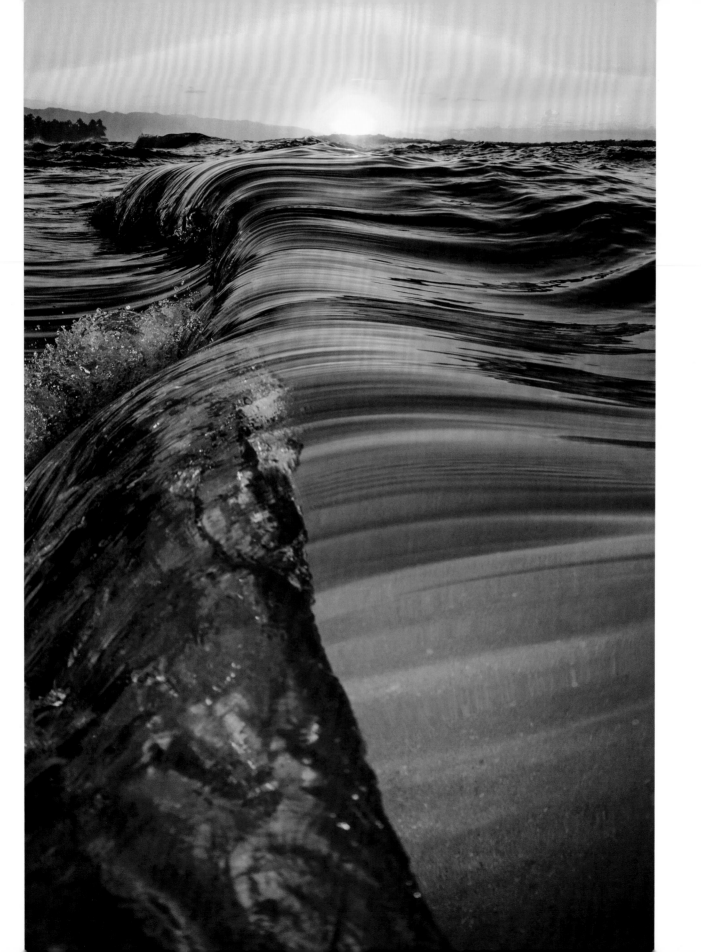

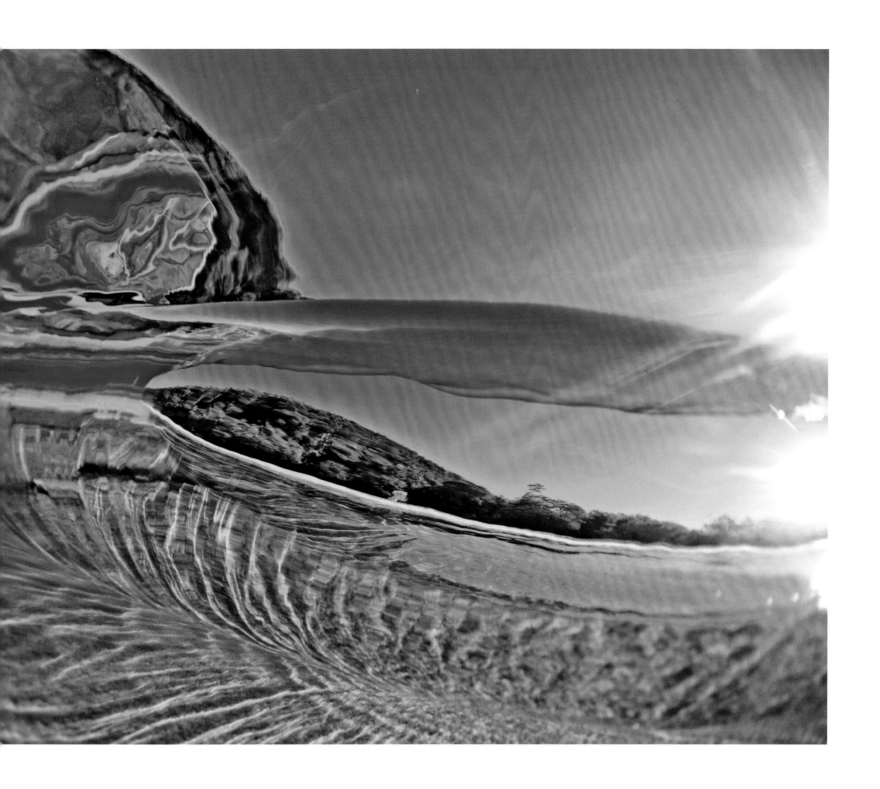

PEACHY KEEN
North Shore, O'ahu
(left)

WAHINE
Mākena Beach, Maui
(above)

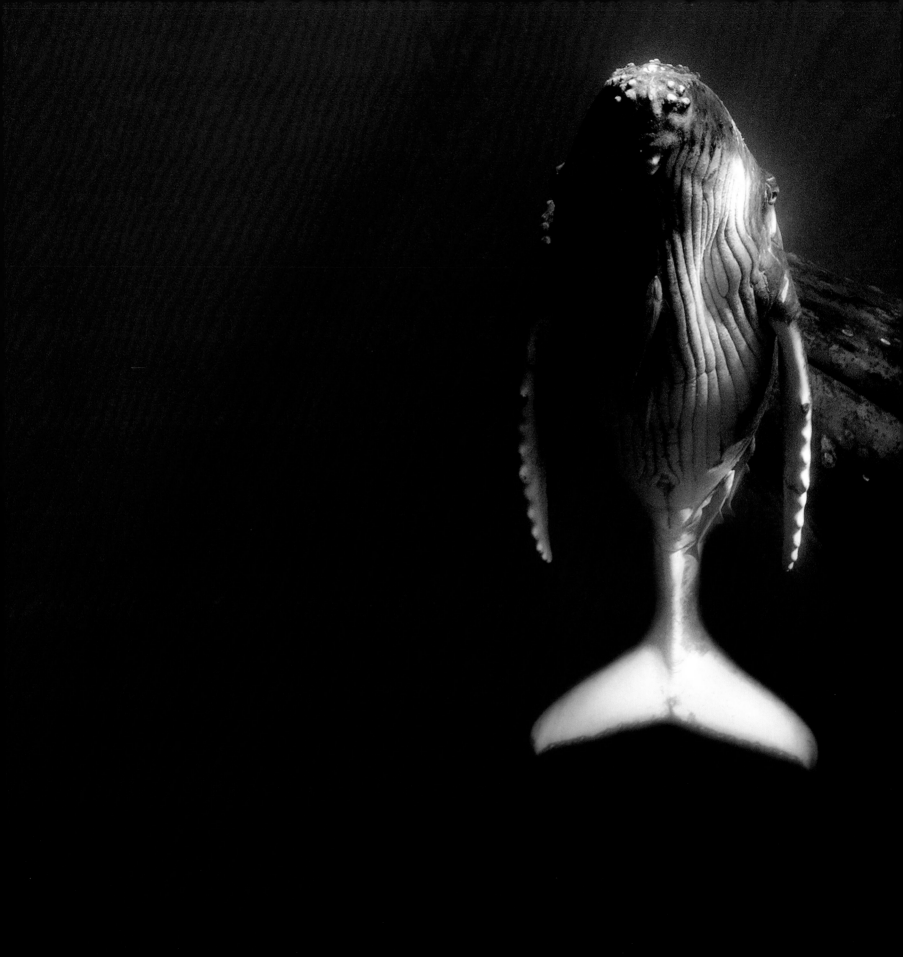

Beyond the Shorebreak

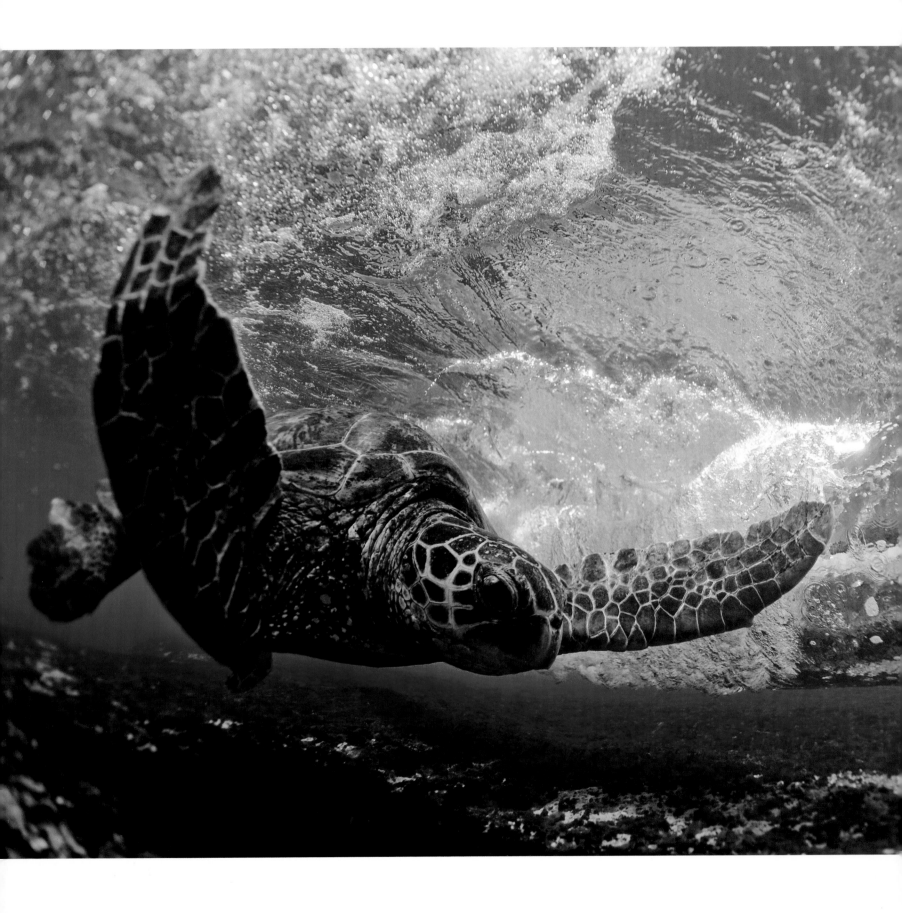

As a surfer, Clark grew up sharing the ocean with the phenomenally diverse marine life of the Hawaiian Islands. Straddling his board, with a carpet of brilliant blue stretching to the horizon, he'd sometimes see turtles or dolphins or even a humpback whale breaching the surface to expel a misty spout of air. But he didn't start photographing marine life until it virtually landed in his lap. One summer day in 2009 he was out shooting small barrels on the inside reef at Laniākea when a honu (green sea turtle) appeared. It seemed friendly, curious, even playful. From underwater, Clark observed how it flapped its flippers like wings. He was struck by the way it rode the momentum of the waves. *Like bodysurfing,* he thought. He snapped a few shots and managed to nail *Flying Honu,* which would find its way into the Smithsonian Museum.

Flying Honu piqued Clark's interest in marine life. He went snorkeling with friends along the coral reefs at Three Tables. He had a buddy who swam with sharks at a spot off Hale'iwa, and one day he brought Clark along.

"That first time I remember thinking *No, you've got to be kidding me—I am not going in there!* But once I was educated, once I was taught what to do, what not to do, and how to approach the sharks, I was much more at ease. Eventually, I could get very close and interact and actually touch them. It's an amazing feeling to be out there one-on-one with a shark. If you're doing it in the right place, with people who are educated and teaching you the right way to do it—I think everybody should take a peek."

Since *Flying Honu* and his foray into swimming with sharks, Clark has added marine life to his subject matter. He likes that it takes him beyond the shorebreak, and that it provides him with a subject when the waves are flat.

"Big waves happen in winter, and summers on the North Shore are a lot more quiet," he says. "The underwater water color is gorgeous, and there is so much life thriving down there. I just keep discovering new things."

MOTHER'S DAY
Tonga
(previous page)

On a trip to Tonga with Juan Oliphant and Ocean Ramsey, we swam in the crystal clear, warm water, surrounded by a pod of curious and tame whales. This shot captured one of the highlights, when the baby whale looked at me for the longest time. The proud mother was behind her baby the entire time, providing support.

FLYING HONU
North Shore, O'ahu
(left)

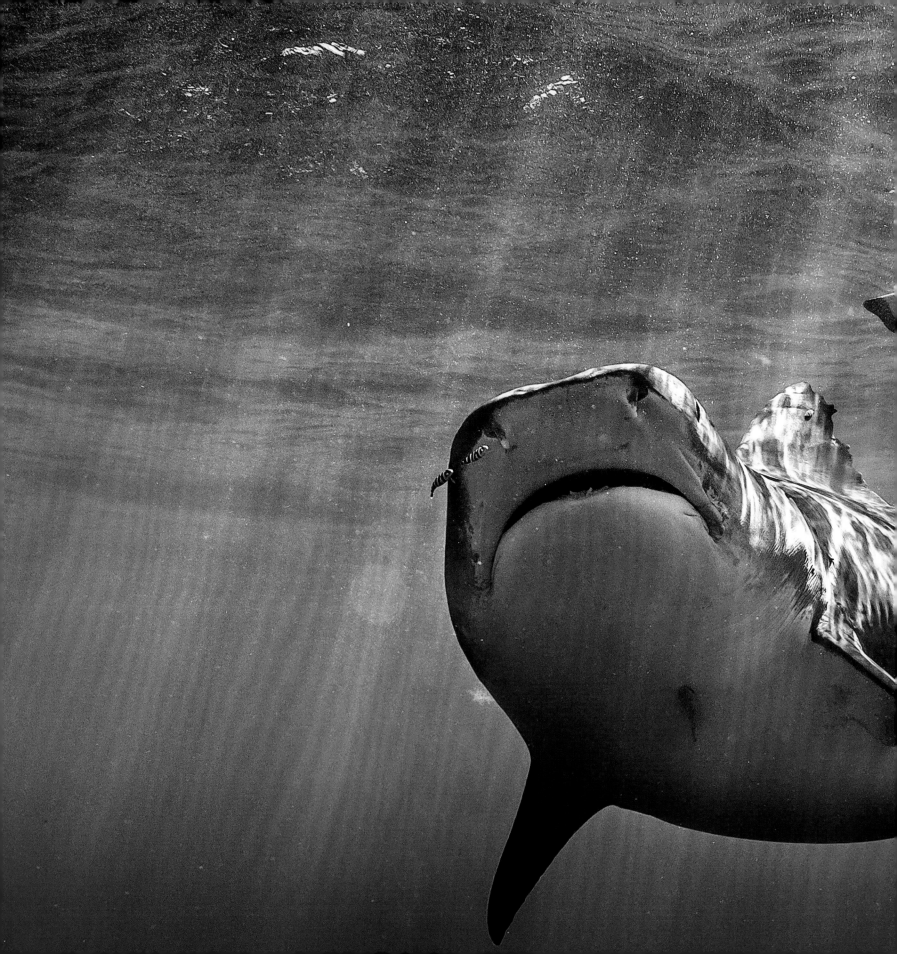

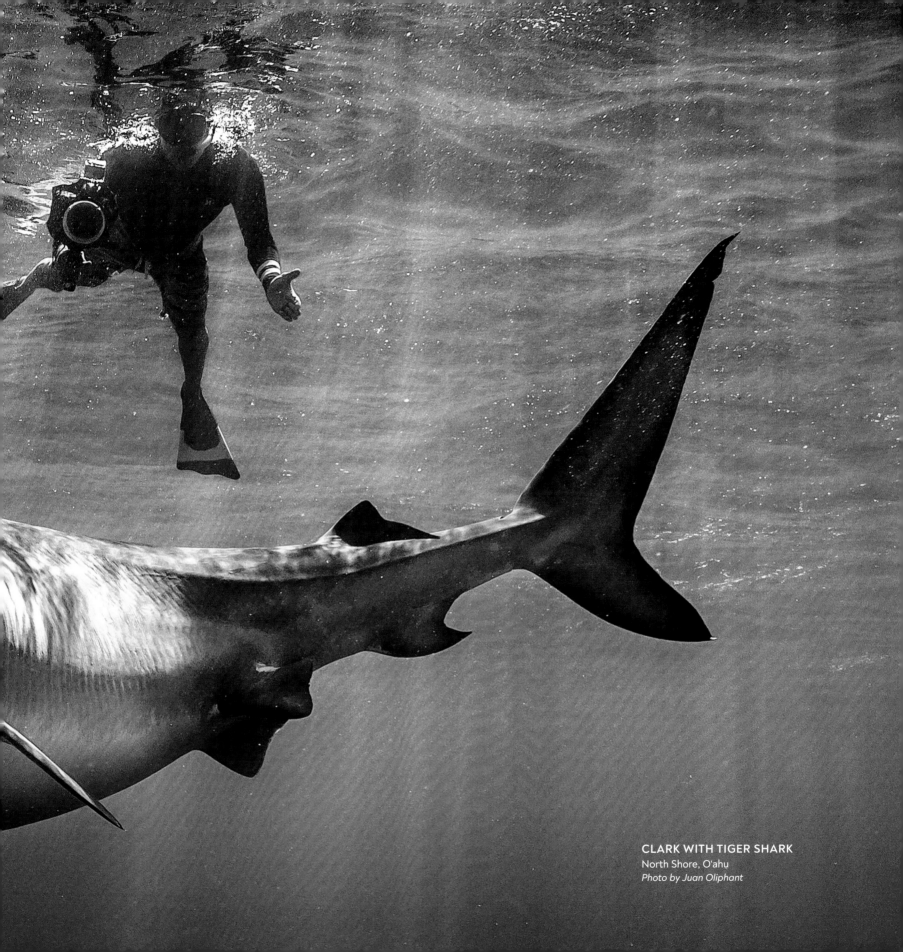

CLARK WITH TIGER SHARK
North Shore, O'ahu
Photo by Juan Oliphant

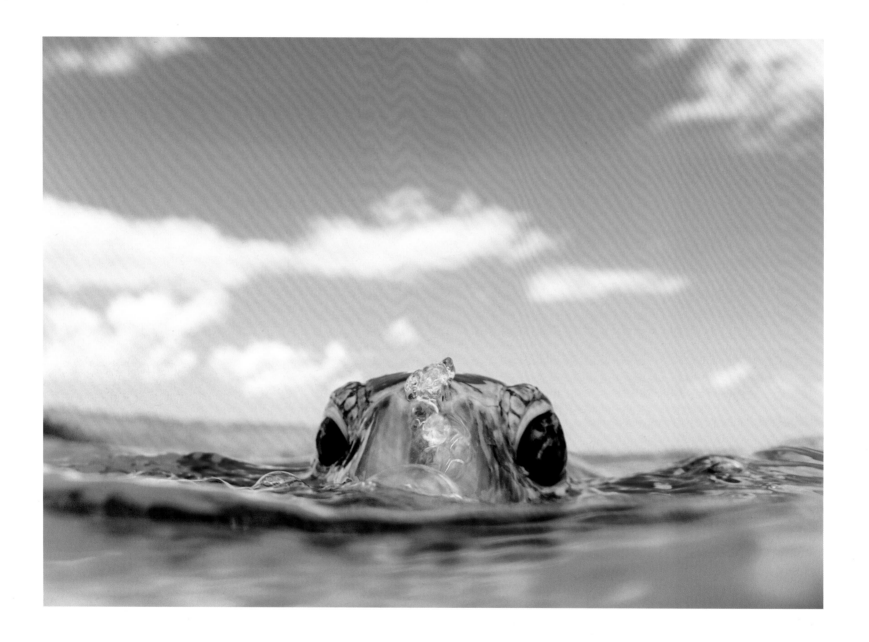

SNAKE EYES
North Shore, O'ahu
(above)

This turtle's head looks like an alien. As the turtle
comes up to the surface for air, it clears water from
its body through its nares (nostrils) before taking
a deep breath.

HALF AND HALF
North Shore, O'ahu
(right)

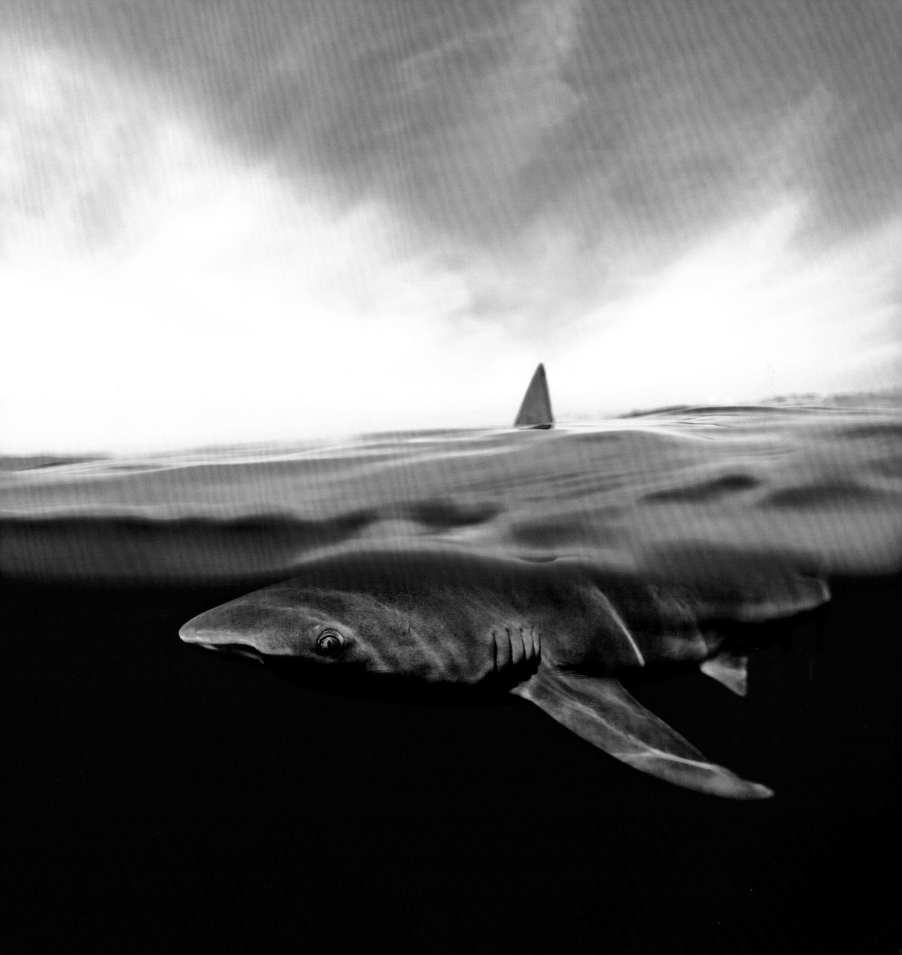

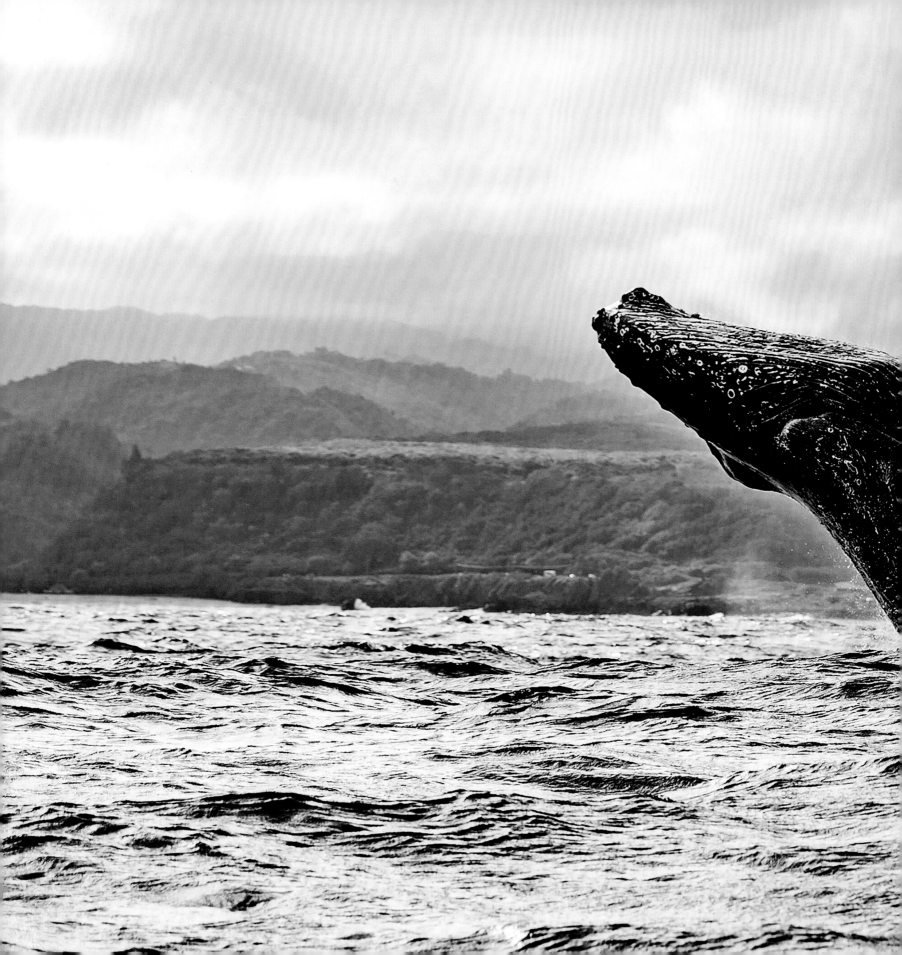

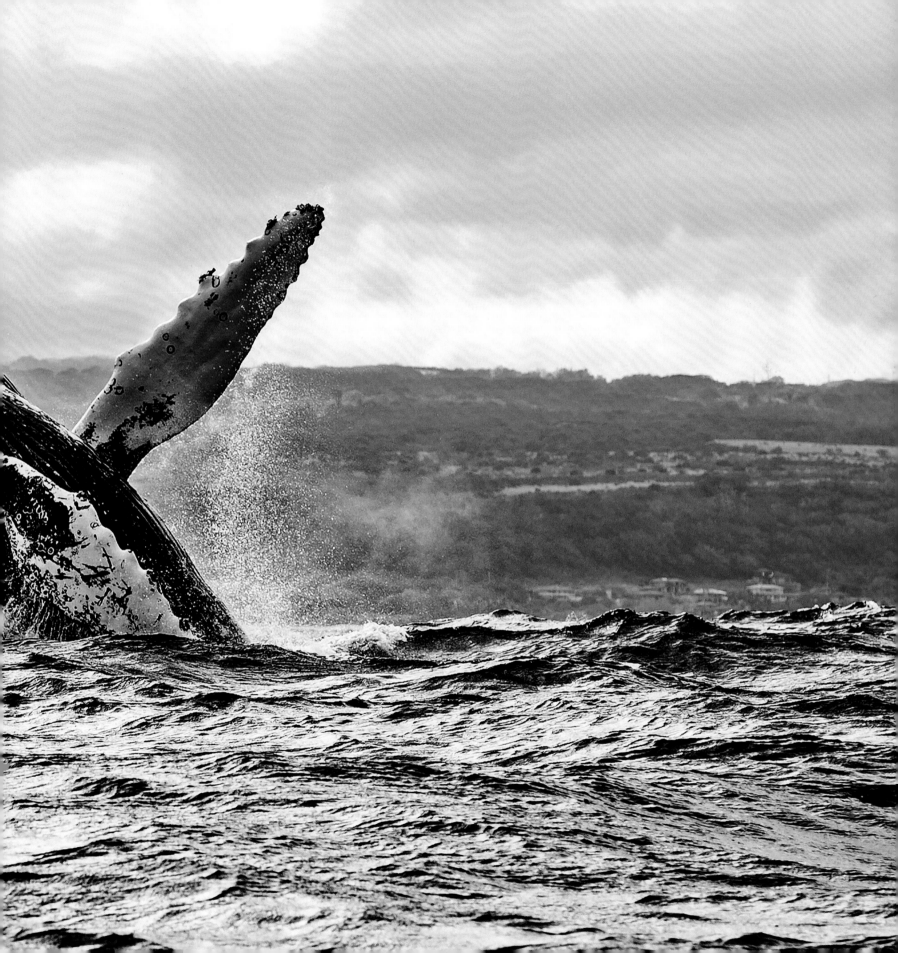

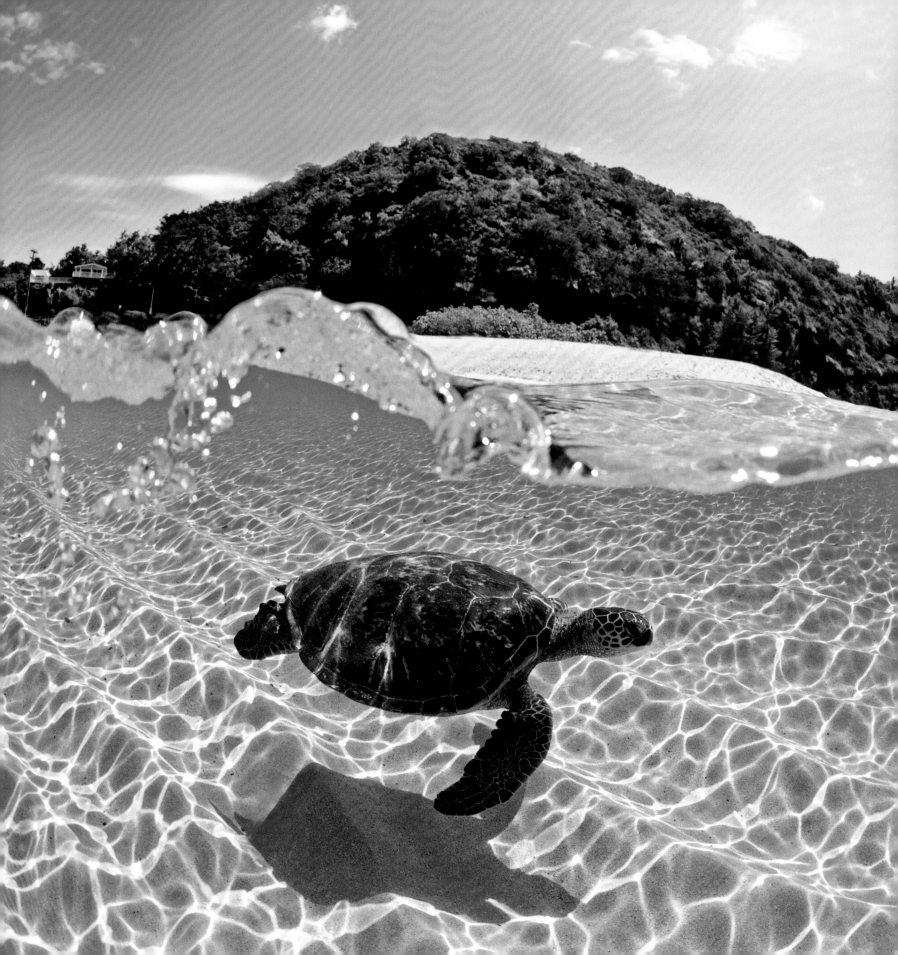

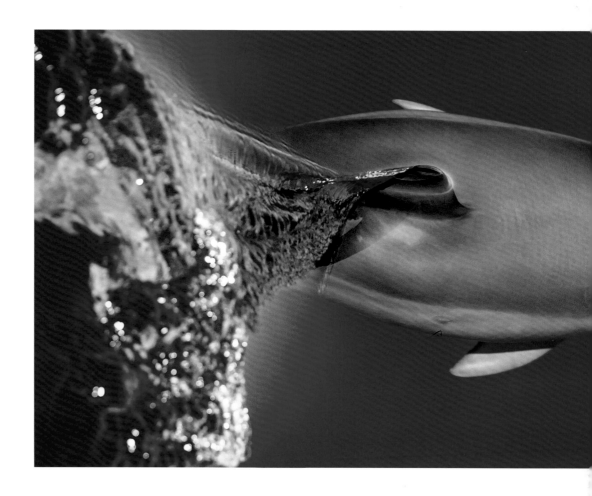

WHALE BREACH
North Shore, O'ahu
(previous page)

WATER BABY
Waimea Bay, O'ahu
(left)

On this day, the water at Waimea Bay was the clearest I've ever seen it. I was working with my 12-inch port, a lens dome that measures one foot in diameter and connects to the front of my water housing. This works together with my fisheye lens to capture great "under/over" shots, in which half of the shot is underwater while the other half is above water. I already had a great day shooting the clear water—golden sand and the lush hills surrounding the valley—when a turtle swam right in front of me, sending the session to the next level.

SEA CARVING
North Shore, O'ahu
(above)

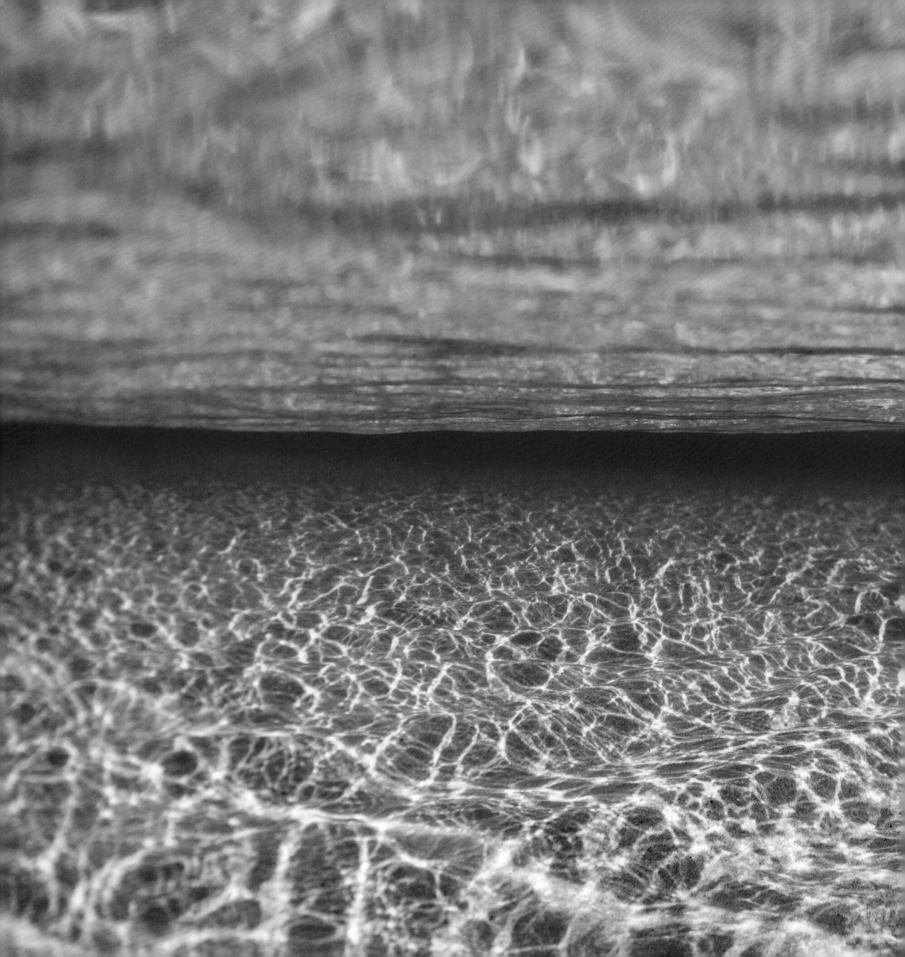

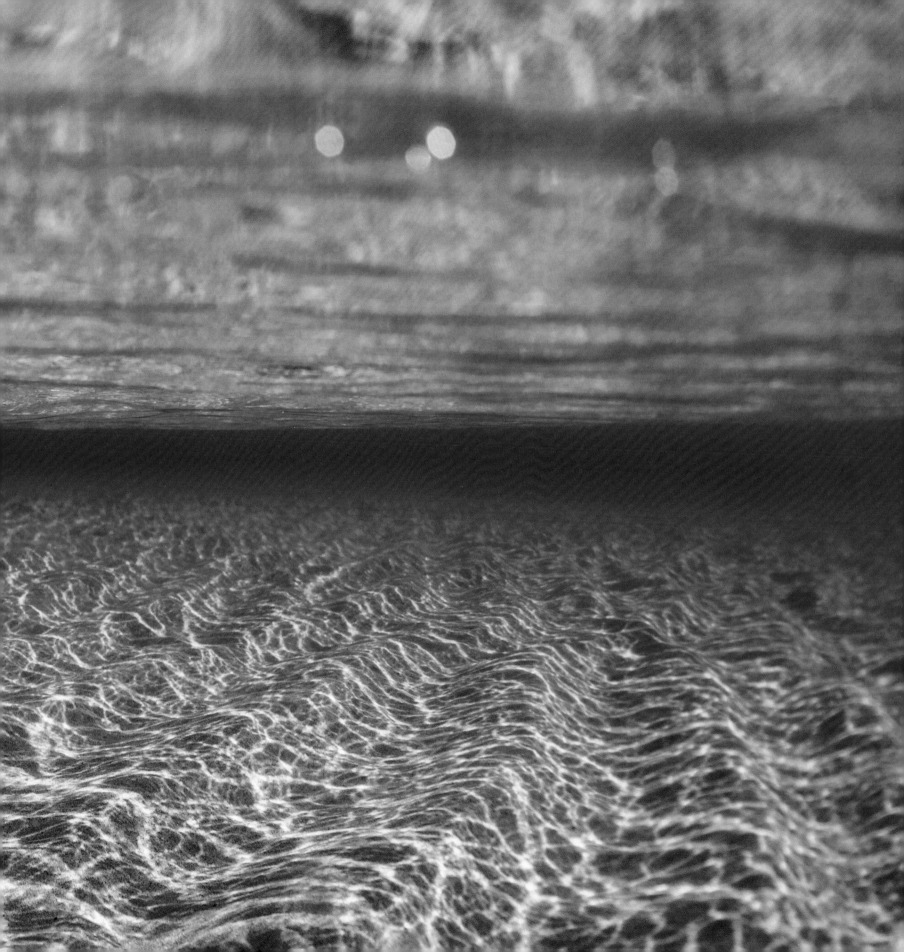

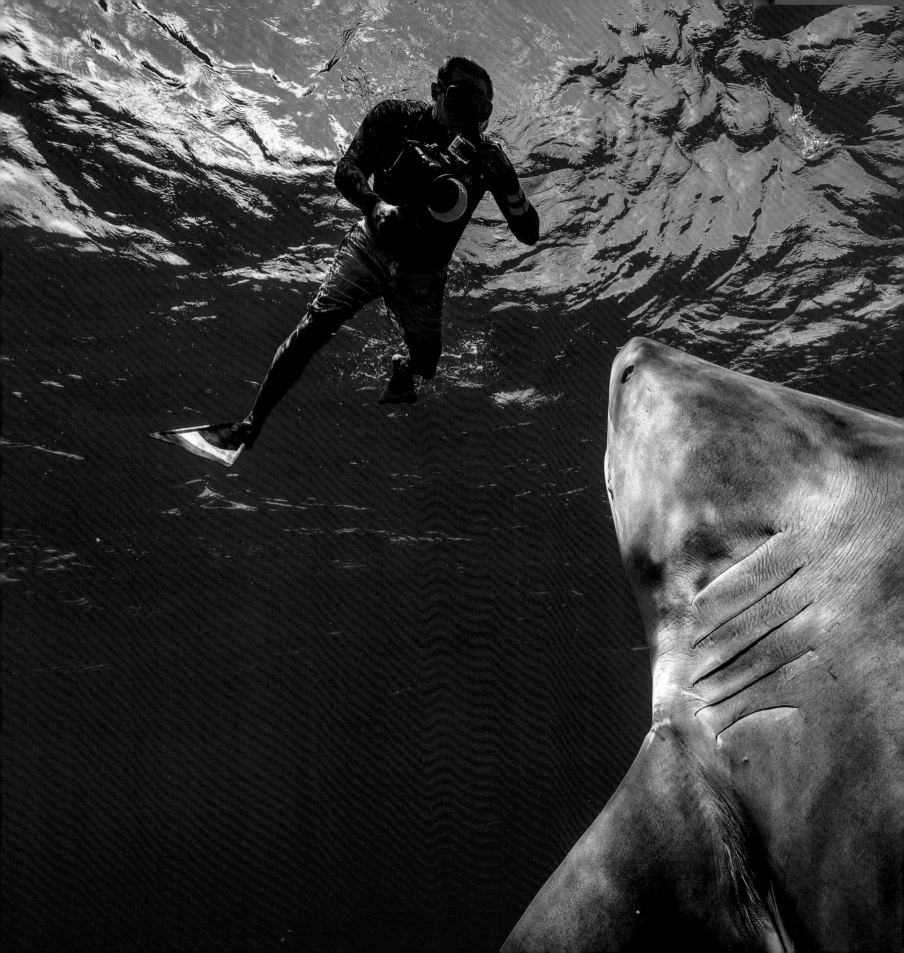

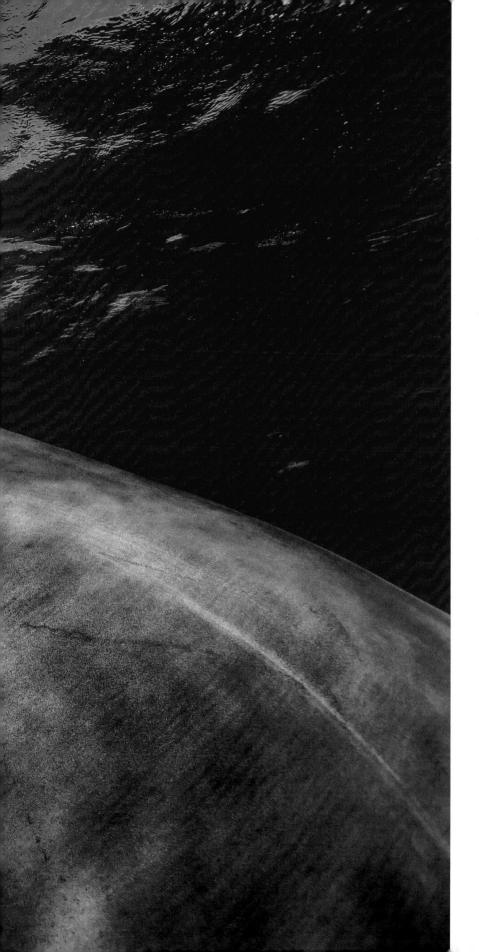

"Shooting tiger sharks is as thrilling as shooting ten-foot shorebreak."

CLEAR WATER
Waimea Bay, O'ahu
(previous page)

TIGER SHARK UP CLOSE
North Shore, O'ahu
(left)
Photo by Juan Oliphant

91

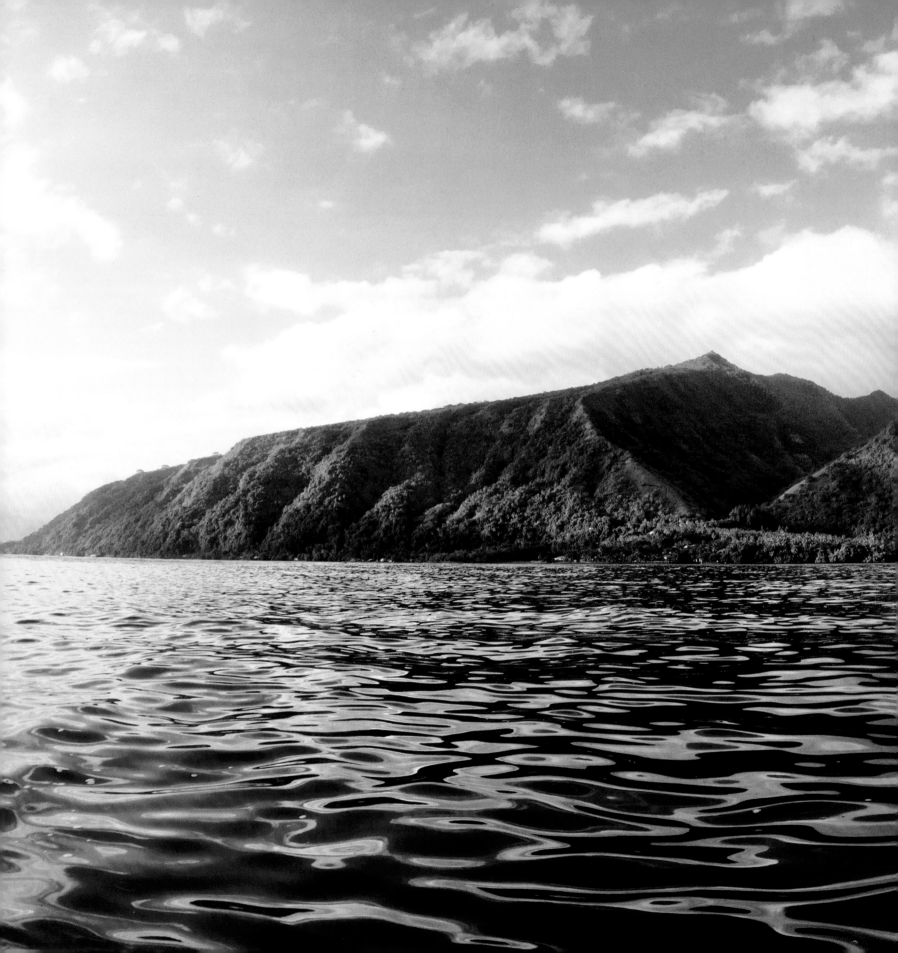

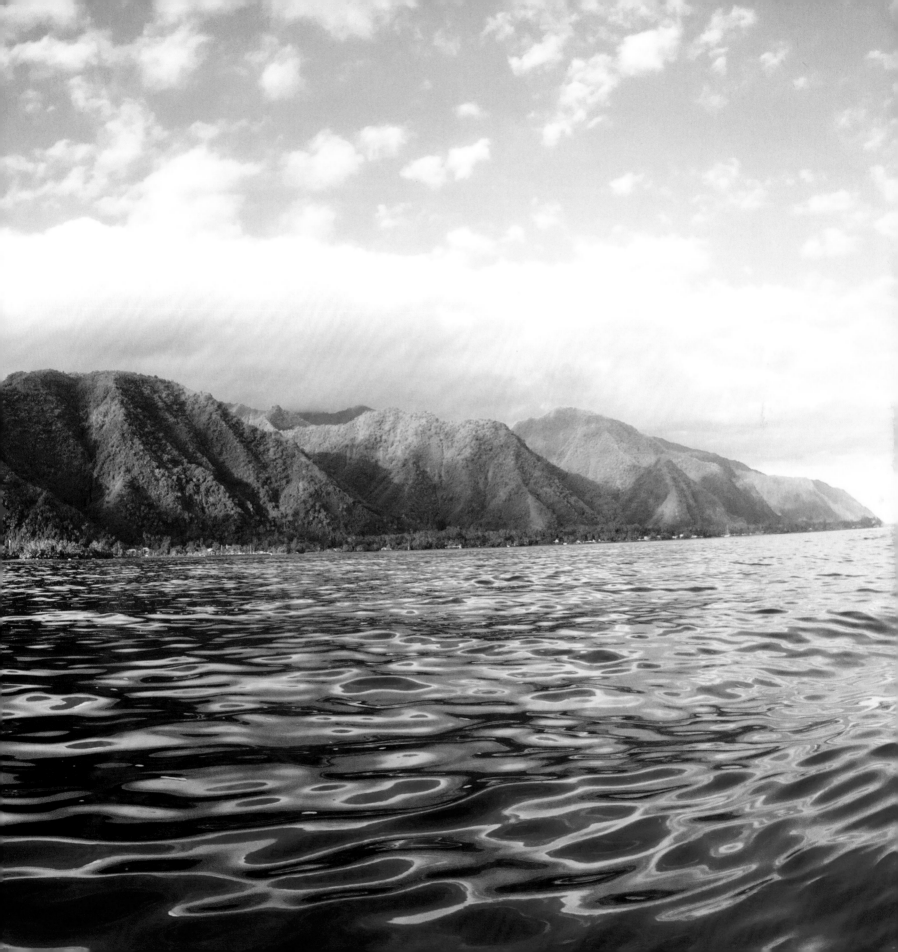

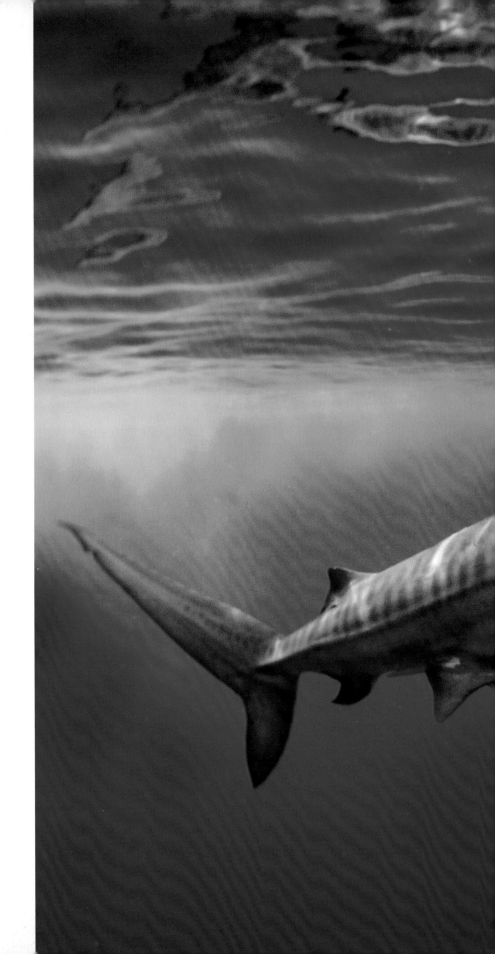

FRENCH POLYNESIA
French Polynesia
(previous page)

TIGER
North Shore, O'ahu
(right)

94

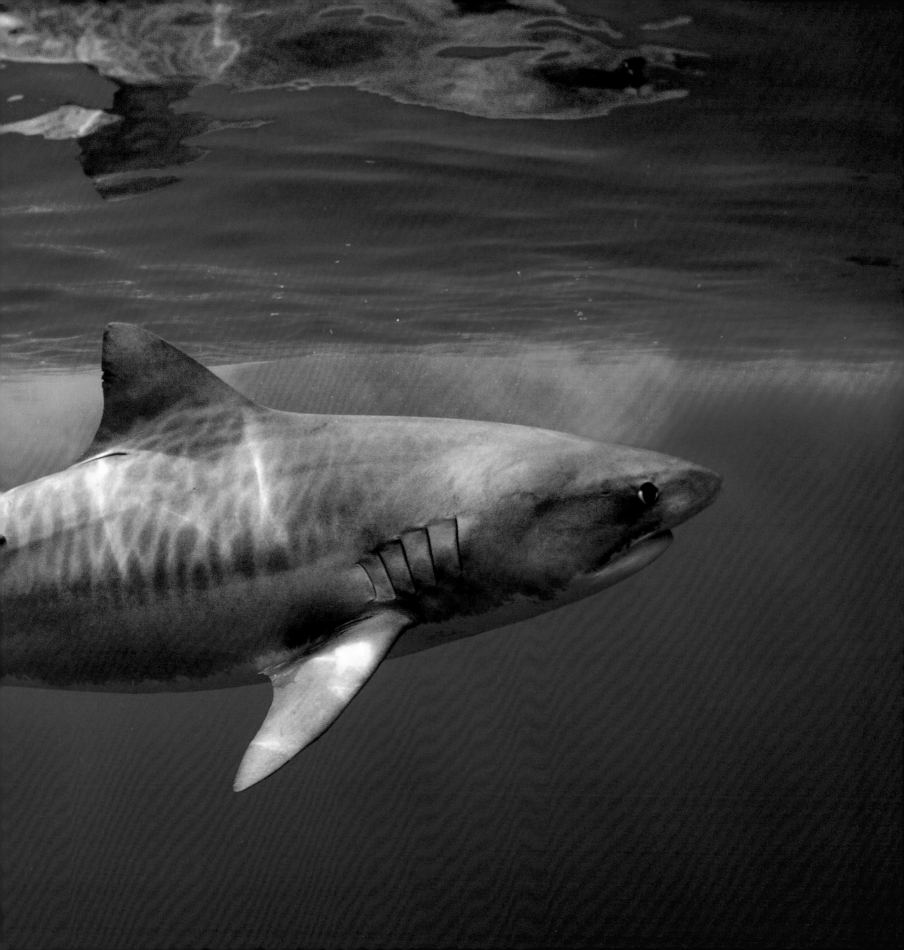

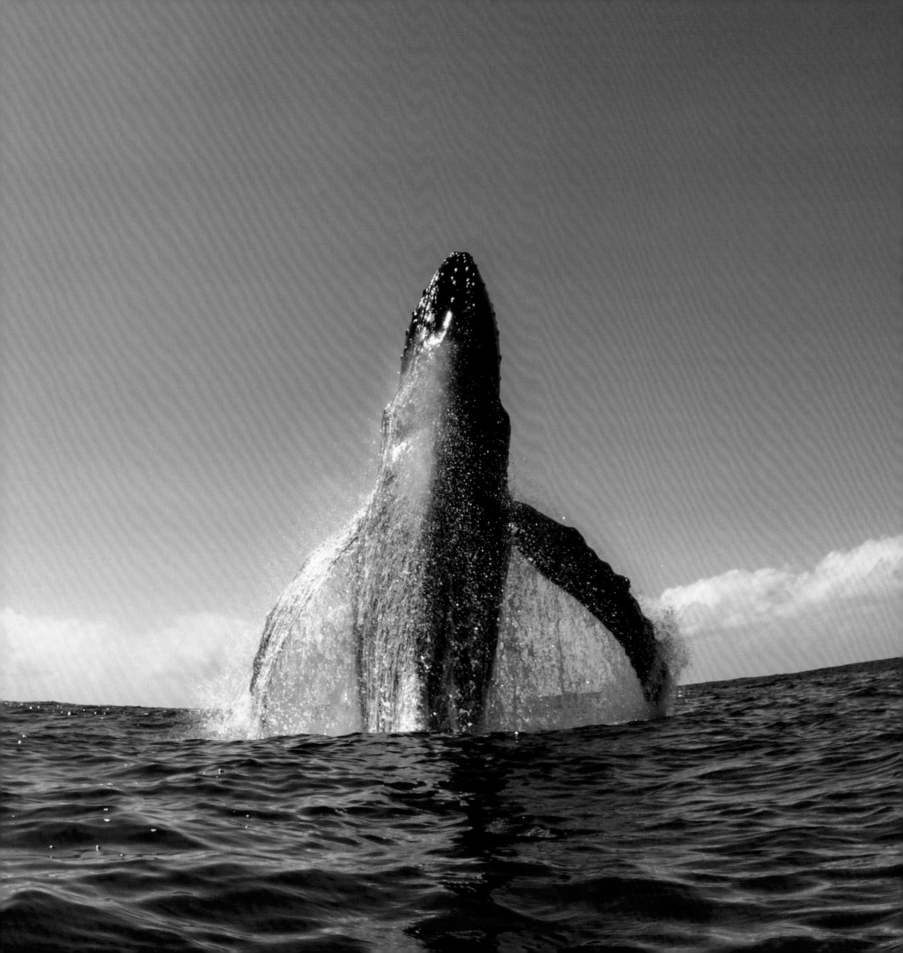

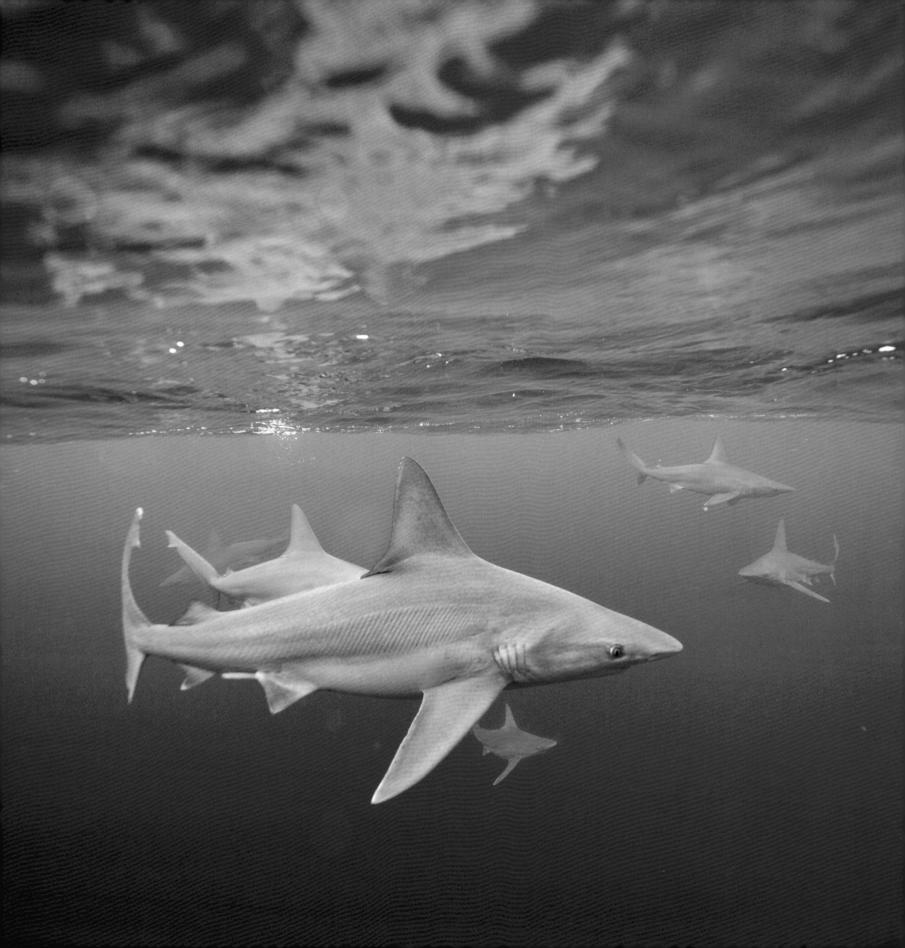

WHALE BREACH CLOSE
(previous page, left)
North Shore, O'ahu

I was several miles outside Hale'iwa, swimming in
the deep ocean and photographing marine life.
I looked down into the darker water and noticed
a big whale coming toward my general direction,
at an angle that would bring it to the surface close
by. Moving at a slow and steady pace, I figured it
would merely skim the surface to get some air and
drop back down. I got excited and was getting
myself ready to bring my camera out of the water
to capture this. The split second before I brought
my head up, I saw the whale do two or three extra
powerful kicks. I remember thinking, "that was
different." The next thing I knew, I was staring at a
whale just 50 feet in front of me, shooting straight
out of the water toward the sky. The surprise, the
sound, the sheer energy. I was in awe and shock,
and luckily my finger didn't freeze and pushed the
trigger to get the shot. Afterward, I realized how
lucky I was that it breached and landed pointing
away from me!

WONDERS OF THE DEEP
North Shore, O'ahu
(previous page, right)

PACIFIC BLUE
North Shore, O'ahu
(right)

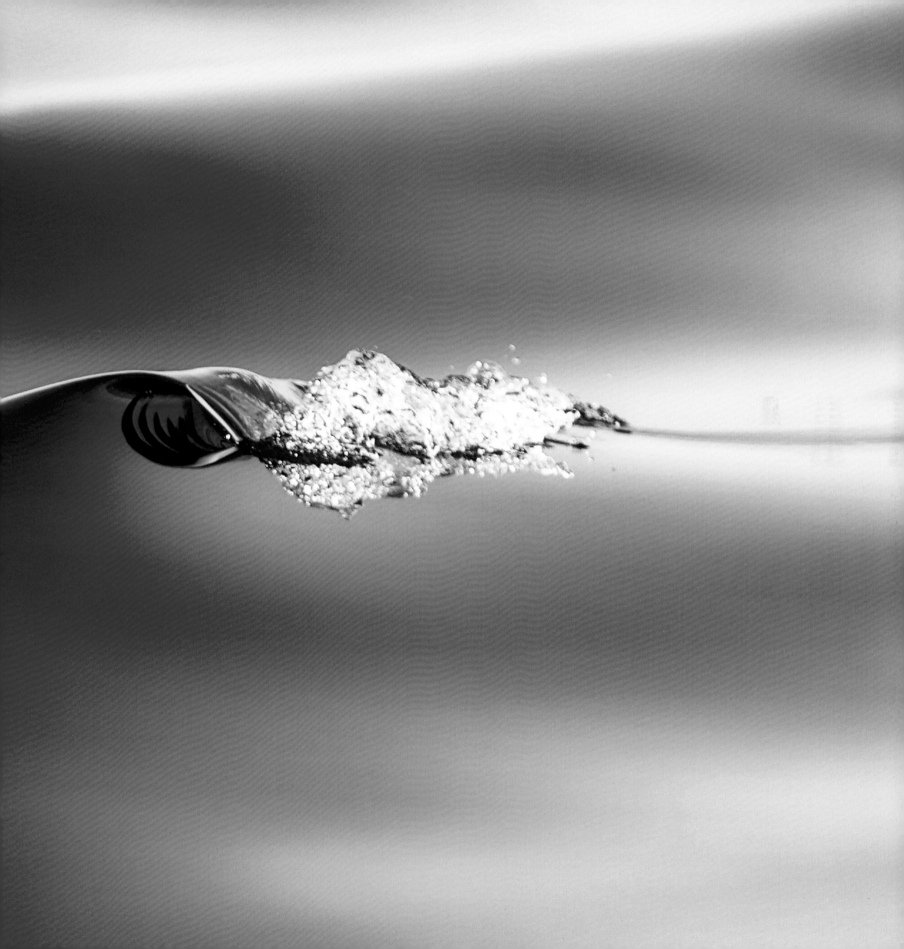

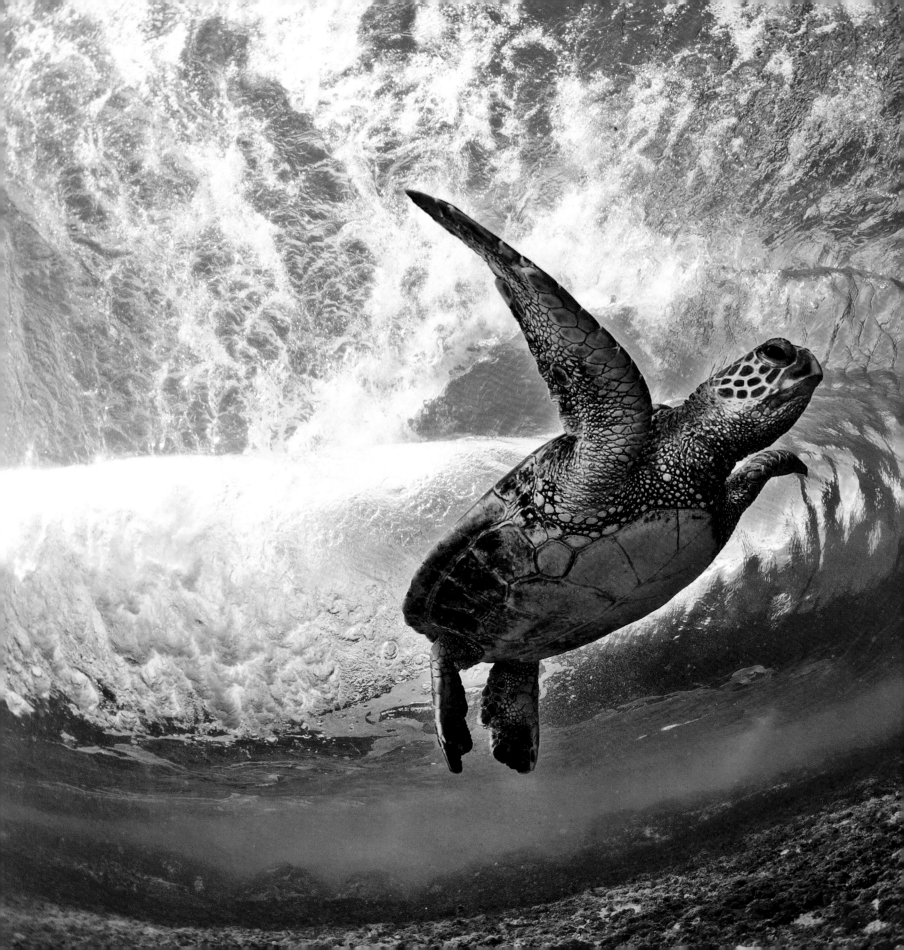

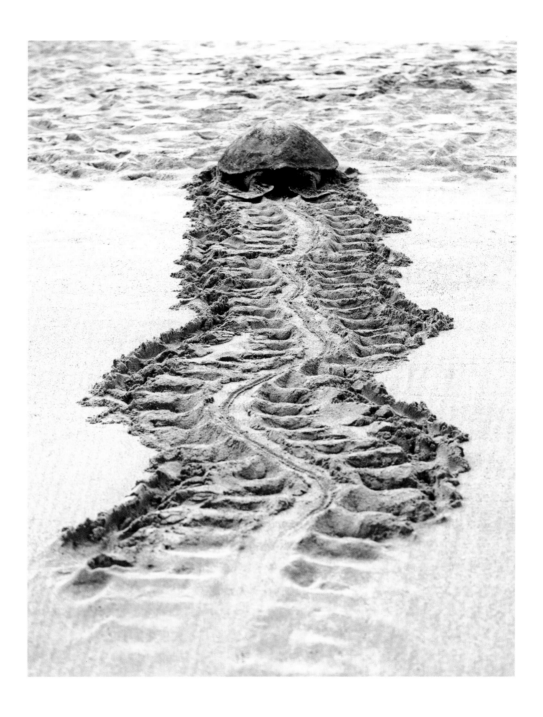

OCEAN EAGLE
North Shore, O'ahu
(left)

HONU TRACKS
North Shore, O'ahu
(above)

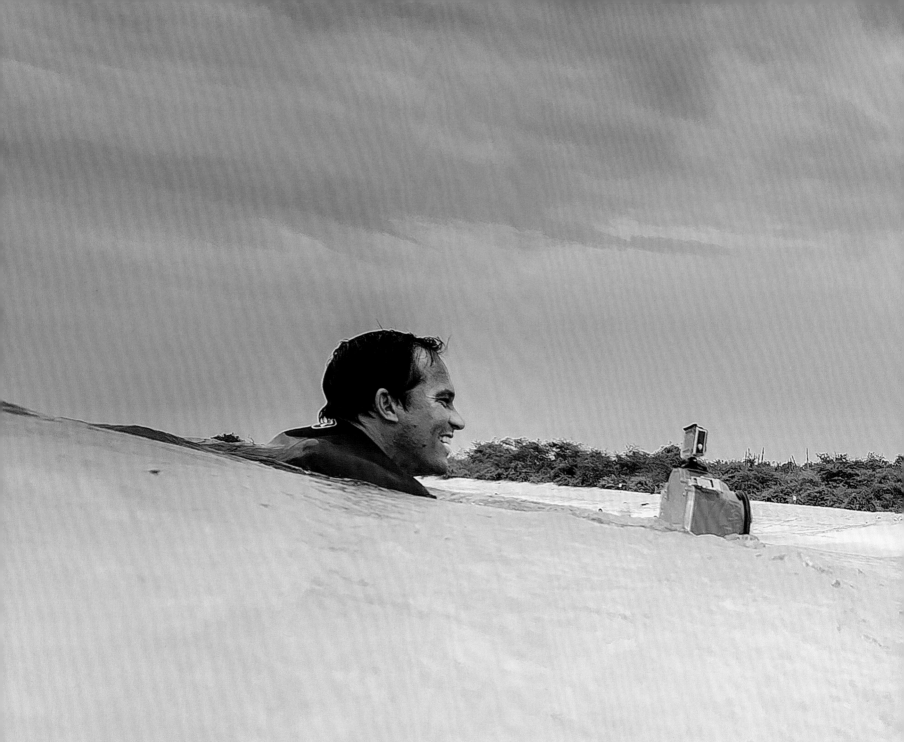

PLAYFUL SEAL

Galápagos Islands, Ecuador
Photo by Juan Oliphant

What appears to be a sleeping seal is actually a playful one. This seal came toward me,
then started rolling sideways down the beach. It made me laugh. I see monk seals in
Hawai'i, but they are shy and tend to keep their distance. Never have I experienced seals
as tame as those in the Galápagos Islands. At one of the hotels, the lounge chairs lining
the docks were taken up by napping seals. Yes, they were laying down and sleeping
in the reclined position in lounge chairs! Some even had two seals per chair.

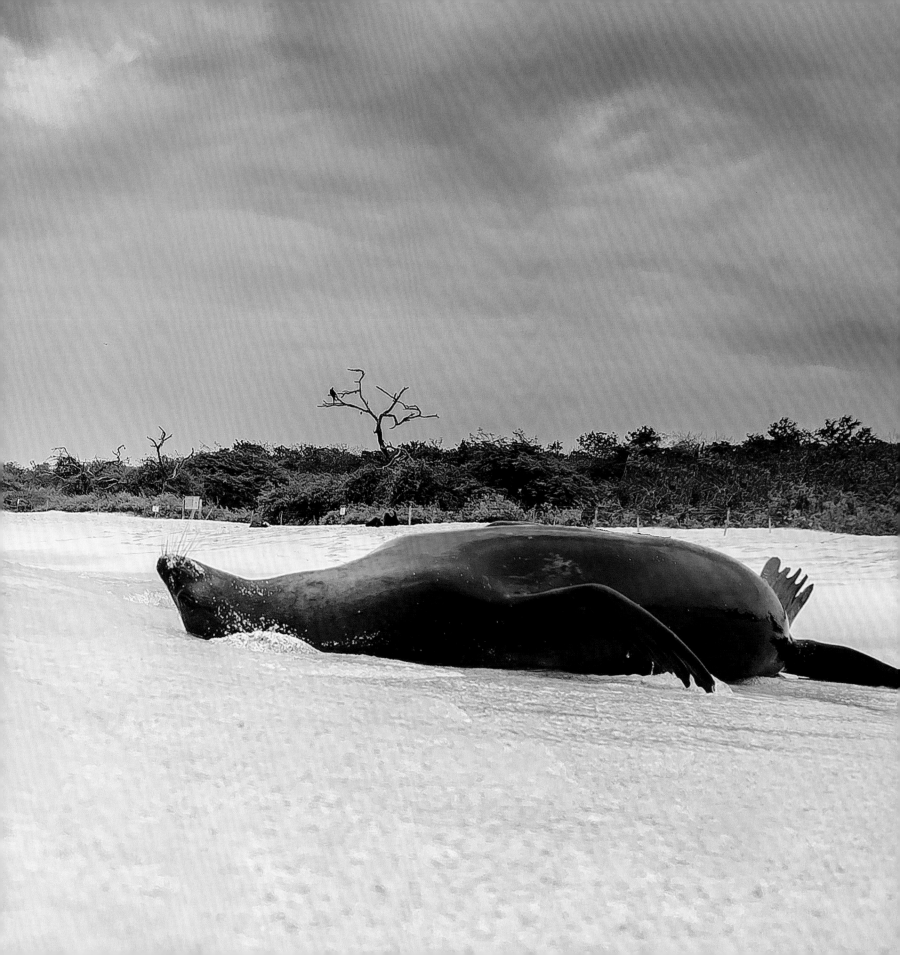

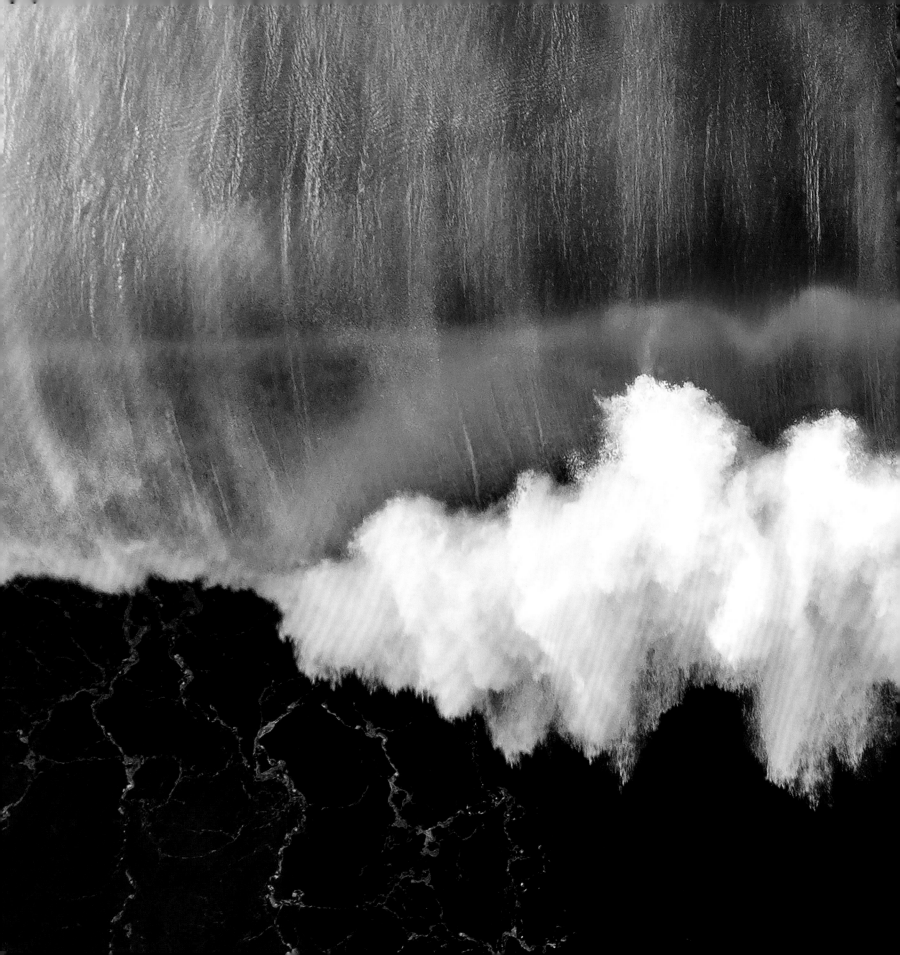

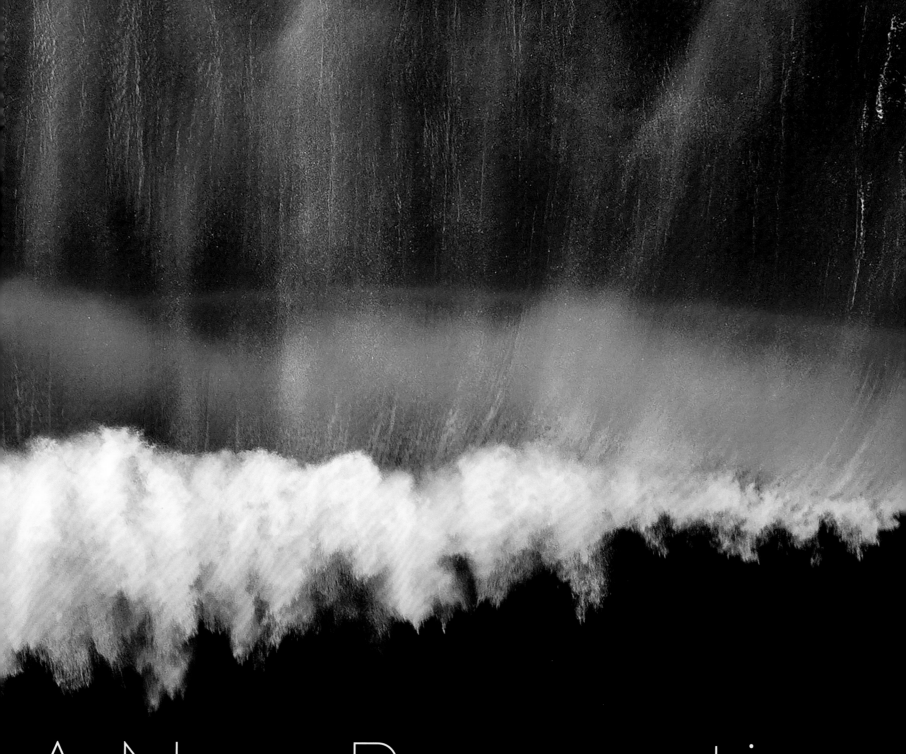

A New Perspective

Most of us watch waves from the shore, a frontal view. Clark's images allow us to see inside the tube, shooting down the line of the wave as it breaks. In recent years, Clark has continued to explore different perspectives of the wave.

In 2014 he went up in a helicopter and shot red-hot lava flowing out of Kīlauea volcano on the Big Island. Soon after, he was flying high above the North Shore, shooting his favorite waves and coastline from this new perspective. The bird's-eye view revealed a graphic, strangely organized element, in dramatic contrast to what Clark had always experienced as a chaos of currents, backdrafts, surges, and explosions. When waves break on shore, the whitewater surges up the beach. The beach—sand, rock, or coral—is typically slanted and uneven; thus the whitewater forms into fingers and rivulets, sidewash and backwash.

"Shooting from overhead actually helps me to understand the break better," says Clark. "There's a whole ecosystem. And the waterfall effect—the wave exploding and shooting up—is really beautiful."

Clark also photographs the wave from underwater as it crashes around him. Viewed from beneath the surface, the tubing wave spirals in a cocoonish shape. And the vortexes! What Clark knew viscerally throughout his nervous system was now decipherable. As waves pound into shallow sand, a sort of backdraft occurs. Clark's underwater shots gave him a new understanding of bathymetry—the relationship between the sea floor and the wave.

"The shallower it is, the more the vortex will form, because when the wave breaks there's all that water and energy that needs to go somewhere, so it starts to spin like a tornado," says Clark. "To get a really good shot, I've got to get slammed, because all those vortex shots are from the front. As the wave pounds down, hits the sand, and fires back up, this is where the vortexes start to form. Then of course the wave mows me down. But it's worth it to get this shot."

GOLDEN PIPE
Pipeline, O'ahu
(previous page)

DANDELIONS
North Shore, O'ahu
(right)

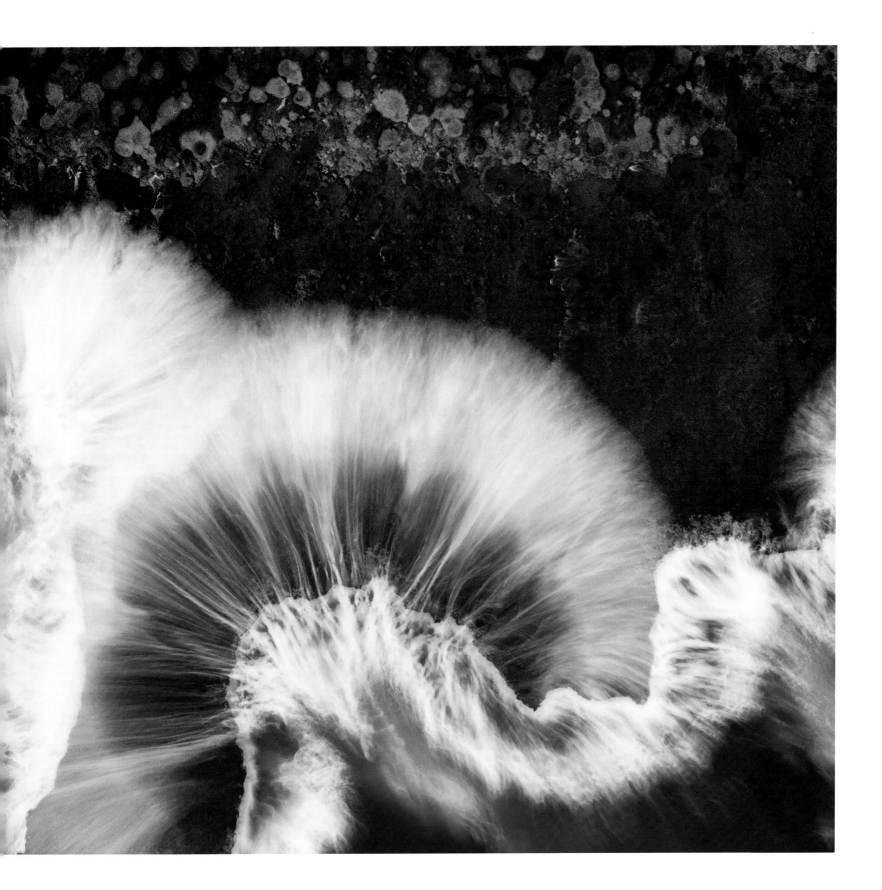

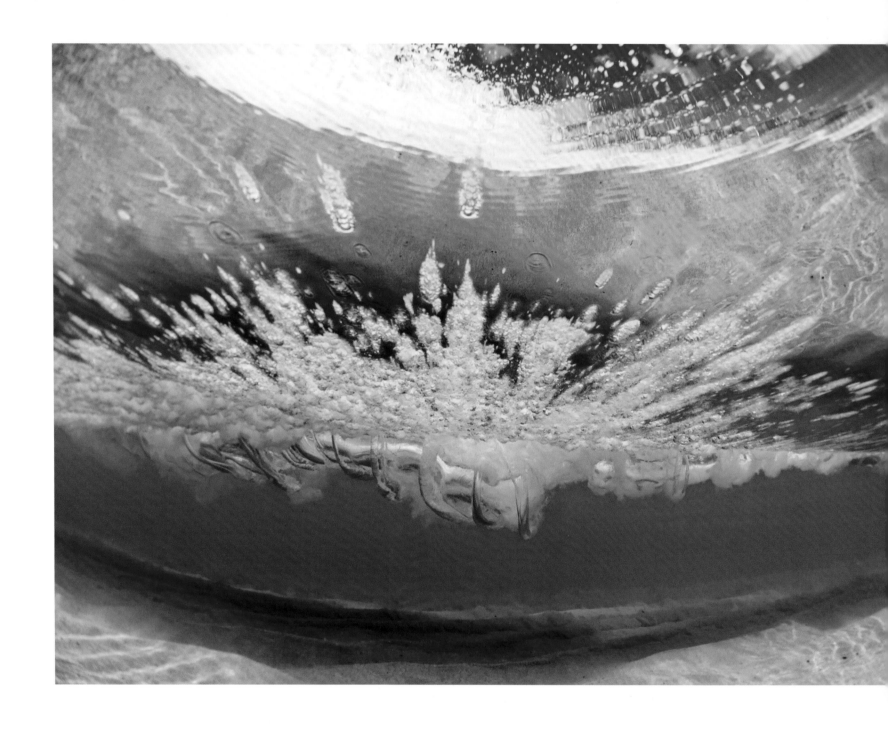

LUMINOUS
North Shore, O'ahu
(above)

TUMBLED
North Shore, O'ahu
(right)

I took this shot a millisecond before the tube and its mesmerizing vortexes hit the camera straight on. Notice the wave breaking only inches above the sand—there is no place to escape.

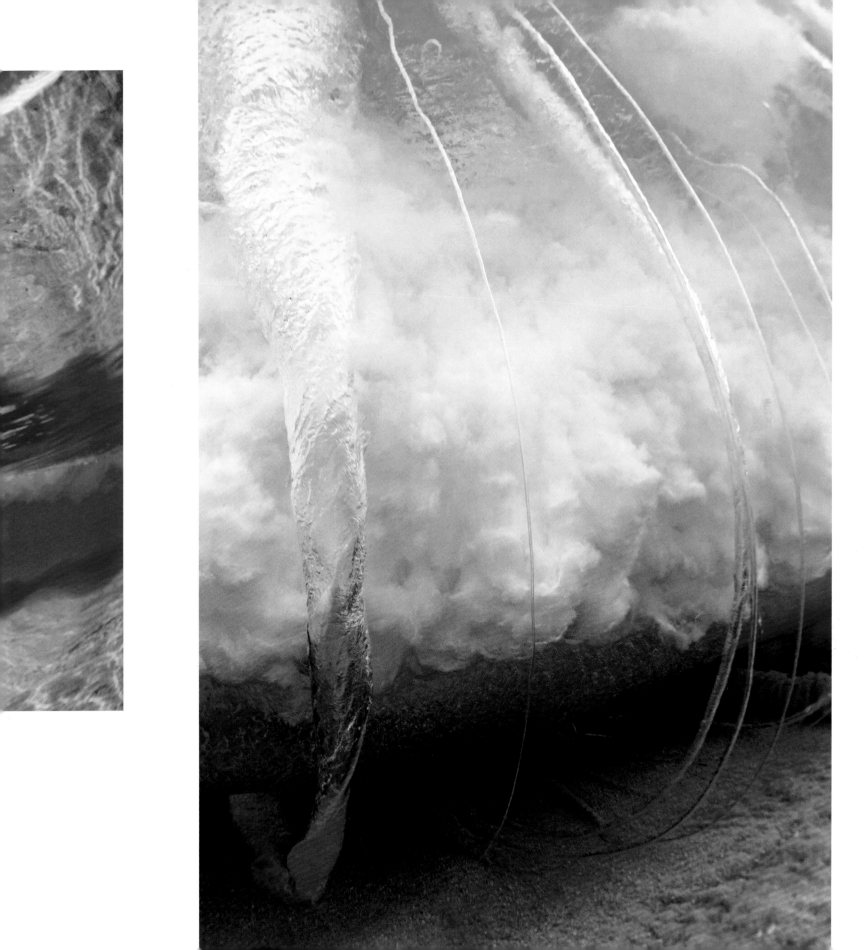

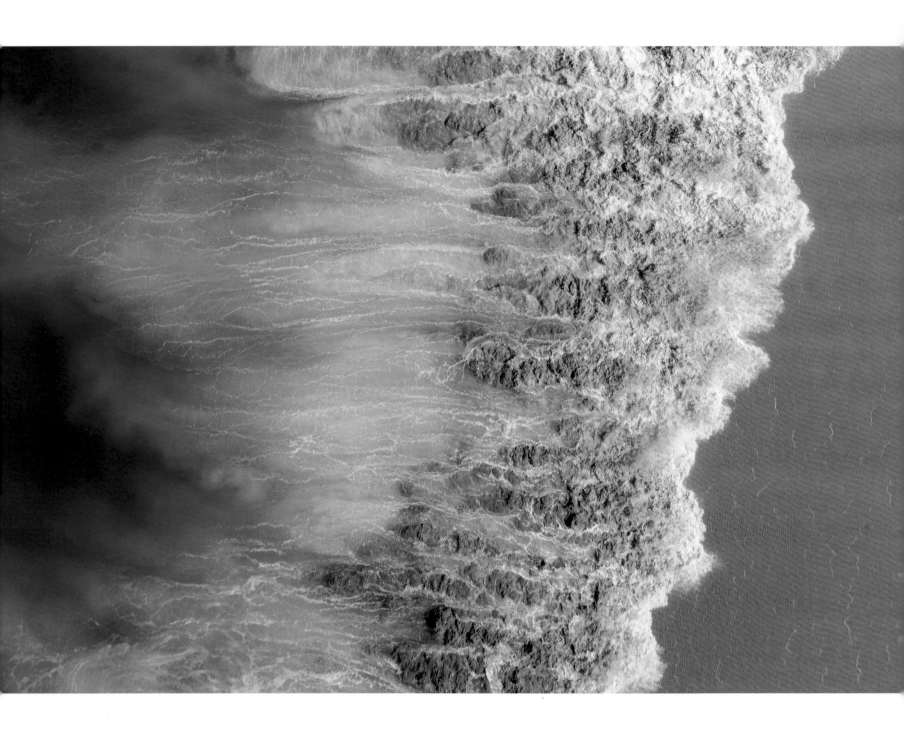

PAINTED SAND
North Shore, O'ahu

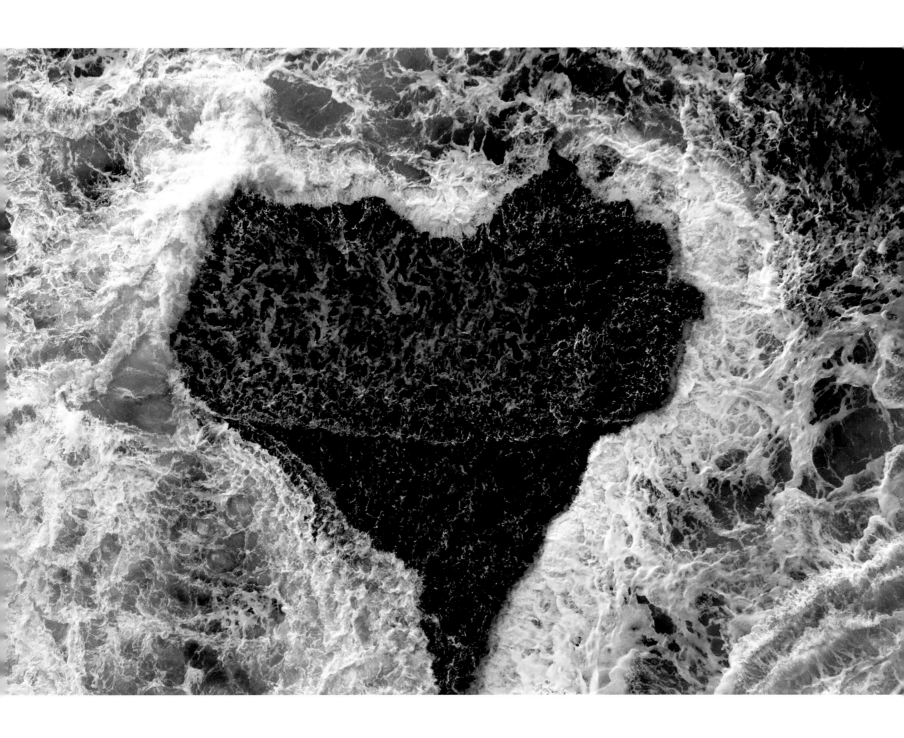

SWEETHEART
North Shore, O'ahu

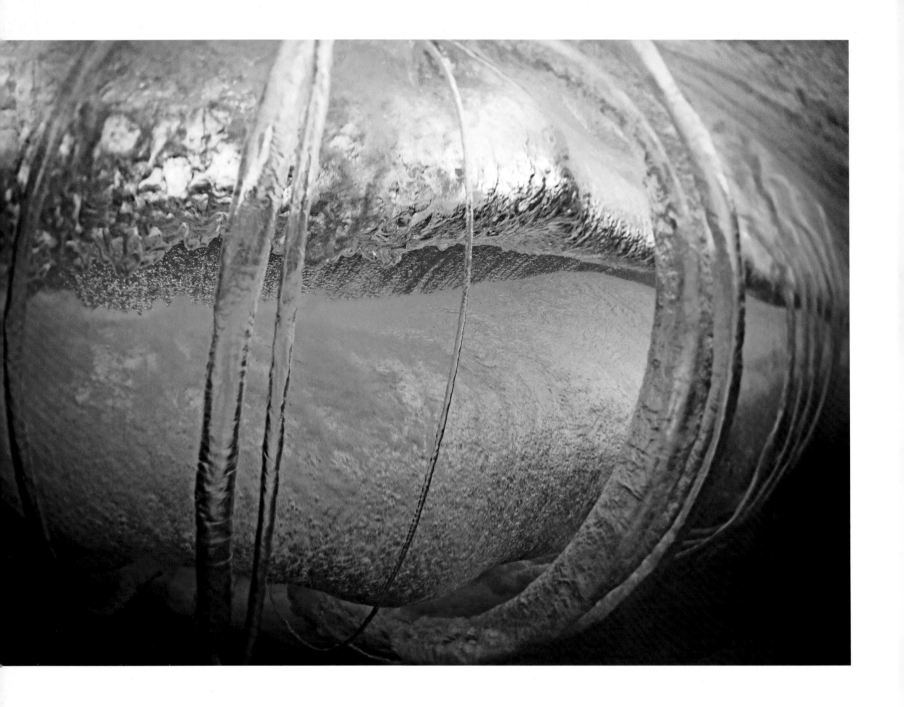

VORTEX 2020
North Shore, O'ahu
(above)

V TRENCH
North Shore, O'ahu
(right)

When this wave hit a shallow sandbar, the force created a
deep trench and sent up foam, sand, and water. The left side
shows the water coming back up after impact. On the right
are the remnants of the tube.

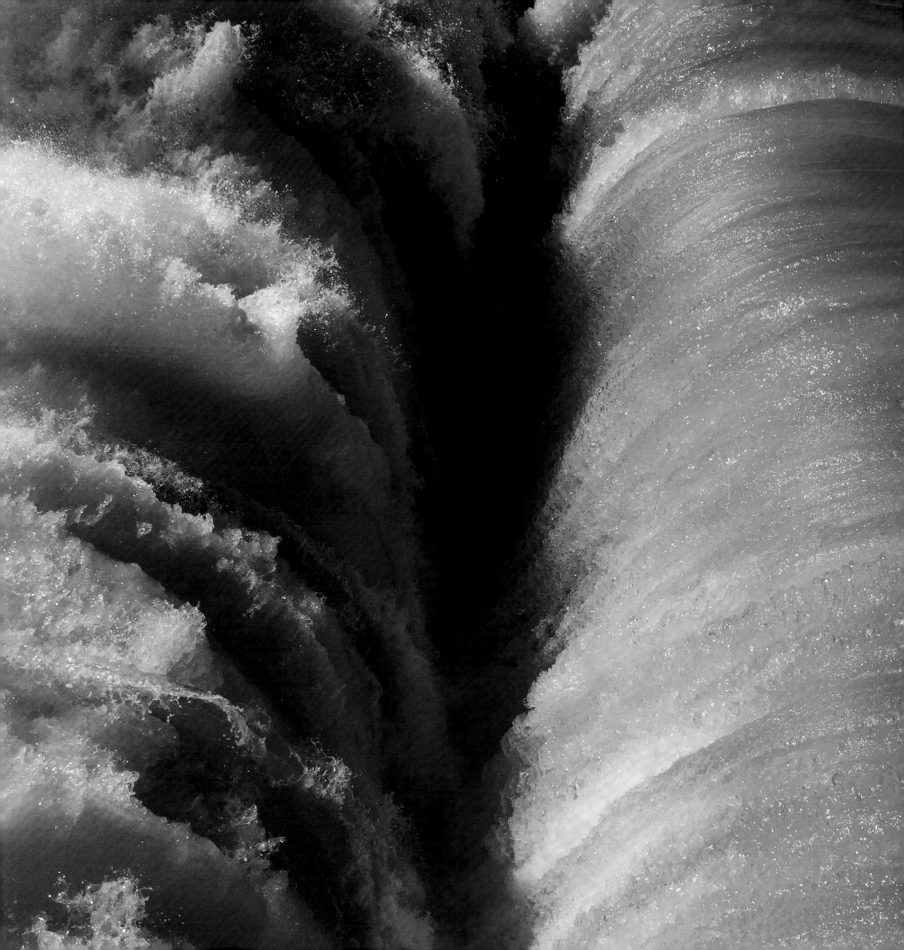

"I strap my camera housing to my wrist with a leash. But on big days I've had the leash shredded, and the camera ripped from my hand, and also my swim fins ripped from my feet. It sucks. It's happened a handful of times, but each time I've been able to retrieve my camera and housing. My camera setup costs more than $10,000, but usually I'm thinking of the photos that I might lose, not the camera itself. I search hard in the water and up and down the coast to find it. Luckily, I have always been able to find my lost cameras."

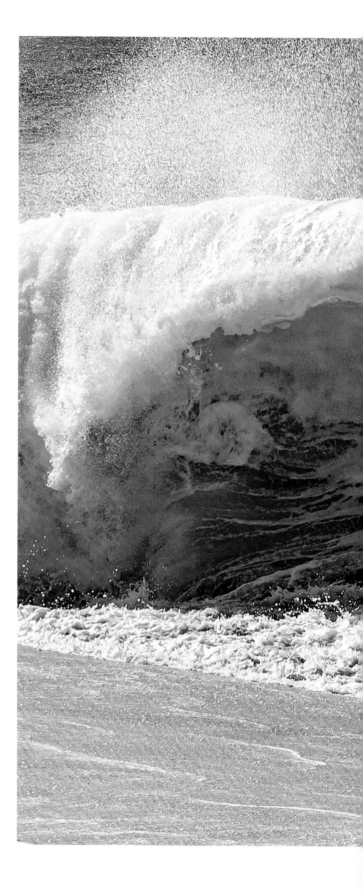

WHITE WALL
North Shore, O'ahu
(right)
Photo by Jerrett Lau

OPTICAL ILLUSION
North Shore, O'ahu
(next page)

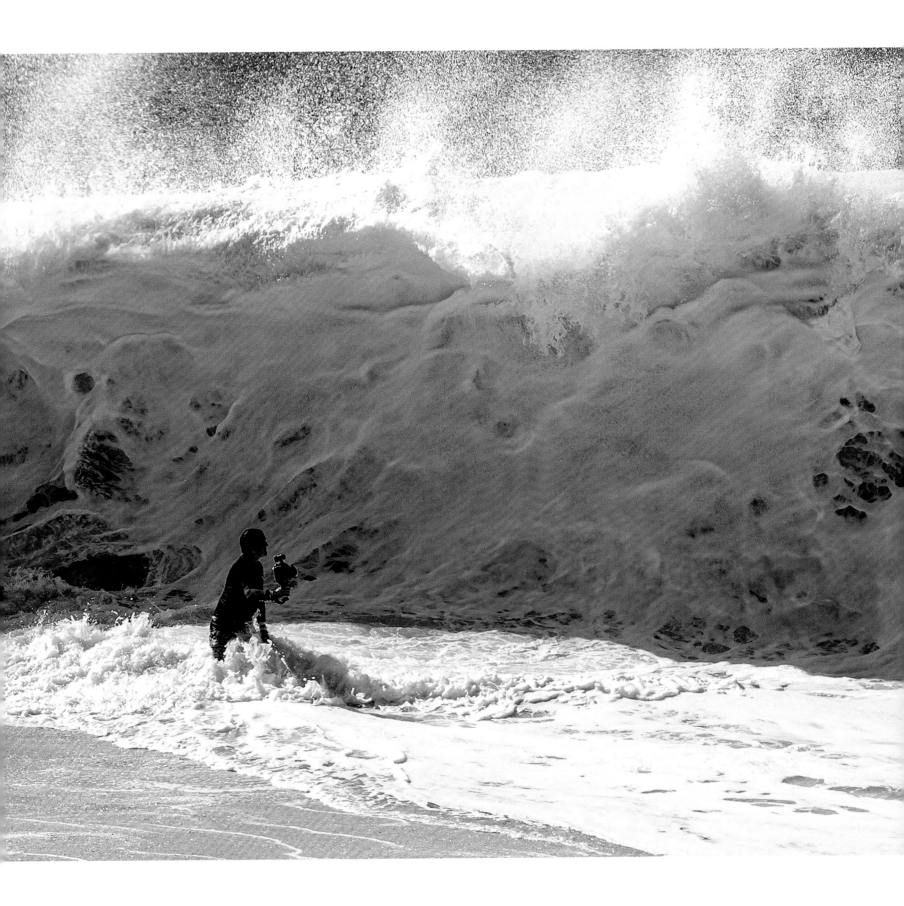

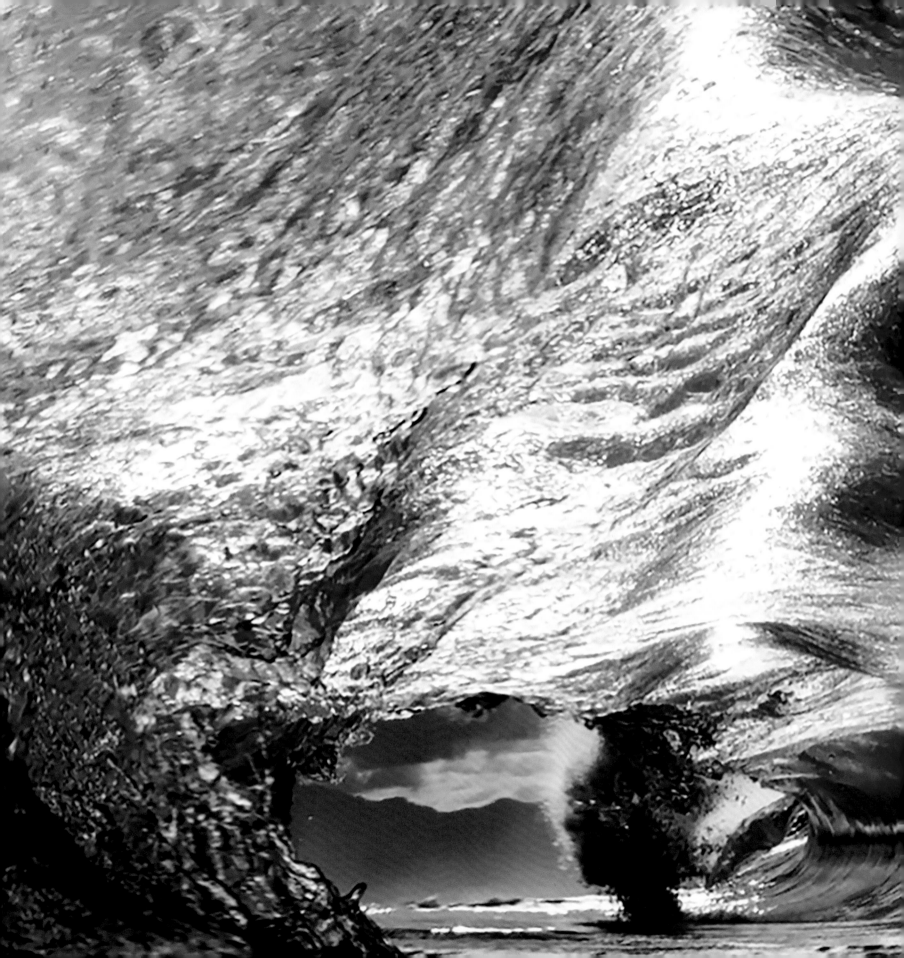

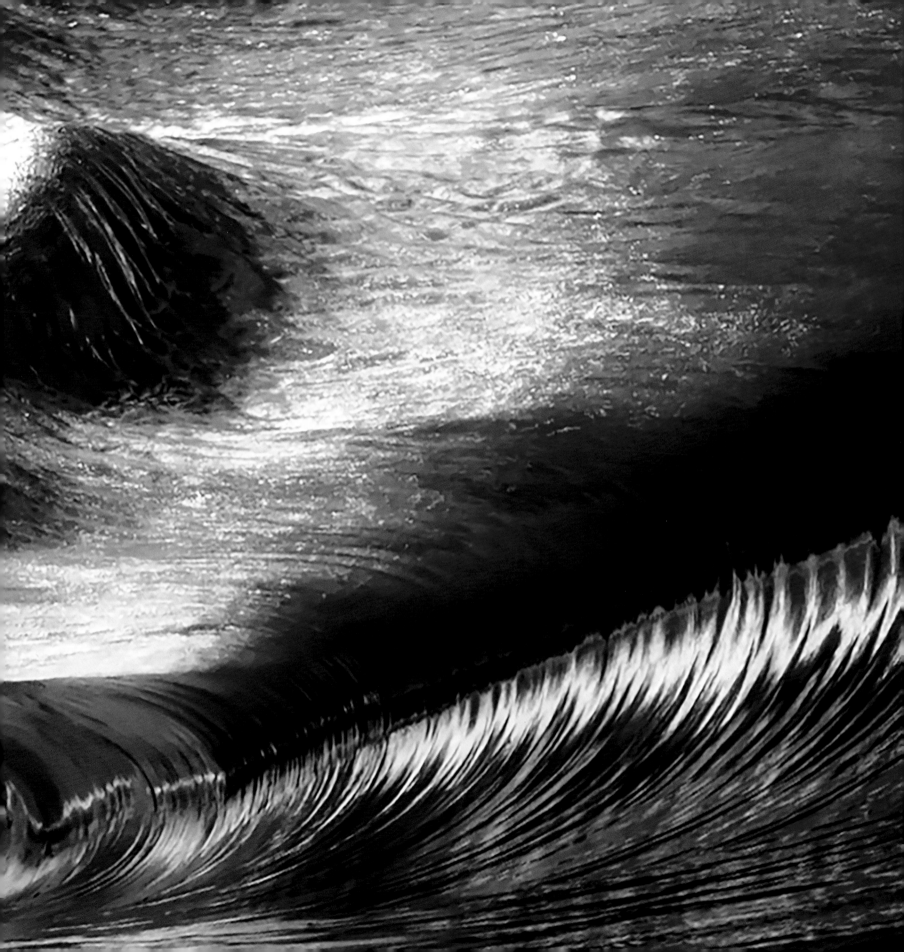

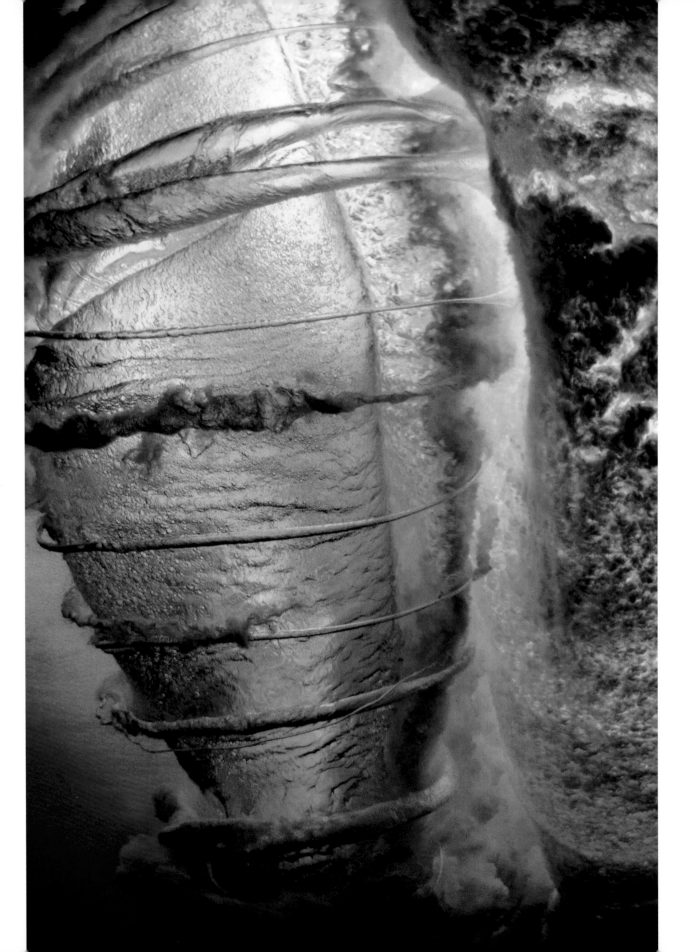

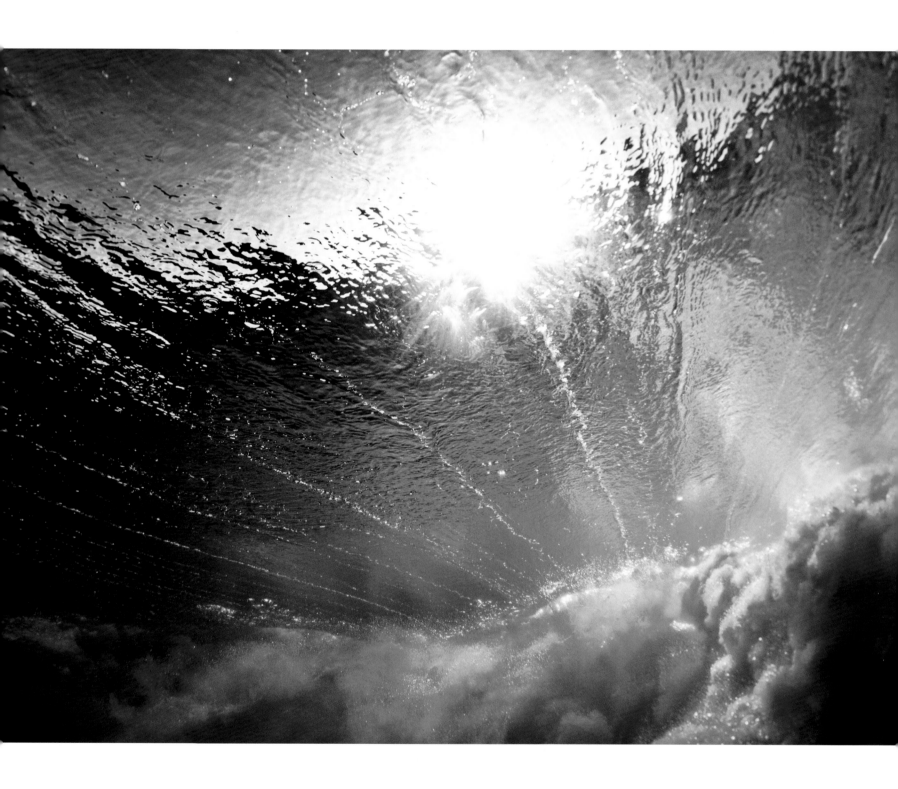

H₂ORNADO
North Shore, Oʻahu
(left)

RADIANT
North Shore, Oʻahu
(above)

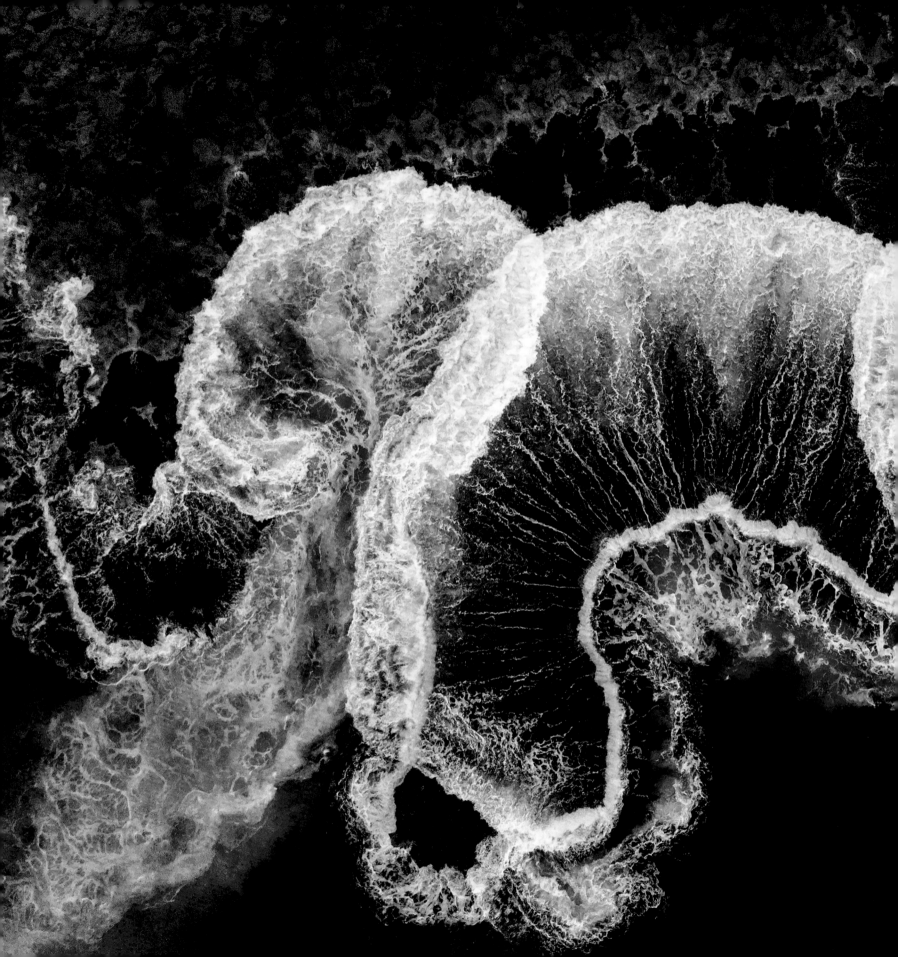

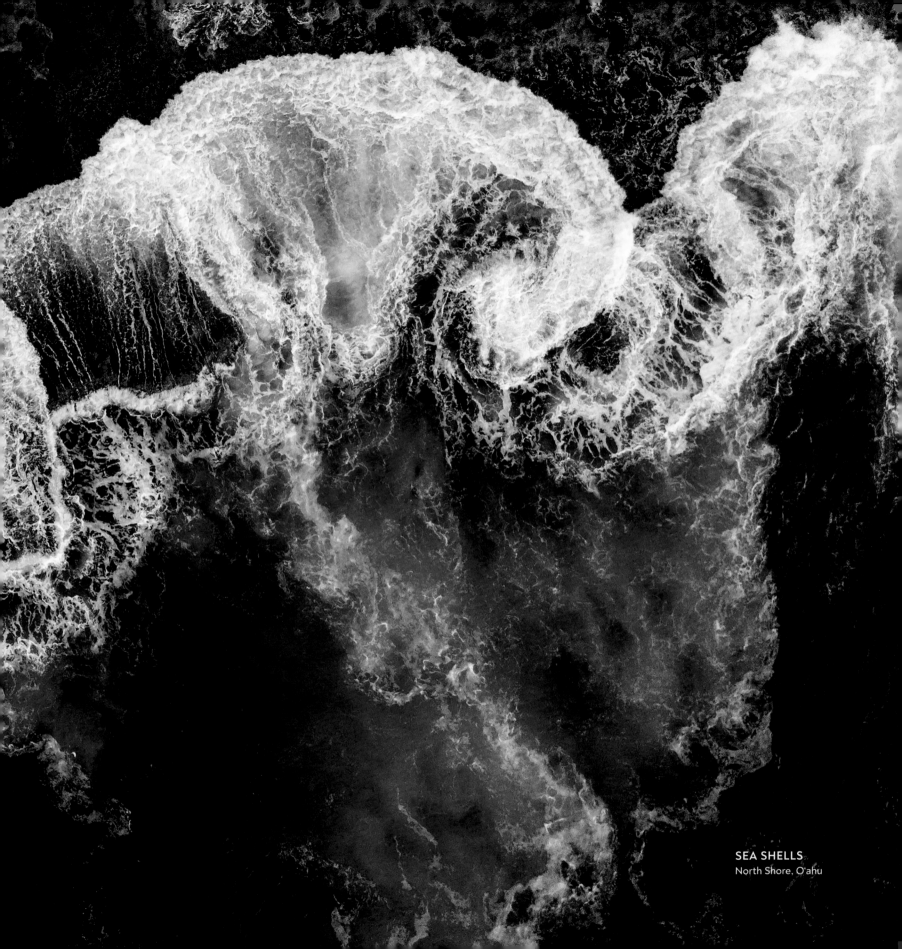

SEA SHELLS
North Shore, O'ahu

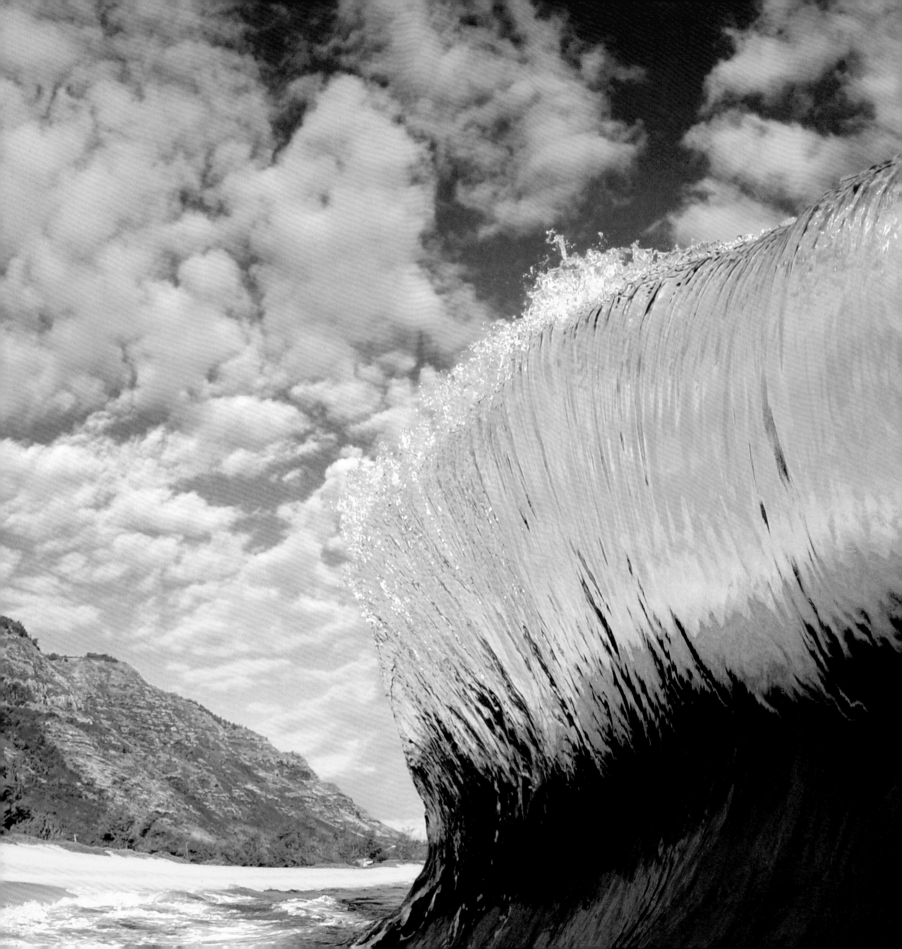

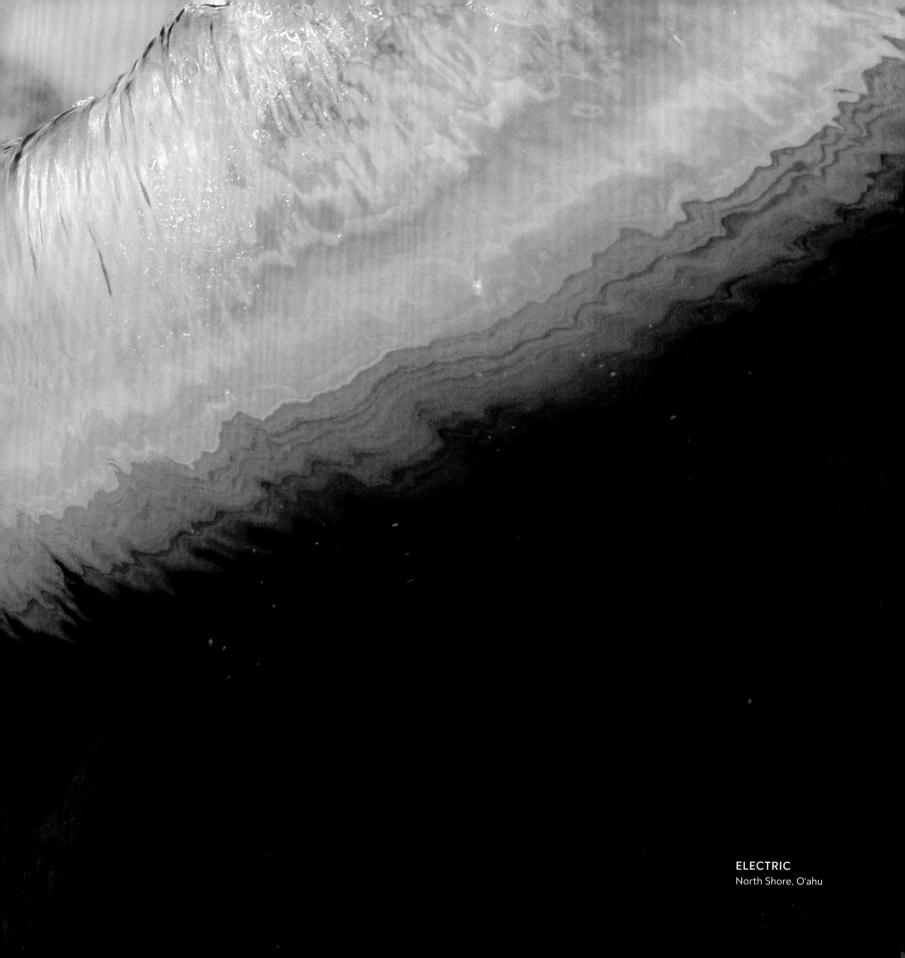

ELECTRIC
North Shore, O'ahu

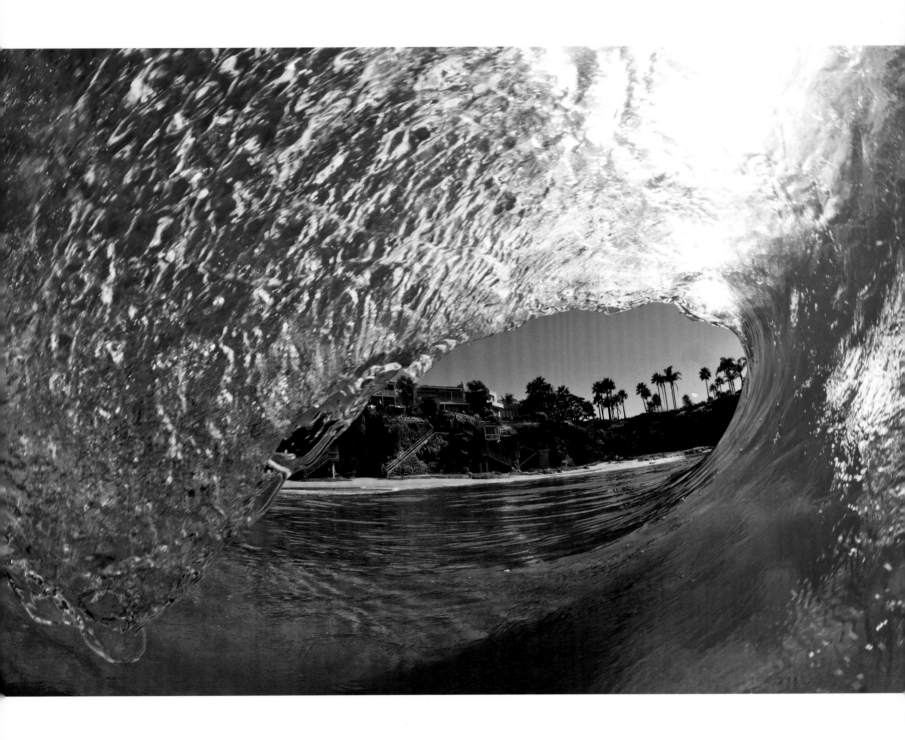

LAGUNA VIEWS
Laguna Beach, California

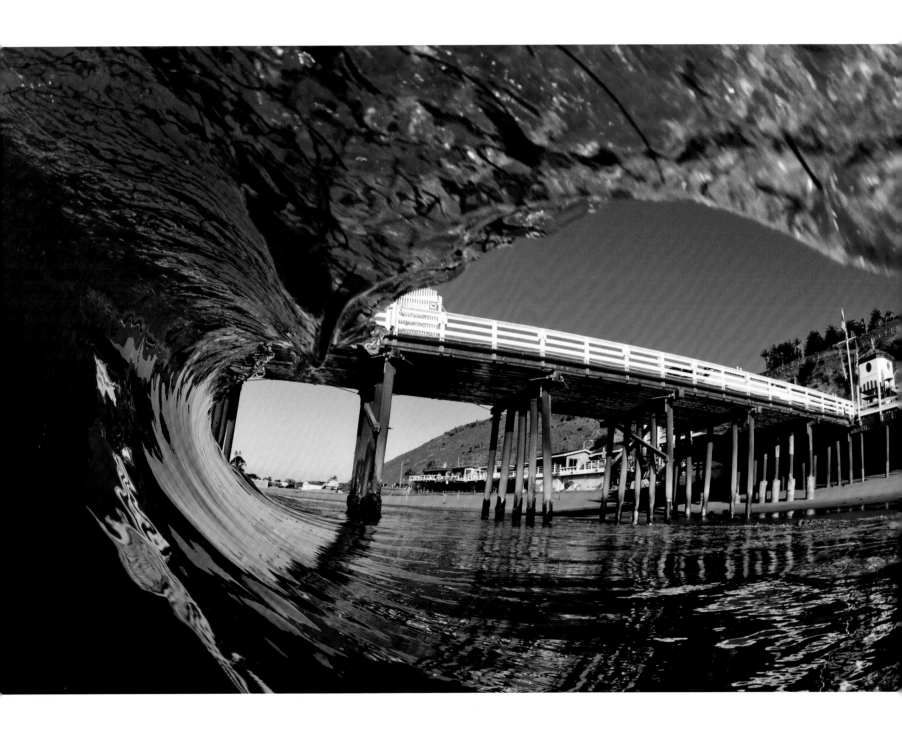

MALIBU PEER
Malibu, California

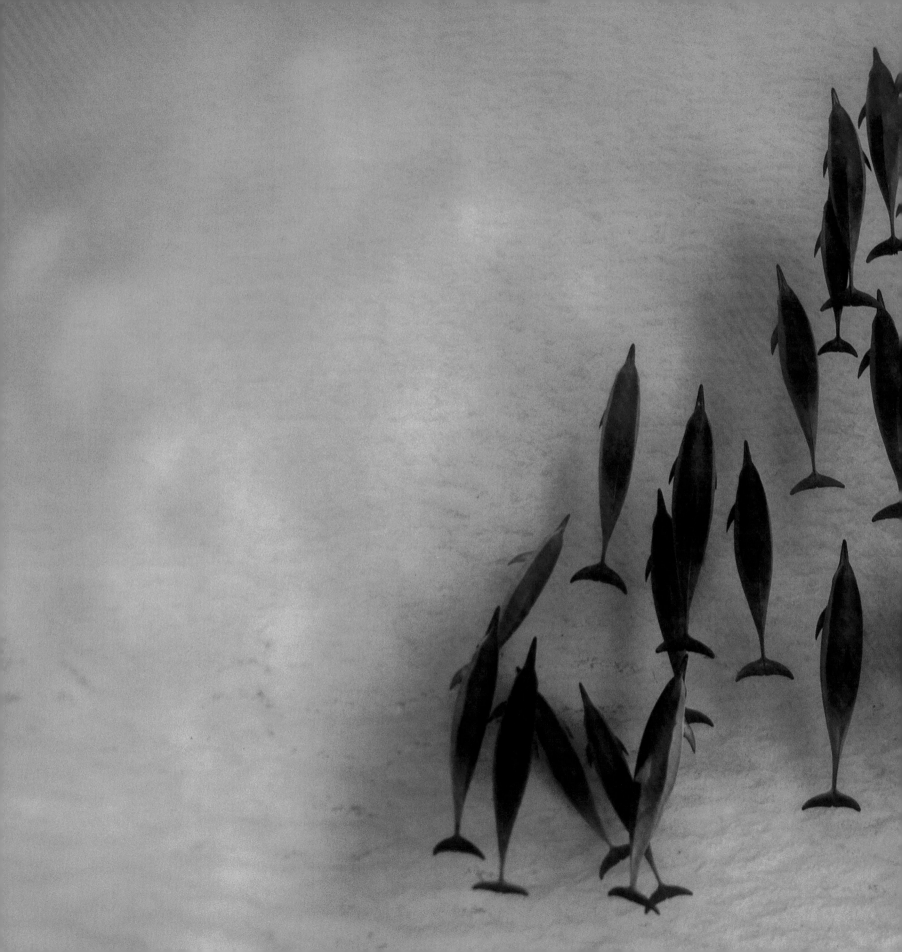

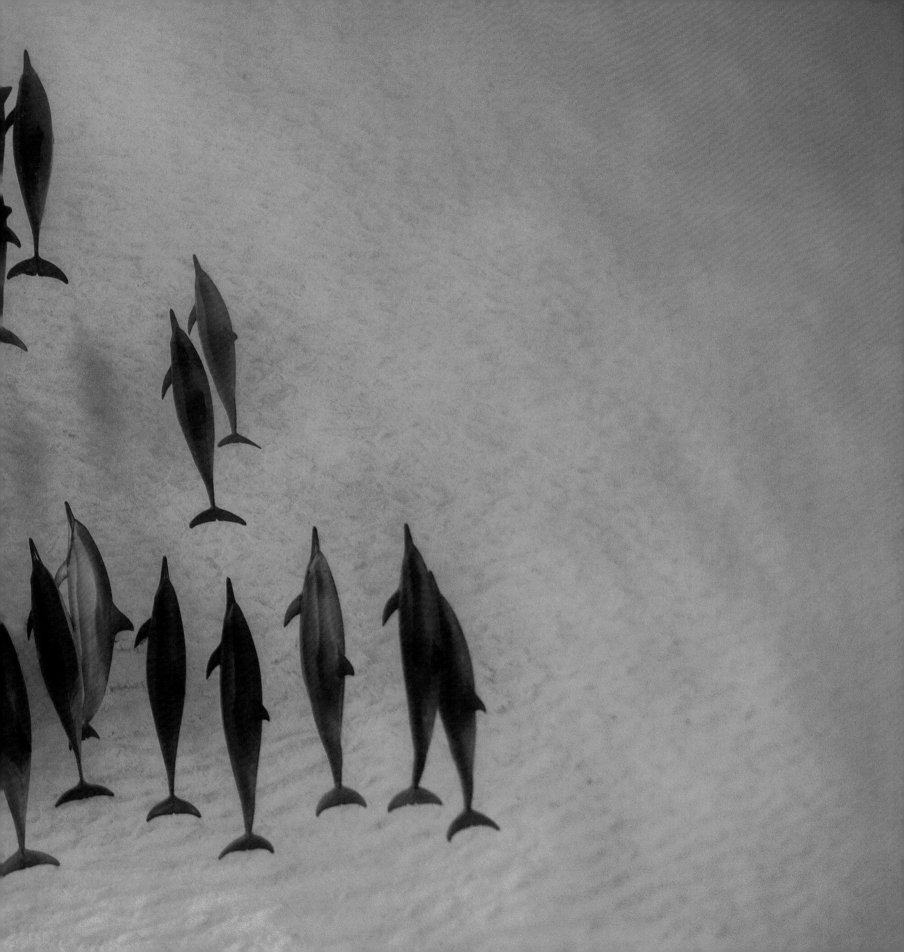

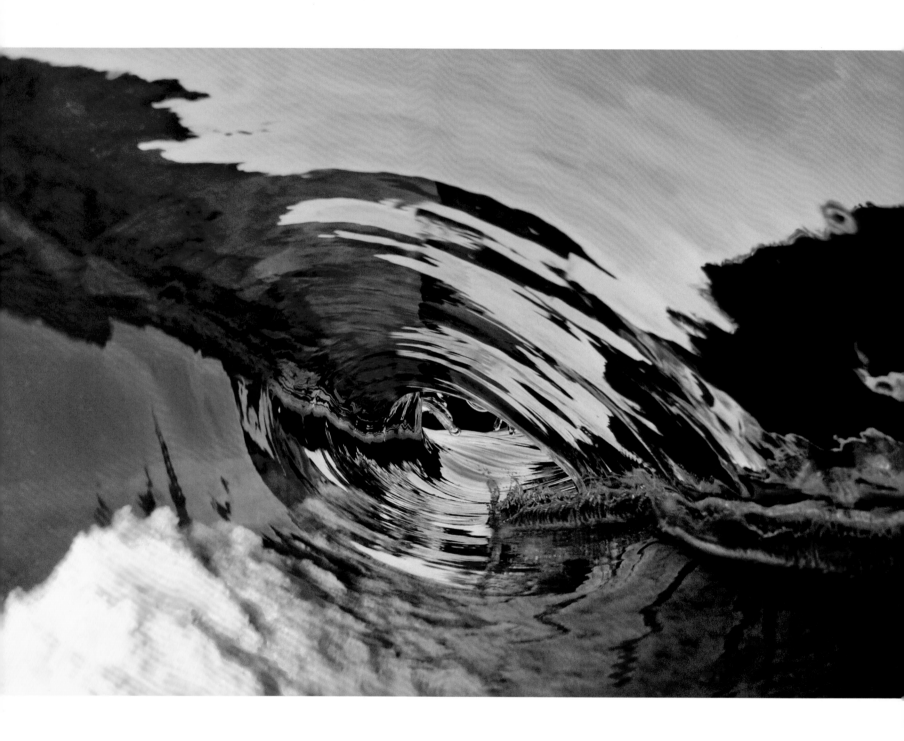

ILLUMINATI
North Shore, Oʻahu
(previous page)

GLASS BOWL
Mākena Beach, Maui
(above)

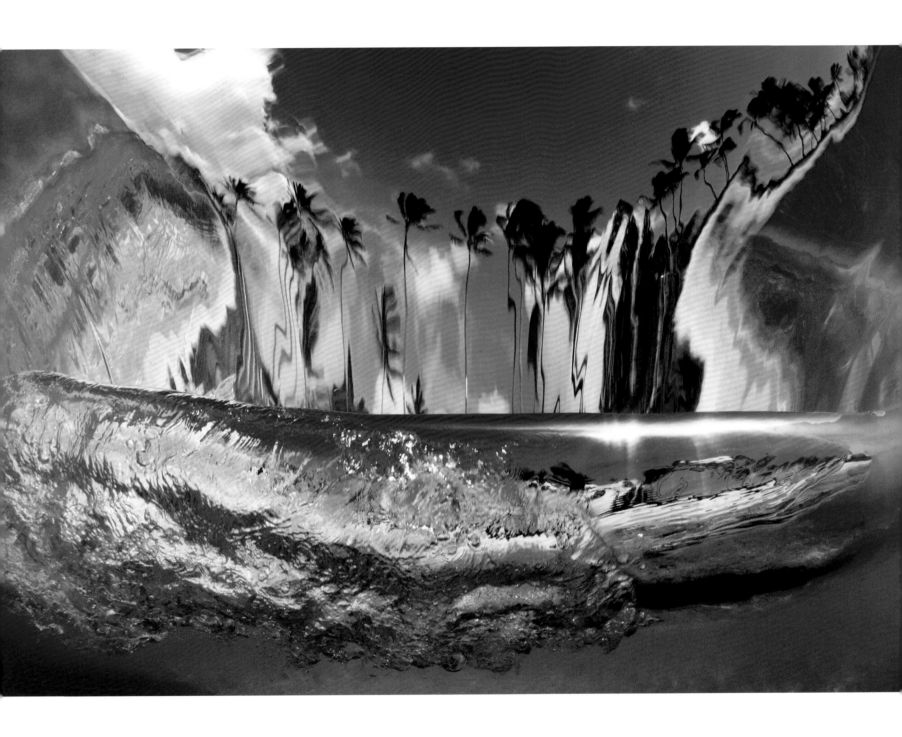

COCONUT ISLAND
North Shore, O'ahu

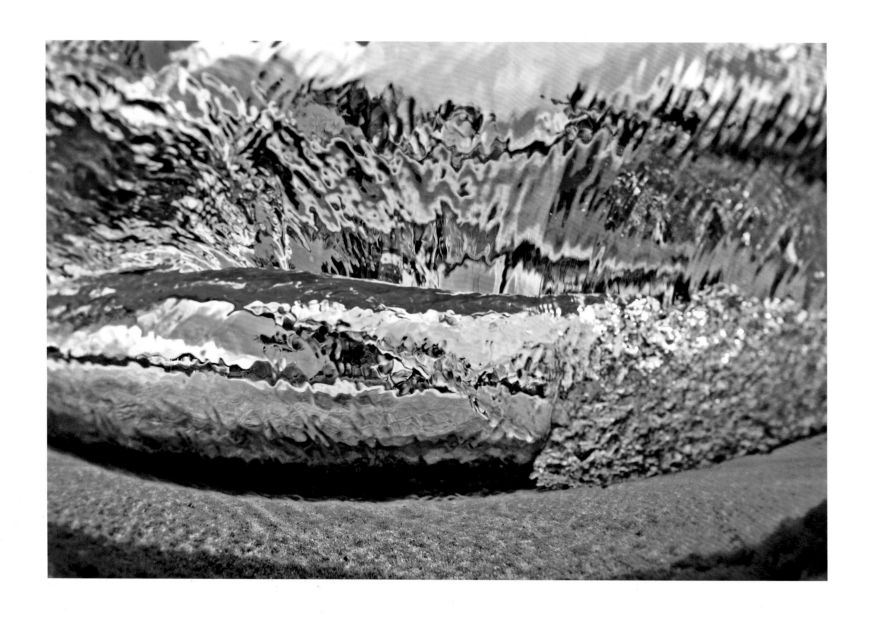

STAINED GLASS
North Shore, O'ahu
(above)

SHOCK WAVE
Mākena Beach, Maui
(right)

The shorebreak with the best clarity in Hawai'i has to be at Mākena Beach on the island of Maui. During the summer months, the waves come here from the Southern Hemisphere. You can instantly tell which pictures are from this beach. The lighting, glassy water, background scenery, water clarity, and sand color all combine to design abstract patterns in the waves. The longer you stare at these shots, the more layered and three dimensional they look.

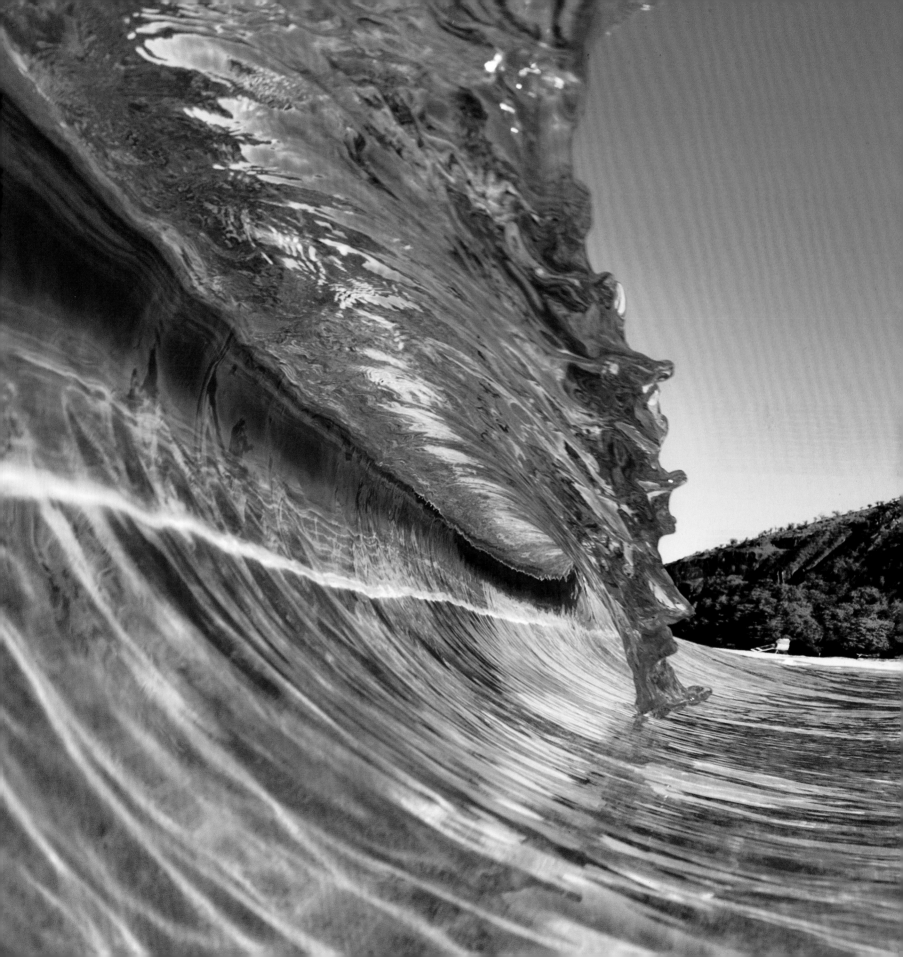

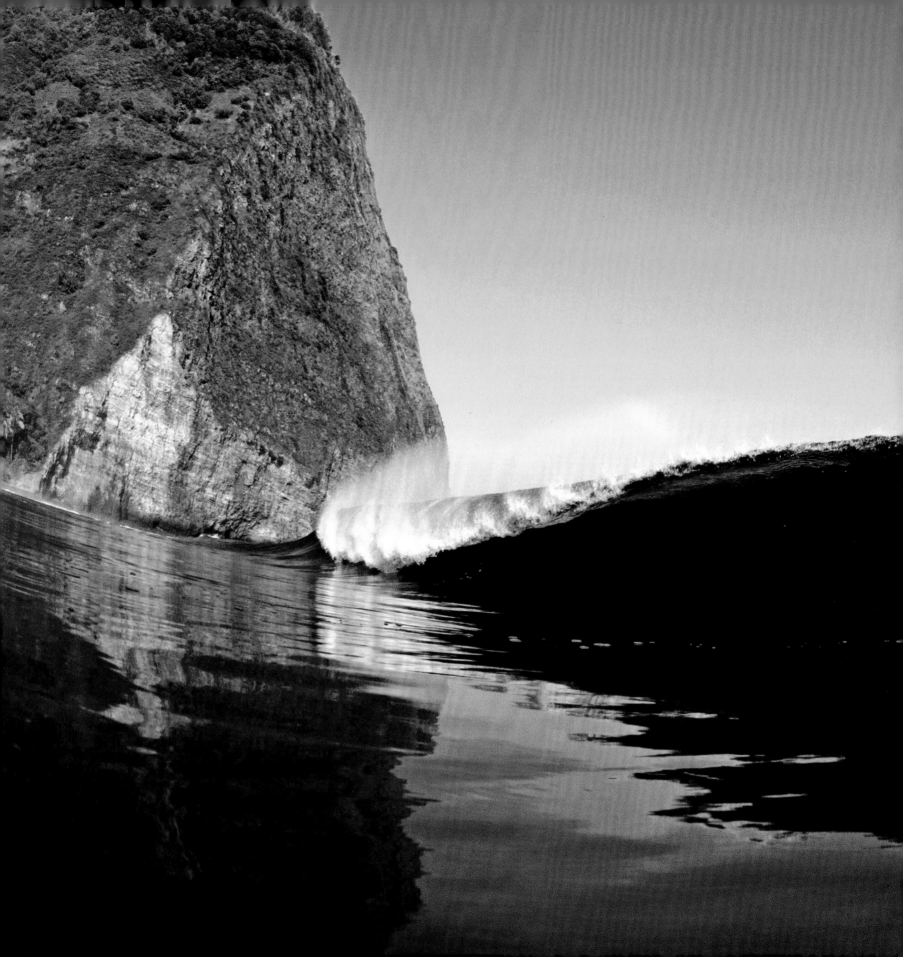

The Tube
Is the Truth

Most waves are not hollow. A tubing wave is formed by a very specific bathymetry, primarily a forceful swell meeting shallow water. For a surfer, the average tube ride lasts just a few seconds. Angling across the wave face, the surfer spots the hollow section forming ahead, positions for it by stalling or speeding up, tucks under the breaking lip, gets encased, holds the line, and exits out the tube's mouth. The tube ride requires experience: surfers need to surf a lot of hollow, dangerous waves to learn the craft.

The tube is spectacular to look at, and even more spectacular to experience. In the vastness of the sea, one surfer slots into a tubing wave in a fleeting intimacy. Once perfectly positioned inside, a surfer expends little effort to stay there, achieving a sort of lotus position with the rarest view. Surfers call this moment many things: getting "barreled," "slotted," "piped," "pitted," "shacked," "kegged," "green roomed." Writers have called it the "watery womb," or compared the sound of the lip striking the trough to "the muted roar of a conch shell held up to the ear." World surfing champion Shaun Tomson famously explained, "Time is definitely expanded when you're in the tube."

Before Clark took up photography he surfed the Waimea shorebreak, which is very much a tube, but by no means a makeable one. He'd take off on a big, wonky wave, angle across the steep face, and slot himself in the barrel, the lip curling overhead and hammering down, creating that teardrop view that would become the subject of so many of his photos. Then the Waimea wave would clamp down and collapse into itself, drilling him deep into the ocean with Niagara force. For most surfers, this last part is painful. We call it "the spin cycle," "being rag-dolled," "getting blasted." Clark exhibited a preternatural sangfroid and calmly suffered repeat beat downs at Waimea. In fact, he kind of loved it.

OFFSHORE RUNNER
Hawai'i Island
(previous page)

AZURE BLUE
North Shore, O'ahu
(right)

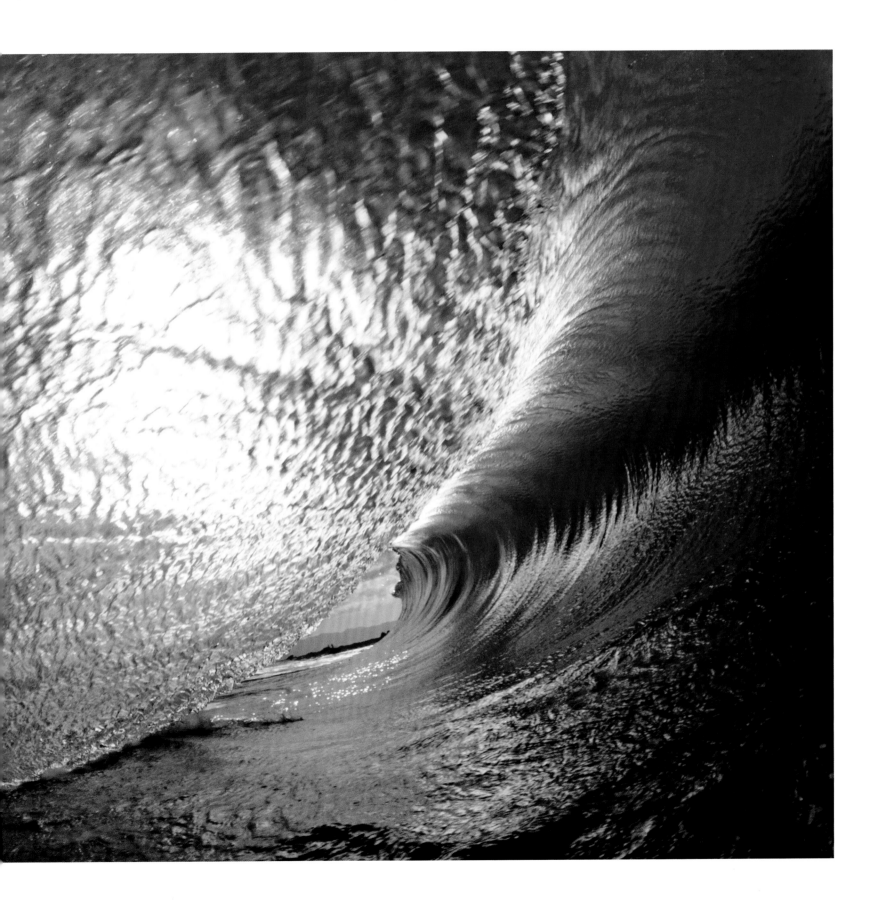

THUNDERSTORM
North Shore, O'ahu

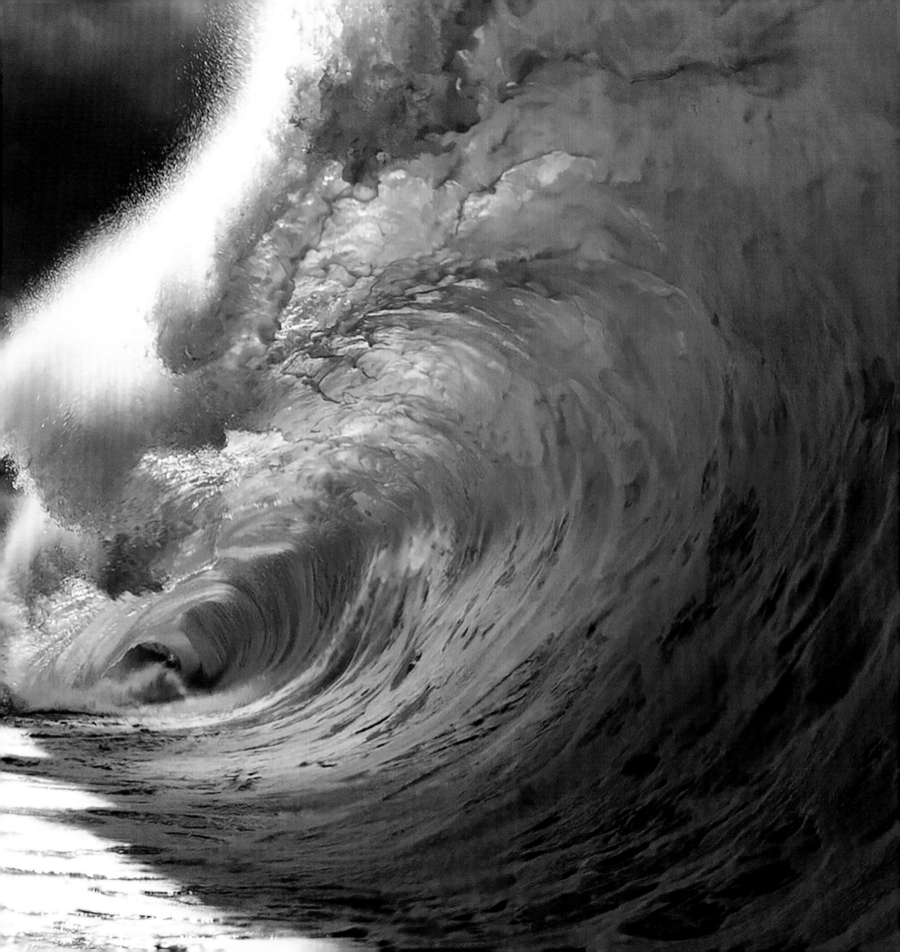

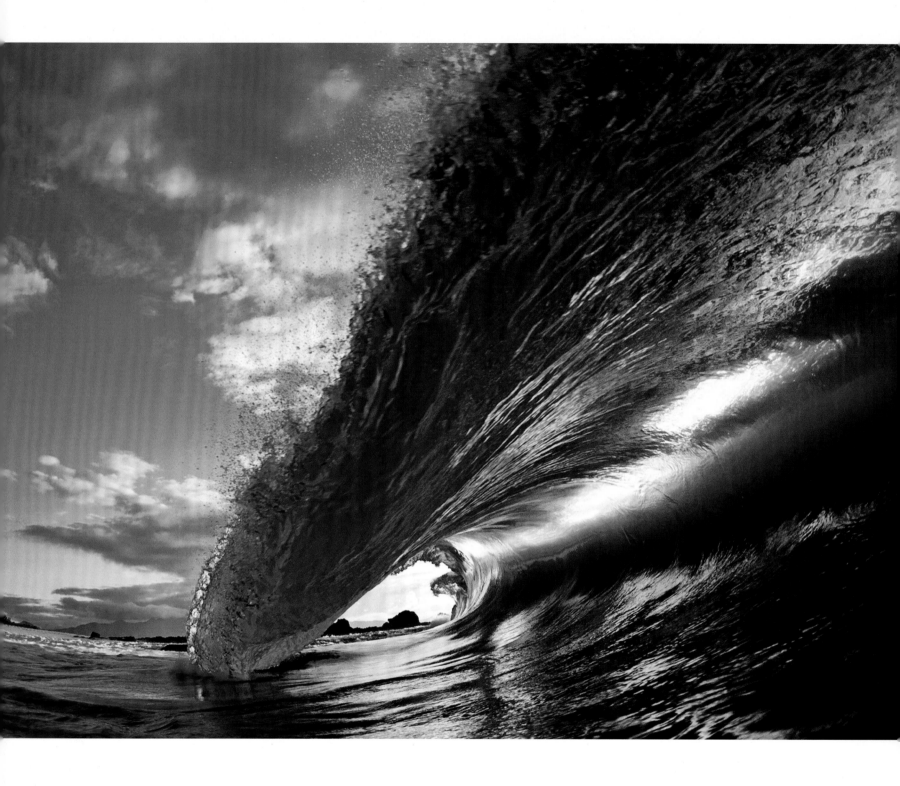

POINT OF CONTACT
North Shore, O'ahu
(above)

GLITTER
North Shore, O'ahu
(right)

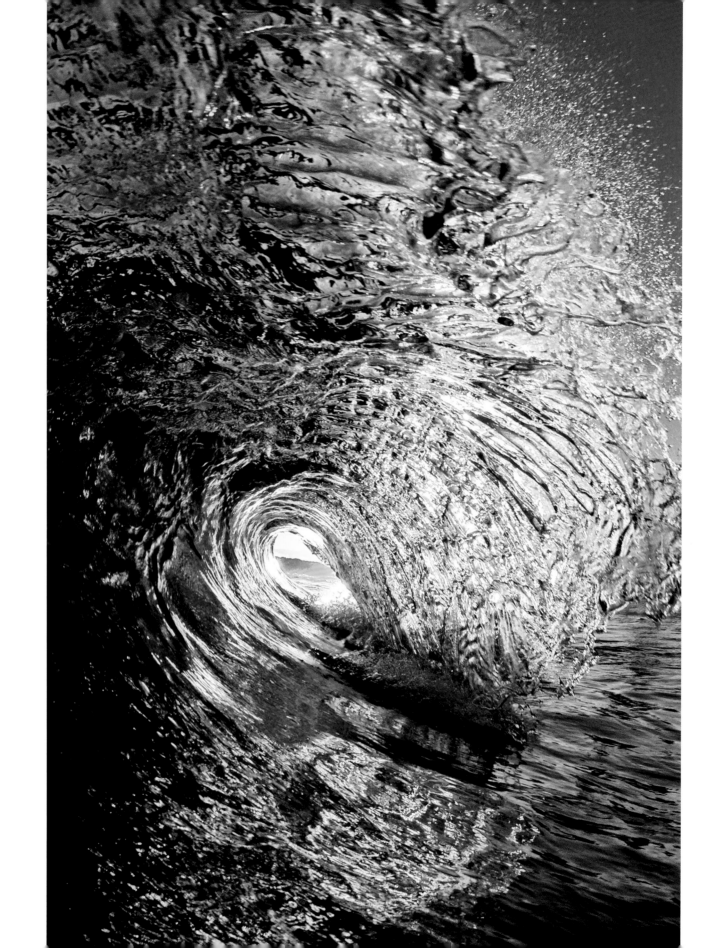

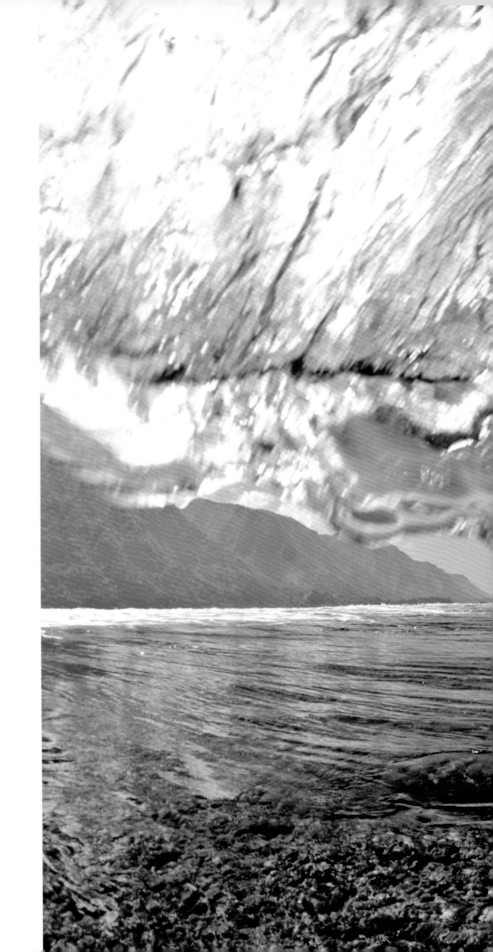

TAHITIAN JEWEL
French Polynesia

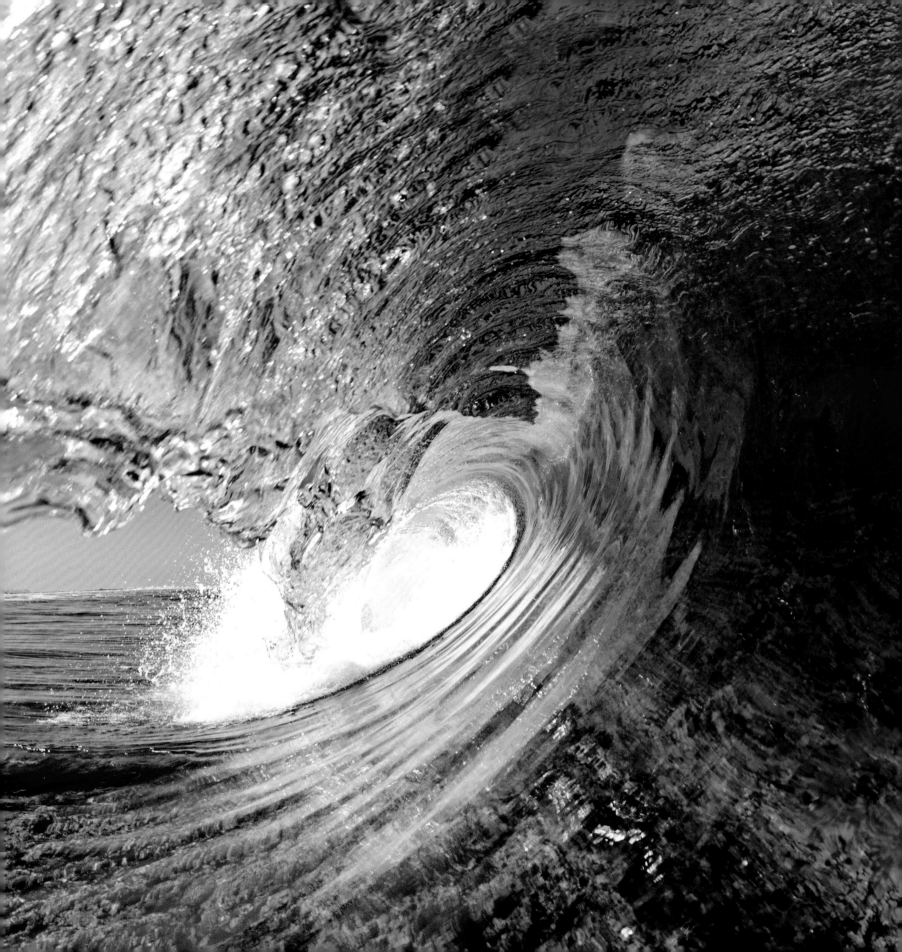

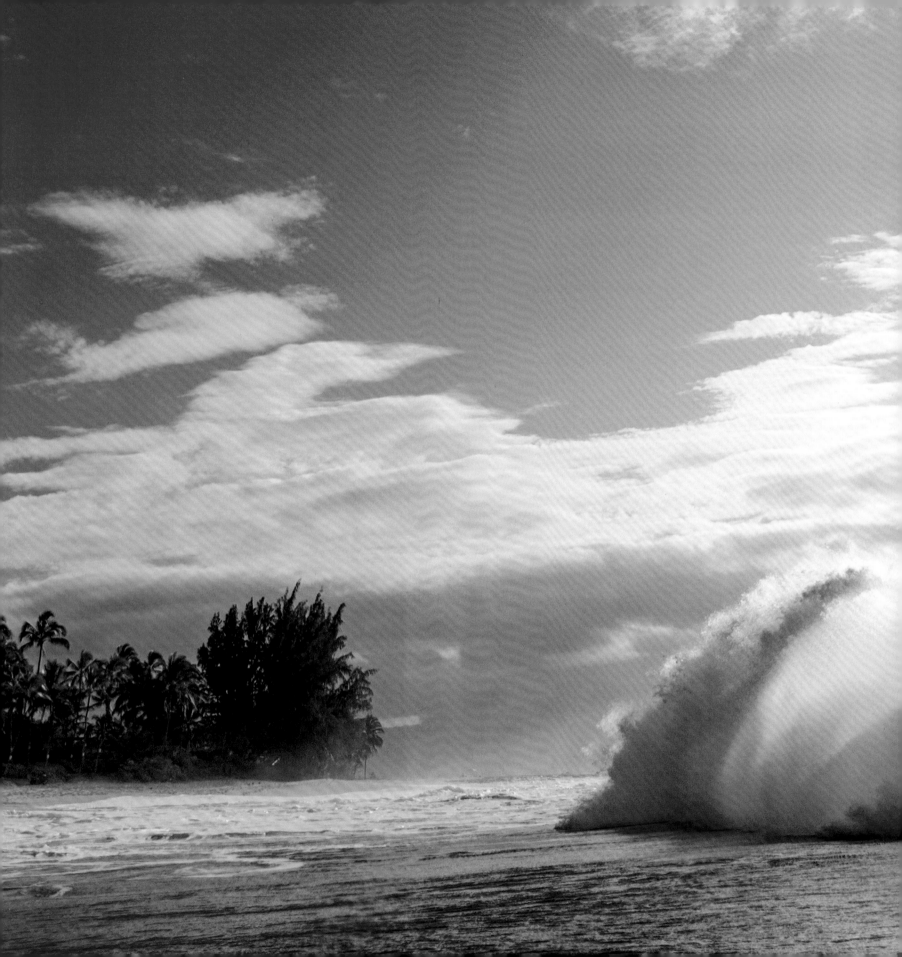

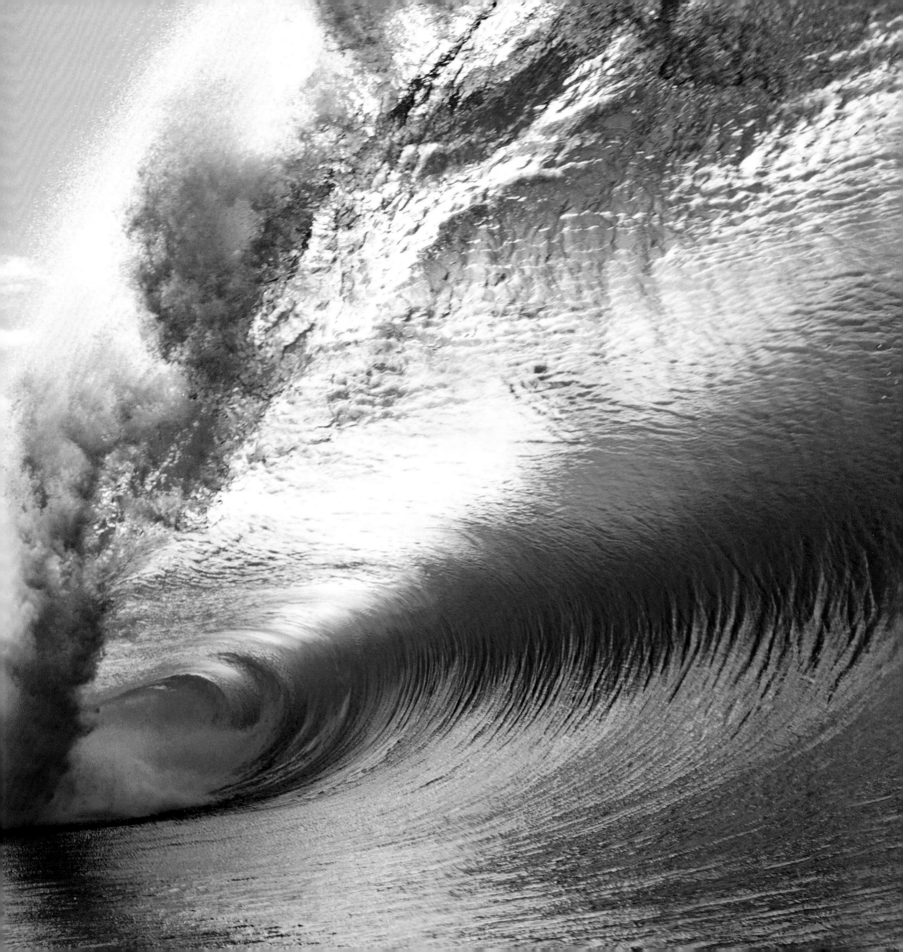

"In big waves, there are scary moments when I can't breathe and there are ten waves coming. I can't get out, and I can't breathe, but I've still got to go under because a big wave's coming. That's when I start to wonder: *What am I doing out here? I have two beautiful children and a wife.* Don't get me wrong—I love it—but there are moments where I'm scared shitless."

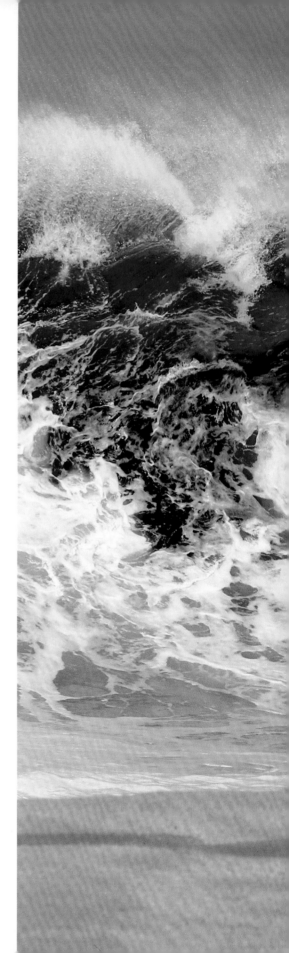

MEMORIAL DAY
North Shore, O'ahu
(previous page)

HOLDING STEADY
North Shore, O'ahu
(right)
Photo by Jacob VanderVelde

144

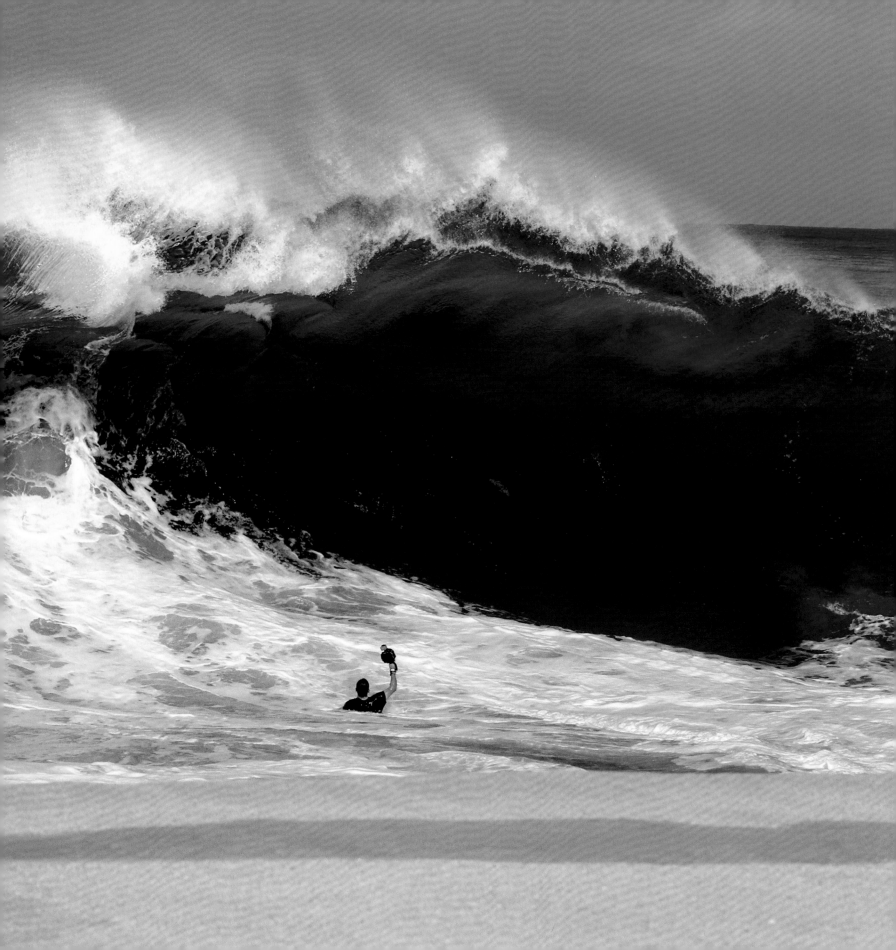

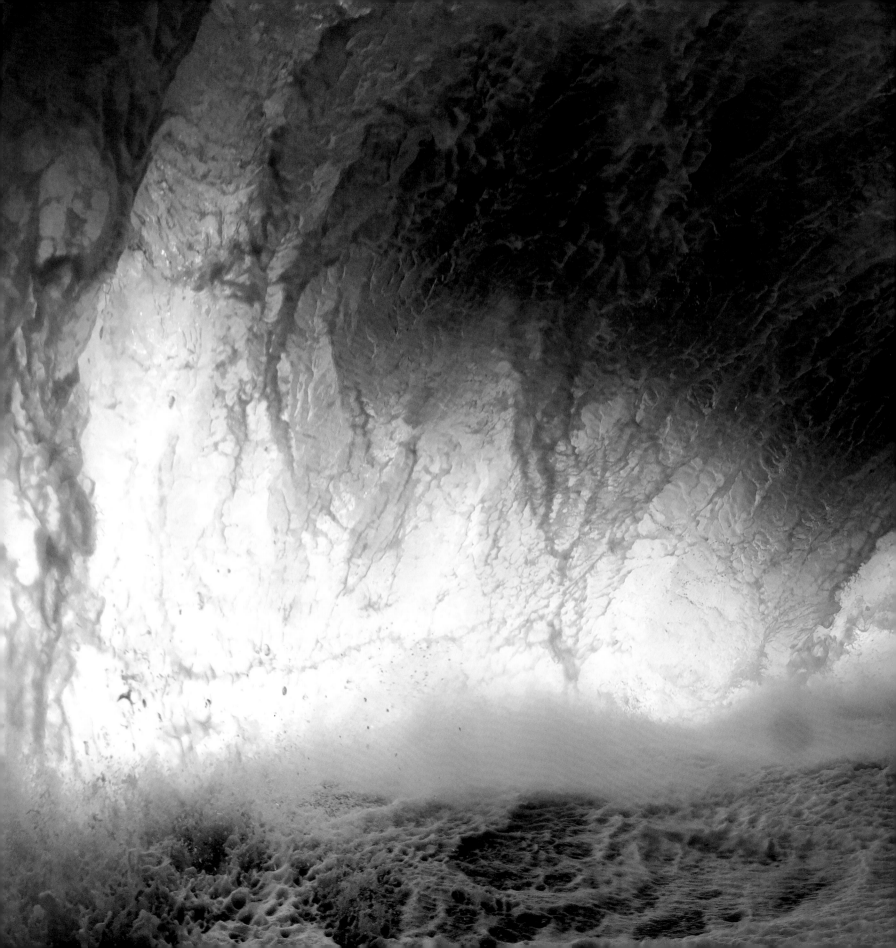

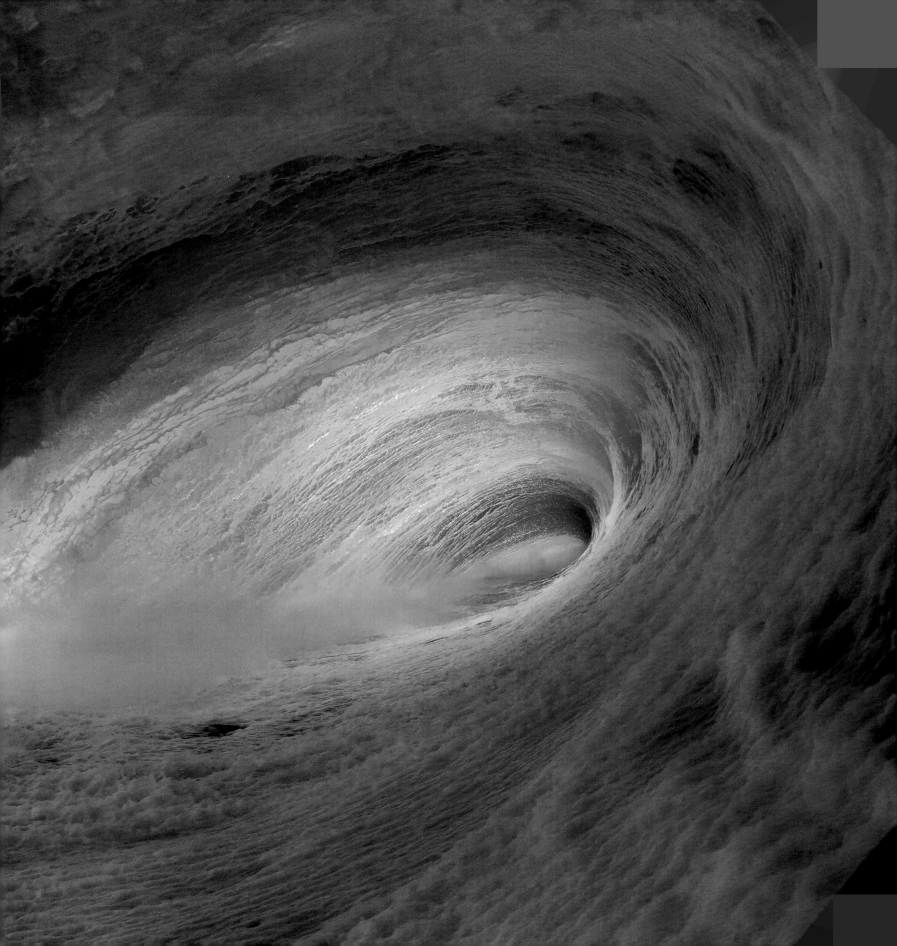

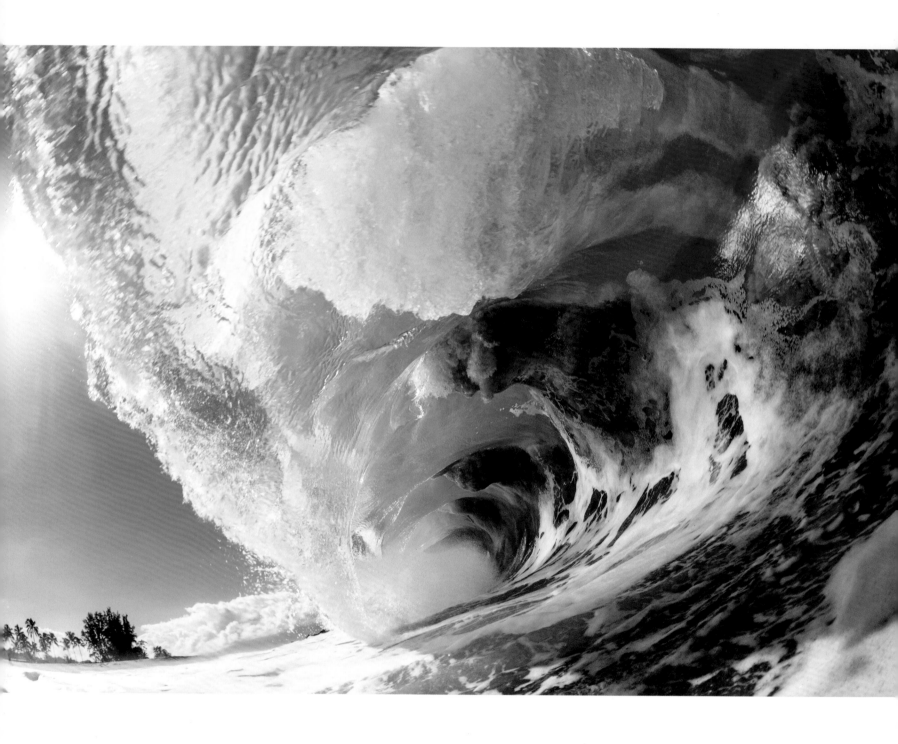

THE ABYSS
North Shore, O'ahu
(previous page)

SAND CASTLES
North Shore, O'ahu
(above)

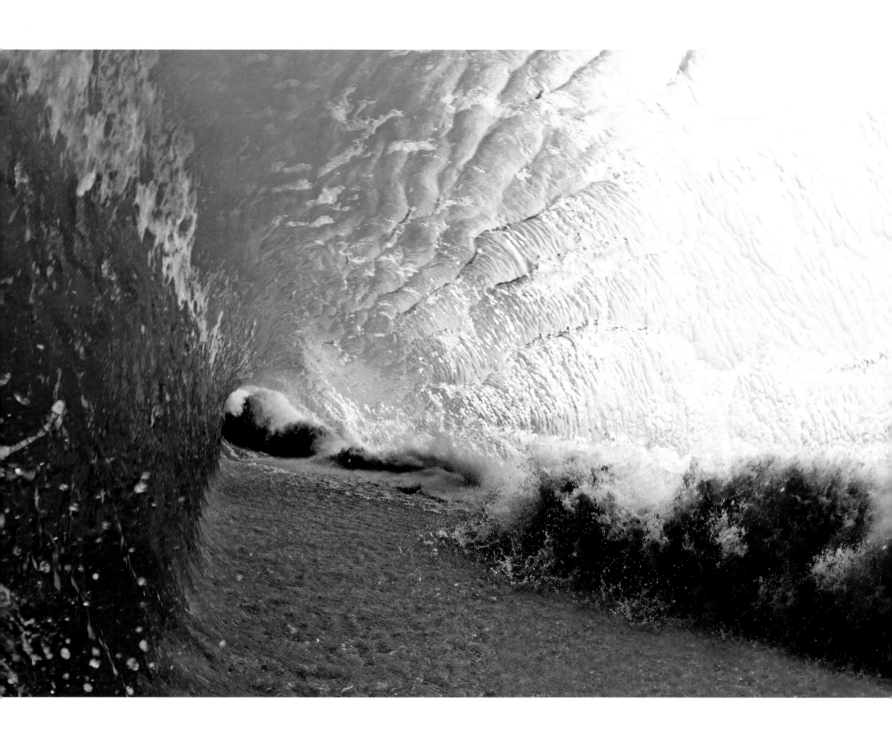

NO WAY OUT
North Shore, O'ahu
(above)

SLOW MOTION (SEQUENCE)
North Shore, O'ahu
(next page)

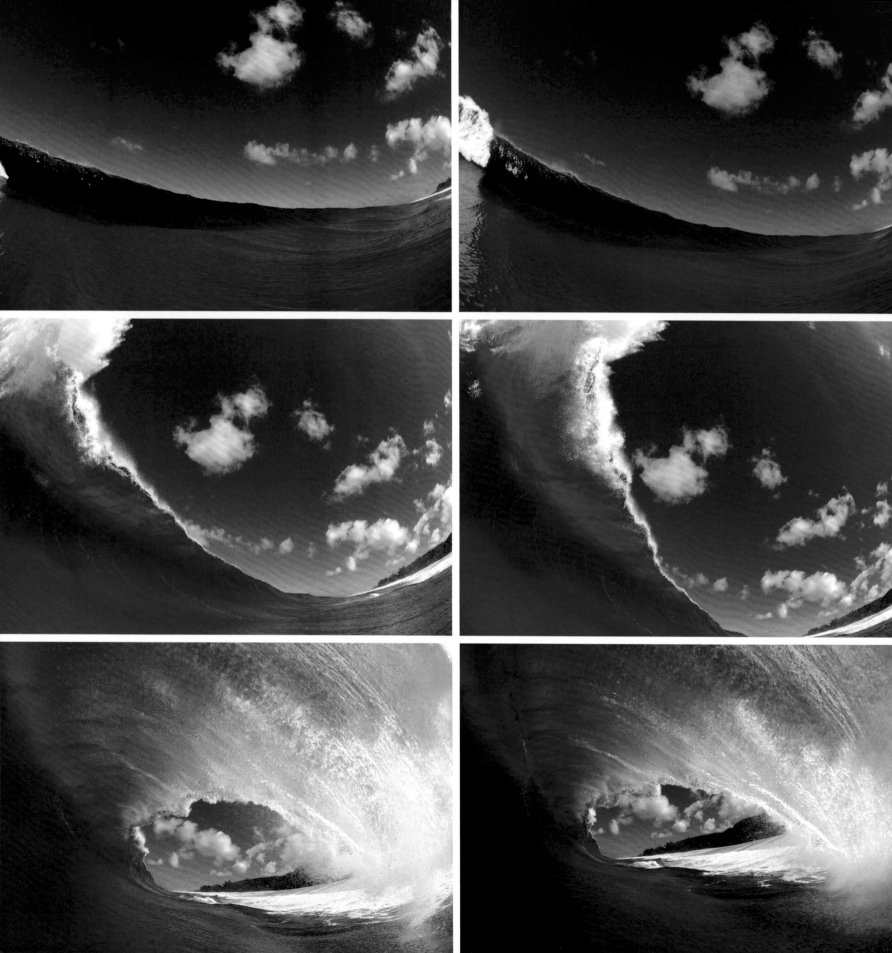

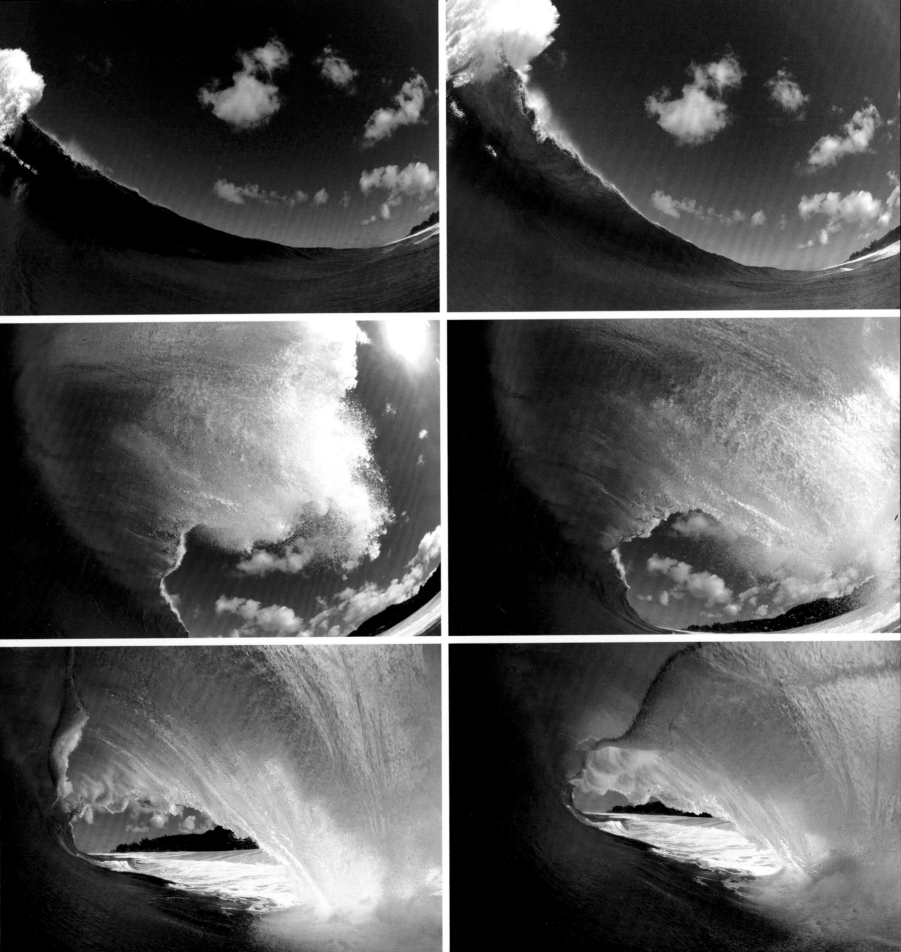

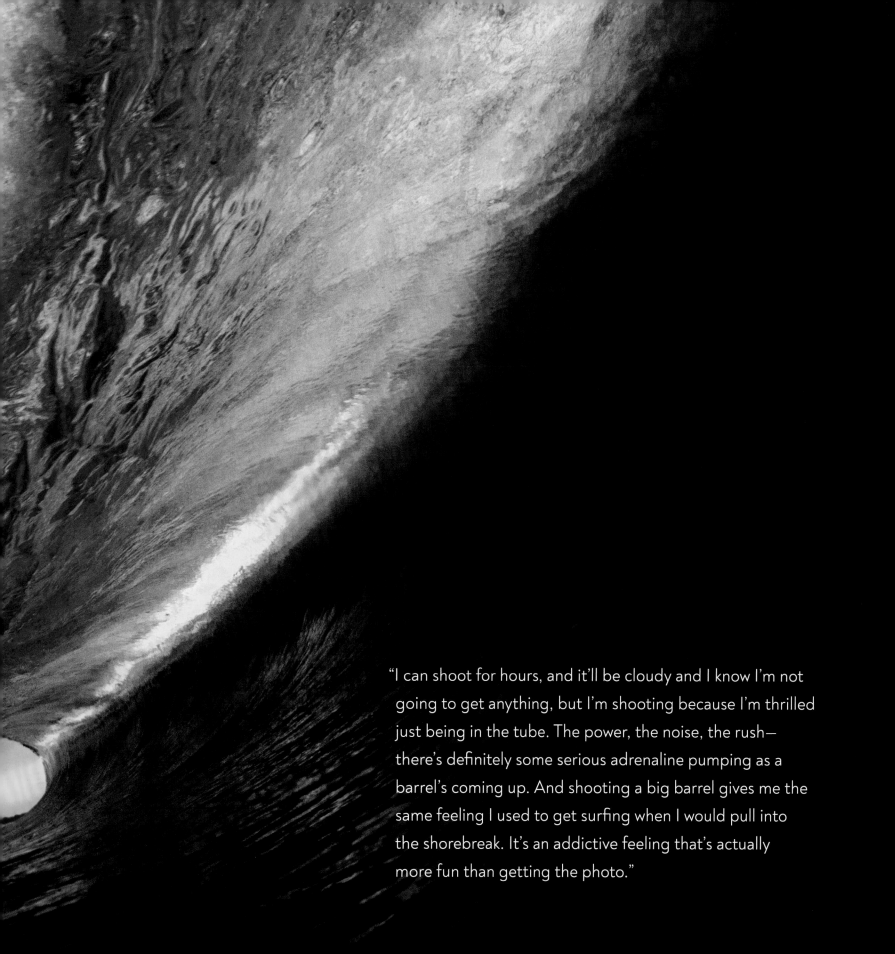

"I can shoot for hours, and it'll be cloudy and I know I'm not going to get anything, but I'm shooting because I'm thrilled just being in the tube. The power, the noise, the rush—there's definitely some serious adrenaline pumping as a barrel's coming up. And shooting a big barrel gives me the same feeling I used to get surfing when I would pull into the shorebreak. It's an addictive feeling that's actually more fun than getting the photo."

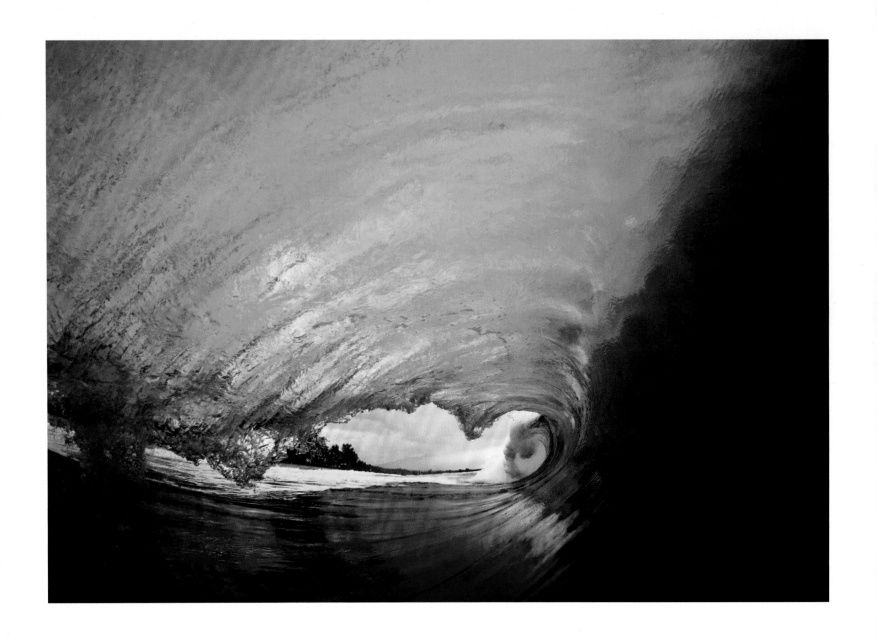

PEACH GLOW
North Shore, Oʻahu
(previous page)

FIREWORKS
North Shore, Oʻahu
(above)

NIGHT MAGIC
North Shore, Oʻahu
(right)

154

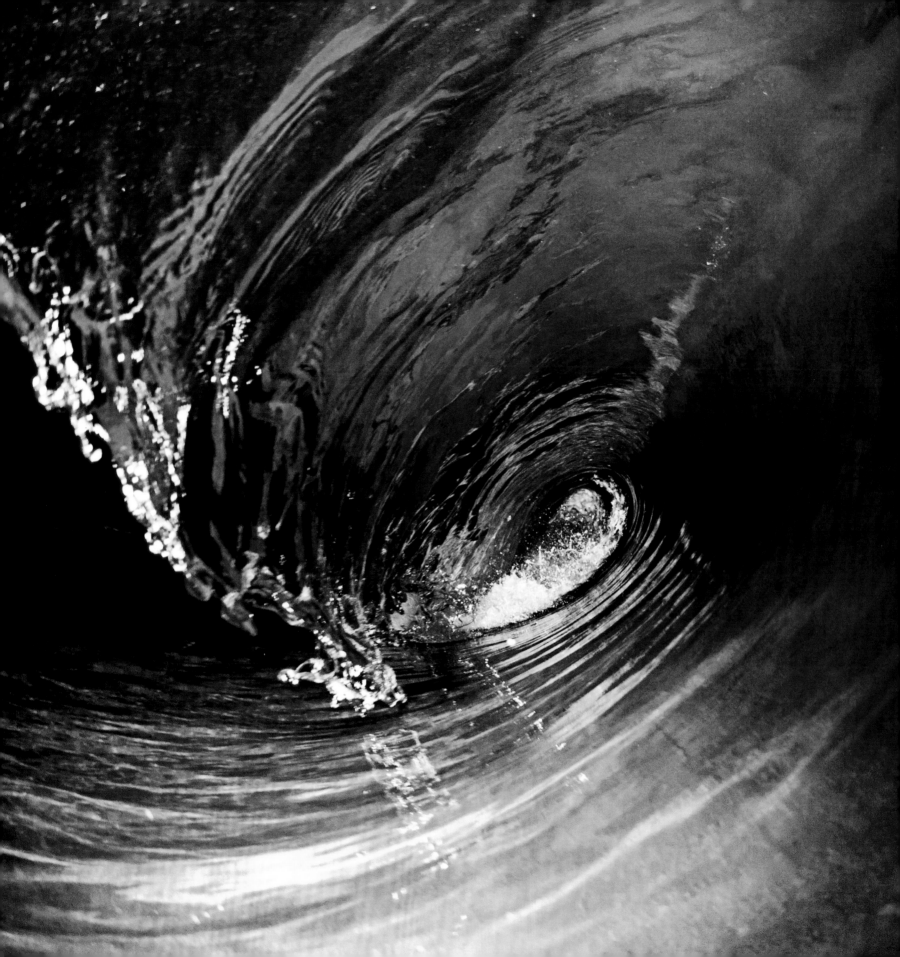

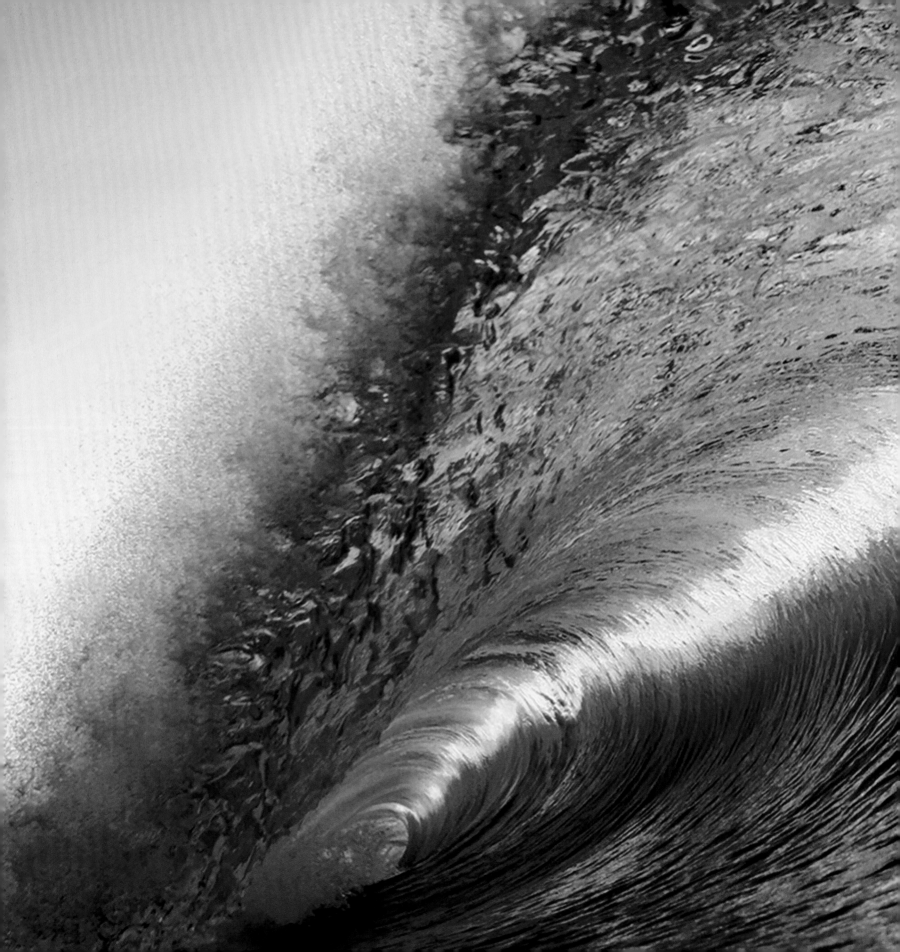

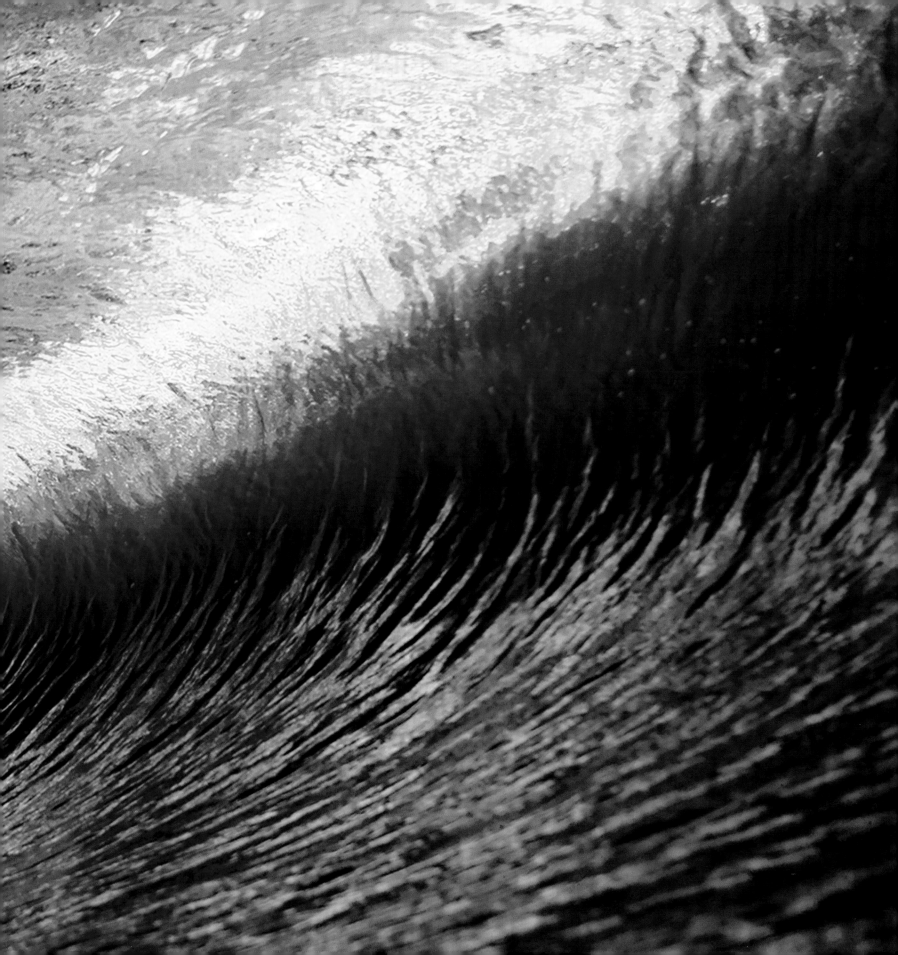

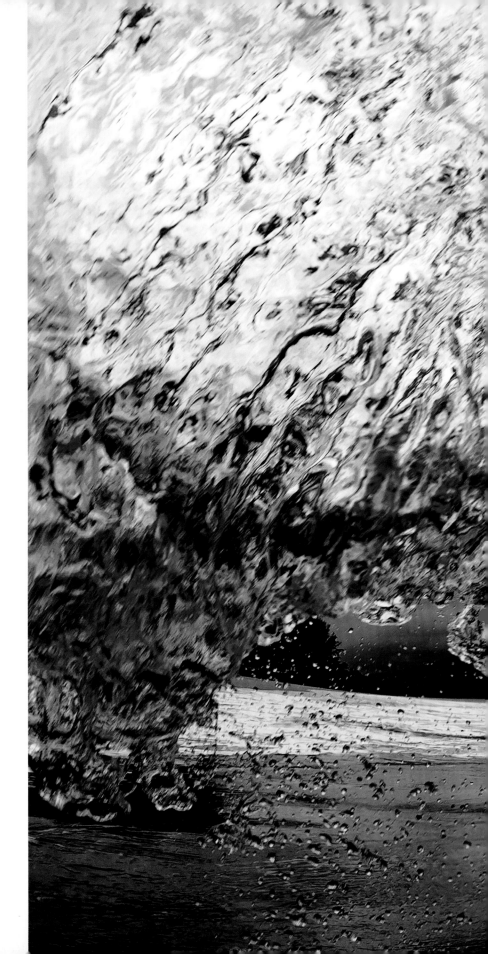

"I like the power and the thunder of being right in the heart of it. It's not just taking the shot; it's knowing where to be. My timing has to be exactly right so that the barrel breaks perfectly over me."

SHINER
North Shore, O'ahu
(previous page)

STORM WARNING
North Shore, O'ahu
(right)

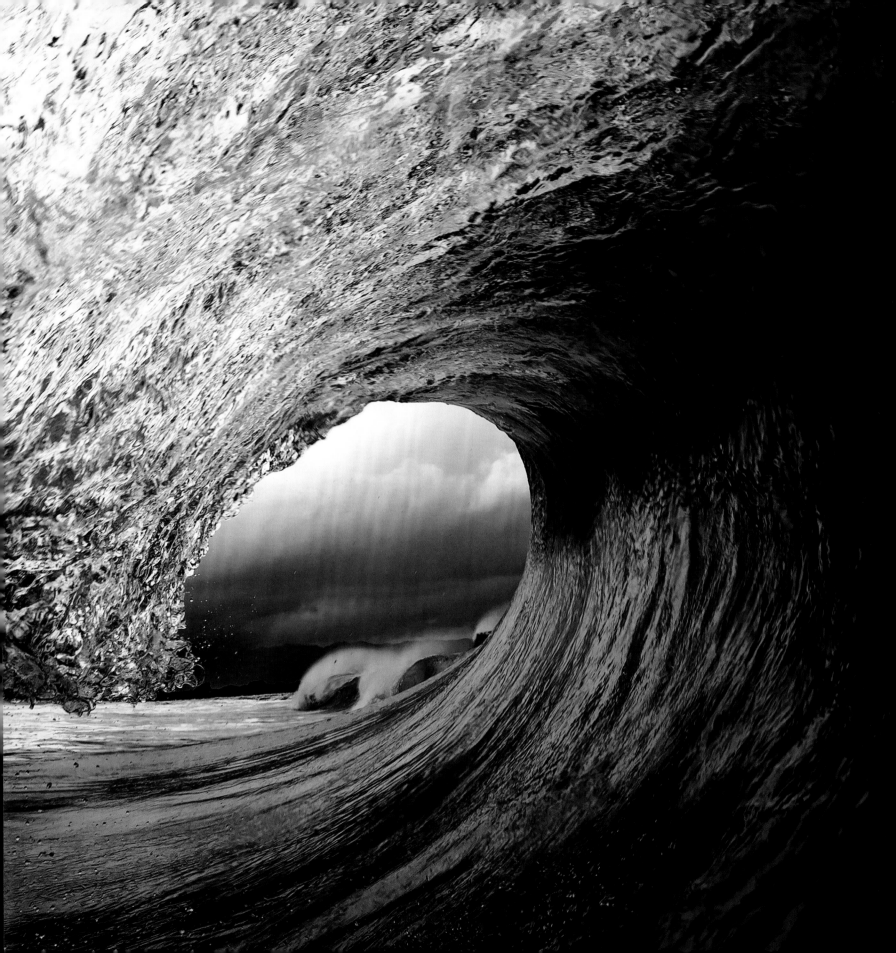

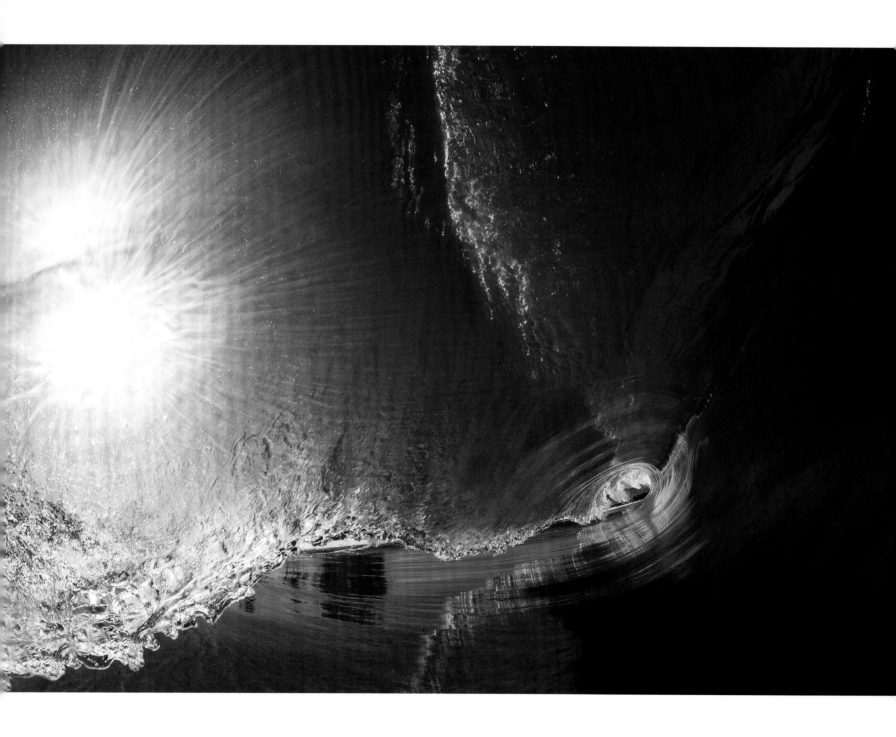

SUNROOF
North Shore, O'ahu

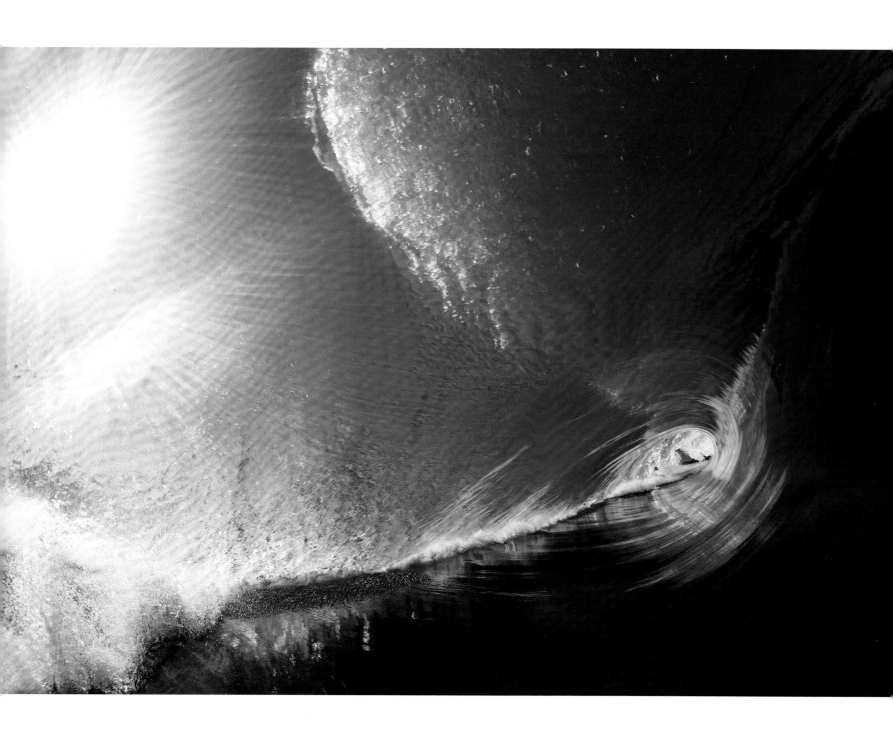

IN THE BLUE ROOM
North Shore, O'ahu

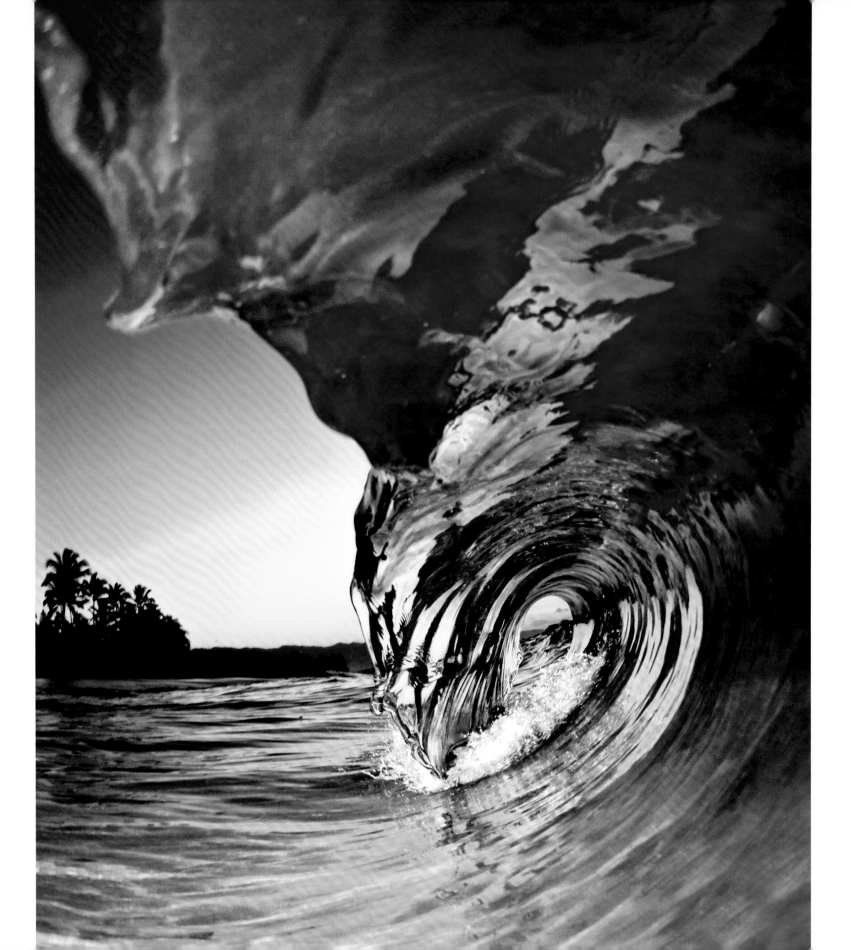

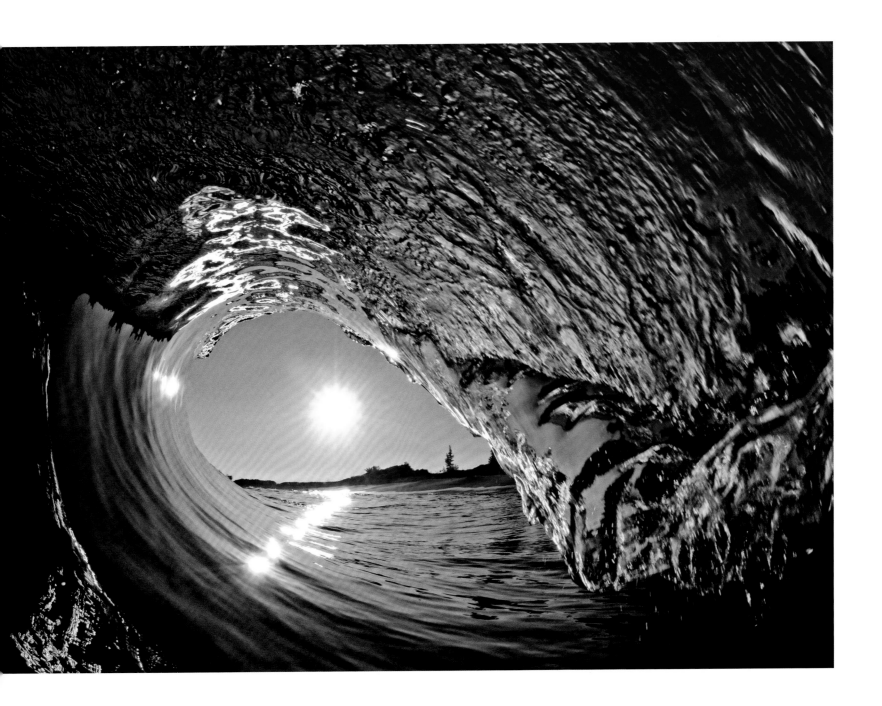

TWILIGHT
North Shore, O'ahu
(left)

BLUE RISE
North Shore, O'ahu
(above)

Look closely in the arch of the wave (10 o'clock position) to see the sun, beach, and landscape reflected upside down. The curve of the wave, especially a glassy one, has similar inverting effects as a spoon. Combine this with a bright sunrise shining in front of the transparent and reflective water. The result is a multifaceted jewel created by nature.

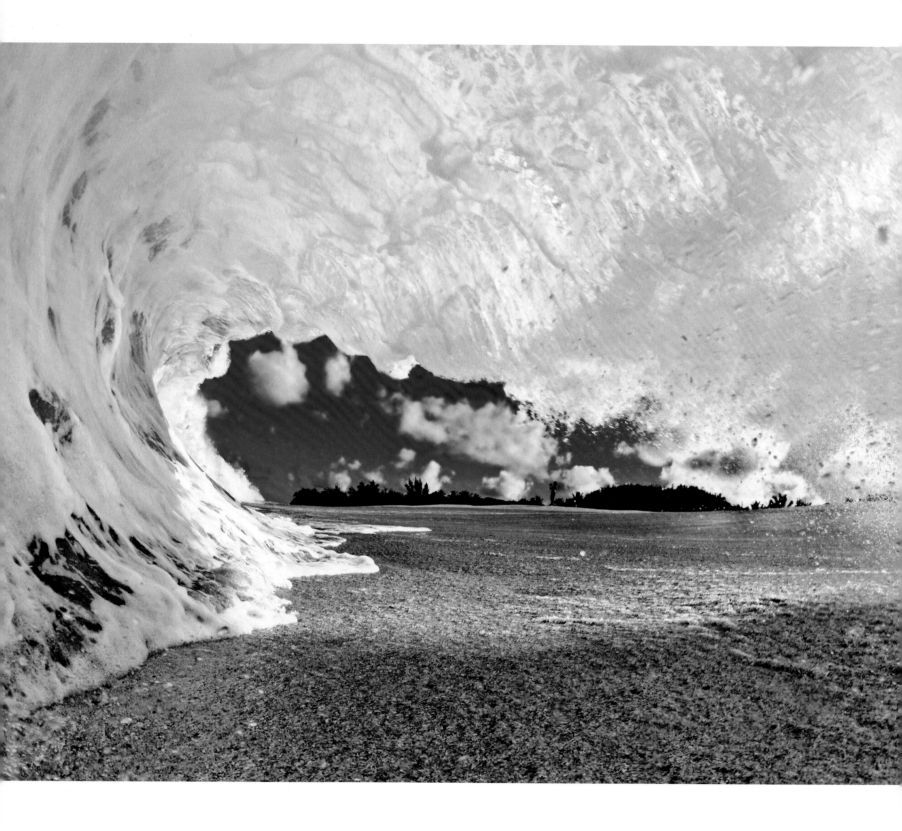

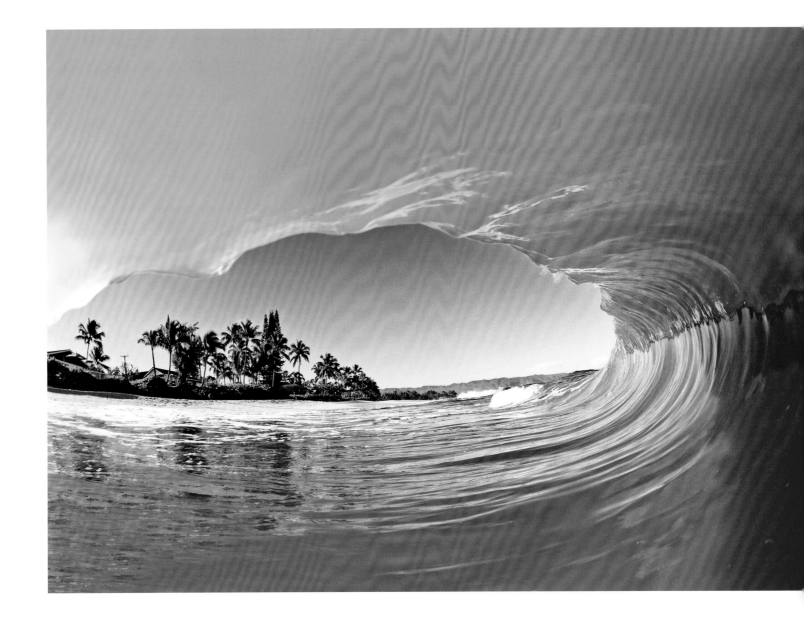

SANDY SHACK
North Shore, O'ahu
(left)

RED DIRT
North Shore, O'ahu
(above)

After heavy rains, the North Shore waters turn brownish red from the volcanic dirt runoff. This is when "Brown Water Advisories" are issued. While driving by a surf spot the morning after a big storm had passed, I had to jump in. Visibility was zero, but the sky was clear, waves were peeling, and nobody was out. After I showed my wife the shots, she got very upset and had me clean and sterilize all of my cuts.

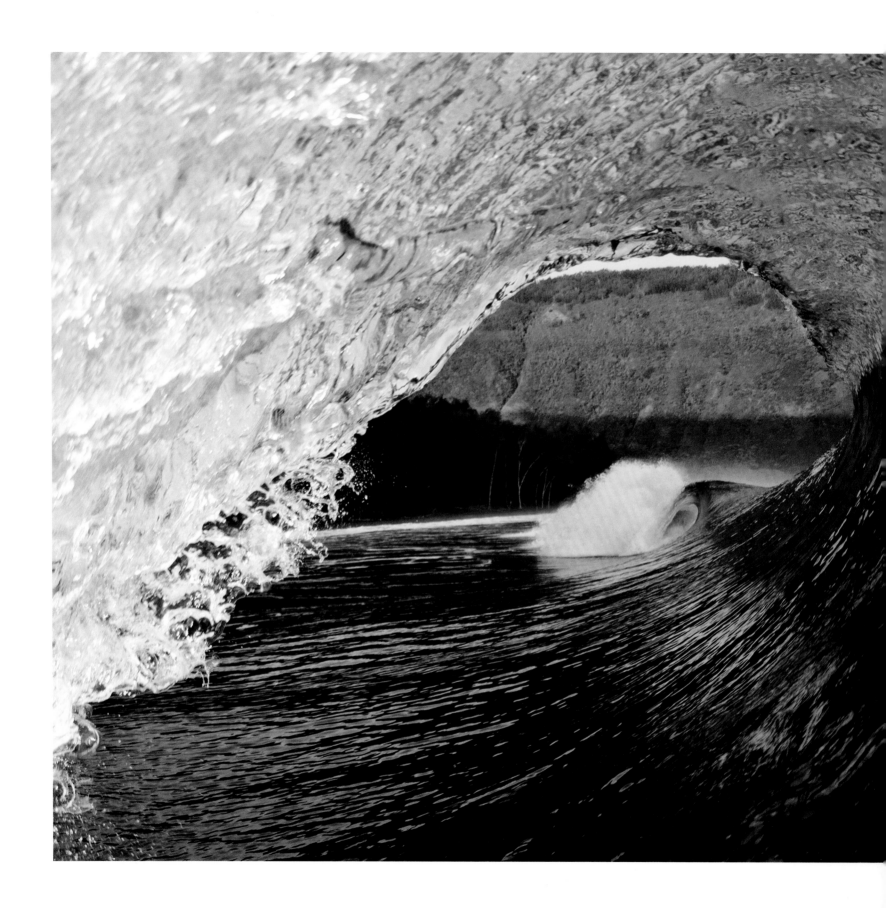

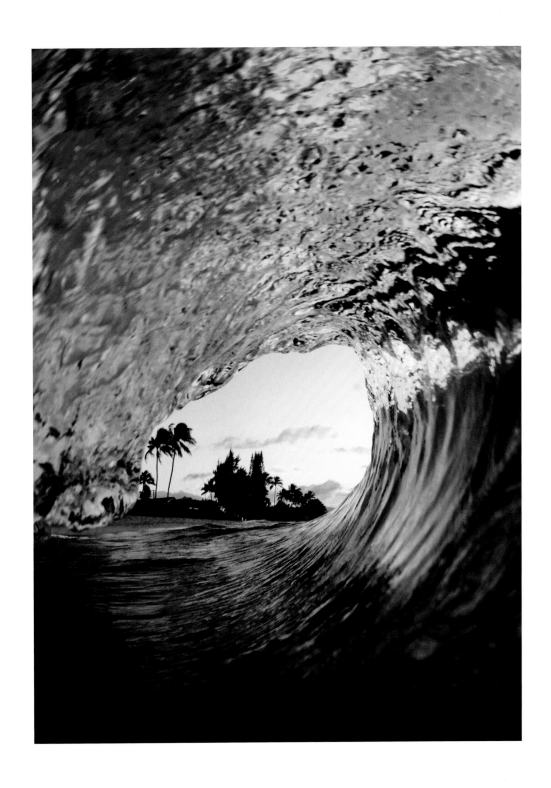

THE SECRET CAVE
Hawai'i Island
(left)

THE VIEW
North Shore, O'ahu
(above)

167

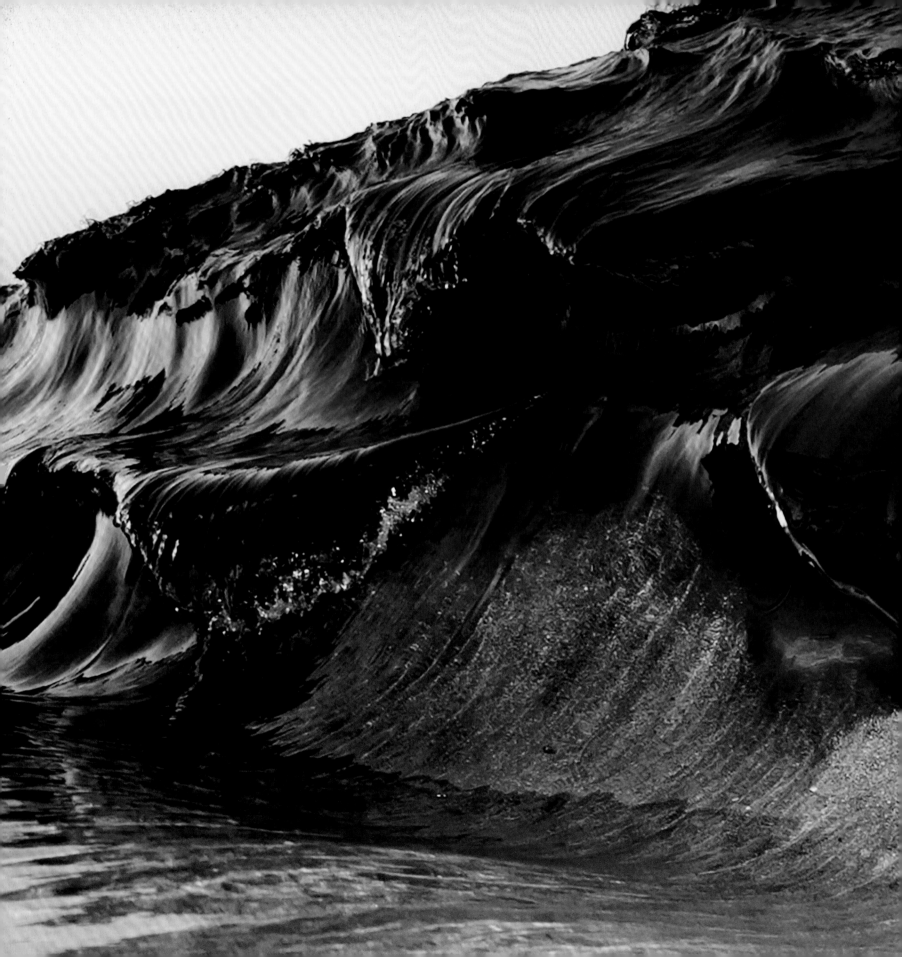

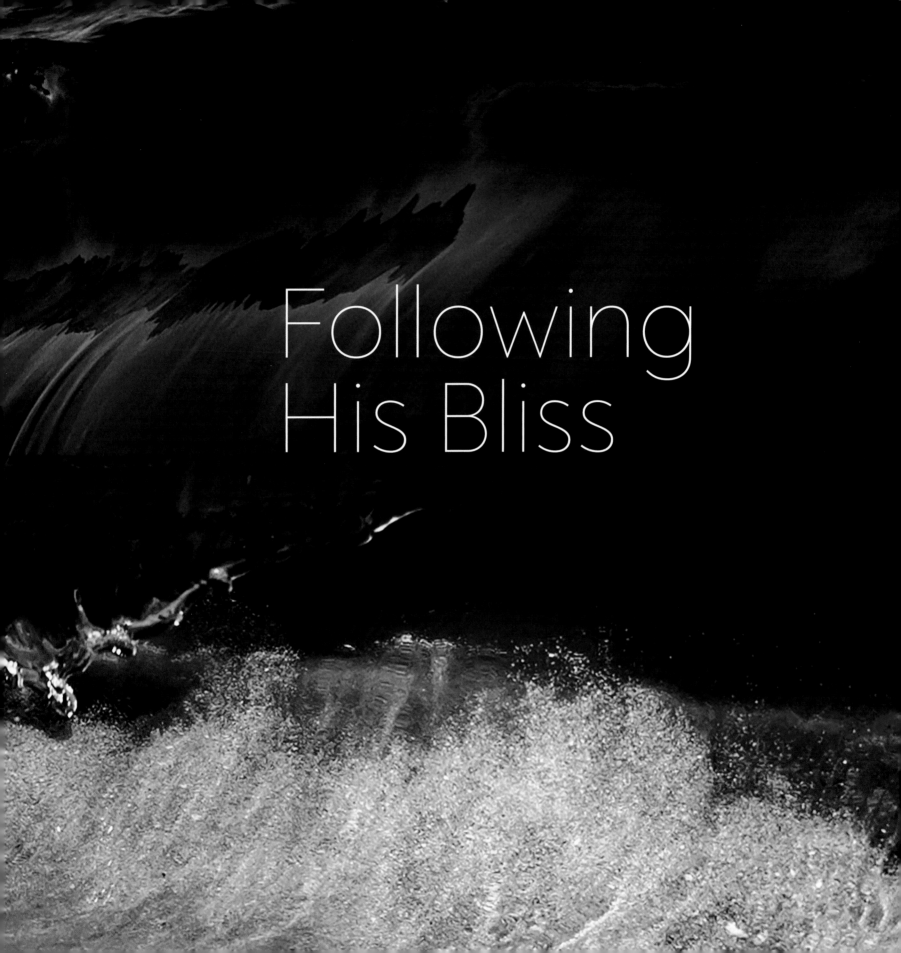

Following His Bliss

Five thousand miles separates the Chelsea arts district of New York City from the North Shore of Oʻahu. But culturally speaking, it's more like a million. Though there is a thriving artist community in Hawaiʻi it's not a scene the way it is in New York. From the perspective of this mainstream art world, Clark Little would be seen as an outsider artist. And Clark is just fine with that.

In fact, Clark's not entirely comfortable being called an artist. That title suggests to him a selfishness and pretension that is at odds with how and where he was brought up. First and foremost, Clark is a Hawaiian surfer. And baked into the Hawaiian surfing life is humility and respect. Your ego can get only so big in the face of twenty-five-foot monster waves. And if the ocean doesn't slap you down to size, your fellow surfer will.

For most of his fifty-three years Clark has lived on the North Shore, aka "the country," where the lifestyle is relaxed and slow-paced. Families start young, and ʻohana (the Hawaiian word for family) carries tremendous weight. The ambition and opportunism found in urban art hubs would not go down well in Hawaiʻi. Here, what matters most is bravery, honesty, self-reliance, physical prowess, communion with nature, and actions that speak louder than words.

Clark embodies these qualities. While his photographs have been exhibited at the Smithsonian Museum and published in *National Geographic*, he's not defined by these achievements. He's not reading *Artforum* and wondering where he sits in the hierarchy. He's hanging out with his family; he and lifelong friends are gathering in the living room to watch the Conor McGregor fight; he's driving a couple of blocks up the hill to see his pops and the newest plumeria cuttings; and he's keeping an eye (and an ear) on the surf at all times, the way he has for as long as he can remember. When the swell's up and the conditions come together, he's racing down the hill, not with a surfboard but with a camera.

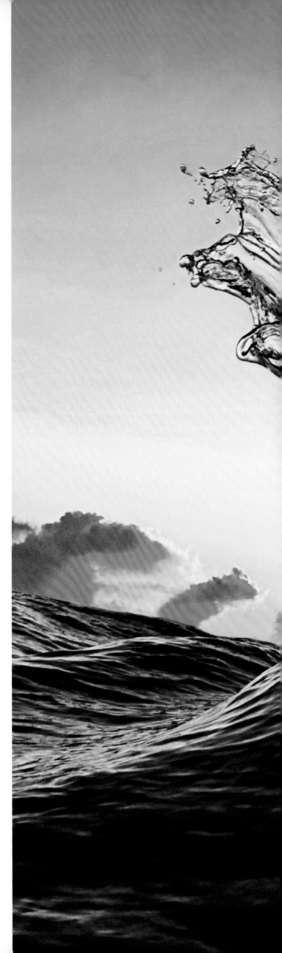

SLIPPERY STEPS
North Shore, Oʻahu
(previous page)

MARLIN
North Shore, Oʻahu
(right)

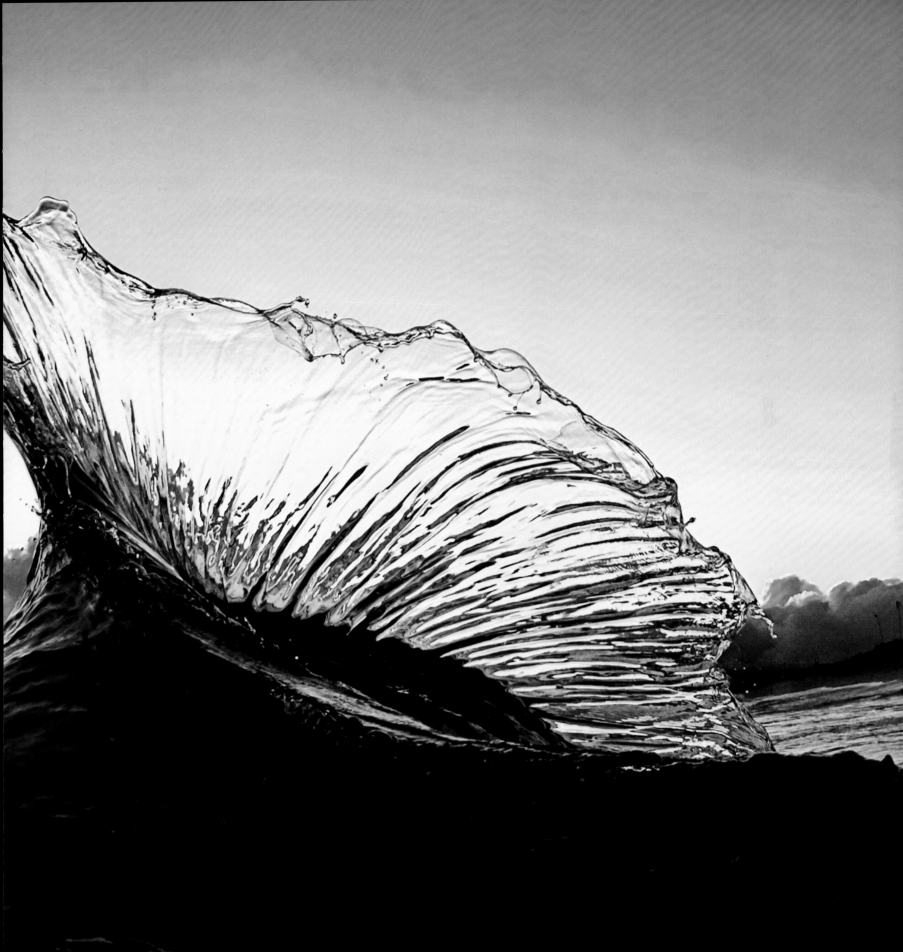

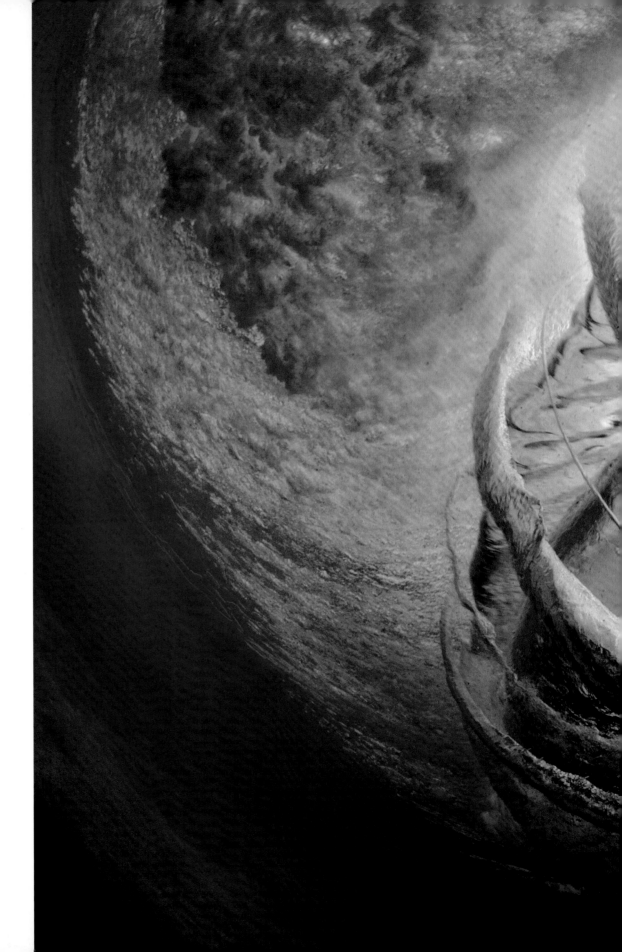

BEAR CLAW

North Shore, O'ahu

This shot was captured by turning the camera up to the wave while swimming under it. The tube is rolling toward the beach from the bottom right to the top left. In the far left corner is the whitewash created by the lip's impact. In certain conditions, especially with large waves, there can be enough room to swim between the ocean floor and the surf, without getting hit by the wave or its tornado-like vortices that spin around the barrel.

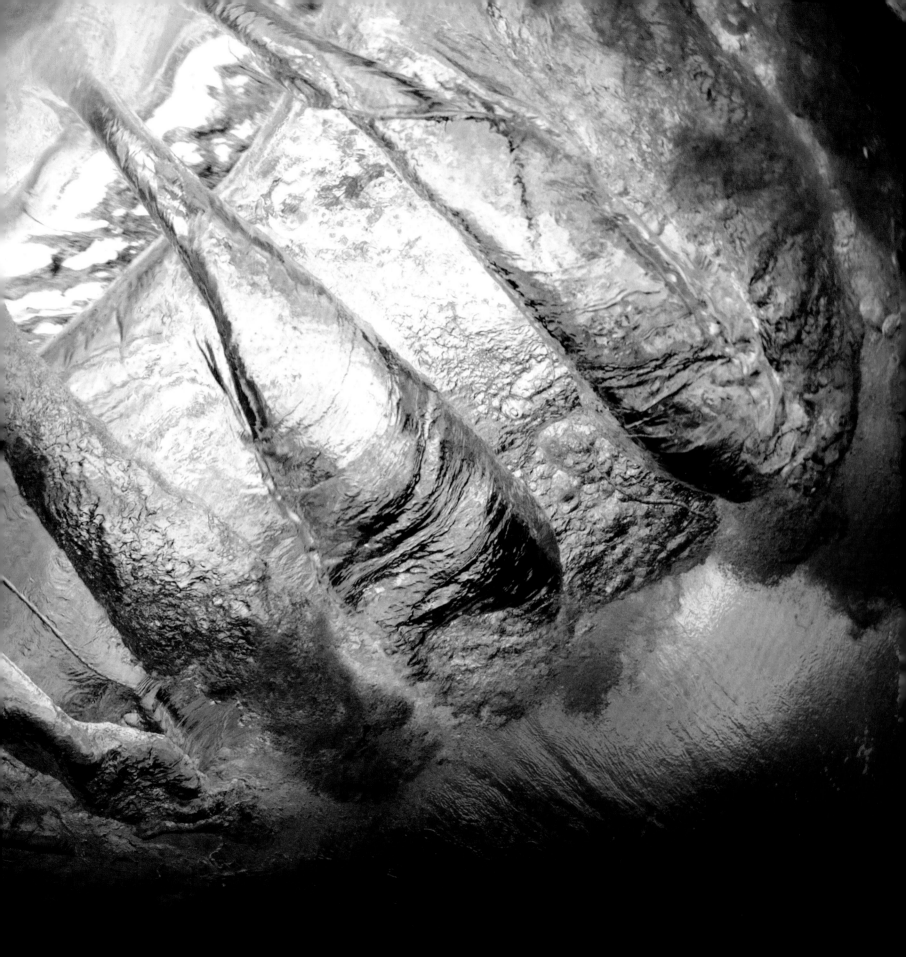

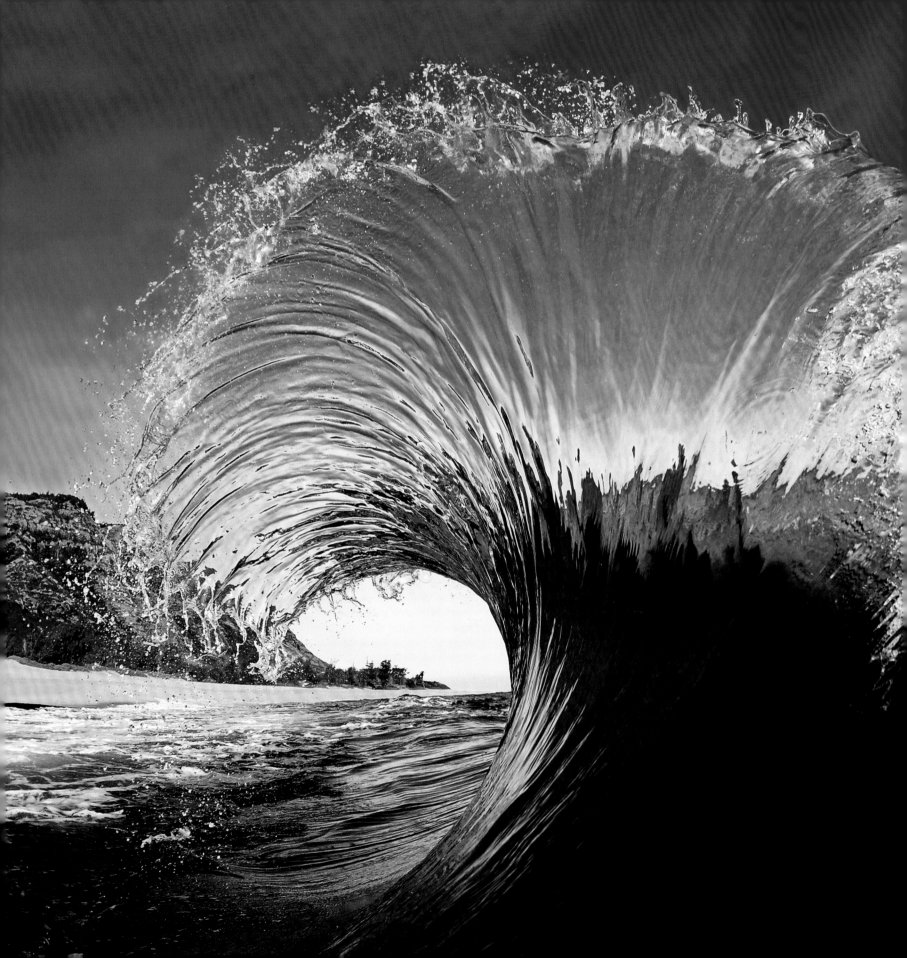

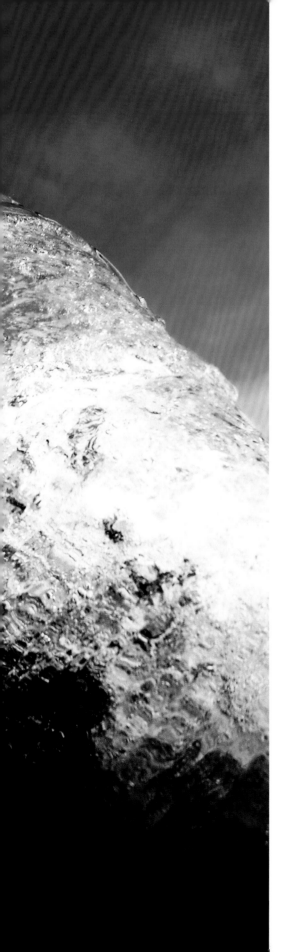

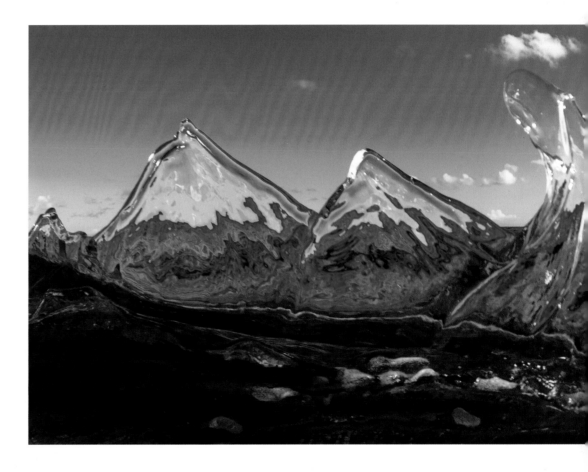

MOHAWK
North Shore, O'ahu
(left)

This phenomenon is formed by two waves colliding against each other. When a wave hits the shore, sending the water up a sloping beach, that water comes back down and can create an outgoing wave. The wave marching back out to sea is called "backwash." If the timing is right, this backwash can hit the next wave coming in, just as it breaks, sending up a fan of water.

BLUE MOUNTAINS
North Shore, O'ahu
(above)

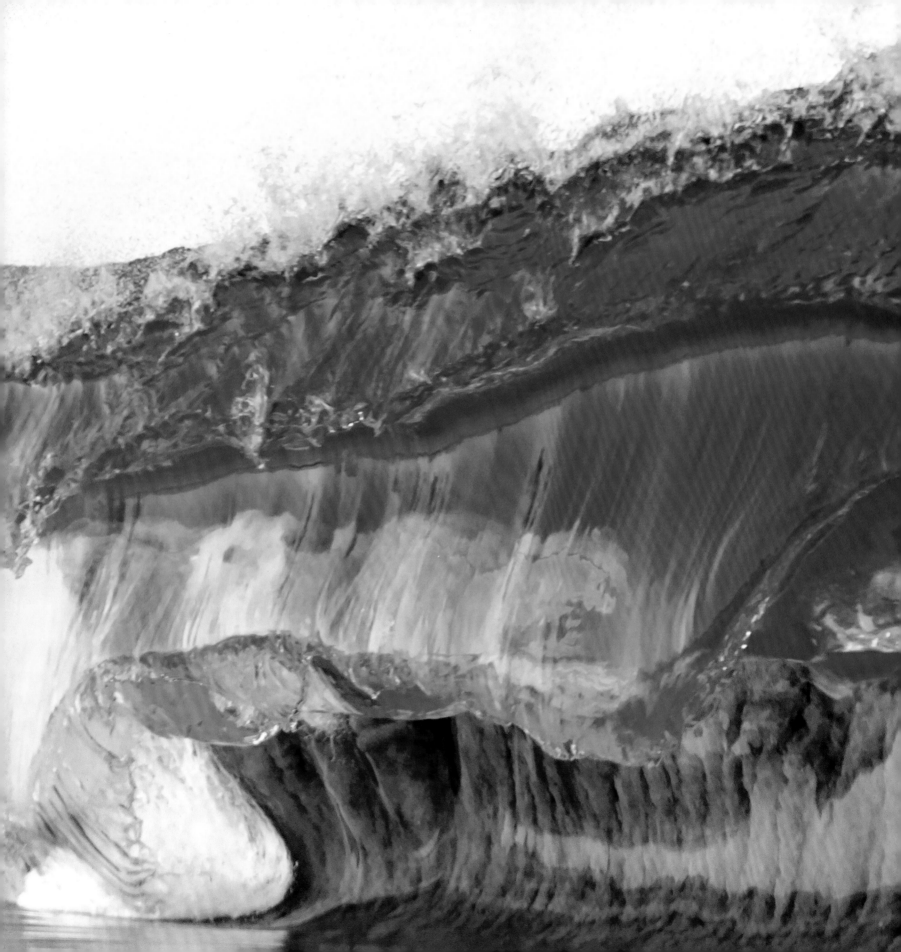

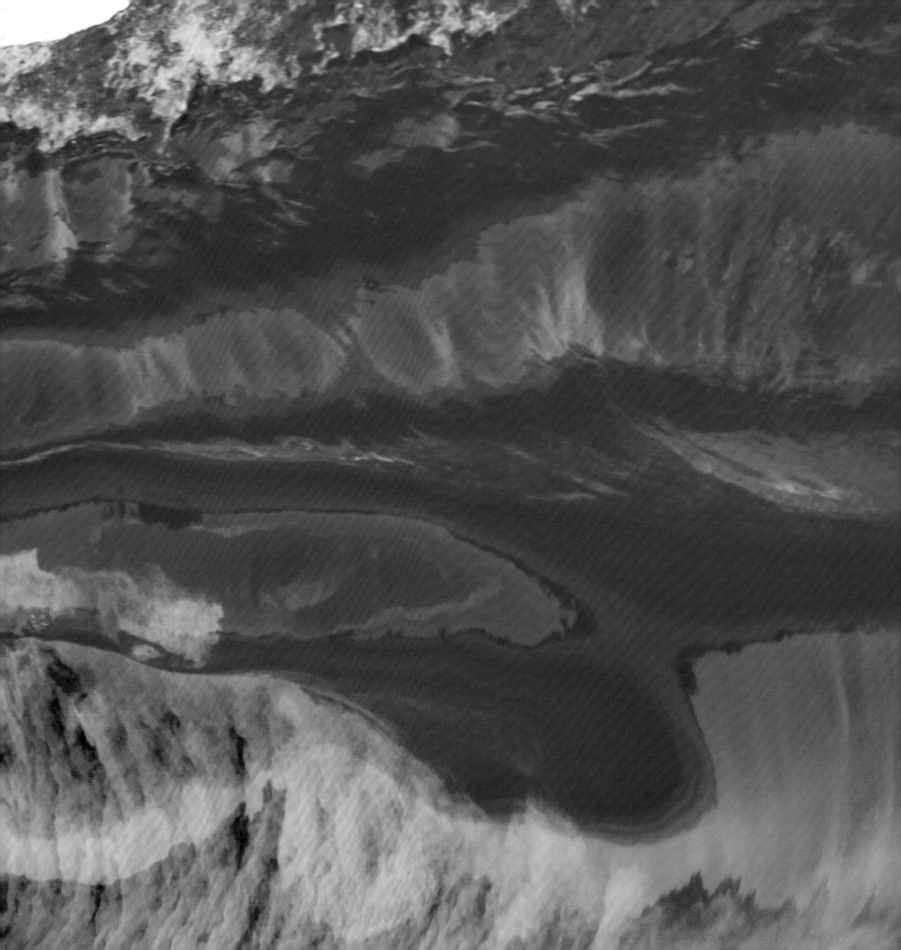

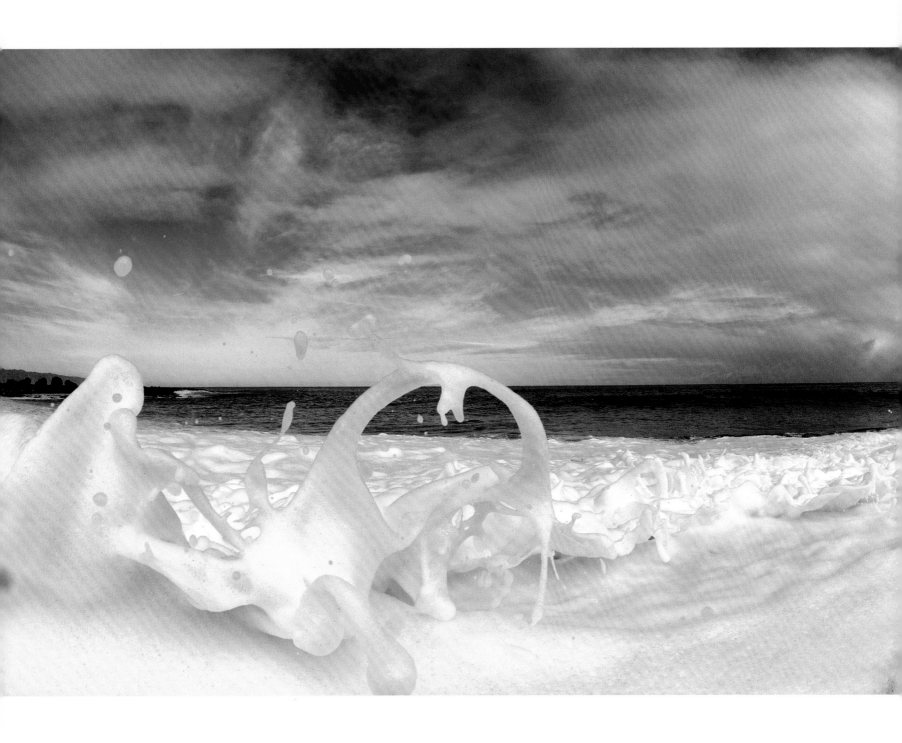

GLASS WALL
North Shore, O'ahu
(previous page)

FROSTY
North Shore, O'ahu
(above)

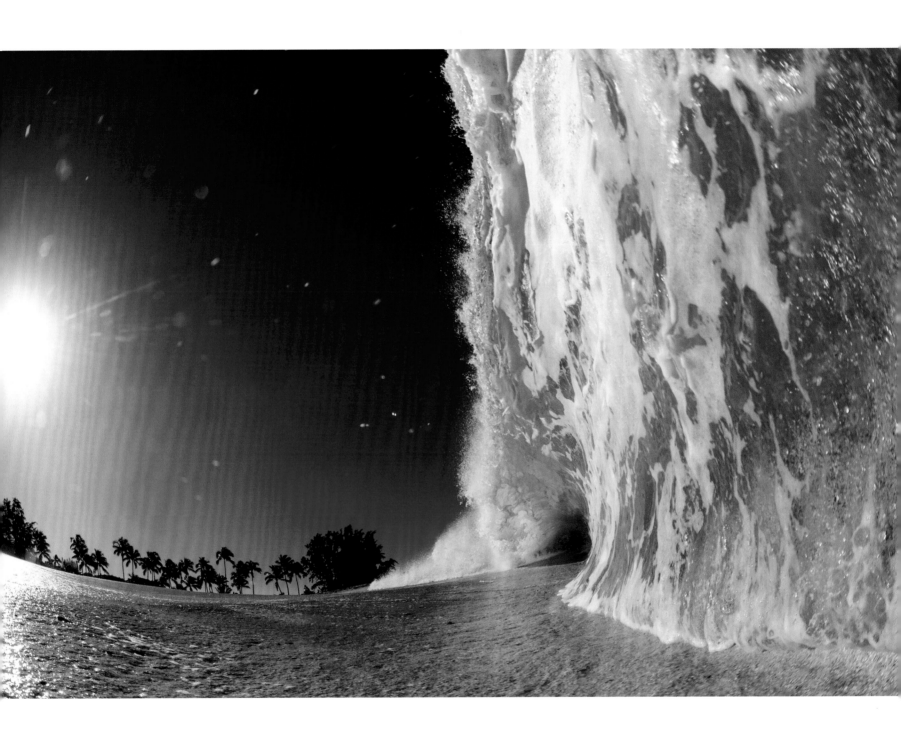

THE WALL
North Shore, O'ahu

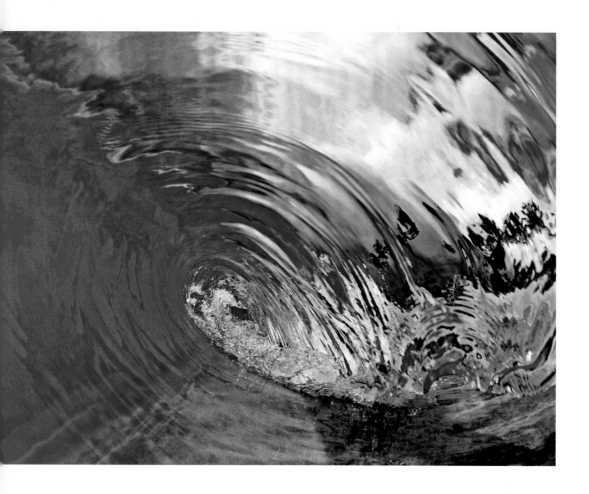

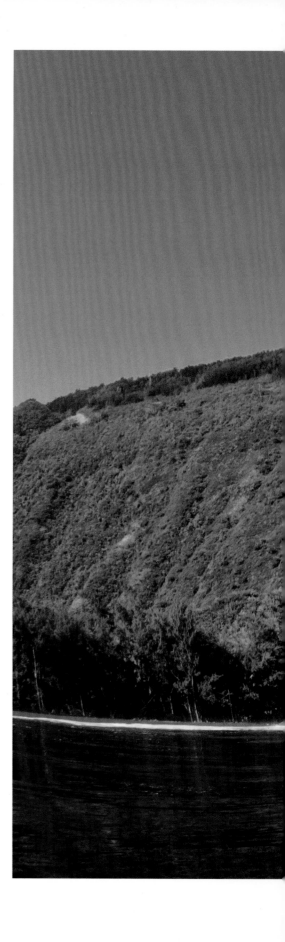

LOOKING GLASS
North Shore, O'ahu
(above)

BIG ISLAND
Hawai'i Island
(right)

Each island in Hawai'i has its own unique beaches that are hidden away, including this black sand beach on Hawai'i Island. Unlike the water's aqua color found in white sand beaches, the dark colors are a result of the fine black volcanic sand underneath. This is a spiritual place, and when the conditions are right, it's pure magic.

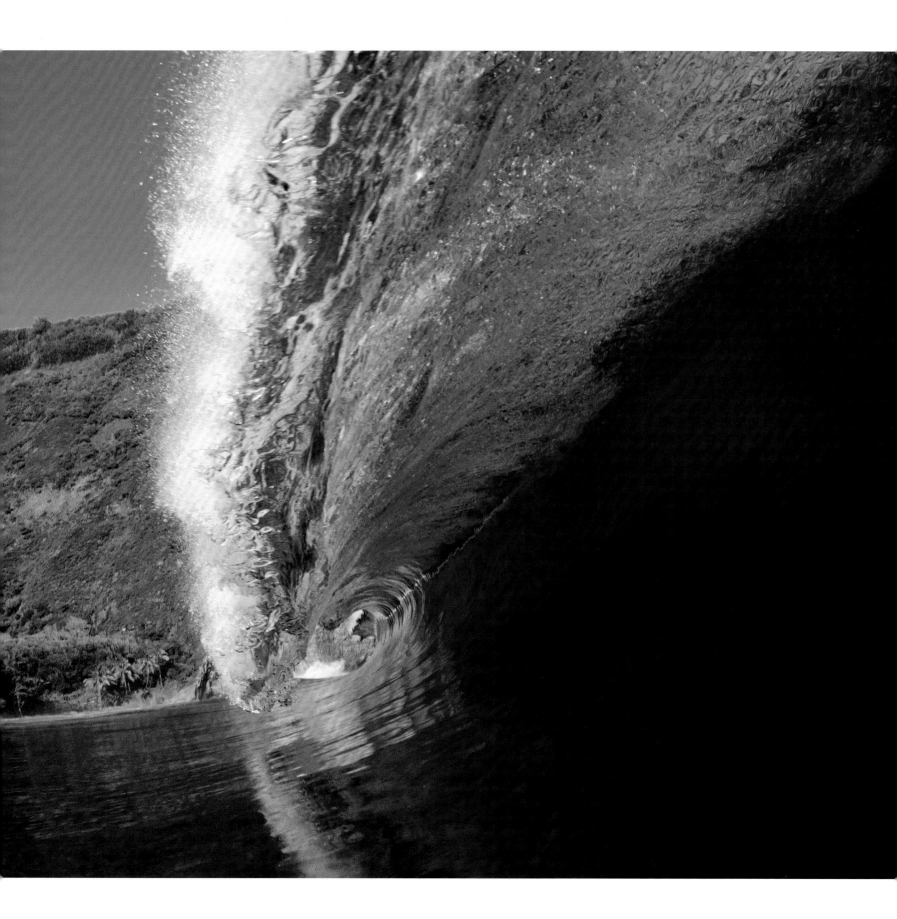

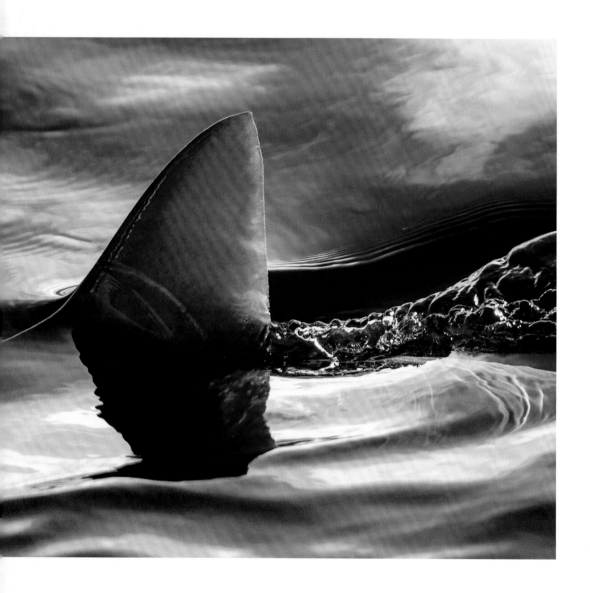

SHARK FIN
North Shore, O'ahu
(above)

RELAXATION
North Shore, O'ahu
(right)

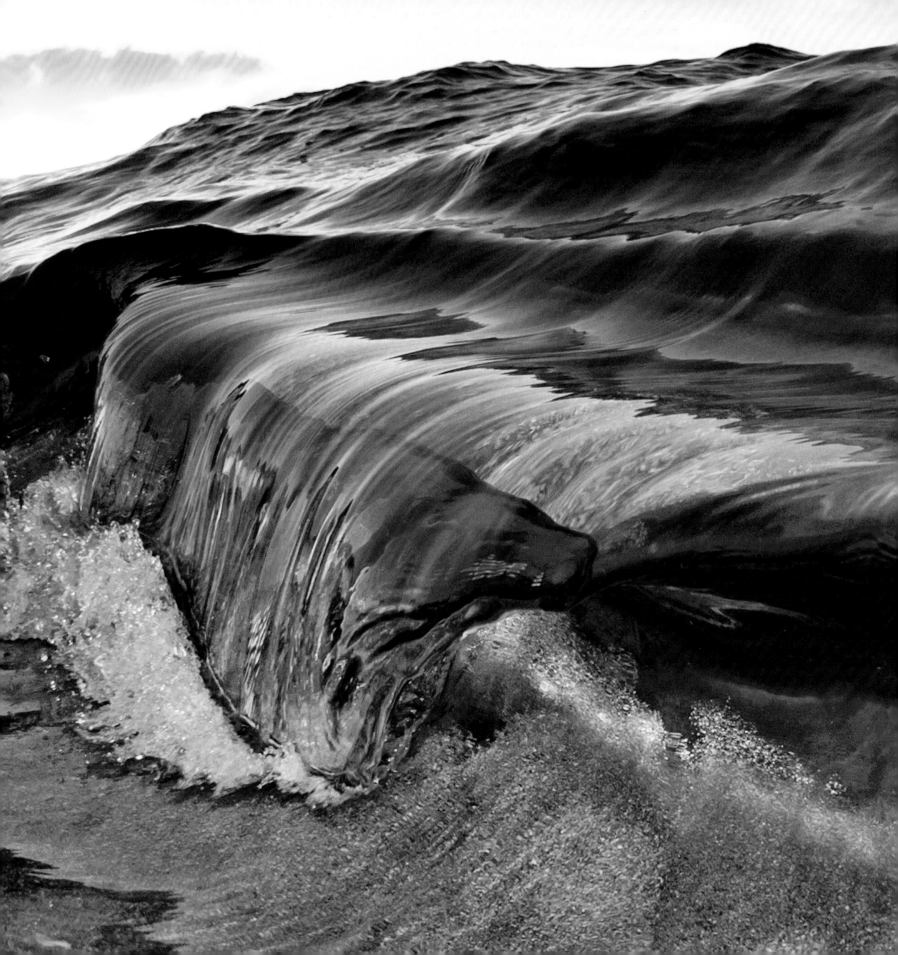

BLOWN GLASS
Mākena Beach, Maui
(right)

CLARK SHOOTING (SEQUENCE)
North Shore, O'ahu
(next page, left)
Photos by Dane Little

CLARK'S FAN
North Shore, O'ahu
(next page, right)

When people look at pictures of me shooting waves, they often want to see what my camera captured at that exact moment. It's rare to be able to match up a quality sequence with one of my waves. My son, Dane, took these two pictures of me shooting. The shot from my camera is on the right and is taken at the same time as the first picture in the sequence. With the help of the sequence, you can see what happens to this wave after my shot.

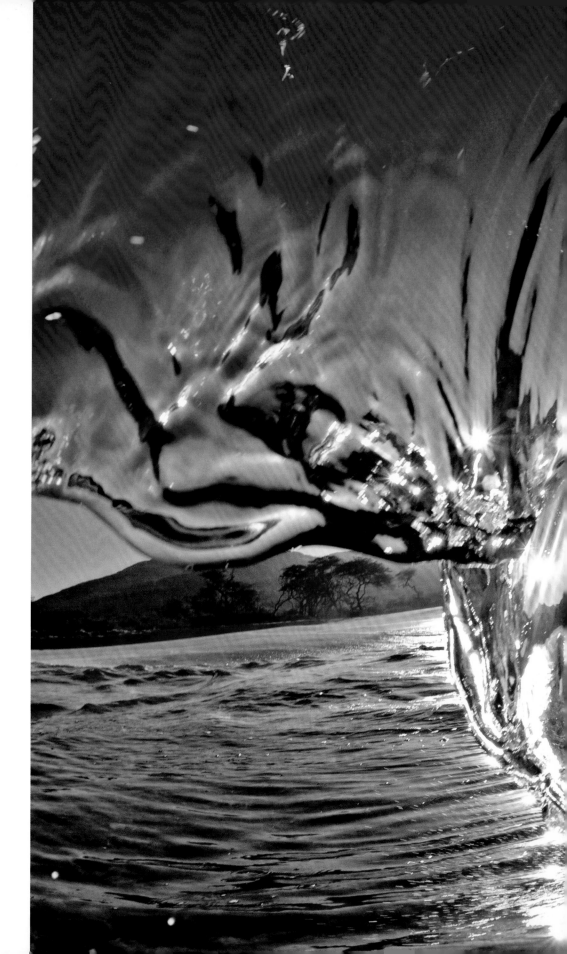

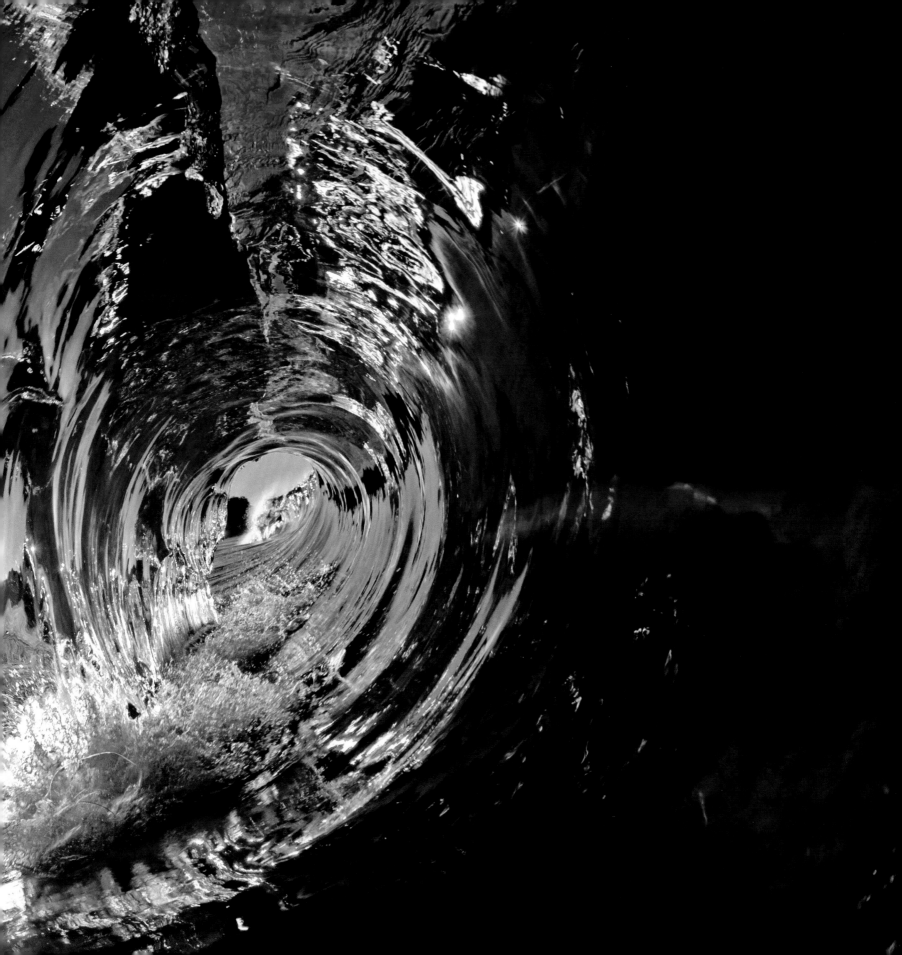

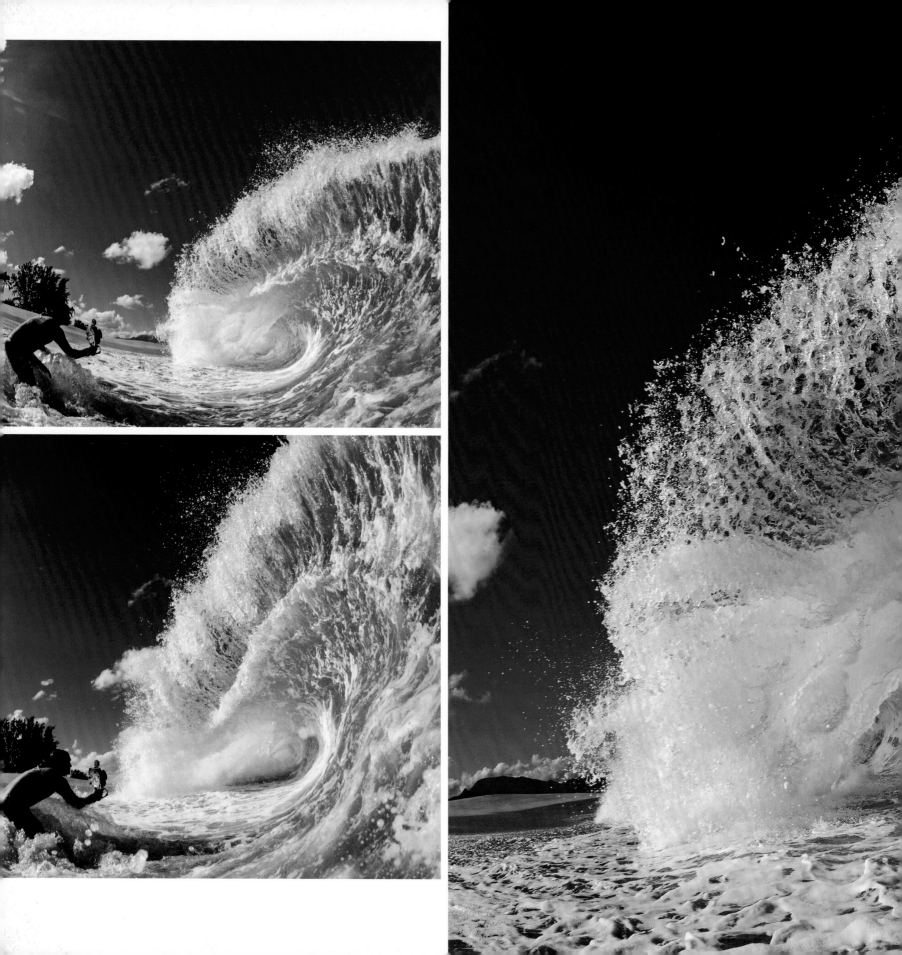

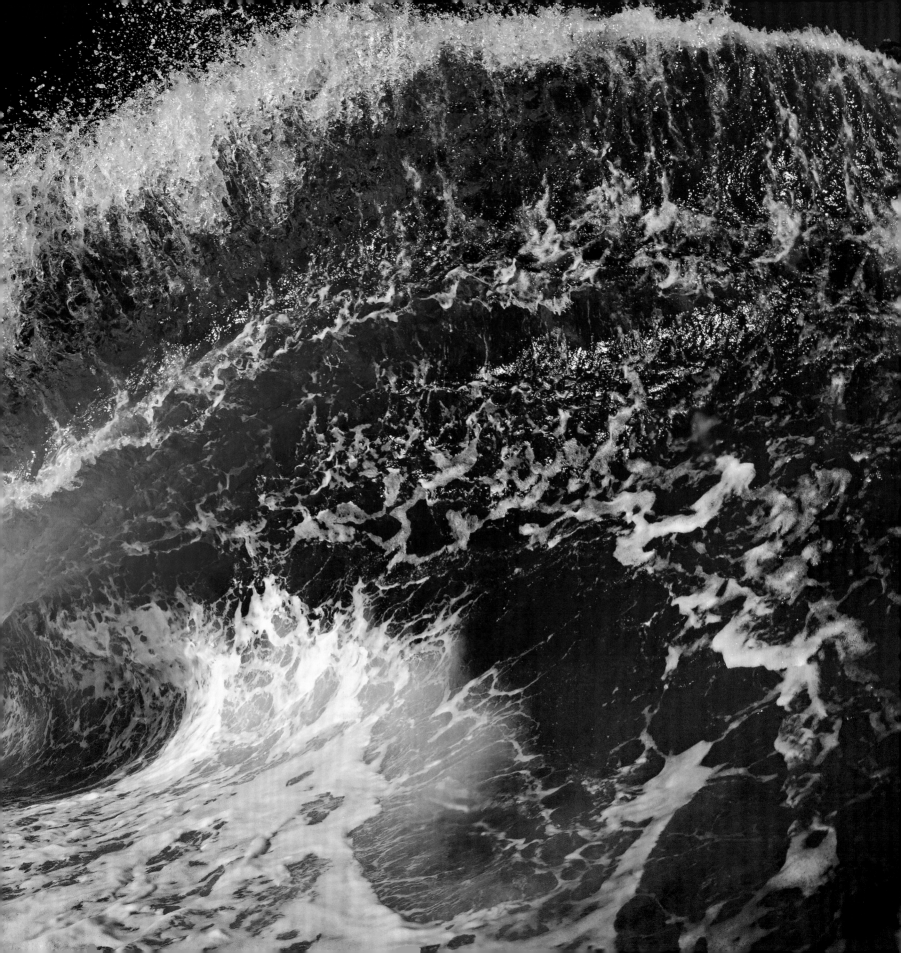

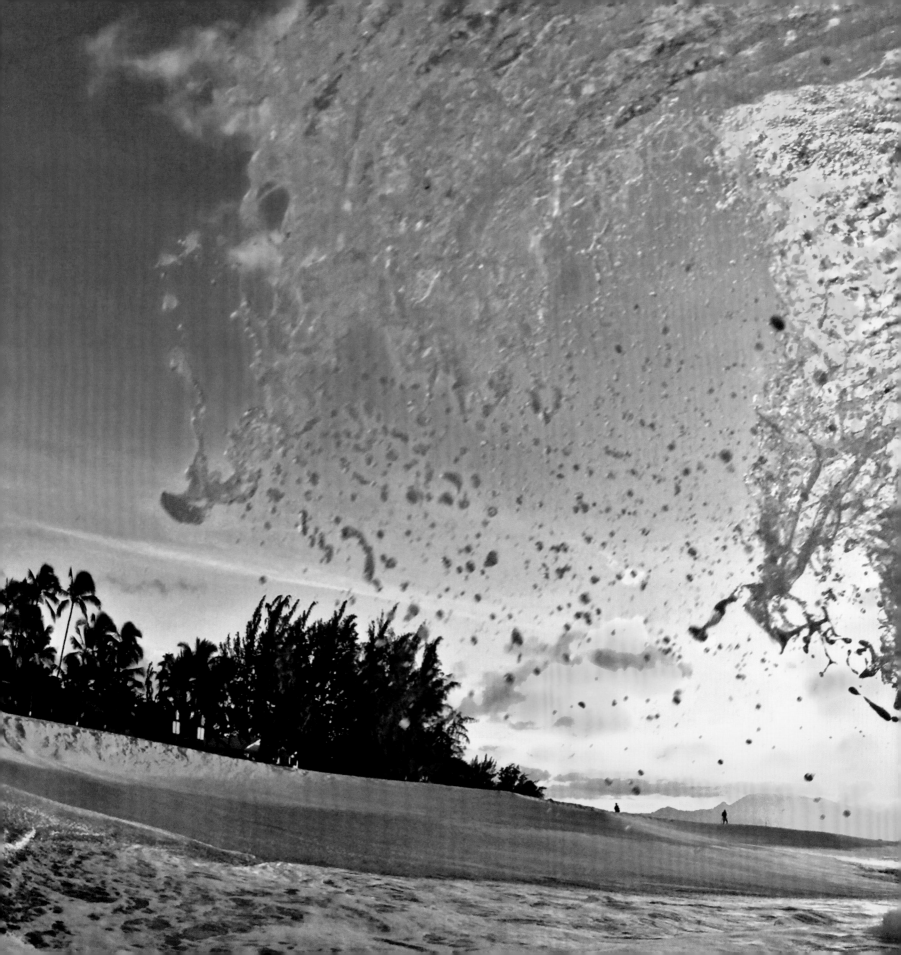

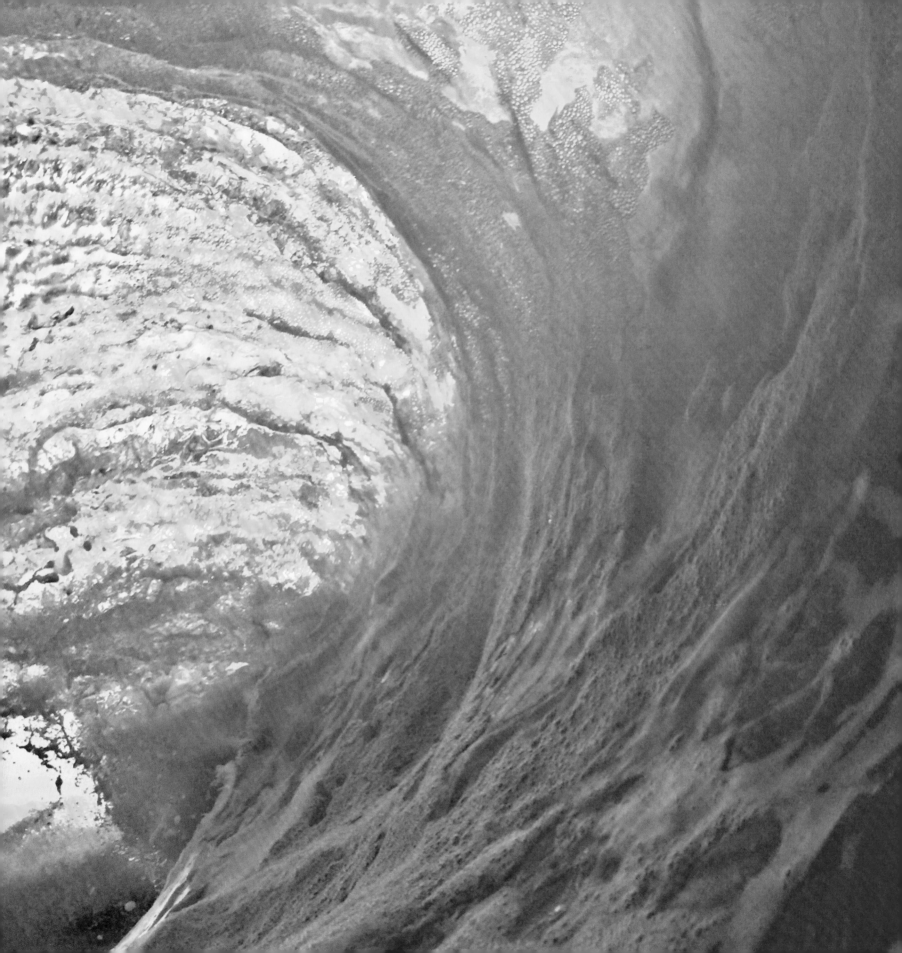

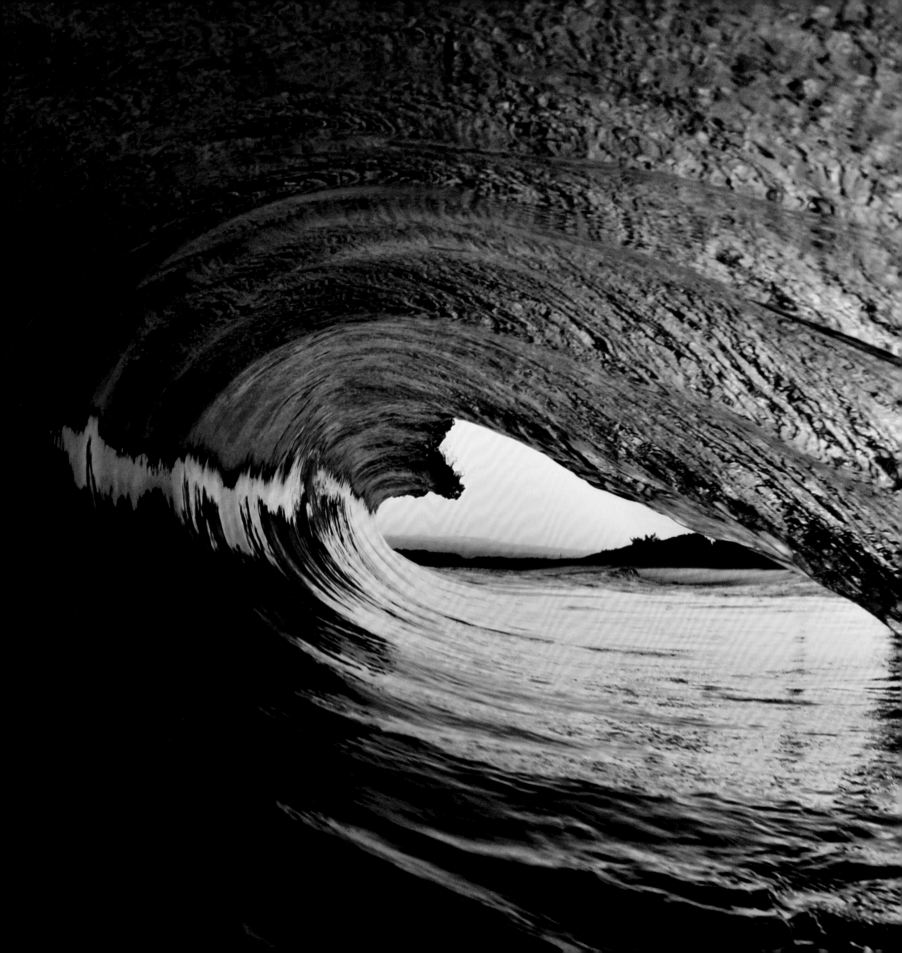

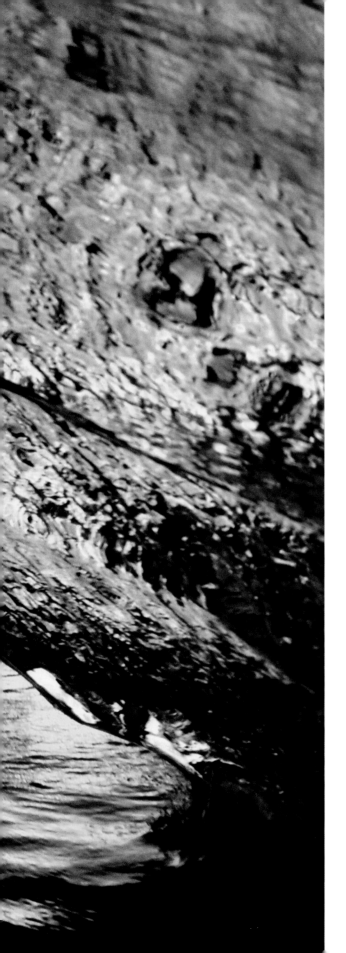

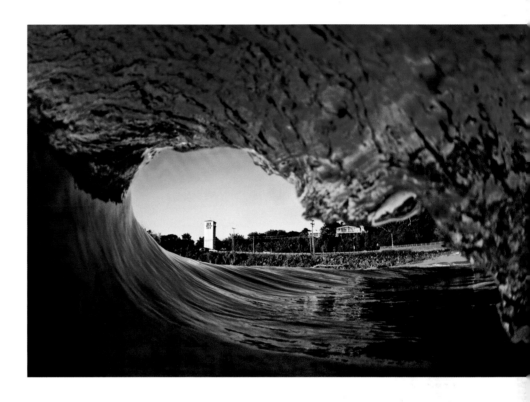

RAKU ART
North Shore, O'ahu
(previous page)

RACE TRACK
North Shore, O'ahu
(left)

CLARK'S VIEW
Waimea Bay, O'ahu
(above)

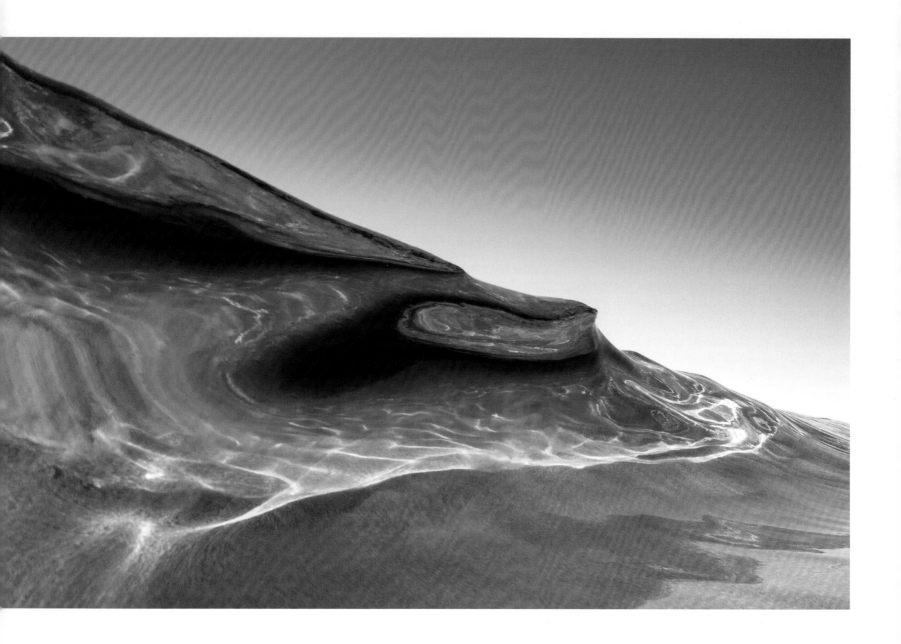

WATER
Mākena Beach, Maui
(above)

MAUI WOWIE
Mākena Beach, Maui
(right)

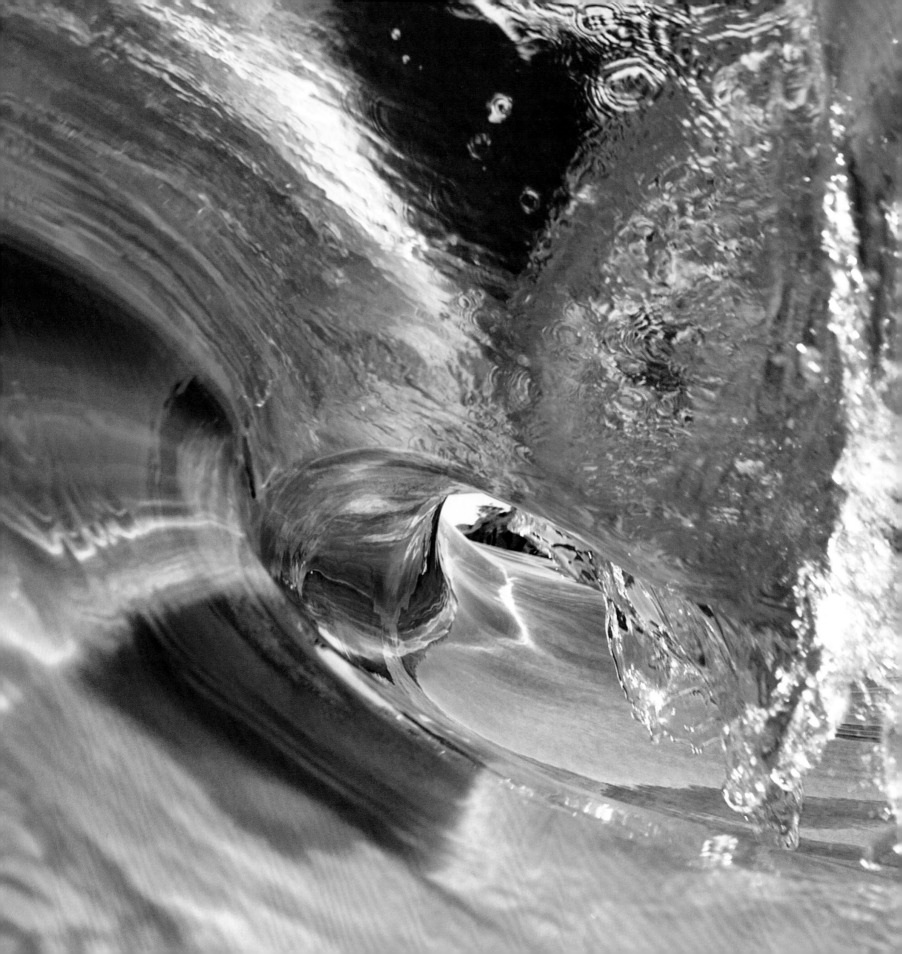

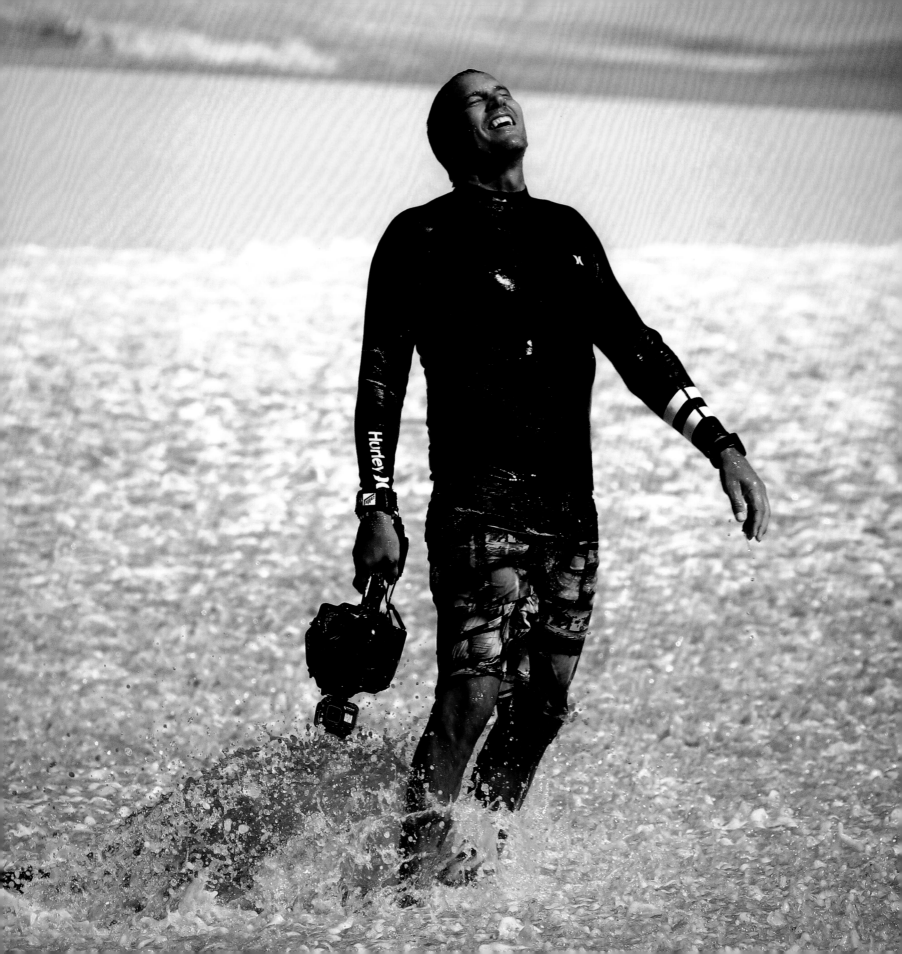

"I went with my heart—which was shooting shorebreak. I figured if I put all my energy into what I love, it would be successful. And leaving my job at the botanical garden and being able to focus 110 percent on my photography made it a lot more successful."

CLARK LITTLE
North Shore, O'ahu
Photo by Peter King

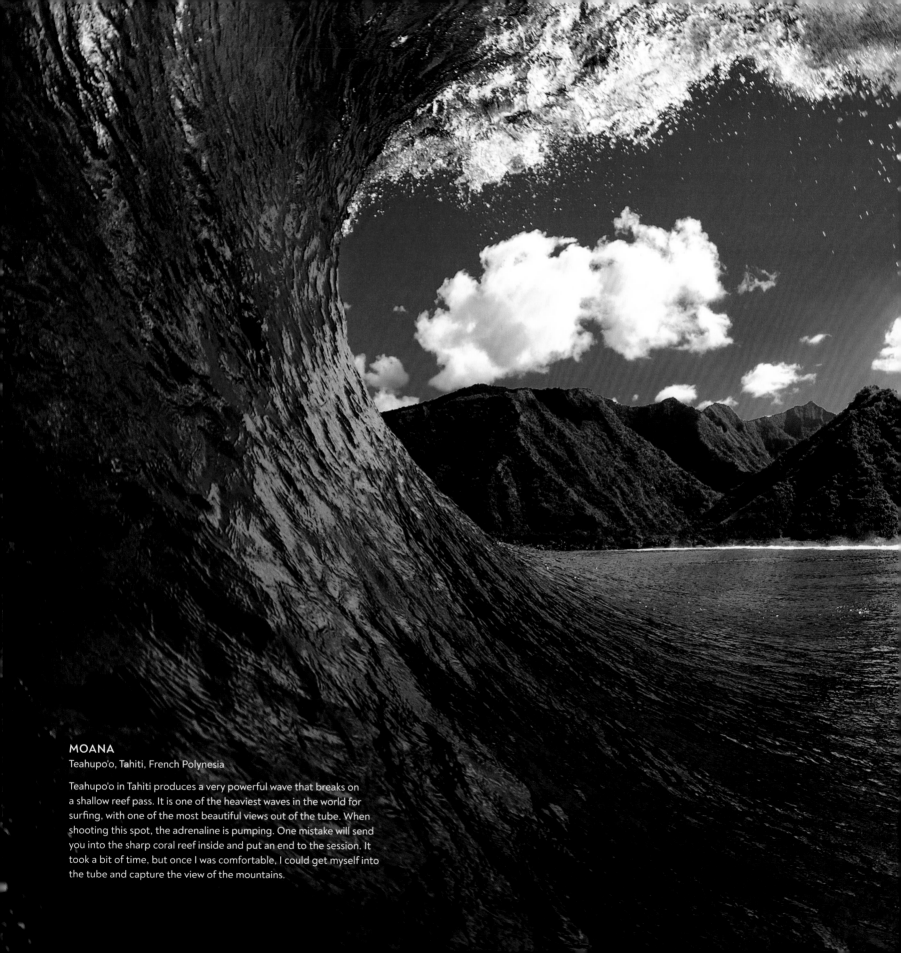

MOANA

Teahupo'o, Tahiti, French Polynesia

Teahupo'o in Tahiti produces a very powerful wave that breaks on
a shallow reef pass. It is one of the heaviest waves in the world for
surfing, with one of the most beautiful views out of the tube. When
shooting this spot, the adrenaline is pumping. One mistake will send
you into the sharp coral reef inside and put an end to the session. It
took a bit of time, but once I was comfortable, I could get myself into
the tube and capture the view of the mountains.

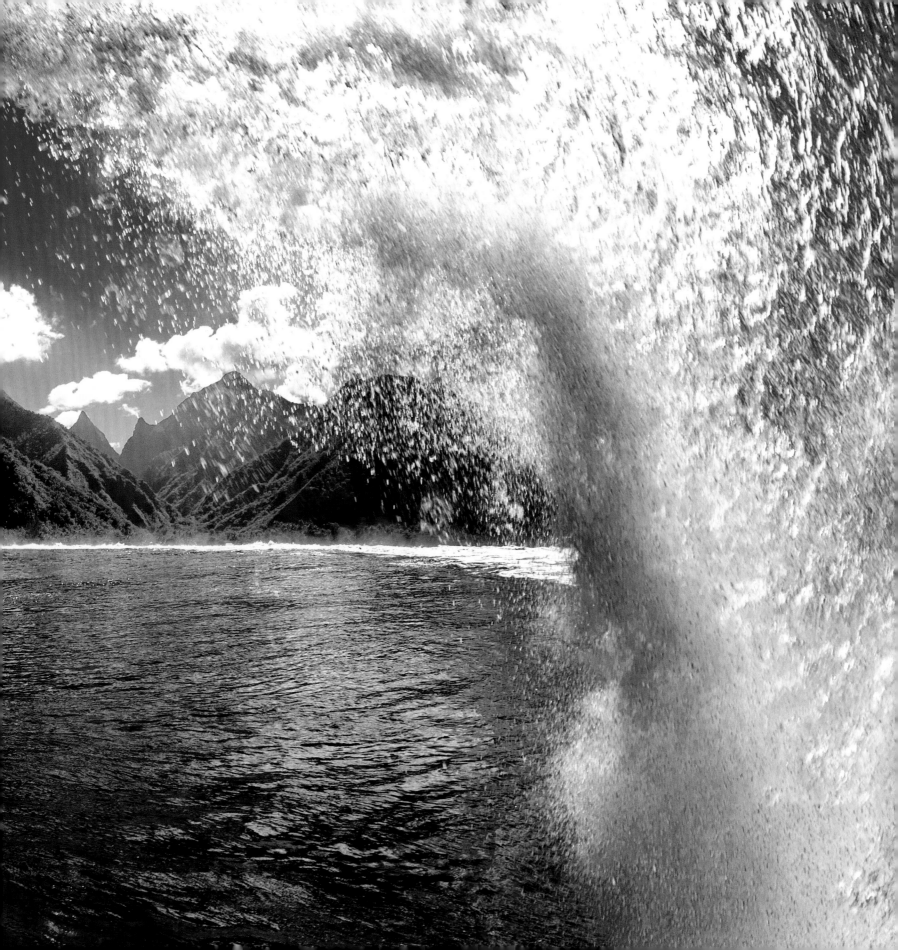

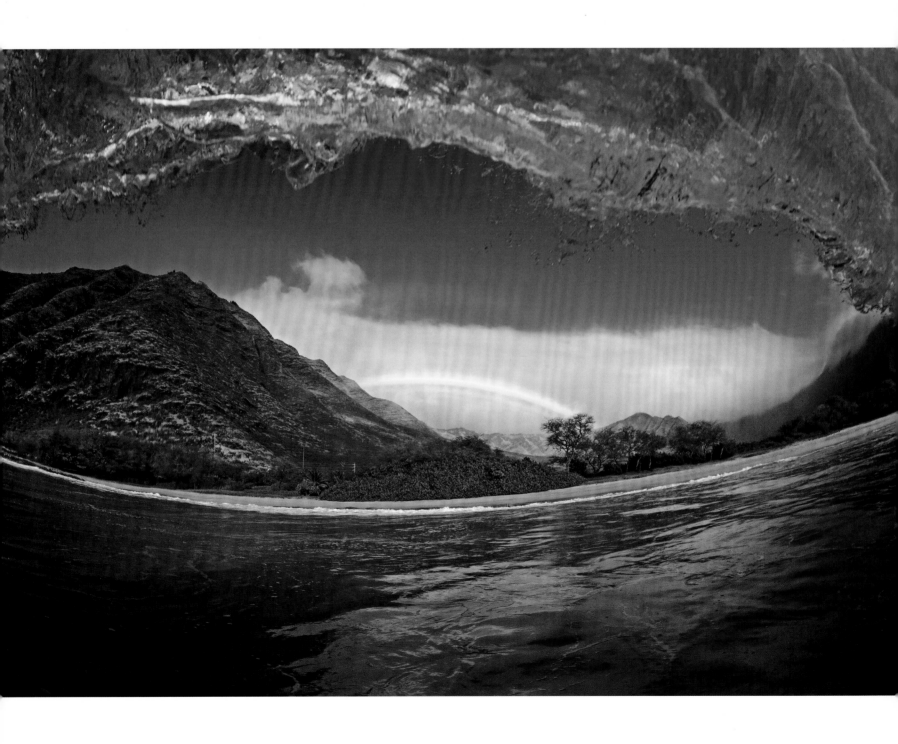

FEEL THE MANA
O'ahu

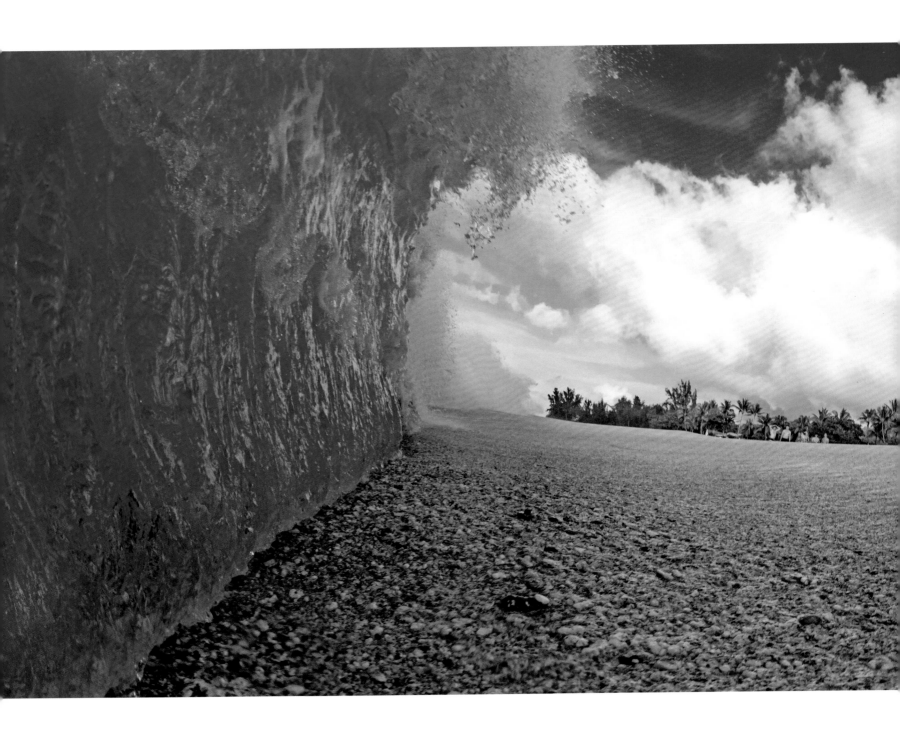

GREAT WALL
North Shore, O'ahu

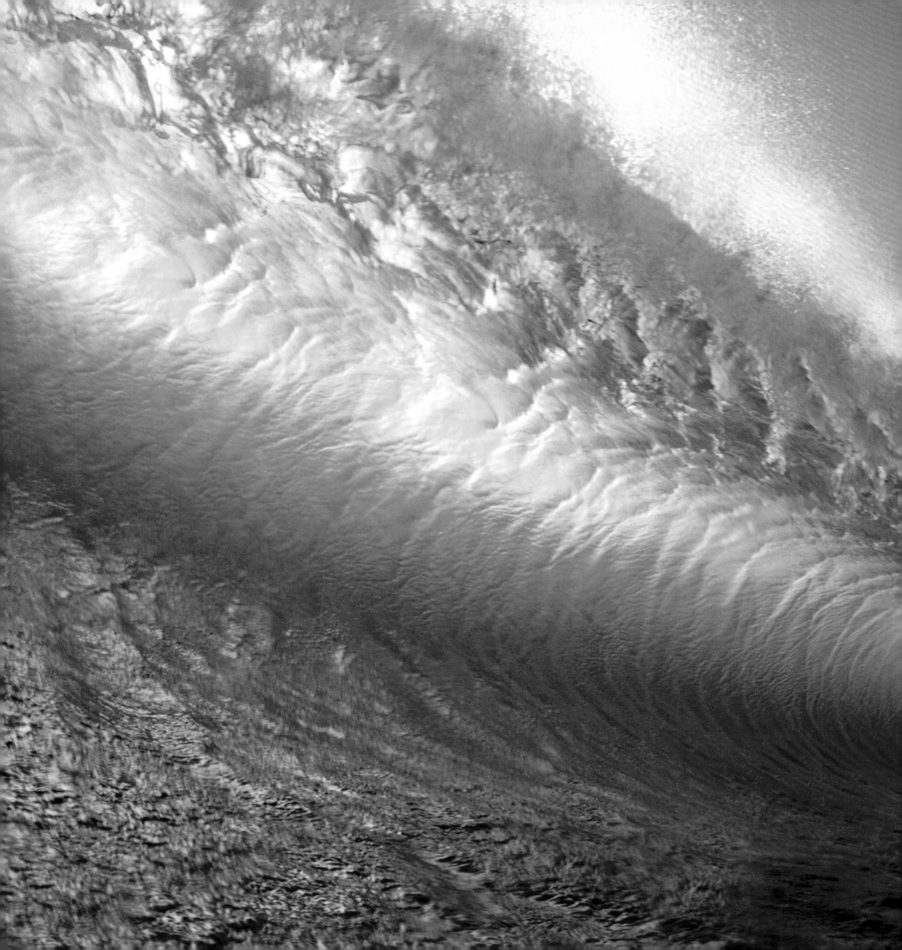

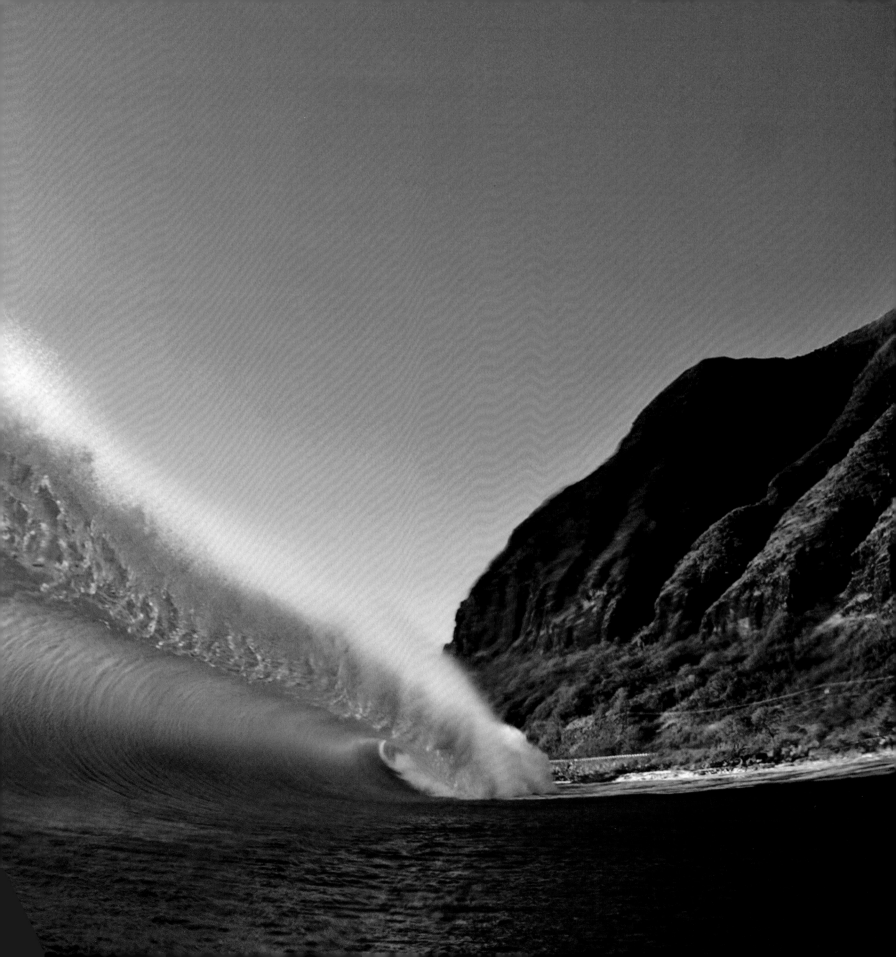

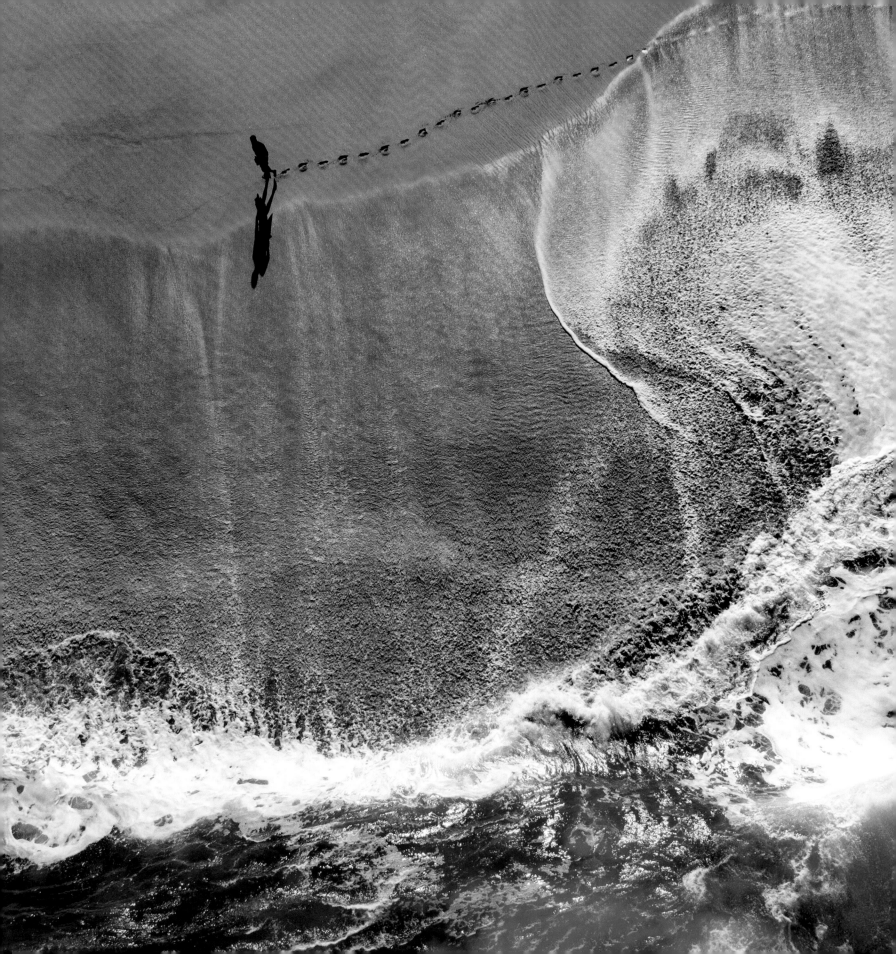

Afterword

By Clark Little

It takes a lot to nail a good shot. Part of it is the luck of being in the right place at the right time. And part of it is doing all I can to make those variables work in my favor. As the wave's forming, and the rip is pulling me out, I'm trying to get into that perfect spot where the barrel's coming over my head. There's a lot of tugging, a lot of pulling, a lot of fear. *Should I go out and not get sucked over the falls, or should I commit and kick really hard and try to get the shot and get sucked over the falls? Do I commit, or do I not commit?* I would say 95 percent of the time people miss the shot because they don't want to get sucked over or they're scared because it's so big and powerful. Timing and positioning are everything.

There's also the timing and positioning that happens before I even get into the water. I look at Surf News Network and Surfline. I check the winds. I check the buoys out on NOAA's Weather Buoy page. Swell direction is important. Ke Iki loves the west swells. I make sure there are no big storms—heavy rain makes the water dirty. That's why I like shooting at one of my secret spots, on a different side of the island. There's not as much mud or silt; it's a harder, volcanic rock, so it doesn't stir up the ocean as much. With the offshore winds, the water color becomes a deep teal that's beautiful to photograph. But the biggest thing of all is sunshine. Without sun there's none of that contrast and those beautiful effects in the water.

I've shot waves on the neighbor islands, on the mainland, and in other countries. Ke Iki is by far my favorite spot to shoot. It's the most powerful and beautiful shorebreak wave in the whole world. The water's clear about 95 percent of the time. The view out of the barrel is incredible. And the raw power, the way the sand gets sucked into the shorebreak—there's a lot going on that translates into a great photo.

SCREAMER
O'ahu
(previous page)

CLARK LITTLE FROM ABOVE
North Shore, O'ahu
(left)
Photo by Peter King

I think my best shot so far is *Rainbow Shave Ice*. Between the blue of the ocean, the high clouds, the transparency, and the coconut trees in the background—it just represents Hawai'i in a nutshell. *Rainbow Shave Ice* is a small reef wave. I've learned that it's not always the big ones that are beautiful. With the big, thick ones there are usually four lips, which looks powerful and gnarly. But with the small, clean, glassy ones, I get this crystalline glass sculpture effect.

I shoot with a high shutter speed. I use a fish-eye lens, or a 24 millimeter, which gives that deep depth of field. I usually focus in at about three feet to infinity, which means that everything I shoot will pretty much be in focus. It's important to capture the sandy beach, or the mountains, or the coconut trees, or whatever is in the background, as well as the wave breaking over. I usually use shutter priority, so my f-stop changes automatically. There are so many variables. But the main thing is getting in the right spot to take the shot.

What's helped me most of all, no doubt, is my decades of surfing and bodysurfing experience. But I also think my seventeen years working at the botanical garden has helped as well. Landscaping with flowers and bamboo, shaping a garden to get that perfect scape. In the ocean, it's the same thing— waves breaking over, and I'm looking at the background, balancing everything out. Whether on the land or in the ocean, it's all working with the natural elements, right?

RAINBOW SHAVE ICE
North Shore, O'ahu

A flash attached to the top of the camera housing was inserted into the face of a moving wave, firing at the perfect moment, illuminating the water and ocean floor beneath. Colors and shapes from three worlds—land, sky, and water—converge together. The name of this image comes from the Hawaiian shave ice (snow cone) flavor that includes all of the colors in a rainbow.

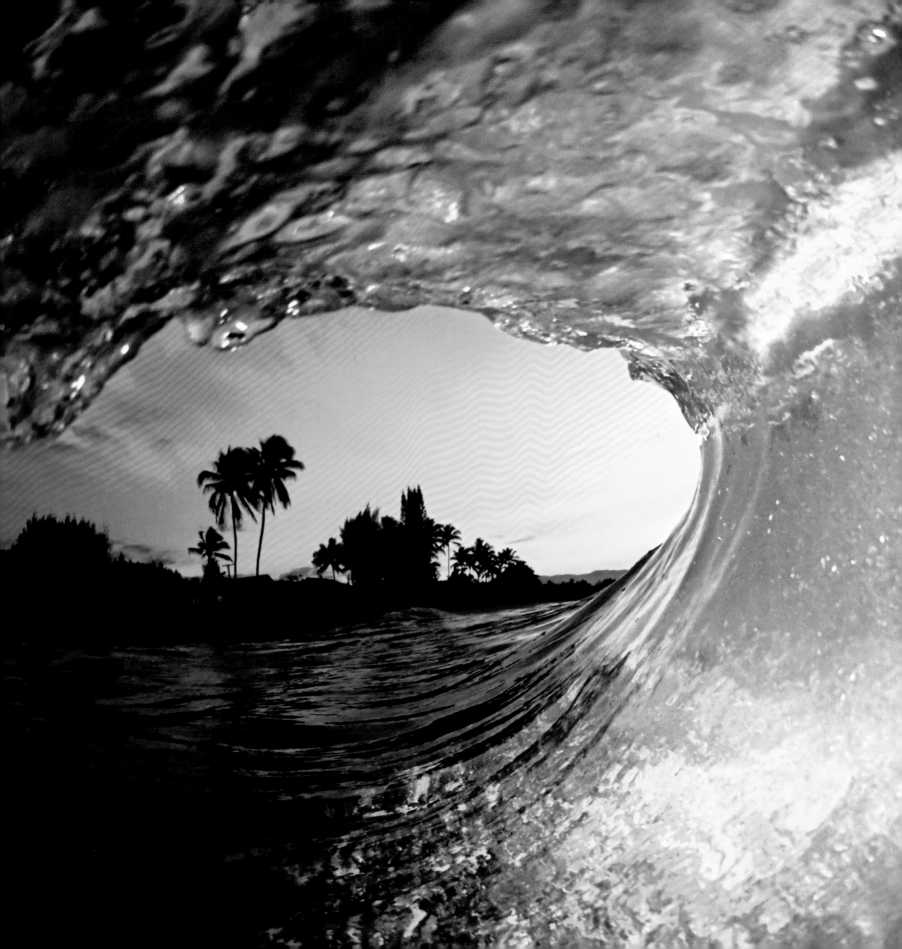

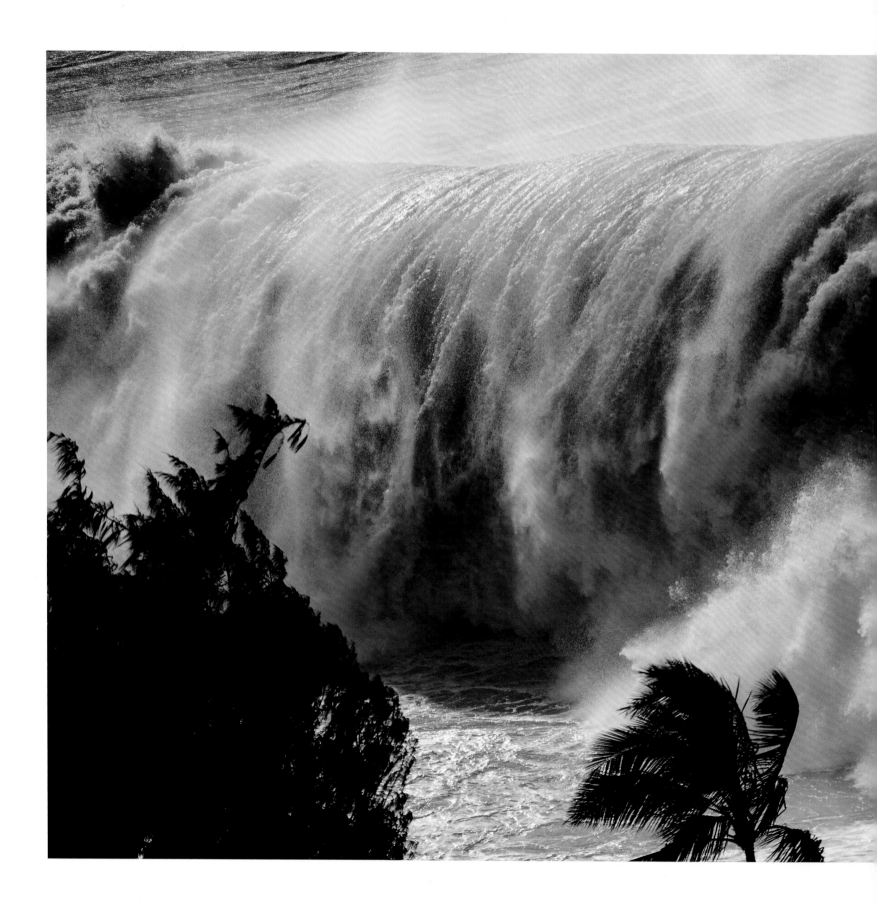

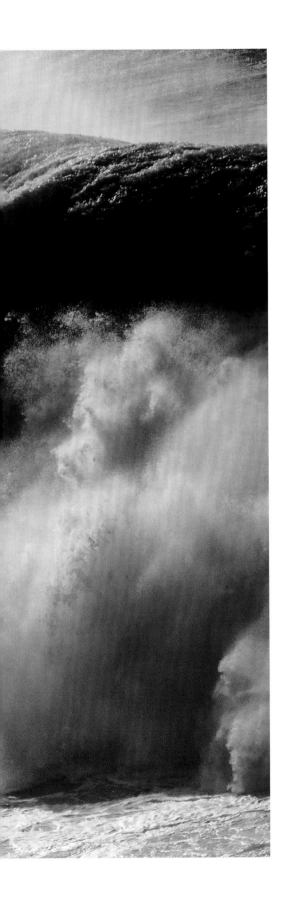

What I do takes maximum physical fitness. I have to be an athlete and a photographer. I have to be in shape and know the ocean. To get that heavy, big, five-lip shot, I have got to put myself in heavy situations. In the winter, when it's firing, I'll do three to six hours per session, sometimes two in a day. I can lose up to fifteen pounds during the season. So if I'm not shooting every day, I'll do pullups, bench presses, and lunges for my legs—about an hour workout, a couple of times a week.

Several years ago, I was way out in the middle of Ke Iki during a powerful swell, and there was this huge set. I was kicking as hard as I could, but it just broke right in front of me. I was so far out there. The waves just kept coming and landing on my head, pushing me deep into the ocean. I would make it back up just in time to get another breath before the next one landed on me. After getting ragdolled by seven or eight waves and held under for extended periods, my body started to weaken and I started to fade out. My family was flashing through my head. I was able to get through this on my own, but when I made it back to shore, I did some serious reflecting. Now I'm more cautious before I go out in extra large surf.

But I like big waves. On a personal level, they are more exciting for me. Just that feeling of the wave sucking up, and I'm standing there in knee-deep water, holding my housing up, thinking *Holy crap!* Then hammering the trigger and committing to it. It feels personal. And I think it relates to my brother Brock, who passed away in 2016. He's always been a big inspiration, the person I've looked up to all my life. He took care of me from when I was a baby all the way through grade school. He was a crazy surfer, loved big waves, loved the ocean. It's neat to be able to be in the ocean just like he was all his life.

EDDIE BIG WAVE
Waimea Bay, O'ahu

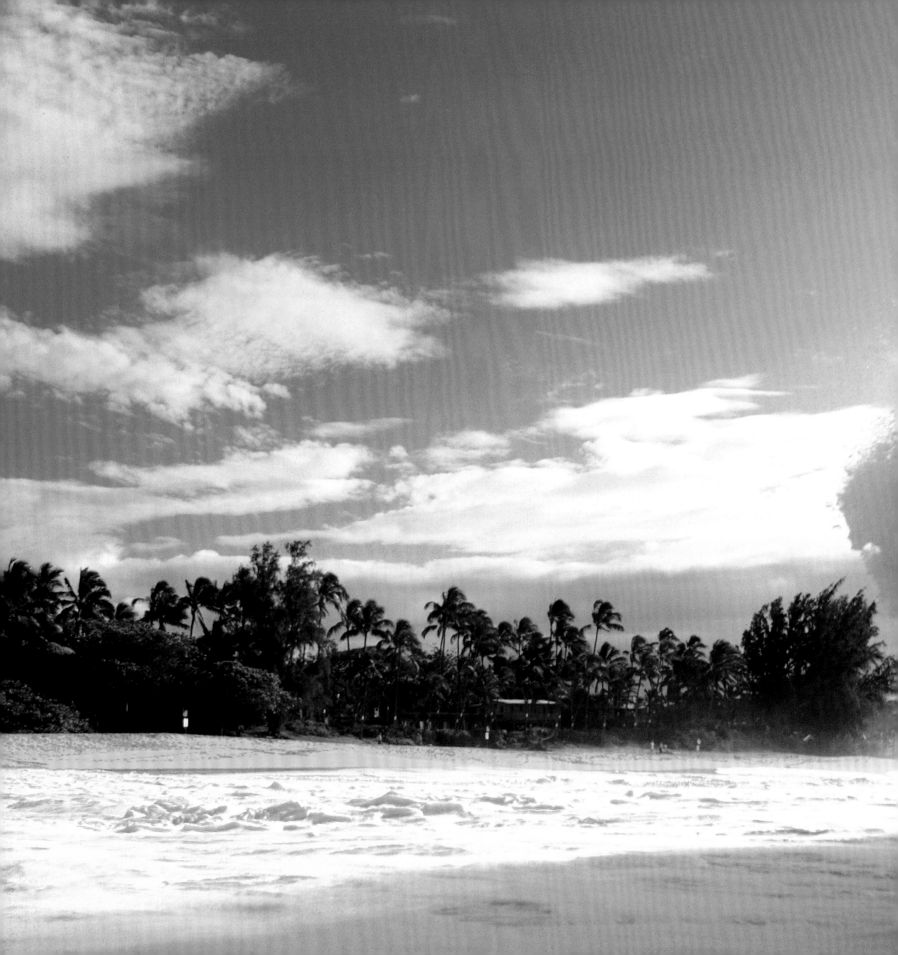

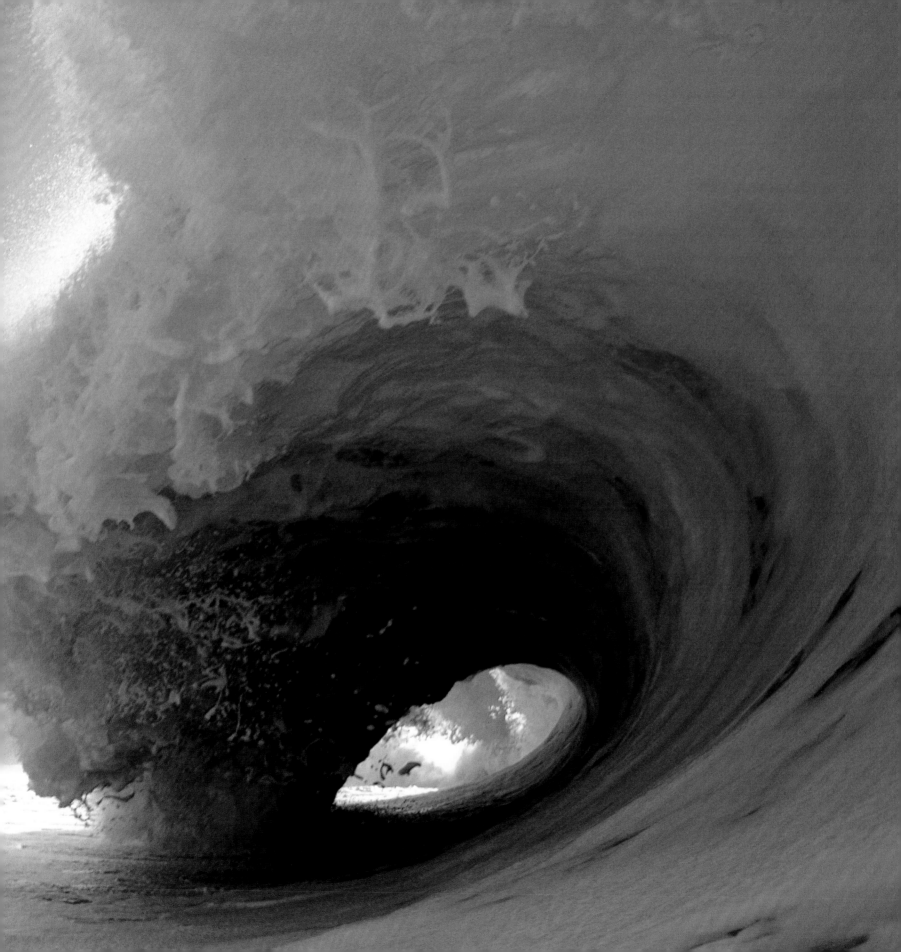

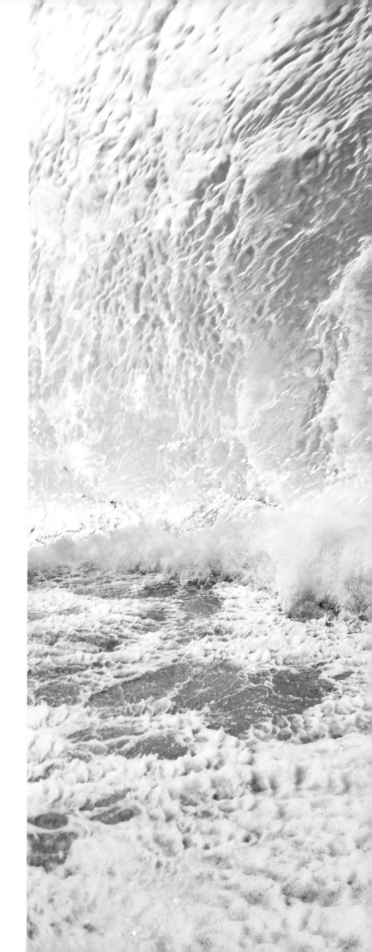

"There are so many tricks and techniques I do to stay safe. Tuck and roll. Land as flat as I can. Run underwater through the wave with the camera tucked under my arm like a football. Do a burst of kicking with my fins. Anchor myself using my free hand or fins. I have an arsenal of countermeasures that work with different situations. I do it without thinking."

THRILLER
North Shore, O'ahu
(previous page)

YUKI CAVE
North Shore, O'ahu
(right)

210

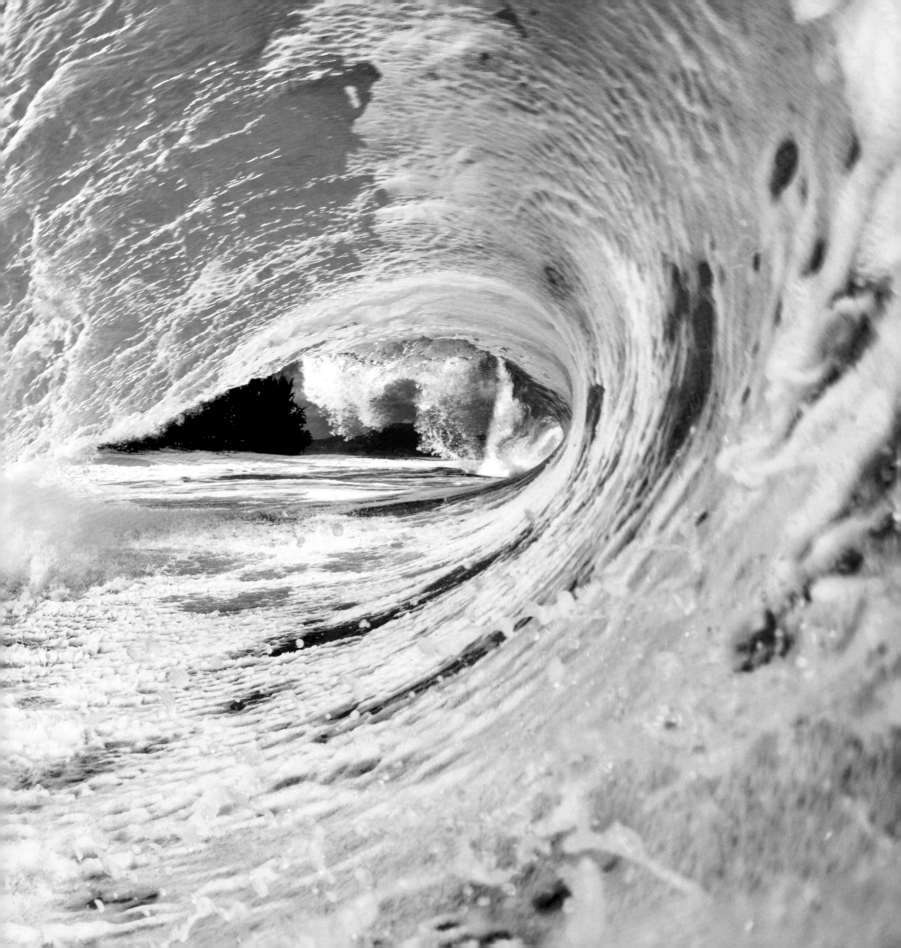

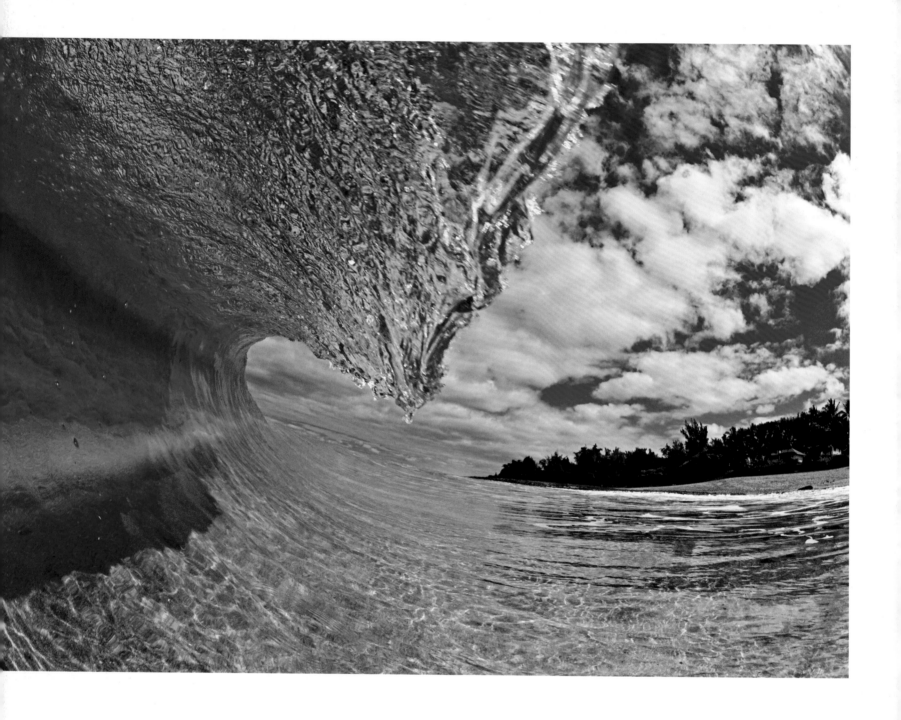

JADE
North Shore, O'ahu
(above)

SKY BLUE
North Shore, O'ahu
(right)

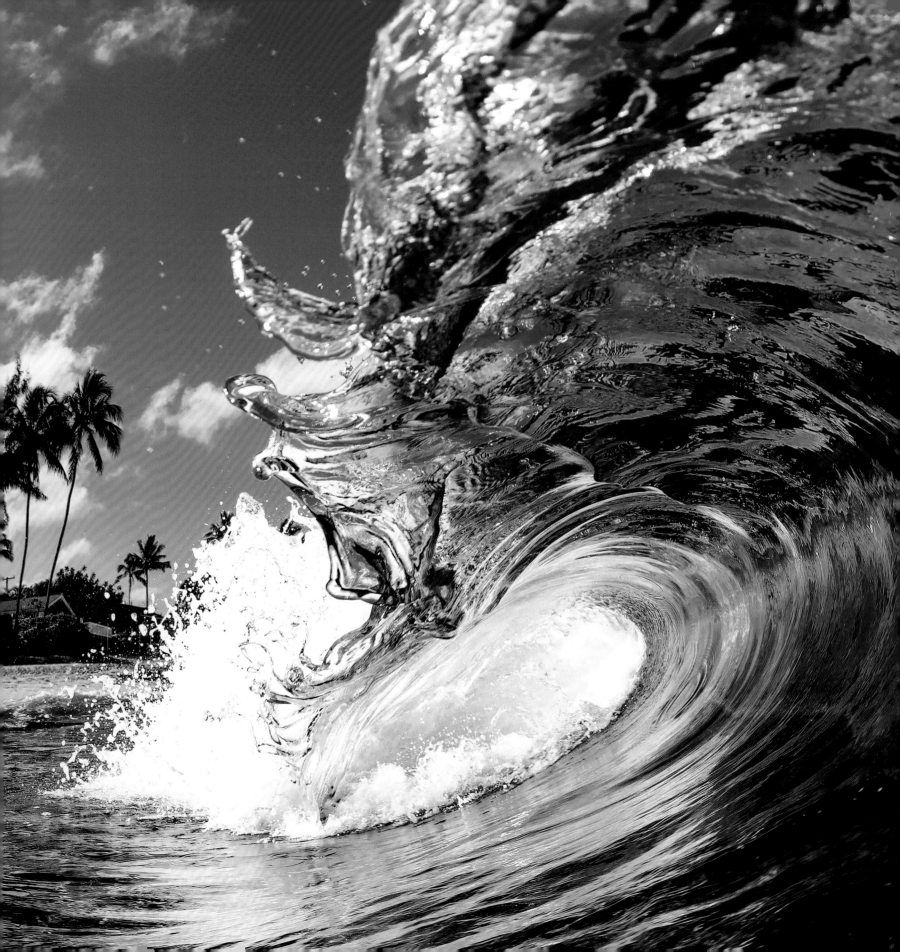

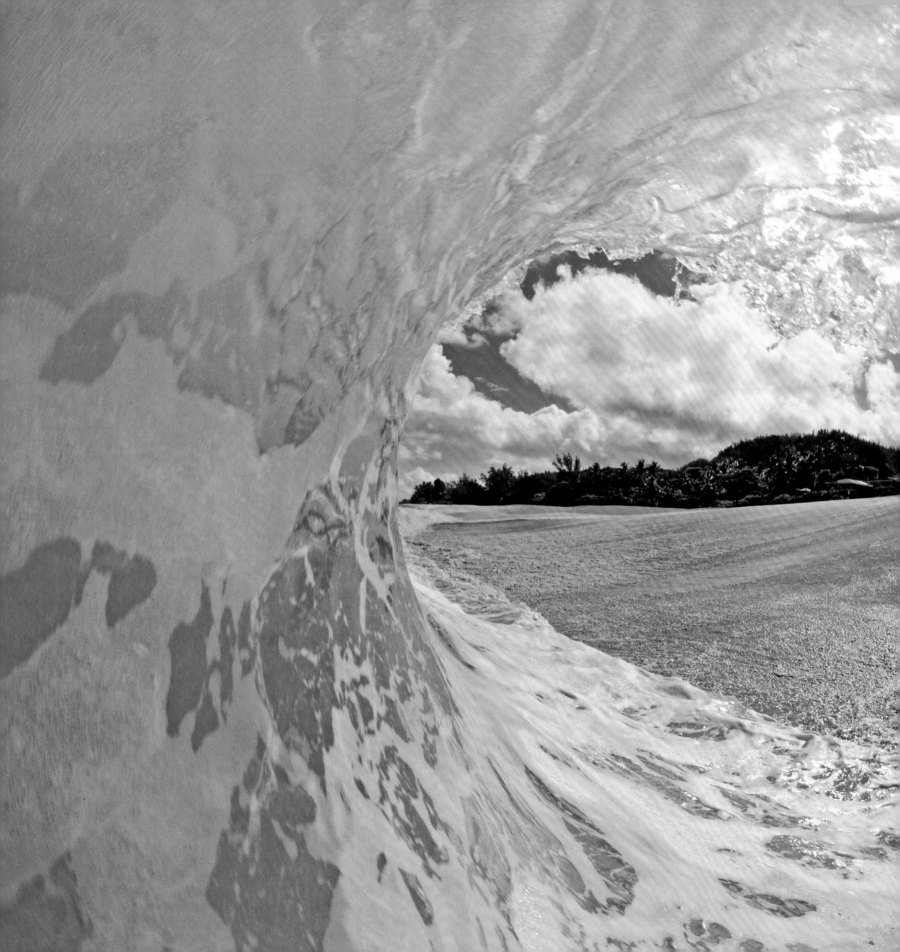

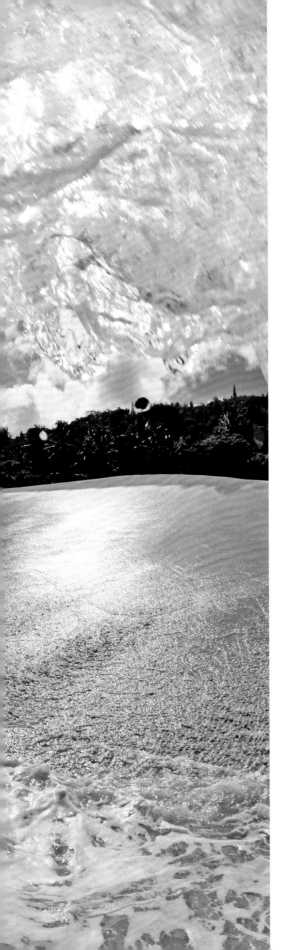

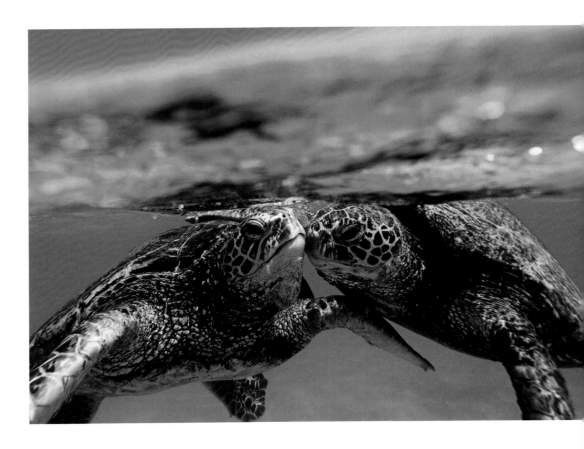

SAND AND SEA
North Shore, O'ahu
(left)

HONU KISS
North Shore, O'ahu
(above)

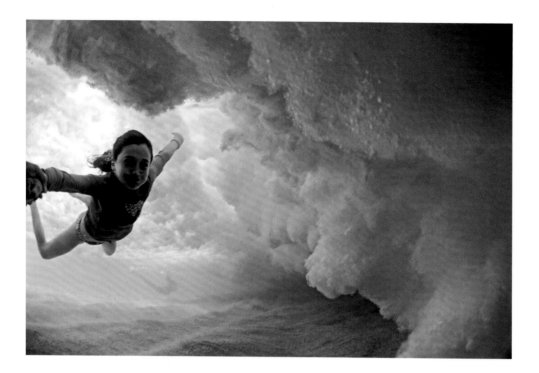

Acknowledgments

From Clark Little:

To my father, Jim; my wife, Sandy; and my children, Dane and Allison, for their love and unwavering support.

To the team at Clark Little Enterprises including Rich Tully (Media & Licensing); Karli Nakasone (Operations); Patricia Lavarias and Sandy Little (Text & Editing), for their work on this book and other projects throughout the year. To Kelly Slater and Jamie Brisick, for masterfully putting into words their thoughts and insights. To the contributing photographers, for capturing behind-the-scene shots and often putting themselves on the line to get them. To the team at Ten Speed Press, for the vision of this project and bringing it to realization. To my friends, fans, and fellow shorebreak fanatics, for all of their encouragement along the way.

From Jamie Brisick:

I would like to thank Clark Little, Rich Tully, and Sarah Malarkey for bringing me on board this excellent project.

CLOUD SWIMMING WITH ALLY
North Shore, Oʻahu
(above)

STAMPEDE
North Shore, Oʻahu
(right)

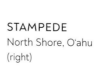

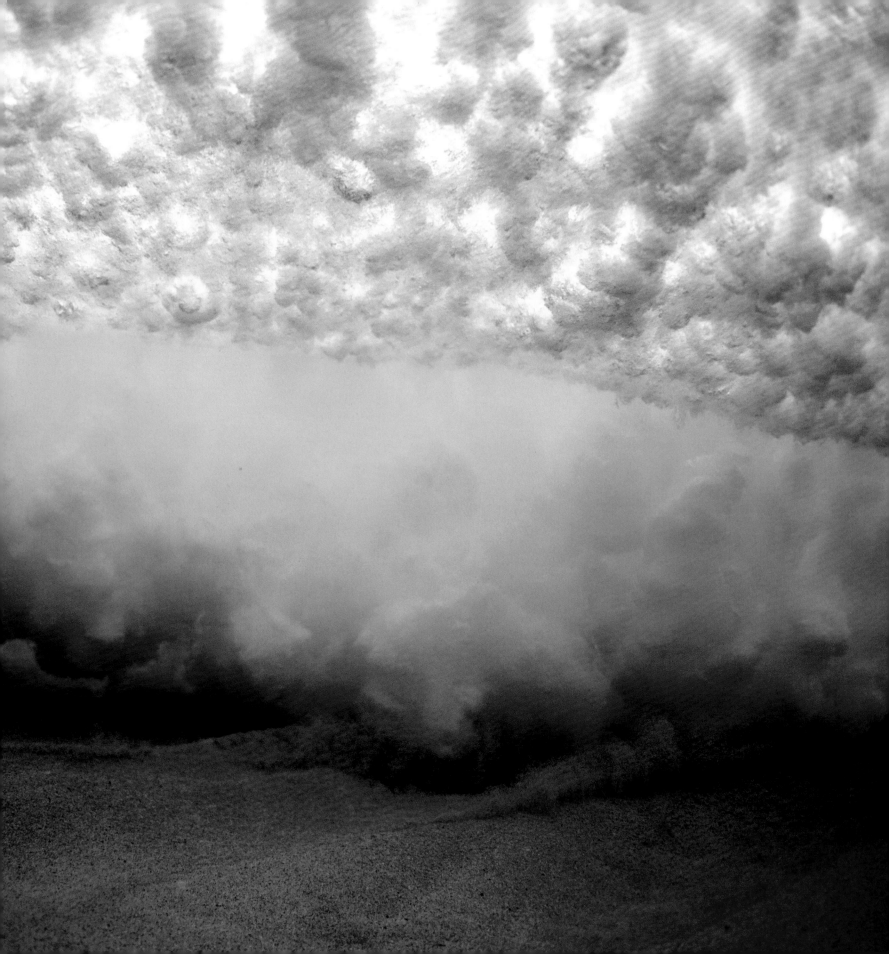

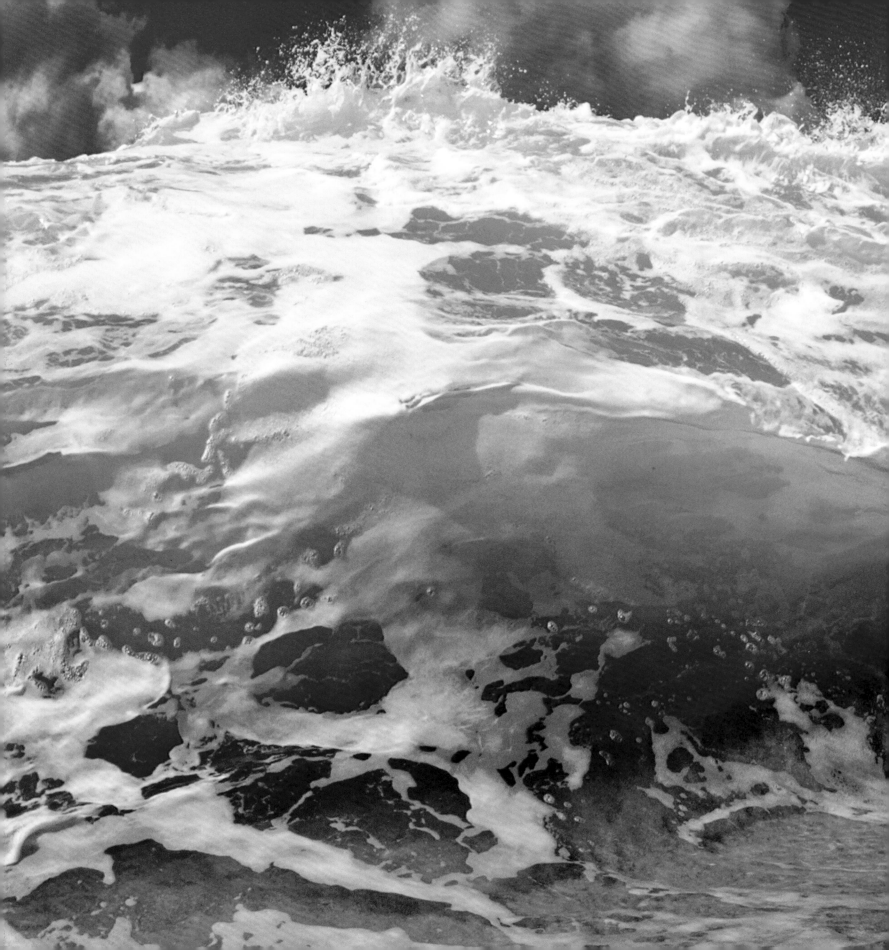

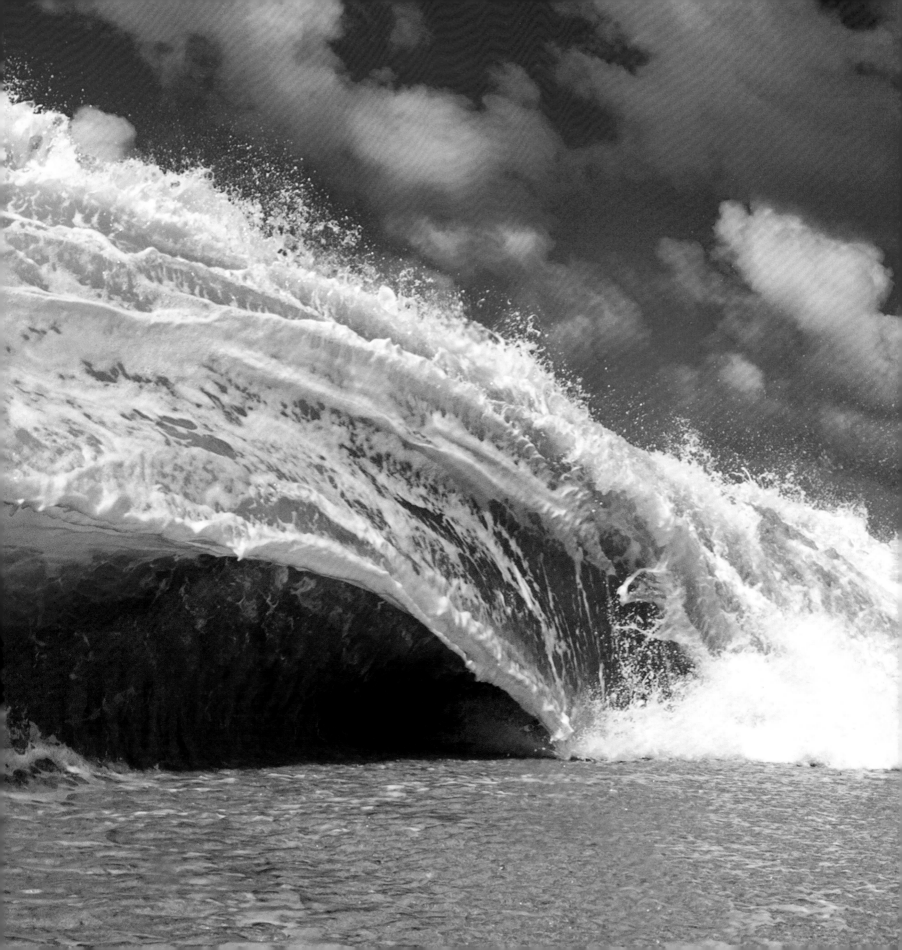

Additional captions

previous page: **WET SLAB**
North Shore, Oʻahu

this page: **CIRCLING**
North Shore, Oʻahu

back cover: **BACKSTAGE PASS**
North Shore, Oʻahu
Photo by Dane Little

front cover: **SKY BLUE**
North Shore, Oʻahu

page i: **HAWAIIAN SNOW**
North Shore, Oʻahu

page ii: **PSYCHEDELIC**
Mākena Beach, Maui

page iv: **RISE AND SHINE**
Hāpuna Beach, Hawaiʻi Island

page vi: **ʻEHUKAI**
North Shore, Oʻahu

page viii: **DOWN THE LINE**
North Shore, Oʻahu

Copyright © 2022 by Clark Little
Photos copyright © by Peter King: pages 194, 202
Photos copyright © by Jerrett Lau: pages 16, 17, 43, 56, 115
Photos copyright © by Dane Little: page 186, back cover
Photos copyright © by Juan Oliphant: pages 80, 90, 102
Photos copyright © by Tharin Rosa: pages xvi–xvii
Photo copyright © by Kelly Slater: page x
Photos copyright © by Jacob VanderVelde: pages 44, 145
Photographs in this book can be purchased at www.ClarkLittle.com

All rights reserved.
Published in the United States by Ten Speed Press, an imprint of Random House,
a division of Penguin Random House LLC, New York.
www.tenspeed.com

Ten Speed Press and the Ten Speed Press colophon are registered trademarks
of Penguin Random House LLC.

Some of the photos in this work by Clark Little were previously published.

Library of Congress Cataloging-in-Publication Data
 Names: Little, Clark, 1968– photographer. | Brisick, Jamie, writer of added text.
 Title: Clark Little: the art of waves / Clark Little; with Jamie Brisick;
 foreword by Kelly Slater.
 Other titles: Art of waves
 Description: First edition. | Emeryville: Ten Speed Press, 2022.
 Identifiers: LCCN 2021015336 | ISBN 9781984859785 (hardcover)
 Subjects: LCSH: Marine photography—Hawaiʻi. | Ocean waves—Pictorial works. |
 Seashore—Hawaiʻi—Pictorial works. | Little, Clark, 1968–
 Classification: LCC TR670 .L57 2022 | DDC 779/.37—dc23 LC record available at
 https://lccn.loc.gov/2021015336

Hardcover ISBN: 978-1-9848-5978-5

Printed in China

Editor: Sarah Malarkey | Production editor: Kim Keller
Designer/Art director: Emma Campion | Production designer: Mari Gill
Production and prepress color manager: Jane Chinn
Copyeditor: Kristi Hein | Proofreader: Adaobi Obi Tulton
Publicist: Natalie Yera | Marketer: Daniel Wikey

10 9 8 7 6 5 4 3 2 1

First Edition